Impressionism:
The First Collectors

Anne Distel

Impressionism:
The First Collectors

Translated from the French by Barbara Perroud-Benson

Harry N. Abrams, Inc.
Publishers, New York

Originally published in French under the title *Collectionneurs des Impressionnistes*

Library of Congress Cataloging-in-Publication Data

Distel, Anne.
[Collectionneurs des impressionnistes. English]
Impressionism, the first collectors, 1874—1886 / by Anne Distel ;
translated by Barbara Perroud-Benson.
p. cm.
Translation of: Les collectionneurs des impressionnistes.
Includes bibliographical references.
ISBN 0-8109-3160-5
1. Impressionism (Art)—France. 2. Painting, French.
3. Painting, Modern—19th century—France. 4. Painting—Private
collections. 5. Painting—France—Paris—Marketing. I. Title.
ND547.5.I4D5913 1990
759.05'4'075—dc20 89-18134

Copyright © 1989, 1990 Editions Trio, Franz Stadelmann, Düdingen/Guin, Switzerland

Published in 1990 by Harry N. Abrams, Incorporated, New York
All rights reserved. No part of the contents of this book may be
reproduced without the written permission of the publisher

A Times Mirror Company

Printed and bound in Italy

Contents

Introduction

"The public that laughs so loudly while looking at the Impressionists is in for an even bigger surprise: their paintings sell!"

(Théodore Duret, *Les Peintres impressionnistes*, Paris, 1878)

More than a century has passed since Duret wrote those lines. The Impressionists, spoken of disparagingly in 1874, have long since entered the annals of history. Their paintings, universally admired, are regularly ranked among the most expensive works of art in the world, accessible only to the very rich and to the largest museums. How did that happen?

In his booklet, Théodore Duret presents himself as one of the eccentric first collectors willing to buy an Impressionist painting. In addition to himself, he lists (in alphabetical order!): "Messrs. D'Auriac [sic], Etienne Baudry, De Belio [sic], Charpentier, Choquet [sic], Deudon, Dollfus, Faure, Murer, De Rasty." The collectors whose names (several of which have been misspelled: the first being, in all likelihood, that of Count Armand Doria) appear on that list will be the subject of this book. By adding a few other collectors that Duret does not mention, we can draw up a small directory of those who were convinced at the outset of the artistic eminence of Monet, Degas, Cézanne, Renoir, Pissarro, and Sisley (as well as Manet, who was older).

The prescience of these collectors has long been recognized; it would be superfluous to praise them. Their names are familiar to everyone—art historian and layman alike—who has dealt with the history of the Impressionist movement, flipped through the catalogues listing the successive owners of a work, or dreamt (turning the pages of reproductions in an auction catalogue) of the incredible museum that any one of them might still have possessed at the beginning of this century. Historians have devoted more or less detailed monographs to many of these collectors and their collections. Bringing them together in the same study enables us to emphasize both their differences and their common ground: the conviction of having made the right choice.

It must be added that, while the collectors' names and their collections are quite well known—or can at least be reconstructed—scant research has been devoted to their lives. These first collectors of Impressionism lived at a period when "gentlemen of independent means" abounded; sometimes it is even hard to learn what occupations they had apart from their collections. The aim of this book is to clarify the biographies of the first private collectors of Impressionism. Because an exhaustive study is not possible within these limited pages, the following chapters propose, not unlike the almanacs and dictionaries that the nineteenth century loved so much, "snapshots" of each of these collectors. By juxtaposing these portraits, with their similarities and contrasts, we hope to provide a sharper image of this small circle of art enthusiasts.

There is no question here of covering the lives of the collectors of Impressionism for the past hundred years. It would require enormous research, and the secrecy in which today's collectors wrap themselves—fearing robbery or taxes—would render

1 Edouard Manet. *Portrait of Théodore Duret*. 1868. Oil on canvas. 43 × 35 cm. (17 × 13¾″). Musée du Petit Palais, Paris (Gift of Théodore Duret, 1908).

My dear Manet,
My job as a journalist does not allow me to repay you for your portrait according to the artistic merit of the painting and, not wanting to pay a venal price, I am sending you a little souvenir from Cognac and a token of gratitude. You will receive [at] 49 Rue Saint-Petersbourg a case of old Cognac brandy that you need not be afraid to let your friends sample.

Letter from Théodore Duret to Edouard Manet, Cognac, September 23, 1868

Duret had asked Manet (July 20, 1868) to conceal his signature, "in that way, you will give me the time to have [people] admire the picture and the painting. I should be able to say that it is a Goya, a Regnault, or a Fortuny. A Fortuny!!! That would be especially admirable. Then, I would reveal the secret; and the bourgeois, taken in, would be forced to swallow [the bait]."

our research almost impossible in some cases. The period we propose to focus on in this book has been arbitrarily chosen, yet its delineators—the first and last Impressionist exhibitions in 1874 and 1886—are significant. Although the lives of these collectors extended considerably beyond that framework, those twelve years marked the height of their activities. They were the pioneering generation; others would follow, but often with different means and objectives.

We cannot discuss these private collectors without also mentioning the picture dealers, for they are inseparable. At the start, therefore, we thought it useful to provide a general picture of the art market, largely centered in Paris, which showed an interest in Manet and the Impressionists.

Paul Durand-Ruel is well known, but how familiar are we with the activities of *père* Tanguy or Pierre-Firmin Martin, to mention only two others? Here too, it is useful to distinguish between facts and legend, and to show how newcomers such as the Bernheim brothers or Ambroise Vollard carried on the work of the first generation of dealers after 1890. The importance of auctions at the Hôtel Drouot, and, later, in Georges Petit's gallery should also be kept in mind.

The Impressionist artists and their paintings might seem to be given short shrift amid all that. On the contrary. Evoking collectors such as Georges and Marguerite Charpentier means accounting for many aspects of Renoir's masterpiece, the portrait of *Madame Charpentier and Her Children*; studying the Cézannes in Victor Chocquet's collection is a means of reconstructing a lost chronology, as John Rewald has shown in an article aptly entitled "Chocquet and Cézanne."

It would be impossible to deal systematically here with the collections owned by the artists themselves, although they often provided inspiration to the collectors in question and gave them fruitful ideas. Edouard Manet and all the artists of the Impressionist group owned paintings by their comrades. At the end of the century, Monet, Renoir, and Pissarro bought works by Paul Cézanne (who was just being discovered) from all the other Impressionists. Edgar Degas was a real collector; he owned many first-class works by Ingres and Delacroix as well as paintings by Cézanne, Van Gogh, and Gauguin. The catalogues of the successive auctions of Degas's collection (in March, May, November, and December, 1918) attest to that artist's taste. Lastly, Paul Gauguin, while still a clerk at a stockbroker's, began collecting works by the Impressionists.

Nor is there room in these pages to discuss the other artists—among them, Léon Bonnat, Giuseppe de Nittis, and Ernest Duez—whose interest in Degas, Manet, or Monet was more unexpected. We shall only make an exception for two faithful participants in the Impressionist exhibitions: Henri Rouart and Gustave Caillebotte. Despite the fact that Théodore Duret intentionally—and probably at the request of the two men—left their names off his 1878 list, the exceptional roles of Rouart and of Caillebotte justify our including them in the chapters that follow.

126

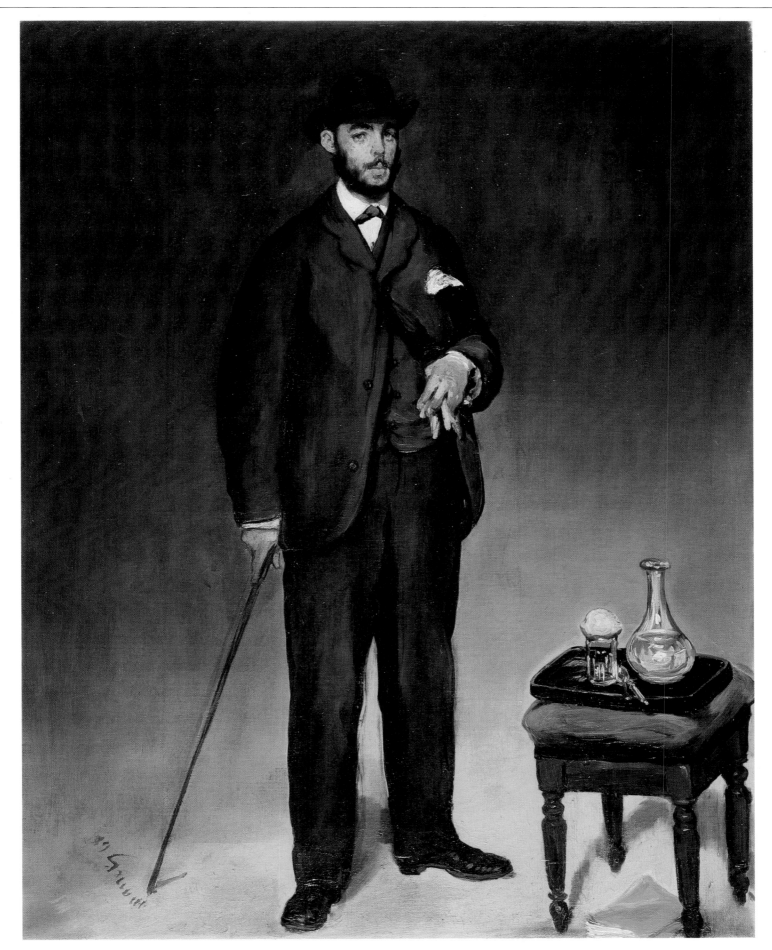

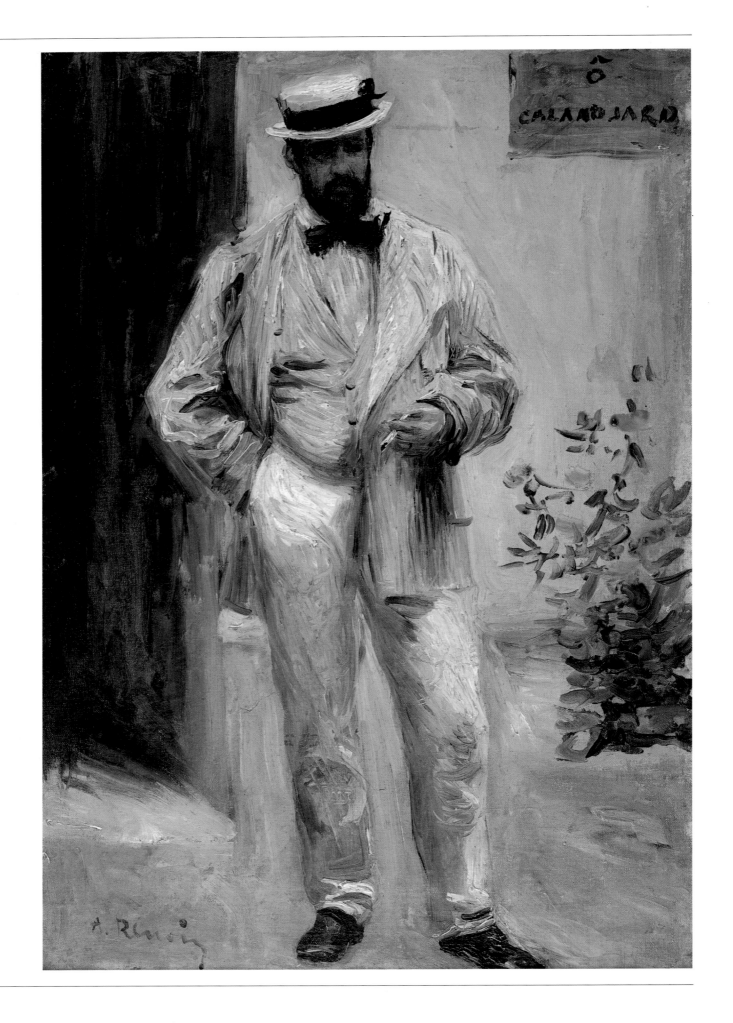

Before 1870

A Patron of the Arts in Le Havre During the Second Empire

Before a young artist succeeds in appealing to dealers and collectors, he is obliged to rely on what might be termed natural customers: relatives, family friends, and so forth. That was true of the future Impressionists. In an age when photography had not yet replaced oil painting, painting a portrait was usually the first step in an artist's professional career. Claude Monet began by painting a series of portraits for the Gaudibert family, rich shipowners in Le Havre, where Monet's family lived (and which has not forgotten Monet's zest as a caricaturist, a talent he practiced good-naturedly at the expense of some of his fellow townsmen). The municipal council had refused to give Monet a scholarship in the past, but now Parisian newspapers were printing articles about the young man in connection with the Salon. Louis-Joachim Gaudibert, Sr., who, for the past decade, had been sponsoring Amand Gautier, an emulator of Courbet's from Lille, needed nothing more to take an interest in Monet. In 1868, the year Monet painted *Madame Gaudibert* (Musée d'Orsay, Paris), he won a silver medal at Le Havre's International Maritime Exhibition. Subsequently, with a shift in opinion that was not infrequent, Messrs. Gaudibert senior and junior acquired other works by the young Claude Monet. Perhaps it was at the Gaudiberts' instigation that one of Le Havre's bigwigs pressed the ostentatious director of the magazine *L'Artiste*, Arsène Houssaye, to intervene on Monet's behalf with the all-powerful Superintendent of Fine Arts, Count Emilien de Nieuwerkerke. That intervention notwithstanding, Monet was barred from presenting a painting two days after the deadline for submitting works for the 1869 Salon. Unfortunately, Mr. Gaudibert senior, a very active provincial art patron, died young in 1870.

A Family of Architects Sponsors Renoir

The first collectors of Pierre-Auguste Renoir's work were members of a Parisian family, the Le Coeurs. When and under what circumstances Renoir encountered Jules Le Coeur (a young architect who had taken up painting in 1863), remains a mystery. By 1865, the two men were already good friends, and Renoir depicted his friend twice in famous paintings dated 1866: *At the Inn of Mother Anthony, Marlotte* (Nationalmuseum, Stockholm), and *Jules Le Coeur in Fontainebleau Forest* (Museu de Arte Moderna, São Paulo). The friends took two sisters as their mistresses: Lise Tréhot, Renoir's mistress and model for his first successful painting at the 1868 Salon, *Lise with a Parasol* (Museum Folkwang, Essen); and Clémence Tréhot, Jules Le Coeur's companion until his untimely death.

Renoir painted a series of magnificent portraits and still lifes for the Le Coeur family. Among them is the 1866 still life *Spring Bouquet*, in the Fogg Art Museum, Harvard University, Cambridge, Massachusetts. Jules's brother, the architect Charles Le Coeur, even saw to it that Renoir received a commission to paint the ceilings in the mansion Charles was building for Prince Gheorghe Bibesco on Avenue de la Tour Maubourg in Paris. Charles Le Coeur sat outdoors for his portrait by Renoir (Pl. 2); this small painting is apparently the last one Renoir painted for the family, probably **11**

10

3 Pierre-Auguste Renoir: Letter to Charles Le Coeur. c. 1866–68. Private collection.

My dear Mr. Charles,
If you want, ask your good lady whether she wants me to do her full-length portrait, holding Jo by the hand. In the garden on days when the weather will be cloudy and on days when the weather will not be cloudy, from 6 to 7 p.m. As I think you will not be leaving for Berck [a holiday place in the country on the French coast of the English Channel] for a fortnight, I would have the time to finish my portraits. But, there is a but. Beware. If you agree to what I ask, you will have to pay for the canvas, since it would be impossible for me to ask Carpentier [Renoir's paint dealer] for it; he would refuse altogether.

As soon as you decide, do write to Carpentier to send you a *thin, very smooth (several layers) 120* canvas [c. 77 × 51″] immediately.

There is a stretcher for a canvas of that size somewhere in the attic or storeroom; you might tell Carpentier just to bring the canvas and nail it on that stretcher, though the job would perhaps be quite long.

If there is no way, don't hesitate to leave me in the lurch. It would only be that. In any case, I shall come on Friday evening at 6 o' clock, to work if the canvas has arrived and to do nothing if that is not possible. Don't count on me too much. One never knows what may happen. I may find the [horse] omnibuses full and not be able to come as far as Rue Humboldt.

My kind regards to your whole charming family.
A handshake for you.
A. Renoir

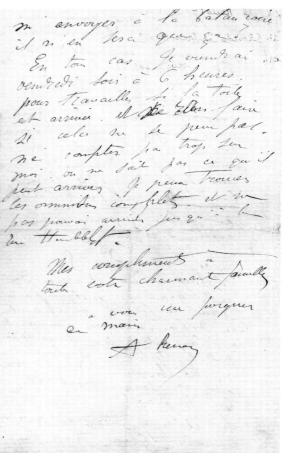

12

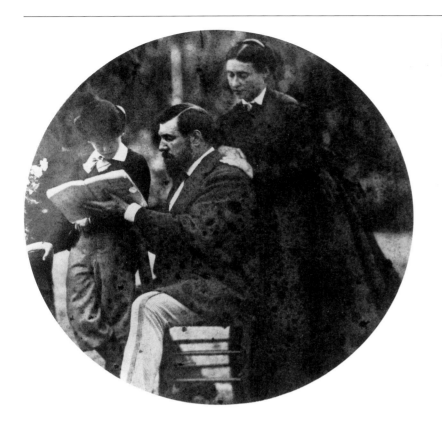

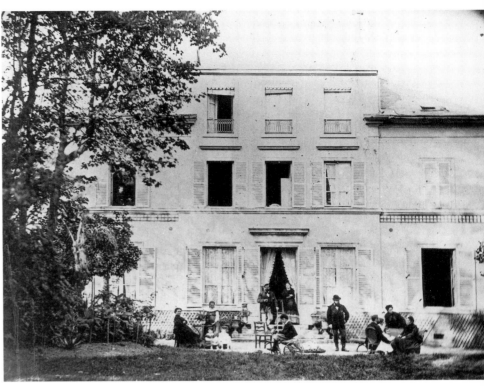

4 Anonymous. *Charles Le Coeur, His Wife Marie, and Their Son Joseph.* c. 1870. Photograph. Private collection.

5 Anonymous. *The Le Coeurs' House on Rue Humboldt,* (now Rue Jean Dolent). c. 1870. Photograph. Private collection.

Charles Le Coeur is standing on the stoop; Jules Le Coeur is standing toward the right, and their brother-in-law, Ferdinand Foucqué (a mineralogist and professor at the Collège de France) is sitting at the right. Charles's son Joseph is playing with a mechanical horse.

6 Anonymous. *The Le Coeur Family.* c. 1870. Photograph. Private collection.
Madame Joseph Le Coeur's daughters, daughters-in-law, and grandchildren are gathered around her. Marie Le Coeur, Charles's oldest daughter, is reading on a bench, protected by her parasol.

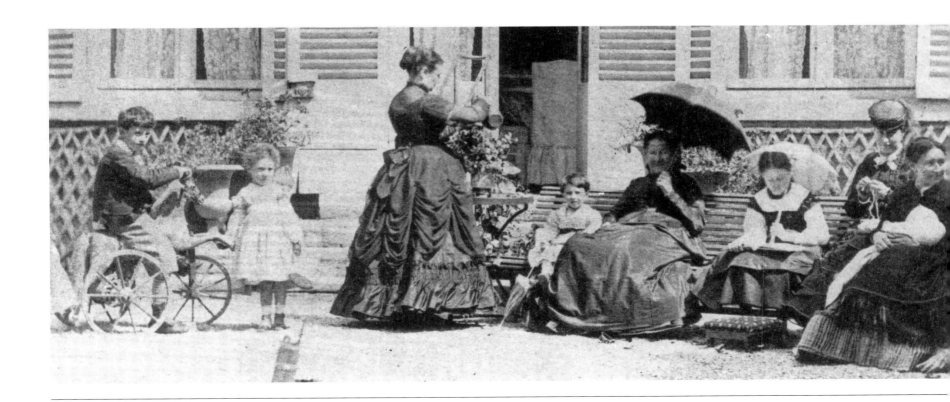

7 Pierre-Auguste Renoir. *The Garden at Fontenay*. 1874. Oil on canvas. 50 × 61 cm. (19¾ × 24″). Collection Oskar Reinhart, Winterthur, Switzerland.
The garden on Charles Le Coeur's estate at Fontenay-aux-Roses, near Paris.

14

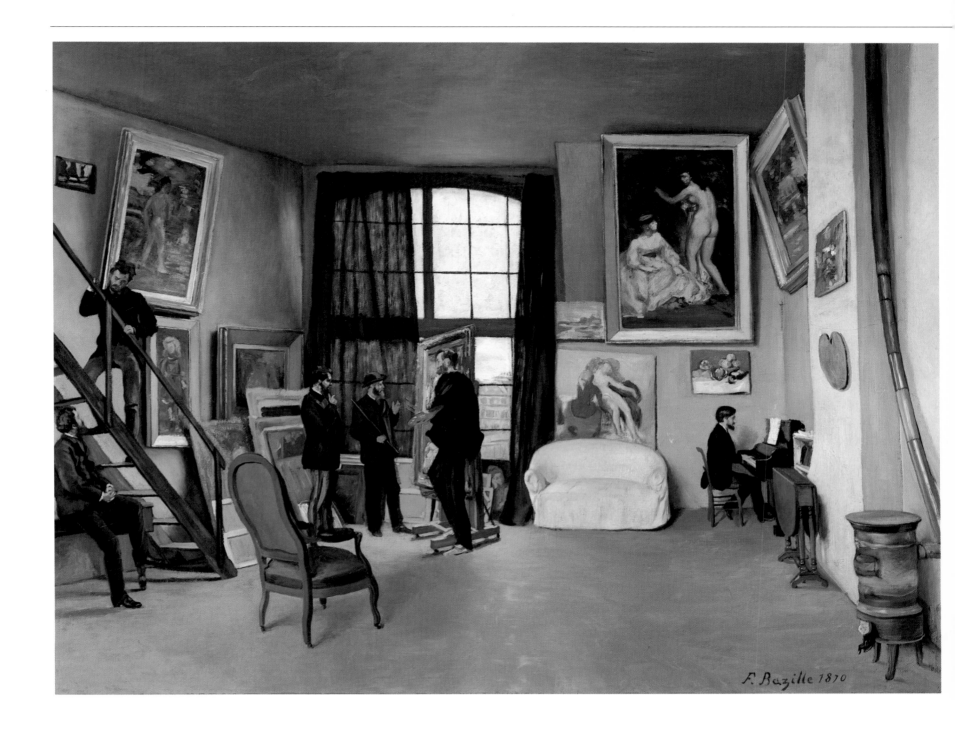

8 Frédéric Bazille. *The Artist's Studio, Rue de la Condamine.* 1870. Oil on canvas, 98 × 128 cm. (30½ × 50⅝″). Musée d'Orsay, Paris (Gift of Marc Bazille, the artist's brother, 1924).
Seldom were collectors allowed into studios. However, fellow artists, dealers, and critics (though less often) were welcome guests. Through those visitors, rumors of innovations leaked out. In this depiction of Bazille's studio, one recognizes the artist as the very tall man standing next to the easel (according to tradition, Manet painted the figure); Manet, wearing a hat and looking at the canvas on the easel; and on the right at the piano, the critic Edmond Maitre. There is some disagreement about the other figures, however. The three men on the left have been variously identified as Renoir, Sisley, Monet, Zola, and the writer and sculptor Zacha-rie Astruc. On the walls, there are many works by Bazille, but also works by Monet (the still life) and by Renoir (the big framed painting with two women). Manet and Bazille, being lucky enough to have personal wealth, often stepped in to promote sales of works by their less well-off comrades.

15

4, 5, 6

11, 159

2

10 Pierre-August Renoir. *Spring Bouquet*. 1866. Oil on canvas, 104 × 81 cm. (41½ × 31½"). Fogg Art Museum, Harvard University, Cambridge, Massachusetts (Grenville L. Winthrop Bequest).

in 1874. Le Coeur family tradition holds that the exaggerated attention Renoir paid to Marie, Charles's eldest daughter, caused him to be banished forever from the garden of their private residence.

Nevertheless, Charles Le Coeur and his wife, Marie, preserved their painting collection intact until the beginning of the 1920s. Owing to the generosity of Charles Le Coeur's heirs, two family portraits entered the Musée d'Orsay in Paris, where, coincidentally, they joined the study for Renoir's large composition *A Morning Ride in the Bois de Boulogne* (refused by the Salon in 1873) and the portrait of *Charles Le Coeur*. These works remain as a tribute to a bourgeois Parisian family, artistic enough to defy convention and buy paintings from a young, completely unknown artist.

The name Le Coeur reappears at another point in the annals of Impressionism. The first painting by Edgar Degas purchased by a French museum was the famous *Portraits in an Office: The Cotton Exchange, New Orleans*, acquired by the Society of the Friends of the Arts in Pau for the Musée des Beaux-Arts, Pau. This sale took place in 1878, at the instigation of one of the artist's friends, Alphonse Cherfils. Now, the founder of that society and the curator of the Pau museum was none other than Charles Le Coeur, the uncle of Jules and Charles. Coincidence or not, the fact is worth noting.

The Role of Fellow Artists

The efforts of Frédéric Bazille deserve particular mention. Bazille was an artist who came from a prosperous, upper middle-class Protestant family in Montpellier. Bazille's uncle collected paintings and was a friend of another collector, Alfred Bruyas, the hero of Courbet's renowned *The Meeting, or Bonjour M. Courbet* of 1854 (Musée Fabre, Montpellier). Consequently, Bazille tried to encourage his uncle to buy Monets. In Paris, Bazille put up Monet and Renoir in his studio. He became a

9 Anonymous. *Inside the Home of Charles Le Coeur*. Early twentieth century. Photograph. Private collection.
In the suite of morning rooms, one recognizes several works by Renoir, in particular, at the far end, *Spring Bouquet* (Pl. 10), 1866, and in the middle in the second row, the portrait of Madame Darras, known as *The Horsewoman* (Pl. 11). Lastly, at the far right, on the shelf, there is a small portrait of *Joseph Le Coeur as a Child*.

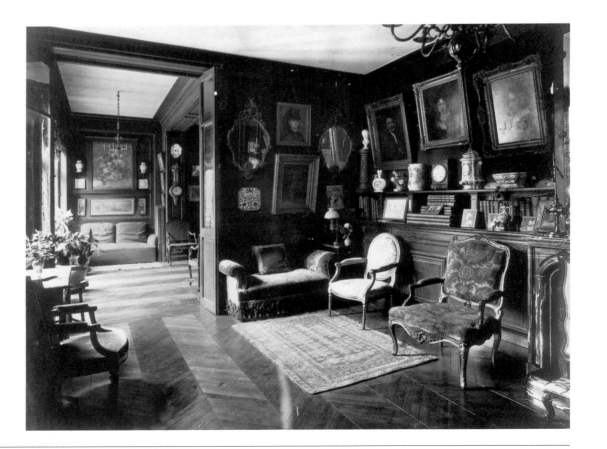

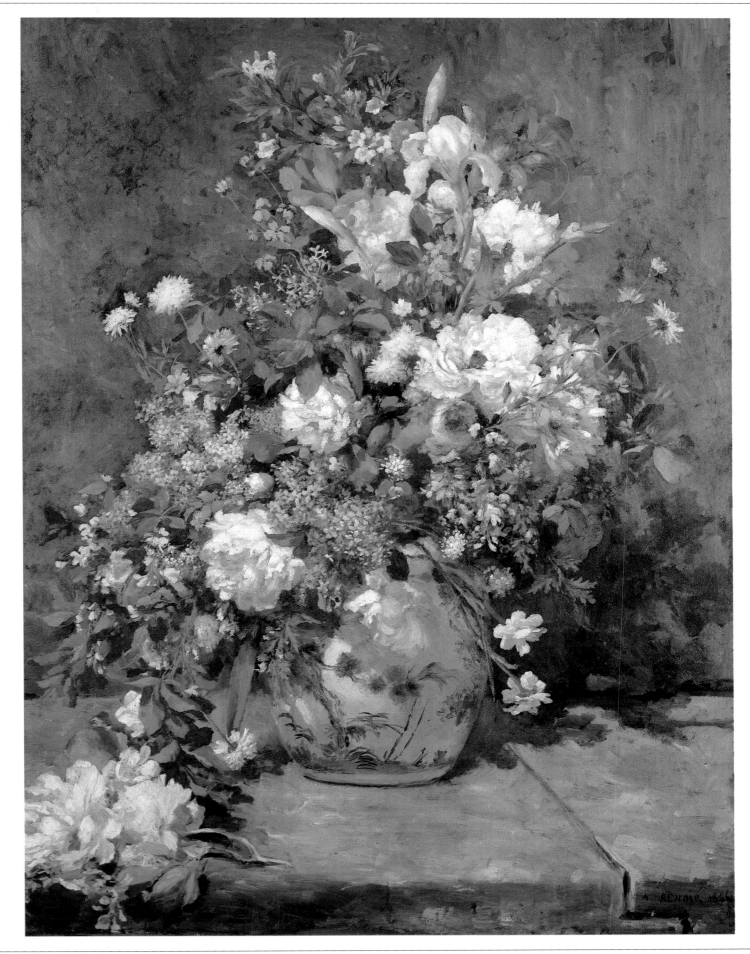

17

11 Pierre-Auguste Renoir. *The Horse-woman*, study for *A Morning Ride in the Bois de Boulogne*. 1872–73. Oil on canvas, 47 × 39 cm. (29 × 15″). Musée d'Orsay, Paris (Gift of Baroness Eva Gebhard-Gourgaud, 1965). Madame Darras, who sat for the large picture refused by the jury for the 1873 Salon (see Pl. 159), was the wife of Paul-Edouard Darras, a professional soldier, an amateur artist, and a friend of the Le Coeurs. Both of them had their portraits painted by Renoir.

▷
12 Claude Monet. *Women in the Garden*. 1866-67. Oil on canvas, 255 × 205 cm. (100½ × 80¾″). Musée d'Orsay, Paris.

collector himself and bought—on credit—Monet's *Women in the Garden*, refused by 12 the Salon of 1867. Acquiring a work in defiance of the Salon's admissions jury, alleged to be omniscient, was an act of independence that was not surprising on the part of Bazille: he was an artist himself and engaged in the battle against that jury's dictatorship. His attitude prefigures the type of collector the new school needed to survive.

Other early collectors of Impressionism would be recruited, like the Gaudiberts and the Le Coeurs, by the artists' own word-of-mouth grapevine. But the majority would owe their introduction to the paintings of Manet and the Impressionists to a combination of picture dealers and auctions operating in a booming art market that deserves the attention we shall give it in the following three chapters.

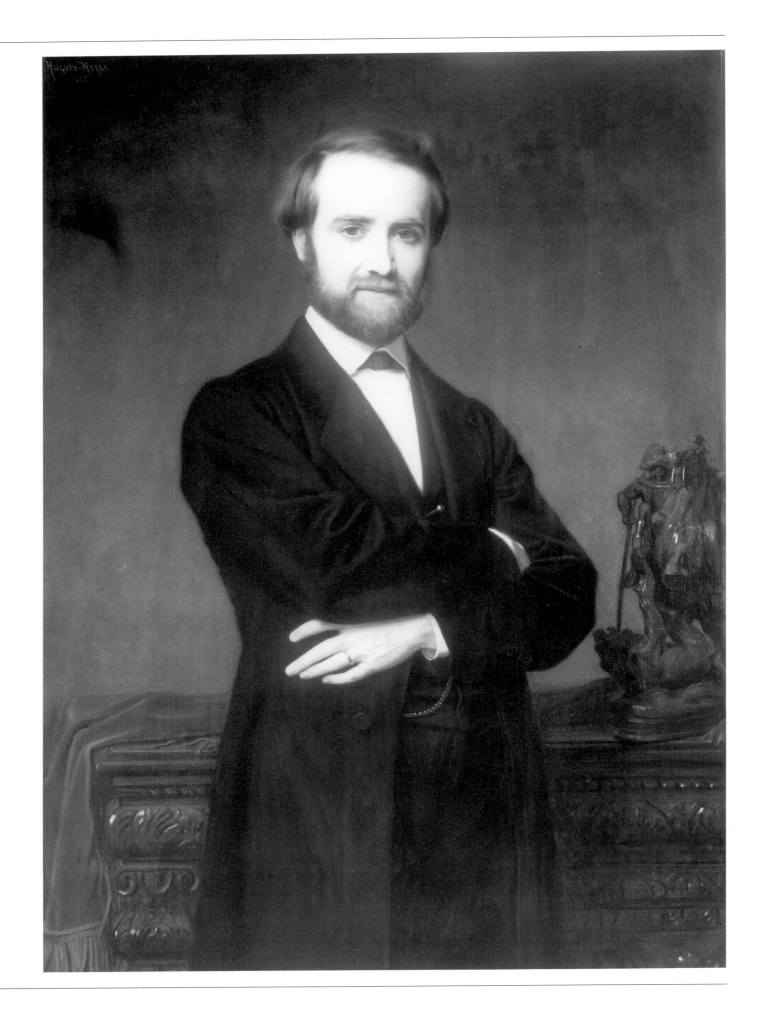

The Parisian Art Market During the Impressionist Era: Durand-Ruel

13 Hugues Merle. *Paul Durand-Ruel*. 1866. Oil on canvas, 113 × 81 cm. (44½ × 31⅞″). Private collection.
Late in the 1860s, Paul Durand-Ruel became interested in the artist Merle, a follower of Bouguereau. Merle, who is quite forgotten today, also painted a portrait of Durand-Ruel's wife, Jeanne-Marie Lafon. She was the niece of Emile Lafon, a painter of religious subjects well known at the time. Madame Durand-Ruel died young, in November, 1871, after having given birth to five children: three sons (Joseph, Charles, and George) and two daughters (Jeanne [Madame Albert Dureau] and Marie-Thérèse [Madame Aude]). Paul Durand-Ruel never remarried. A fervent Catholic, he lived unpretentiously in an apartment on Rue La Fayette.

Only very recently have people really become interested in the details and mechanisms of the art market. These chapters devoted to dealers will contribute to fixing the setting as well as describing the most important individuals in the business of selling paintings in Paris, exclusive of the ancient and non-European art trade.

Paul Durand-Ruel deserves that the first of these chapters be devoted to him alone: Durand-Ruel was both one of greatest dealers of his time, and the one for which the historian has at his disposal a bounty of documents.

When Lionello Venturi published his *Archives de l'Impressionnisme* in 1939, he included the memoirs of Paul Durand-Ruel, which secured the memory of the "Impressionists' dealer" for the future. That source has been widely utilized since, but—like all autobiographies—it is interesting to compare or complete it with other documents. Paul's grandson, Charles Durand-Ruel, and after him, his daughter, Caroline Durand-Ruel Godfroy, have generously opened the gallery's archives to historians. These archives, very detailed despite their gaps, furnish as much information about Paul Durand-Ruel as about his customers and the artists that interested him.

The Start of a Dynasty of Parisian Picture Dealers

Paul Durand-Ruel was born on October 31, 1831, in Paris, at 174 Rue Saint-Jacques, above a shop run by his parents, selling stationery and artist's supplies. Paul's mother, Marie Ferdinande Ruel, had inherited the business; Paul's father, Jean-Marie

13, 16, 23

14 Anonymous. *View of the Durand-Ruel Gallery*. 1845. Engraving. Institut d'Art et d'Archéologie, Bibliothèque Jacques Doucet, Paris.
Between 1844 and 1857, Jean-Marie Durand-Ruel was established at 82 Rue Neuve des Petits-Champs (now 26–28 Rue Danielle Casanova). His ground floor shop had a liquor dealer as neighbor on one side and, on the other side, a shoemaker, a milliner, and a hairdresser, side by side. On the first floor, the five-room apartment was divided into showrooms and living quarters. With his father's guidance, Paul made his start there. Then, early in 1857, he opened a much fancier establishment at 1 Rue de la Paix, at the corner of Rue des Capucines, thereby doubling his annual rent from less than 5,000 francs to 10,000 francs.

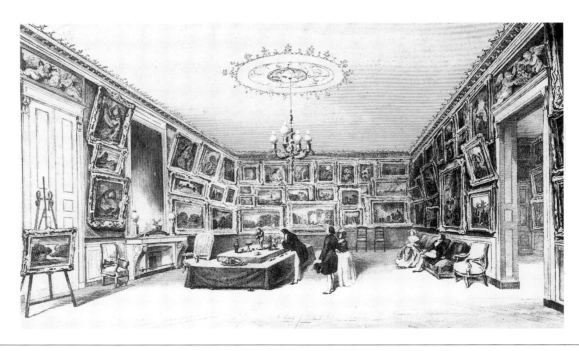

15 Page from Durand-Ruel's Account Books. February, 1873. Durand-Ruel, Paris.

Fortuné Durand, had branched out by selling art supplies. In 1833, Jean-Marie Durand was already engaged in the "sale and rental of paintings, washes, and watercolors of the Modern School." Shortly afterward, in 1839, he left the Latin Quarter and opened a shop at 103 Rue Neuve des Petits-Champs. In 1845, Jean-Marie also had an exhibition gallery at Number 82 on the same street. At that time, he published a collection of engravings of the paintings he offered for sale: Decamps, Marilhat, Steuben, Roqueplan, T. Johannot, Robert-Fleury, J. Dupré, A. de Dreux, Gavarni, Dauzats, and Jadin were placed side by side with Delacroix, whose *Medea* was reproduced.

Although Paul Durand-Ruel grew up in the art business, he showed little interest in it as an adolescent. He was a successful candidate at the Saint-Cyr military school, but had to forgo a military career because of bad health. An ardent Catholic, Paul Durand-Ruel is said to have considered taking Holy Orders and becoming a missionary; however, he resigned himself to assisting his father at Rue Neuve des Petits-Champs. A new move to 1 Rue de la Paix (the shop's lease dates from January 1, 1857) inaugurated a more prosperous era for their business.

In 1860, the Durand-Ruels stopped producing and selling art supplies for good, and their gallery began to make real strides. Paul's father (who died in 1865) had slowly been relinquishing control of the business to his son. This was the period when the younger Durand-Ruel established his first contacts abroad. However, as Paul emphasized in his *Memoirs*, there were only a few buyers for the great number of works on the market. The artists Durand-Ruel backed financially were expensive, even in the opinion of a critic of the time, however small the sums seem in retrospect. In his *Memoirs*, Durand-Ruel rightly dwells on the sale in March, 1870, of the banker Charles Edwards's collection, which was formed within a very short time by Durand-Ruel and was exemplary for that decade. It was composed of the following thirty-two paintings: 1 Corot, 1 Decamps, 11 works by Delacroix, 2 works by Diaz, 1 J. Dupré, 1 Fromentin, 5 Goyas (Spain was in fashion, and Durand-Ruel was to remain a specialist in that field), 4 Millets, 6 works by Théodore Rousseau. That combination of incomparable artists—which had only recently come into vogue with the public in those days—was typical of Durand-Ruel's taste. However, his taste was not limited to one style: during the 1860s, Durand-Ruel was the dealer for that paragon of academism, Adolphe Bouguereau (in 1866, however, Bouguereau went over to a competitor, Goupil).

Business Tactics

In addition to developing his undeniable flair for selecting artists, Paul Durand-Ruel quickly became adept at the purely commercial aspects of his profession.

Throughout his *Memoirs*, Durand-Ruel insists that, at auctions, despite the specter of financial sacrifices, a dealer must prevent the prices of his artists from falling. Likewise, he sought to obtain a sort of monopoly of an artist's work by repurchasing works from small dealers and private collectors, always with the objective of avoiding a disastrous drop in prices.

A final option was to buy from an aging artist whose work, in spite of success with a limited public, had not managed to fetch very high prices. This was the case for Théodore Rousseau, from whom Durand-Ruel (in partnership with another dealer, Hector Brame) purchased seventy paintings in a single transaction in 1866. The following year Durand-Ruel astutely organized a showcase exhibition of Rousseau's work. Unfortunately, when Rousseau died, what remained in his studio was dispersed; and in spite of Durand-Ruel's intervention at the auction, prices dropped. Some of Rousseau's works had to wait twenty years to be resold under good conditions.

A similar operation was attempted with Georges Michel, an artist somewhat apart, nicknamed "the French Ruysdael." Michel, whose Romantic landscapes had

16 Marcellin Desboutin. *Paul Durand-Ruel.*
1882. Drypoint, 20 × 15 cm. ($7\frac{7}{8}$ × $5\frac{7}{8}$″).
Bibliothèque Nationale, Paris.

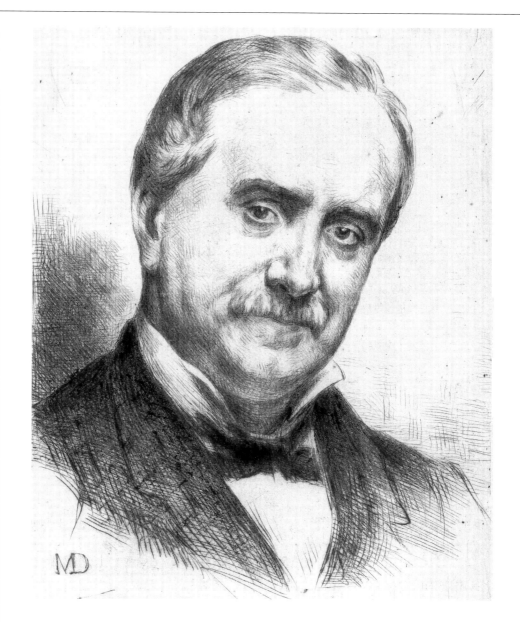

Insidiously implicated in an affair of forged paintings by the dealer Athanase Bague, Paul Durand-Ruel wrote a letter that was a real profession of faith. It was published in the November 5, 1885 issue of *L'Evénement*:

"I have been and am still the friend of Bouguereau, of Cabanel, of Bonnat, of Baudry as well as of Jules Dupré, Ribot, Bonvin, and many others. I was one of the first to recognize their merit and contribute to their fame. . . . Was that a reason to hold great artists such as Millet, Corot, Delacroix, Rousseau, Courbet in contempt and leave them in oblivion? . . . Since that time, considering the scarcity of works by those painters, I have searched among the young artists for those called upon to become masters in their turn. I found some—art not being dead in France as people too often claim—and I offered them my support. Lhermitte, Fantin-Latour, Boudin, Roll, Duez, I could say that almost all our great artists know what I have done for them and honor me with their friendship. I come to my great crime, the one that towers above all the others. For a long time, I have bought and greatly admired works by very original and skillful painters, many of whom are men of genius, and I seek to make them known to collectors. I consider that works by Degas, by Puvis de Chavannes, by Monet, by Renoir, by Pissarro, and by Sisley are worthy of being included in the most beautiful collections.

Many collectors are already starting to agree with me; not all of them are of my opinion. It is a question of personal opinion that one is free to discuss."

paved the way for the Barbizon School, was not exactly a contemporary artist, but the financial arrangement that Durand-Ruel arrived at with two bankers was interesting. Durand-Ruel wrote to the De Camondo brothers at the end of May, 1874: "Last October, I settled a matter with you and Mr. Charles Edwards connected with the works of Michel. I sold you 100 paintings by that artist at 1,500 francs each, and I received payment in cash, promising to take back any of the paintings you might decide not to keep after a year. We decided that, during that year, I would work at selling those paintings for you and that I would pay you the [sales] price, less a 5% commission for myself. Up to the present, business has been deplorable. I have only been able to sell four paintings." Regardless of the outcome of the affair, it serves to reveal the hidden protagonists of the art trade: the financial backers Charles Edwards, for whom Durand-Ruel formed the collection sold in 1870, and Abraham and Nissim de Camondo—all three bankers and fathers of famous collectors. This episode also demonstrates the risk inherent in investing a large sum of money, which might only bear fruit in a future as uncertain as it was distant. The search for financial partners was thus all the more difficult. Moreover, Durand-Ruel stated in his *Memoirs* that Edwards had financed him at such high rates that he had almost been driven to bankruptcy.

23

TABLEAUX

ET

OBJETS D'ART

SOCIÉTÉ GÉNÉRALE DES ARTS

EN COMMANDITE ET PAR ACTIONS

Capital social : 1,500,000 francs,

SOUS LA RAISON SOCIALE

DURAND-RUEL ET CIE

GALERIES D'EXPOSITION :

PARIS : { 16, RUE LAFFITTE;
11, RUE LE PELETIER;

LONDRES : 168, NEW BOND STREET;

BRUXELLES : 4, RUE DU PERSIL.

17 Full-Page Advertisement in a guide to Paris given to customers staying at Hôtel du Louvre. 1876. Library of the Musée d'Orsay, Paris.

On July 1, 1869, Paul Durand-Ruel, full of confidence, signed an eighteen-year lease for premises with two entrances: on 16 Rue Laffitte and on 11 Rue Le Peletier. It was a former restaurant with billiard rooms and small covered courtyards; many changes had to be made in order to adapt it to its new functions. In 1870, the rent was already 30,000 francs per year.

Two thousand of the three thousand shares of Société générale des Arts belonged to Durand-Ruel personally. The other shareholders were Pasturin, Berlencourt, Malinet, Dubourg, Premsel, Hourquebie, Isaac Pereire, and Victor Poupin—a mixture of financiers and picture dealers. Dissolved in 1875, the company was reborn early in 1880, as a firm partnership with regard to Durand-Ruel and as a limited partnership with regard to several other partners; the support of Jules Féder and Union générale, a Catholic bank, made the partnership possible until the abysmal failure of that bank at the beginning of 1882. Later, in September, 1893, after Charles Durand-Ruel died, a firm partnership, "Durand-Ruel and Sons," was formed between Paul and his sons, Joseph and George. The partnership would be renewed several times, without any capital from outsiders.

From 1845, Durand senior had published collections of engravings to enhance the gallery's reputation. His son Paul, using a more subtle method, founded a magazine entitled *Revue internationale de l'art et de la curiosité* in order to promote the artists in whom he was interested. With the same idea in mind, Paul organized "lectures on the 1870 Salon, open [to the public] in the galleries of Mr. Durand-Ruel, Rue Laffitte 16," in June, 1870.

Durand-Ruel at Rue Laffitte in 1870

In 1870, Durand-Ruel left his shop in the Rue de la Paix to move to a much larger gallery with two entrances: at 16 Rue Laffitte, and at 11 Rue Le Peletier. The Impressionists would make those two addresses famous; the gallery remained there until the beginning of the 1920s, with only a brief move back to Rue de la Paix early in the 1880s. Driven away by the demolitions ordered to extend the Boulevard Haussmann after World War I, the gallery moved to Avenue Friedland in 1925. That was the address at which the house of Durand-Ruel celebrated the centennial anniversary of Impressionism.

The gallery's transfer to Rue Laffitte was for an obvious reason: from the late 1860s, that busy street, which opens on the Boulevard des Italiens, had already become the base for "experts," or appraisers, and picture dealers. Moureaux was at Number 5, Beugniet at Number 10, Alexis Febvre—perhaps the first dealer to risk buying a Manet, *Boy with a Sword* (The Metropolitan Museum of Art, New York)—at Number 12, Weyl at Number 15, Gustave Tempelaere at Number 28. Detrimont, Gustave Coubet's and Charles-François Daubigny's dealer—for whom, in 1868, Claude Monet requested a letter of recommendation from his friend, the painter Amand Gautier—was at Number 33. Martin had just moved to Number 52. Latouche, at 34 Rue La Fayette, was almost at the corner of Rue Laffitte. Rue Laffitte remained the hub of the Parisian art market until World War I.

An ancient thoroughfare along which shops and private homes stood side by side (those of the millionaire Sir Richard Wallace or the Rothschilds, for example), Rue Laffitte was located at the very heart of Parisian cultural life: the Paris Opéra was on Rue Le Peletier until it burnt down in 1873.

When the Franco-Prussian War broke out in 1870, Paul Durand-Ruel took advantage of his experience abroad and left for London with his paintings. He organized a series of exhibitions in the German Gallery on New Bond Street for his regular artists: Corot, Millet, Dupré, Daubigny, Diaz, Fromentin, Isabey, Ricard, Bonvin, Cabanel, Merle, Pils, and Roybet. In 1871, Durand-Ruel hung one of Monet's works and two of Pissarro's on the line in the German Gallery, an innovation that went almost unnoticed at the time. Why was that? Claude Monet and Camille Pissarro (born in 1830 and 1840 respectively) were not novice painters. The works they submitted to the Salon jury during the 1860s, accepted or not, would have been known to Durand-Ruel. The presence of the three men in London enabled them to come into contact, probably through the artist Charles-François Daubigny.

Though the first transaction on record between Monet and Durand-Ruel took place in June, 1871, after the dealer returned to Paris, it concerns a purchase made in London. The same is true for Pissarro. A little later, in January, 1872, Durand-Ruel bought his first works by Degas. He purchased his first canvas from Renoir in March, 1872 (*The Pont des Arts, Paris*, 1867, The Norton Simon Museum, Pasadena, California), and his first works by Alfred Sisley in December, 1872. In January, 1872, Durand-Ruel had noticed two paintings by Edouard Manet owned by the artist Alfred Stevens, and proceeded to buy more than twenty canvases from Manet in a single transaction, mainly figure paintings, for a total of 35,000 francs. No single painting cost Durand-Ruel more than 3,000 francs. That was cheap: at the time, the government—always parsimonious—rarely paid less than 3,000 francs for a Salon painting. For example, Alexandre Cabanel's *Death of Francesca da Rimini and Paolo Mala-*

testa (Musée d'Orsay, Paris) was purchased for 12,000 francs in 1871, the same price paid for Jules Lefebvre's *Truth*, which the government bought that year too. By sharp contrast, at the same time paintings by Meissonier were fetching tens of thousands of francs; about 1871–72, Sir Richard Wallace bought one for 200,000 francs. Bouguereau demanded 35,000 francs from the American John Wolfe in June, 1873, for his large painting *Nymphs and Satyrs* (The Sterling and Francine Clark Art Institute, Williamstown, Massachusetts). In March, 1873, Durand-Ruel paid 96,000 francs at an auction at the Hôtel Drouot for Delacroix's *Sardanapalus* (The Louvre, Paris).

During the 1870s, along with the Impressionists and the masters of the preceding generation—Millet, Daubigny, Daumier, all of whom died before 1880—Durand-Ruel exhibited and sold the works of artists who are quite forgotten now. No one, for instance, remembers the authors of a panorama of episodes from the siege of Paris in 1870–71. However, it is also true that Durand-Ruel was Courbet's agent in Paris during his exile. That was both courageous (for Courbet had been convicted for participating in the Commune) and paradoxical on the part of an extreme conservative, but it testifies to Durand-Ruel's discernment in artistic matters. In the October 31, 1873, issue of *Le Figaro*, Durand-Ruel asserted: "Business has been stopped solely by fear of [the country's] falling into the hands of the Republicans again; and all of us, as Frenchmen and as tradesmen, long for the restoration of the hereditary monarchy, which alone can put an end to our troubles."

Durand-Ruel also purchased paintings by Pierre Puvis de Chavannes who, in spite of commissions from the government (notably, the first series of *The Life of St. Genevieve* for the Pantheon in 1874–78), was not unanimously accepted. Later Durand-Ruel exported Puvis de Chavannes's works to the United States.

A group of artlovers, upset that Camille Corot had not won a prize at the 1874 Salon, presented that great artist, at Durand-Ruel's, with a medal of honor specially designed for the occasion. Durand-Ruel's approach to purchasing and to exhibiting was exemplified by the "Retrospective Exhibition" he organized in 1878, the year of the Paris Exposition Universelle. Durand-Ruel's exhibition contained over 350 works borrowed from collectors, by artists passed over by the official exhibition: Corot, Millet, Rousseau, Delacroix, Courbet, Ricard, Diaz, Daubigny, Tassaert, Huet, Troyon, Chintreuil, Fromentin, Barye, and Decamps. This range of artists was typical of many contemporary collections. At the time, Pissarro stated bitterly, in a letter to the collector Eugène Murer: "At Durand-Ruel's, where the chefs d'oeuvre of our masters have been brought together, there is not a soul, an utter lack of interest." However, J. Alden Weir, a young American artist studying painting in Paris—who did not yet like the Impressionists—was favorably impressed by the exhibition.

Nonetheless, from the 1870s, the artists who, in 1874, would come to be known as "Impressionists" depended primarily on the sales of their works at Durand-Ruel's gallery, or on the regular advances he agreed to pay them, without even the hope of a real contract. The picture dealer did not hesitate to convert to Impressionism his customers of long standing such as Jean-Baptiste Faure, the most famous baritone of his time, or to find new ones such as the fabric dealer Ernest Hoschedé. (Both of these collectors will be dealt with in later chapters.) Durand-Ruel served as expert-appraiser at the famous auction organized by the Impressionists in 1875; the group's second exhibition took place on his premises in 1876. The seventh Impressionist exhibition, held in 1882, was actually composed of paintings from his stock, which was growing.

Success and Difficulties: the 1880s

Paul Durand-Ruel himself has emphasized the importance of the financial support he received early in the 1880s from Jules Féder, one of the shareholders in L'Union générale, a Catholic bank. The rising prices for Millets, Courbets, and the whole Barbizon School were also good for Durand-Ruel's business. These factors enabled 25

19 Pierre-Auguste Renoir. *La Loge*. 1874. Oil on canvas, 80 × 63 cm. (31 × 25″). Courtauld Institute Galleries, London.
Vollard related that Renoir sold this painting for 425 francs to *père* Martin, probably after the first Impressionist exhibition on Boulevard des Capucines and then, thanks to Durand-Ruel, on New Bond Street in London. In 1886, it already belonged to a leading citizen of Nantes, Louis Flornoy, a merchant and shipowner about whom not much is known, except that his son, John—an artist—was in touch with Pissarro. In 1899, Flornoy resold *La Loge* for 7,500 francs to Durand-Ruel, who considered it the brightest jewel in his private collection. ▷

18 E. Bichon. *Exhibition of Works in Watercolor at Durand-Ruel's, Rue Laffitte*. 1879. Print. Bibliothèque Nationale, Paris.

him to further promote the Impressionists. A hopeful Pissarro wrote to his sister Esther on January 4, 1881: "Durand-Ruel . . . came to see me and took a large part of my paintings and watercolors and offered to take all I do. Peace for a while, and the means to produce significant works." Durand-Ruel also tried to secure the production of Eugène Boudin, a precursor of Impressionism. On February 5, 1881, Boudin wrote to his friend F. Martin—not to be confused with the dealer P. F. Martin—in Le Havre: "The year had hardly started when Durand-Ruel turned up one morning; I showed him a few canvases. He said, 'I'll take them. And this one, and that one.'

'Right,' I said, 'all of them?'

'All.'

"And to think I was hampered by my stock. . . . I took the dear man at his word and started to surrender all my big daubings. . . . He asked me to work only for him; I would readily agree, because I don't care for the others; but I reserved the right to serve my few private collectors and to give some to my picture framer." In February, 1882, alas, the collapse of the L'Union générale bank dashed these hopes and plunged Durand-Ruel into debt.

Undaunted, he organized his first one-man shows devoted to Monet, Renoir, Pissarro, and others. To this end, Durand-Ruel rented premises at 9 Boulevard de la

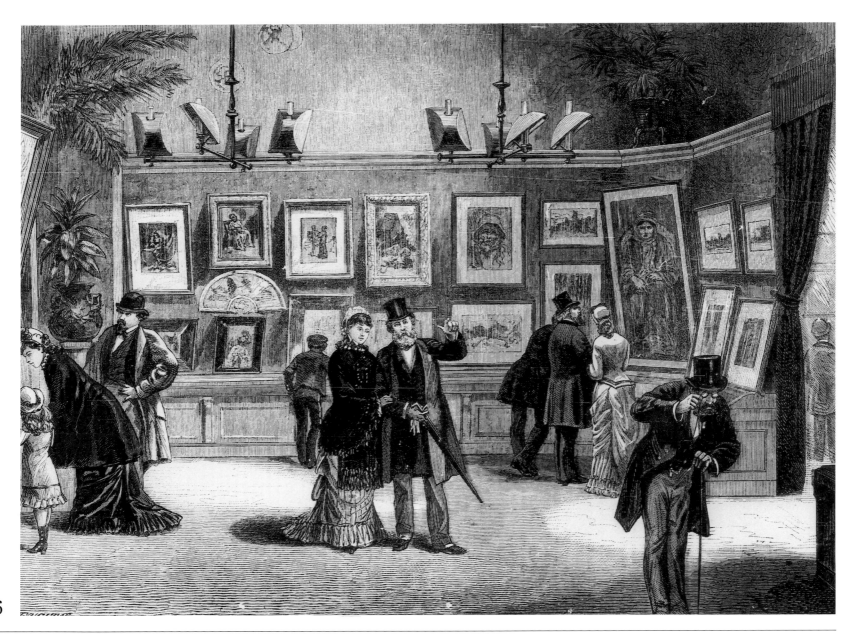

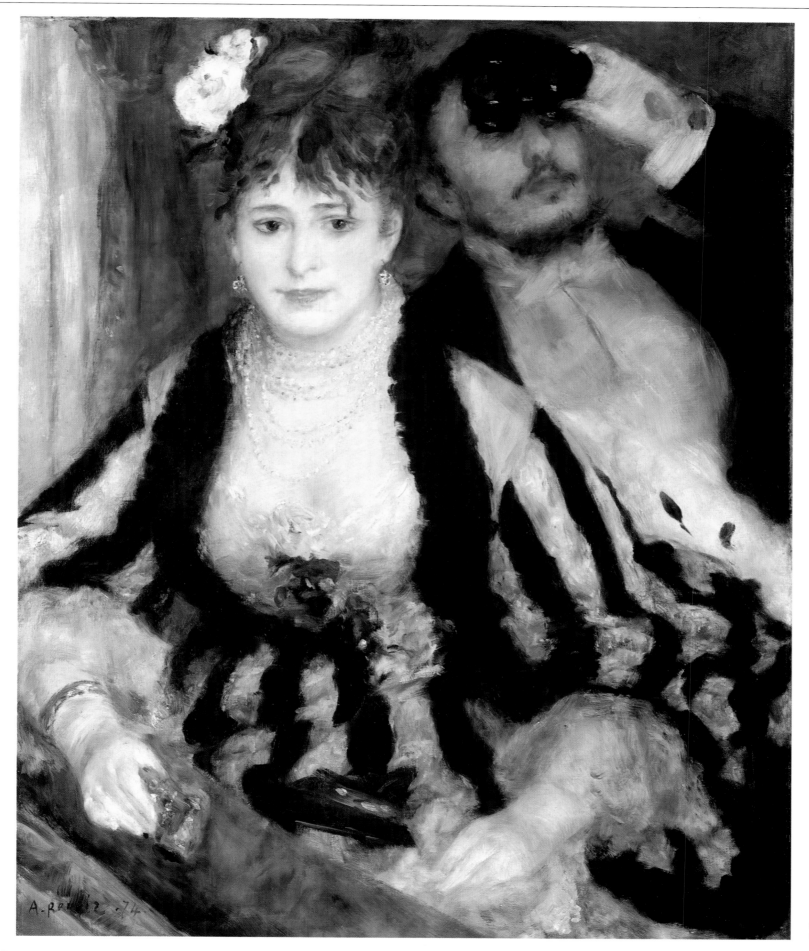

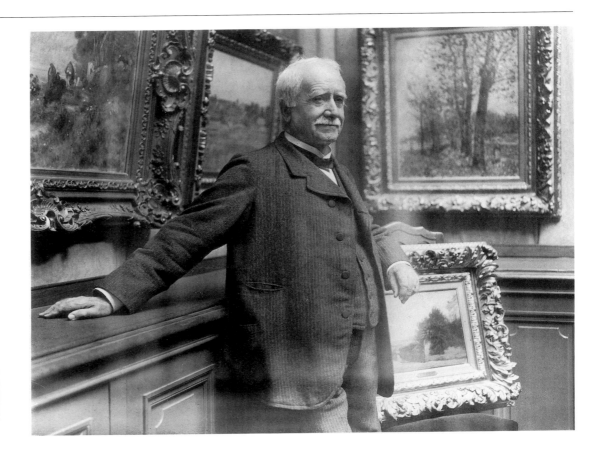

"One recalls his somewhat husky tone of voice, his polite and attentive behavior, hands crossed behind his back in a familiar gesture, and his serious gaze, sometimes alight with mischief. This recollection of the dealer's personality would not be complete without at least mentioning [Durand-Ruel] the collector. Little by little, the drawing rooms of his private residence on Rue de Rome had welcomed works by Masters such as Renoir, Monet, Degas, Pissarro, Miss Cassatt, and so forth, which had attained the highest prices. Mr. Durand-Ruel, a very peculiar dealer, resisted all the entreaties of buyers to the very end and, a very peculiar collector, only agreed to show his pictures to a very limited number of interested persons, whether or not they were capable of understanding them. There had to be an indescribable something more, of which the favored could be rather proud."

Arsène Houssaye, "Du Divan Le Peletier aux hôtels d'Arsène Houssaye," in: *La Renaissance de l'Art français et des Industries de luxe*, April, 1925.

Madeleine. Monet's show in March, 1883, was "marvelous" according to Pissarro, but "doesn't make a penny in entry fees; a bad idea [those] exhibitions of a single artist: the newspapers, knowing that a dealer is behind it, don't breathe a word. It's discouraging." Very worried, Pissarro wrote to Monet (June 12, 1883): "The other second-hand dealers and speculative collectors ... say: he [Durand-Ruel] is good for 8 more days. But this has been going around for several months."

The critic Albert Wolff's article on the Manet sale in the February 7, 1884, issue of *Le Figaro* gives quite an accurate picture of Durand-Ruel's reputation: "Among that gathering of friends and moonstruck people, the expert Mr. Durand-Ruel deserves special mention. All the paintings by Millet, Rousseau, Corot, and Delacroix passed through his hands at a time when they were worth little. Now, this good man wants to start over with the Batignolles School, of which Manet was the leading light for a while. All the wildest Impressionists, Caillebotte and *tutti quanti* [are] his. Mr. Durand-Ruel forecasts the brightest future for these masters...."

Durand-Ruel Leaves for New York

Durand-Ruel's financial salvation came from the United States. As early as the spring of 1883, he started out—albeit modestly—in Boston. Pissarro wrote to him good-humoredly (May 19, 1883): "What will it be like in Boston if they call us sick and crazy in Paris ... it is so far away, we won't hear!" Durand-Ruel's glorious deed was to exhibit the "Impressionists of Paris" in New York in April and May, 1886, with the support of the American Art Association and, in particular, the dealer James F. Sutton. While the exhibition did well with the critics, its commercial success was limited. A second exhibition took place in 1887, in spite of complications with customs. Paul Durand-Ruel decided to open a branch in New York. Paul's youngest son, Charles, managed the gallery until his untimely death in 1892, whereafter

Charles's two brothers, Joseph and George, took over. This was the beginning of the Impressionists' success in the United States. From 1890 on, it grew steadily.

Nevertheless, the late 1880s were particularly difficult years for Durand-Ruel. Although he remained optimistic and energetic, Paul Durand-Ruel was growing old. And beyond the money problems that supposedly prevented him from buying, there was something else: an inability to keep up with his artists' development. Indeed, Pissarro was currently under the full influence of Georges Seurat; Renoir was hesitating undecided after his large *Bathers* (Philadelphia Museum of Art), which had been greatly informed by Classicism and the art of Ingres; even Monet's work tended to be ever more allusive. To some extent, the increasing competition from dealers such as Georges Petit and Theo van Gogh of Boussod and Valadon was helpful, for it enabled the Impressionist artists to sell their works and survive without being a burden to Durand-Ruel alone. Yet Paul Durand-Ruel was sometimes a bit impatient. Pissarro unburdened himself to his son Lucien (July 12, 1888): "Durand is annoyed to see Monet do business with Boussod and Valadon; he wanted to hold on to [the exclusive rights for] Monet. He has made the first move with me, but is not giving me very big wages. I took the opportunity to tell him that I really needed money, and he promised to send me some. We'll see if he keeps his promise; I believe it is in his interest not to keep me on tenterhooks too long. . . ."

Early in the 1890s, with the untimely death of Theo van Gogh, Durand-Ruel regained his supremacy as the Impressionists' dealer: he held the great Renoir and Monet exhibitions. Success had finally come to the Impressionists: "Monet opened his exhibition," wrote Pissarro. "Well, barely open, my dear man, all was sold, at 3,000 to 4,000 each!"

Durand-Ruel assembled the collections of the "second generation" of collectors of Impressionism. These neophytes—among them Count Isaac de Camondo, François Depeaux, Etienne Moreau-Nélaton, Antonin Personnaz (all of whom later made bequests to French museums), and the H.O. Havemeyers in America—did not know the painters as well personally, nor did they attend the auctions at the Hôtel Drouot

21 Anonymous. *Paul Durand-Ruel's Apartment*, at 35 Rue de Rome in Paris. c. 1914. Photograph. Durand-Ruel, Paris.

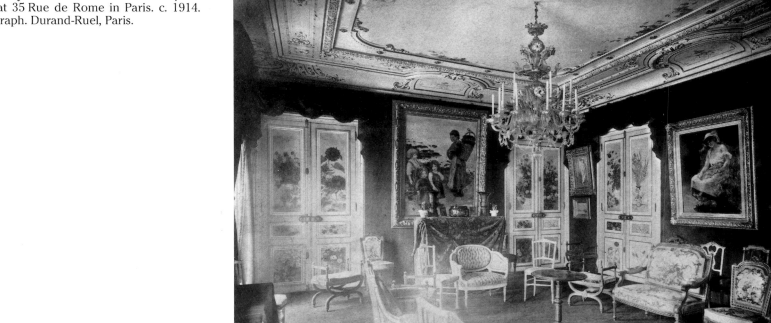

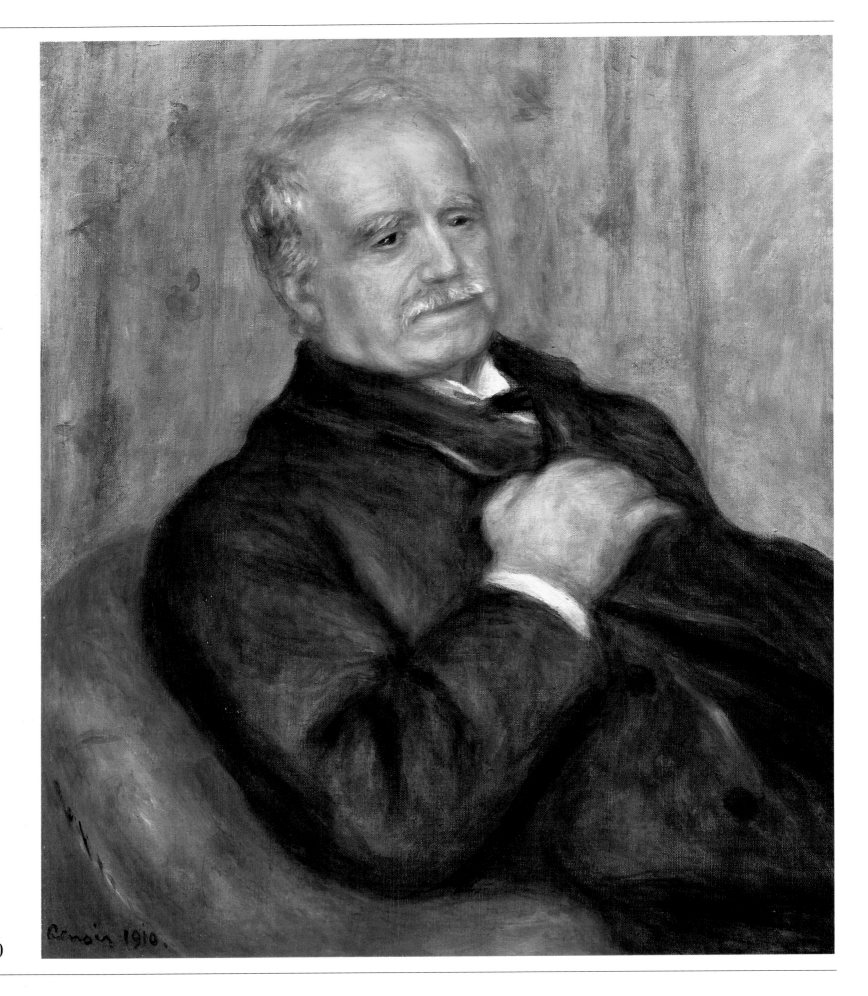

30

22 Pierre-Auguste Renoir. *Paul Durand-Ruel*. 1910. Oil on canvas, 65 × 54 cm. (25¾ × 21½″). Private collection.

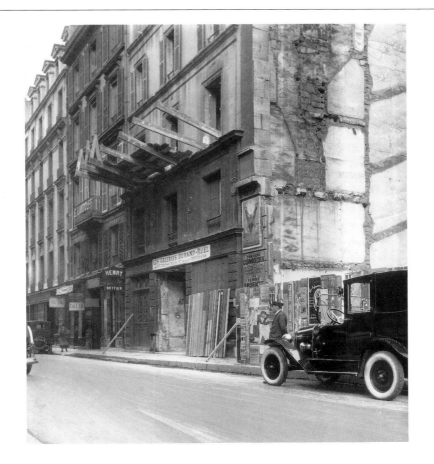

23 *Pulling Down the Building at 16 Rue Laffitte.* c. 1920. Photograph. Durand-Ruel, Paris.

as often. Durand-Ruel came to terms with his colleagues Petit, Vollard, the Bernheim brothers, and Rosenberg, without really loosening the reins of the gallery until the eve of World War I. A revered patriarch, and depicted as such in a portrait by his loyal 22 friend Renoir, Paul Durand-Ruel was consulted, but he already belonged to the past. Other dealers took up the new artists. Durand-Ruel seems to have bought works by Cézanne only at the express request of certain faithful customers. He did not care for Seurat or Gauguin, though Gauguin's first exhibition in 1893 was held in his gallery. He went so far as to refuse to organize a posthumous exhibition for Van Gogh. And although Durand-Ruel devoted an exhibition to Pierre Bonnard in 1896, he was not attracted to the Nabi artists.

Durand-Ruel remained true to an intensely colorful vision exemplified by Monet and Renoir, backing painters such as A. André, D'Espagnat, Moret, Maufra, etc. He apparently felt bitter toward government authorities for their perceived mistreatment of him, presumably due to his militant stance as a devout Catholic on the question of the separation of Church and State. Paul Durand-Ruel, it is true, did not receive the Legion of Honor, nominated by the Ministry of Commerce and Industry, until July, 1920.

In May, 1913, health problems led Paul Durand-Ruel to arrange for his succession. When he died on February 5, 1922, all Durand-Ruel's wealth was invested, both in the stock of the firm his sons managed and in an ultramodern gallery, designed to meet twentieth-century requirements. Thus, right up to the end, Paul Durand-Ruel put his trust solely in "his" artists.

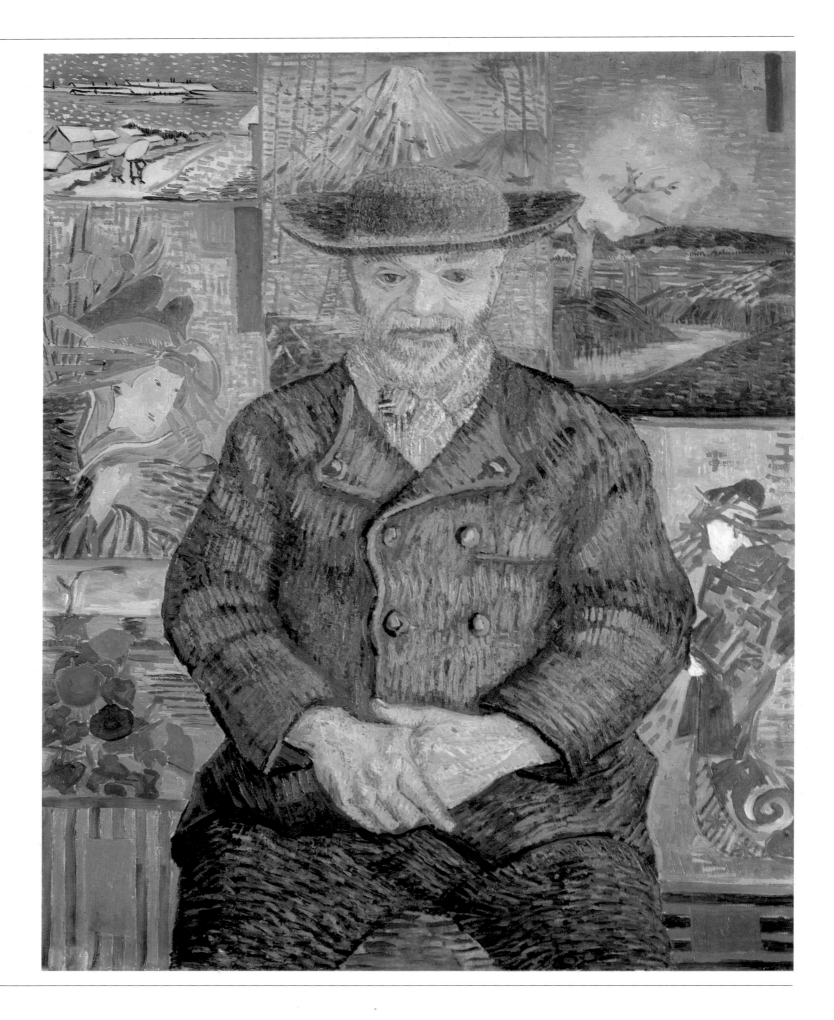

The Parisian Art Market During the Impressionist Era: The Other Dealers

24 Vincent van Gogh. *Portrait of "Père" Tanguy.* 1887. Oil on canvas, 92 × 75 cm. (36¼ × 29½"). Musée Rodin, Paris.

Durand-Ruel was not the only dealer working in Paris; the Didot-Bottin directory for 1870 listed over one hundred picture dealers in the capital, not counting the curio shops. Even if we leave out the dealers who sold religious paintings and those who specialized in Old Masters, the number of dealers in contemporary art remains large.

Carpentier

Among the first to take an interest in a future Impressionist was Marie-Charles-Edouard Carpentier. In September, 1869, writing to his friend Bazille, Renoir mentioned a painting he was exhibiting at Carpentier's and added, "I am going to try to saddle him with [it] for a hundred francs or so." The same year, Camille Pissarro gave Carpentier's address as his own in the Salon catalogue. These two indications prove that Carpentier was interested in the young generation of artists.

Carpentier had entered into partnership with Armand Deforge in 1858. Deforge, who originally had a shop that sold art supplies, had made a good name for himself in the mid-nineteenth century after turning to the picture trade. He dealt mostly in artists such as Diaz and Muller, who specialized in pleasant, bright genre painting. Perhaps it was through Diaz—whom Renoir later said had helped him at the very start—that the Impressionists made contact with Deforge. Deforge also sold Daubigny, an artist who was well known for his kindly attitude toward the new school.

Carpentier seems to have succeeded Deforge definitively in 1865. After the Franco-Prussian War of 1870, however, Carpentier's business rapidly declined.

Cadart

Although Alfred Cadart made his name as a publisher of prints, he also exhibited paintings at his publishing house, Galerie Cadart et Luquet, located at first on Rue de Richelieu and then on Rue Neuve des Mathurins. In the late 1860s and the mid-1870s, works by Jongkind were shown there along with some by Manet (whose engravings were published by Cadart), by Boudin, and by Berthe Morisot. However, Cadart died in 1875—too early to be able to really help the Impressionists. His widow's efforts to continue his activities were not successful.

Latouche

Another dealer important to the young artists was Louis Latouche. He sold "fine colors and modern paintings" in a shop at 34 Rue La Fayette from January 1, 1867. An artist himself, Latouche sent paintings to the Salon regularly between 1866 and 1882. After 1867—no doubt because his own work was rejected—he agreed to represent the young protesting artists soliciting signatures on a petition demanding the organization of a new Salon des Refusés (there were many works rejected that

33

year). Among those who signed the petition were Manet, Monet, Bazille, Renoir, Pissarro, and Sisley.

Latouche had exhibited and acquired paintings by Monet before 1870. He bought more in 1872, and at the auction organized by the Impressionists in March, 1875. Pissarro was a customer at Latouche's; the artist paid in paintings, which Latouche resold quickly to Durand-Ruel. It seems that Latouche did not like Renoir's painting, however.

In 1874, we find Latouche mentioned in both the bylaws of the *Société anonyme des artistes peintres, sculpteurs, graveurs, etc.* (Private Company of Painters, Sculptors, Engravers, Etc.) and among the exhibiters of works of art at the first Impressionist exhibition on Boulevard des Capucines. As his letter to Dr. Gachet (dated April 26, 1874) proves, Latouche was at the heart of the battle the new movement provoked: "Today, Sunday, I am on duty at our exhibition. I am guarding your Cézanne [*A Modern Olympia*, now in the Musée d'Orsay, Paris]. I cannot guarantee its state; I'm really afraid it will return to you punctured."

178

After 1875, it seems that Latouche thought of himself more and more as an artist and left the running of the shop to his wife. On August 1, 1886, Madame Latouche sold her business to Contet, who was still at the same address on the eve of World War I.

Legrand

Another name often mentioned by the artists was that of Alphonse Legrand. It appears in Pissarro's correspondence and in Monet's account books for the 1870s. Between 1876 and 1878, Legrand's business address was 22A Rue Laffitte, just a few doors from Durand-Ruel. According to Georges Rivière, Renoir's friend and biographer, Legrand had worked for Durand-Ruel. In 1873, Durand-Ruel had rented a shop at 8 Rue La Fayette, but the lease was in the name of Legrand, who assigned it to Victor Poupin. Rivière correctly added that Legrand (bankrolled by Gustave Caillebotte) was the French agent for a type of cement used in interior decoration and manufactured by an English company called McLean's. Moreover, Legrand managed to convince Renoir to go in with him and experiment with painting on the cement. Legrand had a daughter named Delphine; Paul Gachet, Jr., the son of the famous collector, was a childhood playmate of the girl, whom he called Ninette. Her portrait by Renoir (Collection McIlhenny, Philadelphia) was shown at the second Impressionist exhibition in 1876. Legrand took an active part in organizing that exhibition: he rented the rooms on Rue Le Peletier from Durand-Ruel. In 1878, Legrand and Caillebotte tried—unsuccessfully—to put together an exhibition for the group. In May, 1877, Legrand acted as expert-appraiser at the auction the Impressionists held at the Hôtel Drouot.

Even more interesting is the fact that Legrand seems to have been behind an early foray of Impressionist painting into America in 1878. The endeavor was apparently unsuccessful, since Legrand wrote to Pissarro that his paintings were being returned to him. Legrand maintained contacts with various collectors in Boston, notably Quincy Adams Shaw, who collected Millet. During the summer of 1886, Legrand attempted once again to sell works by Pissarro and the Impressionists to the New Yorker dealer Knoedler, who had come to Paris to investigate the art scene. Legrand was definitely open to the new painting; it was at his shop that Gauguin expected to find buyers for his works in 1883. After that, Legrand is no longer mentioned; he may simply have stopped working.

Poupin

Another dealer, already mentioned, who was a satellite of Durand-Ruel, was Victor Poupin. He appeared suddenly in January, 1874, the date on which he took over Legrand's lease to the shop on Rue La Fayette, which he occupied until 1879. In 1875, Poupin bought several canvases directly from Monet. Renoir mentioned Poupin when he dictated his recollections to Ambroise Vollard. Poupin seems to have had an especially close relationship with Durand-Ruel: many times Durand-Ruel deposited large groups of paintings with him—by Sisley, Monet, Pissarro, and Renoir—perhaps to protect them from judicial distraint, the effects of which would have been as disastrous for Durand-Ruel as for the artists. Afterward, like Legrand, Poupin sank into obscurity.

Many other names can be found in Durand-Ruel's archives: among them, Tibulle Hagerman, who had a shop at 1 Rue Auber between 1870 and 1877. Hagerman was also an expert-appraiser at the auctions of modern paintings held at the Hôtel Drouot by the auctioneer Tual, who was interested in the Impressionists. Durand-Ruel seems to have used Hagerman above all as a front, in particular at the Hoschedé auction of 1878.

E. O'doard (or O'doart) is also listed as a dealer in ancient and modern paintings at 98 Boulevard Haussmann, but he disappeared early in the 1880s. O'doard too had works by Monet and by Pissarro.

Another dealer worth mentioning is Ernest Hourquebie, who had a shop at 12 Rue Joubert.

Zola Helps Historians

One privileged witness to the Parisian art market in the late 1870s can further elucidate our inquiry: Emile Zola. For his novel *L'Oeuvre (The Masterpiece)*, published in 1886, Zola assembled notes derived principally from his conversations with the painter Antoine Guillemet. Zola's novel—full of clear allusions to Manet, Monet, Cézanne, and others—also depicts typical dealers: *père* Malgras and Naudet. Zola's notebooks provide valuable information about these characters: among others, he mentions the Beugniets, Brame, Petit, and Martin.

The Beugniets

Very little is known about the Beugniets. Adolphe had a store at 10 Rue Laffitte from 1848. His son, Georges-Albert-Félix, took over the business at the same address in 1893 and became the recognized dealer for the "horticultural production" of the flower-painter Madeleine Lemaire, whom Marcel Proust so admired. This led the dealer Ambroise Vollard to remark jokingly that Beugniet's shop window—a few doors from Durand-Ruel—looked like a florist's display.

Yet the house of Beugniet had not always been that conservative. Beugniet senior had sold works by Daubigny. In 1880, Pissarro wrote to Théodore Duret, a collector of his work, "Degas has laid siege to Beugniet." Pissarro added, "I have done a serious watercolor in order to tempt him; I hope it will succeed." Later Pissarro considered a sustained relationship with Beugniet, "if Durand[-Ruel] totally abandons us." It is also to Pissarro that we owe another interesting note: "That devil Beugniet... only has one eye, but the good one is terribly clairvoyant," and he continues, "besides Beugniet has a great deal of *amour propre*: he wants to discover what he buys by himself; his best friends have no influence whatsoever [on him]."

The dealers Hector Brame, Georges Petit, and P. F. Martin call for more detailed treatment.

35

Brame

The name of Brame is connected with a dynasty of picture dealers. The one Zola evokes ("former actor at the Odéon. Looking very chic, English morning coat, carriage at the door, seat at the Opéra") is the first of that name: Hector-Henri-Clément Brame. He came to Paris in 1848 from his native Lille, and is said to have worked as an actor under the pseudonym of De Lille. In 1865, Hector Brame married the daughter of the picture dealer Gustave Tempelaere.

As a picture dealer, Brame (established at 47 Rue Taitbout since 1864) handled mainly Corot. Shortly before 1870, the dealer even posed for the artist dressed as a halberdier. Brame also handled Millet, Rousseau, and the artists of the Barbizon School as well as Jongkind and Boudin. Perhaps it was his business contacts with Durand-Ruel that led Brame to Impressionism. He was especially interested in Degas. In 1879, Brame lent two works by Degas to the fourth Impressionist exhibition.

Brame's son, Hector-Gustave, took over the gallery from him in 1892. Even though he moved the business to 3 Rue Laffitte, he maintained the same orientation. Since then, Paul-Louis Brame, and then Philippe Brame, have carried on this great tradition of Parisian dealers.

Zola noted that Hector Brame "had caused the speculative purchases of paintings, because he worked with stupid collectors who knew nothing about art, and who bought a painting as [they would] buy securities on the stock market." Paul Durand-Ruel, Brame's partner for a time, considered that the mark of an "eager and excellent salesman."

Zola explained the recipe for success of a now somewhat forgotten genre painter, Ferdinand Roybet: "a capable painter, having just enough of the appearance of originality to please the middle class without shocking them." Here is what the dealer Brame proposed: "I will sell it to you for 5,000 [francs], and if you want to return it to me next year, I will buy it back for 6,000. I am going to sign a paper confirming this for you. . . . He placed a few works in this way during the year; he made prices rise the same way prices for securities go up on the stock market, with such success that, after a year, the collector would no longer want to resell the painting to him for 6,000 francs. If the collector should return it to him, since prices had gone up, he would be sure to sell it to another collector for 7,000 francs. He earned large sums of money, the artist too, and all of that ended in bankruptcy for him and for the artist." Zola's conclusion is exaggerated, but it echoes the difficulties Brame and Roybet experienced around 1884.

Georges Petit

After Brame, Zola continues his description with Georges Petit: "The same game but played on an even larger scale, like the Magasins du Louvre [a department store] devoted to paintings—the apotheosis. He was the son of a picture dealer of the old style who had done good business. A flashy dresser, very smart. He himself began to do business at his father's. Then ambition seized him: he wanted to ruin the Goupils, outdo Brame, be the first and foremost. And he had his town house built on the Rue de Sèze—a palace. He started out with three million inherited from his father. His establishment cost [him] four hundred thousand francs. Wife, children, mistress, eight horses, castle, hunting preserves. He set up galleries and awaited the arrival of the Americans, which took place in May. He set up exhibitions. He bought at ten thousand and resold at fifty thousand. He mostly handled deceased artists: Delacroix, Courbet, Corot, Millet, Rousseau, etc.—worked little with living artists. The high prices came from Brame, but Petit pushed them up even higher." Considering how little can be learned about Georges Petit, and with what difficulty—his archives have been lost—Zola was very well informed.

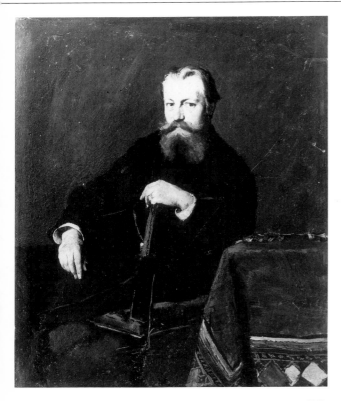

25 Ferdinand Roybet. *Hector Brame.* 1872. Oil on panel, 56 × 44 cm. (22 × 17¼"). Musée des Beaux-Arts, Lyons (Gift of Paul Brame, 1949).

Georges Petit was born in Paris on March 11, 1856; he died there on May 13, 1920. He was the son of Francis Petit, picture dealer at 7 Rue Saint-Georges. Zola was correct in asserting that Francis Petit, who died four months after his wife, left an estate of over 2,500,000 francs; however, almost 900,000 francs of that consisted of works of art, paintings, and watercolors in his commercial inventory. In that inventory there is special mention of a lot of works by Meissonier evaluated at almost 300,000 francs.

Yet, in 1851, when he married, Francis Petit did not seem to be a very rich man. His wife had a bride's trousseau worth 1,000 francs and a small personal income; she did not inherit anything until 1873, when an uncle left her a little more than 40,000 francs. At the time of their marriage, Petit's contribution to the couple's joint resources had been a bit more than 10,000 francs. Francis Petit's subsequent fortune was apparently due to his business acumen: selling Meissonier was profitable. Francis Petit, it must be added, did not confine his dealings to the fashionable social sphere. For instance, he exhibited forty-six drawings by Millet from the Collection Emile Gavet for the benefit of the artist's family in April and May, 1875, "in a room built especially [for the occasion]," at 7 Rue Saint-Georges. He asked Gustave Ricard, one of the best portraitists of the time, to paint the portrait of his son Georges as a child (Musée d'Orsay, Paris).

When his father died in 1877, Georges Petit was already working as a picture dealer at the same address as his father. From 1881, he settled at 12 Rue Godot de Mauroy, behind the Eglise de la Madeleine, an address he kept until his death. The building still exists today; it contained the Petit family residence, the management of the gallery, a printing workshop—for Georges Petit, like Goupil, became a publisher of prints and various artistic publications—a packing room, and especially, several exhibition areas, including an immense hall (over 2,700 square feet) with "zenithal" lighting. The exhibition hall was reached by climbing a monumental staircase at the far end of a long corridor with an entrance at 8 Rue de Sèze.

Petit's establishment was luxurious. Few original pictures exist, but period descriptions mention marble as well as red fabric. After the appointments were

25a Anonymous. *Exhibition of the "Société des Aquarellistes français" (Society of French Watercolorists) at the Galerie Georges Petit, Rue de Sèze, in 1882*. Print. February 25, 1882 issue of *L'Illustration*.

finished, the building was inaugurated in February, 1882, with an exhibition by the *Société des Aquarellistes français* (Society of French Watercolorists). This exhibition was the event of the day, particularly as a very Parisian scandal broke out over one of the works on exhibit: a watercolor by Gustave Jacquet in which all of Paris could recognize a nasty caricature of Alexandre Dumas fils. Duels and lawsuits were contemplated before the affair subsided. What publicity for Petit! It is worth noting that, from its foundation in 1879 until 1882, the Society of French Watercolorists had always organized its annual event at Durand-Ruel's.

His father's estate had scarcely been settled before Georges Petit set up as Durand-Ruel's rival on every front. In 1878, Petit was the expert-appraiser at the auctions of the Faure and Hoschedé collections that Durand-Ruel had formed. We shall dwell at length on those sales later, since they included works by Manet and the Impressionists; and they were landmarks in the group's history. At the Hoschedé auction, Petit bought 2 Monets, 1 Sisley, 1 Morisot. (In fact, Petit bought one of the Monets on the artist's behalf. It was a first opportunity for contact, and Petit advanced Monet the 300 francs that the artist had requested in September, 1878.) All told, Petit's enthusiasm for the new school was mitigated: in June, 1882, Monet wrote to ask Petit whether he should deliver a painting the dealer had purchased two years earlier!

Undoubtedly, Petit's much publicized first Exposition Internationale, inaugurated in May, 1882, had given Monet cause for reflection, for he still feared Durand-Ruel's commercial downfall. After toying with the idea of a sort of private Salon organized by the artists, Petit and the people responsible for this showcase event had decided to form a committee of famous foreign painters—Alfred Stevens, Giuseppe de Nittis, and Raimondo de Madrazo—who would invite painters of their choice to exhibit.

Once again fashionable Paris assembled to attend an exhibition: Edmond de Goncourt, invited to the opening supper at De Nittis's home, obligingly related the encounter, during the musical evening that followed, of Princess Mathilde, cousin of Emperor Napoleon III, and Mrs. Adam, alias Juliette Lamber, head of a literary review and Gambetta's friend. That skillful experiment, which dealt tactfully with the authorities of academism while posing as independent of them, was repeated every year afterward. In spite of the unusual company—Jean Béraud, Léon Bonnat, J.C. Cazin, Henri Gervex, Alfred Stevens, and others—Monet attended Petit's 1885 exhibition as well as at those held in 1886 and 1887.

Like Monet, Renoir had refused to participate in the last Impressionist exhibition; in 1886, he exhibited several paintings at Petit's, including the portrait of *Madame Charpentier and Her Children*. In 1887, he showed five others, including the renowned Ingres-like large *Bathers* now in the Philadelphia museum. At about the same time, Monet confided to Berthe Morisot that he dared not even hope Degas would join them at Petit's. Pissarro had had contacts with Georges Petit from before 1880. The artist finally exhibited at Petit's gallery in 1887, as did Whistler in 1883 and 1887.

Georges Petit's social standing raised the Impressionist artists' hopes for a renewal of their clientele, which Durand-Ruel had not managed to bring about. But Durand-Ruel was not to be outdone by his competitor on the Rue de Sèze. He rented premises at 9 Boulevard de la Madeleine, where he held Monet, Renoir, Pissarro, and Sisley exhibitions in rapid succession in 1883. In 1884, both men were designated as experts at the auction of the contents of Manet's studio, Petit did not put in an appearance. This jockeying for position was alluded to by Théodore Duret and Albert Hecht, two friends of Manet. In 1883, Manet's mother echoed them: "A clique is forming to entrust Petit with the sale of the paintings. It would be extremely ungrateful not to entrust it to Durand-Ruel who was an admirer and the first buyer of our dear Edouard[s' work]. Petit didn't like his painting and never bought anything from him!" The war between the two dealers culminated in 1885, with a claim against Durand-Ruel that Petit assigned to a third party and with an affair of fake Daubignys.

126

However, from 1883, Petit had purchased works by Monet, Pissarro, Sisley—but not by Renoir—from Durand-Ruel at the same time as he purchased works by painters closer to his apparent taste, such as John Lewis Brown. In 1886–87, Petit bought directly from Monet at full price, and the famous Monet-Rodin exhibition of 1889 took place at Rue de Sèze. Taking advantage of a misunderstanding between Durand-Ruel and Alfred Sisley, Petit became Sisley's regular dealer. A large Sisley retrospective took place at Petit's gallery in February, 1897.

It is quite possible that this new trend in the Petit gallery's taste was due to Isidore Montaignac, one of Petit's many employees, who opened his own business at 9 Rue Caumartin after 1886. Montaignac was the correspondent for the New York dealer James F. Sutton, with whom Durand-Ruel also did business. In 1891, Pissarro wrote about Montaignac to his son: "I have known him for about ten years. . . . He worked for Georges Petit; he was the right-hand man at that gallery. He seemed to be smart and likeable, and then last year I learned from Monet that he had been managing his affairs for a long time . . . as well as Sisley's." In 1893, however, Pissarro complained to his son that Montaignac did not like his painting and had said so to both Monet and Duret. Together with Montaignac and Bernheim, Georges Petit once again made purchases from Monet in 1898–99.

Moreover, when Georges Petit's collection was auctioned on May 4–5, 1921, after the dealer's death, it was greatly surprising to learn that Petit had kept many Impressionist works for himself. People's notions of Petit's taste had been based more on ostentatious exhibitions such as "One Hundred Masterpieces from Parisian Collections," held in 1883. That show had had an honorary committee composed solely of members of the nobility and had displayed a mixture of Old Master (Boucher, Rembrandt, and Rubens) and modern paintings (Corot, Daubigny, Delacroix, Meissonier, Millet, and Rousseau). The Petit gallery, which traded in printed reproductions of works by those artists, had published a luxurious catalogue for the show. That catalogue contained a foreword by the renowned Albert Wolff, the most influential critic of the period and no friend of the Impressionists. Georges Petit also published catalogues of the auctions that took place in his gallery, auctions of "choice collections . . . far from the musty atmosphere, the sickly lighting, and the run-down fixtures of the Hôtel Drouot," according to a remark by a contemporary.

Petit organized numerous great auctions of Impressionist collections; among the most noteworthy were Duret's in 1894, Chocquet's and Count Doria's in 1899, Depeaux's in 1906, and four auctions with works from Degas's studio in 1918–19.

Things were not always so easy for Georges Petit. In spite of his own assets, Petit was always dependent on sleeping partners, of whom we know little. He had difficult periods. In March, 1886, Pissarro echoed the rumors: "Petit is in very bad shape himself, much worse than Durand[-Ruel]; according to what I've heard from competent businessmen, he is reduced to dubious methods."

Like Durand-Ruel, Petit got through this crisis. When he died in 1921, his personal, recorded wealth placed him in the higher income brackets; but his shares in the Société des Galleries Georges Petit represented just a tiny percentage of all the stocks and shares he owned. The Georges Petit Galleries passed over to the Bernheim-Jeune gallery that had had a share in Petit's business since before 1900 and to another dealer, Etienne Bignou. Petit's firm survived its founder under the management of an expert-appraiser, André Schoeller, until the corporation that owned the galleries was dissolved and its assets sold at auctions on April 27, May 10, October 27–28, and December 15, 1933.

Zola's portrait of Georges Petit remains accurate even to the details about his wife, Marie-Julie-Lucie Compère, his daughters, Marianne and Andrée, and his mistress, who—according to André Maurois—was the beautiful Adèle Caussin, known as Madame Caussin, later Marchioness Landolfo-Carcano. The auction of her estate in 1912 exhibited riches and taste in the Georges Petit tradition.

René Gimpel sketched the last picture of Georges Petit in his *Diary of an Art Dealer.* In 1918, Gimpel interviewed the old dealer, "a rutting, obese, hydrocephalic

tom," several times. One by one, "that huge, sybaritic tom" let Gimpel have a few—too few—of his memories.

Père Martin

A final description provided by Zola's notebooks is of *père* Martin. "Martin, Rue Laffitte, [was] a little, old-fashioned dealer, dressed simply, rather badly, rough and ready, democratic. He would go to an artist's studio, purse his lips while eyeing the studies, then stop in front of one.

'What do you want for that? 60 francs, 80 francs? Forget about it. I'm not rich—that doesn't sell at all. I wanted to do you a favor. You have talent, but what do you want [me to do]? I don't know where to put the paintings any more.'

"And he ended up by buying at 40 francs. Moreover, he had sold the canvas beforehand. He went around to artists who were starting to be known but not yet highly rated. A decent sort—very discriminating, a good judge of painting. His whole system was based on the rapid turnover of his inventory. He bought when prices were low, sold immediately with a 20 percent profit, thus operating with small amounts, a minimum of capital, and a quick turnover. He retired with a private income of about 10,000 francs. Combine *père* Aubourg and Martin in my character." The last sentence definitely confirms the fact that *père* Malgras in Zola's *The Masterpiece* was inspired by Martin—but only in part. The vulgar language that peppers conversations in one scene between the dealer and artist was probably inspired by *père* Aubourg, about whom nothing is known. Everything that Zola writes about Martin, on the other hand, is confirmed by existing documents.

Born on February 17, 1817, Pierre-Firmin Martin was the son of a farmer from the Salins-en-Jura area who had become a wine merchant in Montmartre. The younger Martin became a saddler. In 1891, Henri Rouart (Martin's first biographer) recalled that "Firmin" had also played the villain in the local theaters, undoubtedly a passing vocation, no trace of which is to be found in public records. In 1837, P. F. Martin married a seamstress, Victoire-Adèle Davy, who lived with his parents. The best man, the bride's uncle, Stanislas-Maximilien Cloche, was a second-hand dealer; and it was as a second-hand dealer that Martin opened a shop at 20 Rue Mogador in 1852. He soon specialized in the sale of paintings. As early as the 1860s, Martin's very unpretentious shop—from which he moved only temporarily to set up business on Rue Mansart—was already well known to true collectors. The regular customers of the "Mogador circle," as it was facetiously called, were experienced connoisseurs such as Count Doria, Henri Rouart, Alfred Sensier, and Jean Dollfus.

Martin carried works by Corot, Millet, Théodore Rousseau, and Jules Dupré. Soon he discovered Adolphe-Félix Cals, and especially Eugène Boudin and Johan Barthold Jongkind. Jongkind wrote to Martin from Holland on July 21, 1857: "Realize, my good Martin, that you are my darling, my help, my hope, and that I find myself happy, and doubly so, to receive news of you and to learn that you are pleased with what I send you. God willing, I shall see you and my friends and beautiful France again. See you again soon. In the meantime, my good Martin, send me money. And since we have settled our accounts at the rate of 175 francs for each painting, please send me 200 francs now. For the extra 25 francs that I owe you, we shall come to an agreement when I am there. Remember me to your wife. Keep the grill hot for a chop and keep a bottle of aged Médoc from Bercy standing by ready to drink."

Martin had a simple, family business. From 1869, his shop was at 52 Rue Laffitte—a street of picture dealers. After 1870, P. F. Martin very naturally became the dealer of the future Impressionists. In 1870, in the Salon's catalogue, Pissarro gave Martin's address as his agent. In 1874, Martin was the director of the Private Com-

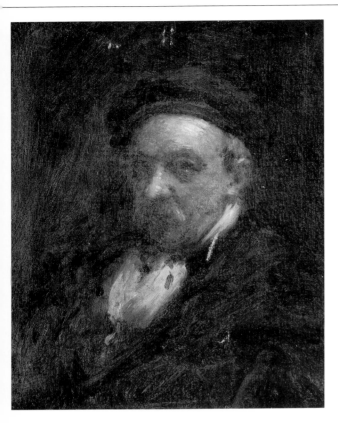

26 Adolphe-Félix Cals. *Pierre-Firmin Martin*. 1878. Oil on canvas, 35 × 27 cm. ($13\frac{3}{4}$ × $10\frac{5}{8}$"). Musée Eugène Boudin, Honfleur (Deposited by the Musée d'Orsay, Paris; gift of Dr. Soubeiran, 1957).

26

27

pany of Painters, Sculptors, and Engravers, Etc. that organized the first Impressionist exhibition.

Martin lived a few doors from Renoir's apartment, at 29 Rue Saint-Georges; at the end of his life, he ran his business from his home. Martin sold works by all the Impressionist artists at low prices. For example, in 1870, the American dealer Lucas bought Pissarro's *The Versailles Road at Louveciennes (Snow)* (Walters Art Gallery, Baltimore) from him for 20 francs. Martin frequently resold works the artists had put in his hands to Durand-Ruel. In fact, he often acted as a broker between artists and the more fashionable dealers or private collectors.

Having had no children, Martin went into partnership with his nephew, Joseph Paschal, who died young. When Martin died, his wife's niece, Léonie-Rose Davy (who became Madame Charbuy) fell heir to his business. Rose tried to continue her uncle's business. Pissarro strongly urged his sons and his friend, the painter Maximilien Luce, to deposit works with her. Unfortunately, her apartment at 4 Rue des Martyrs burnt down in November, 1893. This setback seems to have been decisive; in any case, her uncle had not left her any stock. The inventory of Martin's simple apartment was published recently; certain paintings listed as anonymous may actually have been works by Vincent van Gogh (thanks to his brother Theo, Van Gogh also had known *père* Martin). However, in 1891, no one cared about Vincent van Gogh. Rose Charbuy is probably depicted in Van Gogh's *Woman next to a Cradle* (Vincent van Gogh Foundation/National Vincent van Gogh Museum, Amsterdam), painted in Paris in 1887.

Père Tanguy

We cannot speak of Vincent van Gogh without mentioning *père* Tanguy, about whom Zola says nothing. Julien-François Tanguy has never been totally forgotten, however. Van Gogh painted his portrait twice. The writer Octave Mirbeau published a description of him in 1894, as did Emile Bernard in 1908. This reliable testimony has been used several times since then.

Tanguy was born on June 28, 1825, at Pledran, near Saint-Brieuc, in Brittany. He was his parents' fifth child; his father was a weaver and his mother, a spinner. Both of them stated that they were unable to sign their names when he was born. As a young man, Tanguy was a plasterer and then a pork butcher. Suddenly, early in the 1860s, he went to Paris with his wife and their daughter. Tanguy became a color grinder at a shop that sold artist's supplies on Rue Clauzel. In that same street, probably in 1873, he opened his own artist's-supplies shop at Number 14. The premises were tiny—less than 300 square feet. Two other small rooms and a kitchen in the back shop served as his home. In the spring of 1891, Tanguy moved to Number 9, an establishment just as simple. He died there on February 9, 1894.

For twenty years, works by Cézanne, Pissarro, Armand Guillaumin, and the other Impressionists to whom Tanguy supplied paints were shown in Paris in those two shops successively. Later, Tanguy displayed works by Paul Gauguin, Emile Bernard, and Vincent van Gogh, to whose works he had near-exclusive access. Tanguy's shop, it must be added, was soon known as far away as America: in 1892, Cecilia Waern, an American journalist making the rounds of Parisian studios and other meeting places of avant-garde art, visited *père* Tanguy. Tanguy's fame was admittedly restricted to a small circle of cognoscenti. They included the artists already mentioned and the entire generation of Post-Impressionists such as Georges Seurat, Maurice Denis, Paul Sérusier, and others, who came to Tanguy's—it was almost a pilgrimage—to see works by Cézanne. Victor Chocquet probably acquired his first Cézanne at Tanguy's in 1875 (as Renoir told the dealer Vollard). Dr. Paul Gachet came to Tanguy's as well; and Théodore Duret, sent by Pissarro. However, in the end, few of Tanguy's visitors were rich and bold enough to buy what he displayed.

24

24, 28

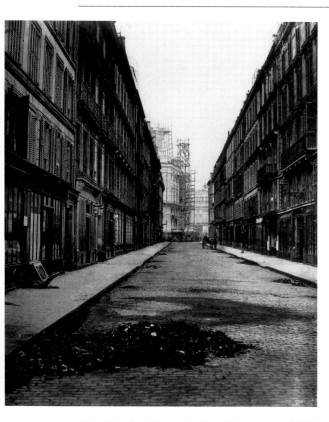

27 Charles Marville. *Rue Mogador*. c. 1865. Photograph. Bibliothèque historique de la Ville de Paris.
One of *père* Martin's shops, at Number 20 on the left, draws attention with canvases on the sidewalk. At the far end of the street, the new Paris Opéra is under construction.

Vincent van Gogh and Emile Bernard left us vivid depictions of Tanguy: a little, 24, 28
broad-shouldered man, sitting on a chair, with a flattened face and nose, and close-cropped hair. Tanguy was a virtuous man, almost a saint. He forgot his own poverty in order to help those even less fortunate. Of working-class background, Tanguy was a socialist. It has been said, though not yet verified, that Tanguy, a Communard through sheer thoughtlessness, was jailed and deported to Brest, then finally pardoned in 1873.

Tanguy probably made the acquaintance of the future Impressionists before the Franco-Prussian War, when peddling his products in Argenteuil and in Barbizon. He took paintings in exchange for supplies—usually the Impressionists' only means of settling a debt. For example, on March 4, 1878, Cézanne admitted to owing Tanguy 2,174.80 francs for supplies; he had still not paid Tanguy by August 31, 1885, at which date Cézanne's total debt amounted to 4,014.40 francs. That was an enormous sum in view of poor Tanguy's financial position—he paid an annual rent of 200 francs. Despite the fact that Madame Tanguy carefully, and rightfully, kept paintings as

security, the credit Tanguy extended to artists amounted to true patronage—for a painting by Cézanne sold for 200 francs at Tanguy's in 1884.

Tanguy liked to talk to the artists and collectors. Emile Bernard described him making remarks as he unwrapped a package of canvases by Cézanne as though it were a treasure. Octave Mirbeau gave us Tanguy's words: "That poor Vincent [van Gogh]! I'll bet you've never seen his *Vase with Gladioli*. It's one of the last paintings he did. A-a-a ma-a-ar-vel! I must show it to you! I tell you, no one had his feeling for flowers. He felt everything, poor Vincent! He felt too much! Which meant that he wanted the impossible. I am going to get the *Vase with Gladioli* for you. Mr. Pissarro, who looked at it for a long time, and all those other gentlemen, said that Vincent's flowers are like no one else's. Mr. Emile Bernard said that Vincent's flowers are like princesses." But Tanguy was generally a close-mouthed fellow; he needed to feel accepted before opening up like that.

When Tanguy fell ill in 1892, he was in such dire straits that Emile Bernard took up a collection to help him. After Tanguy's death on February 9, 1894, his friends—Emile Bernard, André Bonger (a friend of Vincent van Gogh and Theo's brother-in-law), and especially Octave Mirbeau—helped Tanguy's widow. They organized an auction on her behalf, canvassing artists, collectors, and dealers. It was held at the Hôtel Drouot on June 2, 1894. The list of the works sold there—nearly a hundred—is a real tribute to *père* Tanguy. Cézanne, Guillaumin, Monet, Pissarro, Renoir, Mary Cassatt, and Berthe Morisot were represented, as well as Bernard, Cross, Dubois-Pillet, Gauguin, Luce, Maufra, Seurat, and Signac. Two works by Van Gogh were sold: one was listed as "Van Gogh," and the other as "Vincent." He was virtually unknown at the time. The auction brought in 14,000 francs.

Tanguy's widow—a "poisonous" shrew according to Van Gogh—complained: "the auction did not fetch what it would have if it had been held at Georges Petit's, for there would have been many more collectors than at the Hôtel Drouot. For I must tell you that I had very beautiful things at my sale, and unfortunately they were given away for nothing, because nearly everyone there was a picture dealer; and the word had gone round not to raise the prices.... The paintings by Cézanne and Guillaumin were sold very cheaply. Mr. Vollard, a picture dealer just opened on Rue Laffitte, took all the Cézannes." Thus, the succession of the almost legendary *père* Tanguy was already established.

Paris was home to picture brokers as well as to dealers. Although these men did not own a gallery or a shop, they were well known to collectors and artists alike.

Portier

Alphonse Portier was a typical broker. A former textile dealer, he became coowner of a paint shop in 1875, and soon began making contact with the Impressionists. Portier was the manager of the fourth Impressionist exhibition in 1879. From then until the end of his life, Portier bought and resold works by Pissarro, Monet, and Degas. He was totally lacking in commercial aggressiveness: "Portier is hopeless; very nice, very honest, but not on the go, not at all," said Pissarro. Still, Portier knew painting and the artists, the smart set among the collectors of Impressionism in the late nineteenth century—De Camondo, Rouart, Chéramy, Depeaux, Princess de Polignac (née Winnaretta Singer), and the Havemeyers—became his customers.

Portier lived at 54 Rue Lepic, where, coincidentally, he had two young Dutchmen as neighbors in 1886. One was a picture dealer named Theo van Gogh; the other was his brother, Vincent, who had just arrived in Paris and was discovering Impressionism. As a dealer, Theo sided wholeheartedly with the new movement.

29 Anonymous. *Alphonse Portier*. c. 1900. Photograph. Private collection, Paris.
The most visible painting, on the bottom at the left, is a Pissarro.

Theo van Gogh

The Van Gogh family had been in the business of selling paintings for a long time. First of all, there was "Uncle Cent," Vincent van Gogh (1820–1888), a partner in the powerful house of Goupil until he retired in 1878. Then, before becoming an artist, sixteen-year-old Vincent was an employee of Goupil's, first at their branch in The Hague from 1869, then in London in 1873, and in Paris from 1875–76. Theo van Gogh (born in 1857) also worked at Goupil's from 1873. Theo worked his way up the ladder and, by 1883, he was well established there. He managed a branch of the firm at 19 Boulevard Montmartre. Through inheritances, it became Boussod, Valadon and Co. in 1884.

31

30

The firm of Goupil in Paris and its branches abroad were a solid and extremely prosperous family concern. Today, however, it would not be considered very progressive. Theo certainly witnessed the firm's development. From representing artists such as Paul Delaroche, Horace Vernet, Ary Scheffer, Jean-Léon Gérôme (who married the founder Adolphe Goupil's daughter), the gallery went on to sell Millet, Corot, Daubigny, and the artists of the Barbizon School.

Following Durand-Ruel's example, Theo began orienting his choices toward another track—Impressionism. As early as 1884, he purchased a work by Pissarro, whom Theo seems not to have actually met until 1887, through Portier. Then, in 1885, Theo bought a painting by Sisley from the artist himself. In the same year, he sold a Monet and a Renoir. After Vincent van Gogh arrived in Paris in March, 1886, Theo intensified his transactions with works by Manet, Degas, Monet, Pissarro, Sisley, and Guillaumin. Theo bought either from the artists or from middlemen, brokers, or small dealers, or sometimes at the general auction rooms. Exhibiting paintings by all the artists previously mentioned on the first floor at Boulevard Montmartre, Theo set up as a real rival to Durand-Ruel—which led Vincent van Gogh to call those artists *peintres du Grand Boulevard* (main-street painters).

Along with the respected elder artists, Theo maintained contacts with the "sidestreet" painters, thanks to his brother. These included Paul Gauguin—though his paintings were also displayed on Boulevard Montmartre—Emile Bernard, Louis

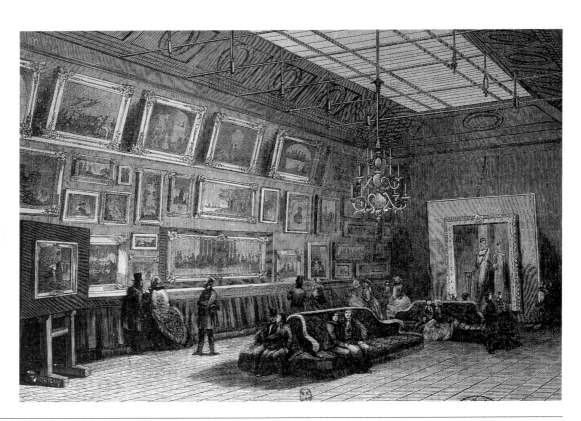

Anquetin, Henri de Toulouse-Lautrec, and Vincent himself. Their nickname came from the fact that they had to be satisfied with seeing their works hung in a restaurant on Avenue de Clichy. Theo van Gogh was also in touch with Seurat and Signac whose divisionism (= pointillism, but the term was derogatory in the 1880s) influenced Vincent.

Another artist whom Theo admired was Adolphe Monticelli, who died in 1886. Theo was also one of the first dealers to take notice of Odilon Redon.

From modest transactions Theo van Gogh went on to more important deals, buying from Monet ten recent paintings at one go, in June, 1888, for over 10,000 francs. There was talk at his employer's of sending Theo abroad, probably to counteract Durand-Ruel's efforts in Great Britain and the United States.

At the same time, Gauguin was receiving 150 francs per month from Theo in exchange for paintings. Lastly, Vincent—bound by the complex relations between dealer and artist as well as between brothers—was completely dependent on his brother. Vincent wrote to Theo: "I would like to make you understand that by giving money to artists you yourself are doing an artist's work; and my sole desire is that my canvases will not make you too displeased with the work you do."

However, the fate of those two brothers, so intimately linked to each other, was tragic. For reasons that remain obscure, Theo's position in the firm went to pieces. Vincent was ill and a heavy burden on his brother until July, 1890, when he committed suicide. Theo survived him by only a few months. He was not able to convince a serious dealer to hold a retrospective of his brother's works. Sick in mind and body, Theo van Gogh died on February 6, 1891. His widow Joanna devoted herself from then on to keeping the memory of the two brothers alive.

Shortly afterward, Durand-Ruel wrote to Camille Pissarro: "The only obstacle to our affairs was that ill-fated [Theo] van Gogh, who ended so miserably. He threw a wrench into the works, and I never could understand your liking him. Since he is gone now, count on me absolutely." However, Durand-Ruel was about to encounter more dangerous rivals than Theo van Gogh: the Bernheim brothers, on the one hand, and Ambroise Vollard on the other.

Bernheim-Jeune

Family tradition holds that the Bernheim-Jeune gallery originated in Paris in the early 1860s. But at that time—between 1866 and 1876—Alexandre Bernheim also had a gallery in Brussels. Somewhat later, the Bernheim-Jeune shop was finally opened at 8 Rue Laffitte, where it remained until the end of the century.

Alexandre Bernheim, the son of a shop owner, was born in Besançon on April 3, 1839. He died in Paris on March 2, 1915. From selling artist's supplies like his father in his native town, Alexandre went on to become a picture dealer—the classic story—and moved to Paris at the suggestion of Gustave Courbet, who was a native of Franche-Comté himself.

Alexandre Bernheim was particularly interested in artists such as Corot, Dupré and the Barbizon School, and Théodule Ribot, for whom he had exclusive rights. Both of Alexandre's sons were born in Brussels in 1870: Joseph (Josse) on January 2, and Gaston on December 22. Under their management, the gallery showed more Impressionist painters during the early 1890s. Joseph died in 1941, and Gaston, in 1953. Their children and their grandchildren took over the gallery, which is still in business at 83 Faubourg Saint-Honoré and at 27 Avenue Matignon—an address that has not changed since 1925.

From 1900, the Bernheim-Jeune gallery had the sparkling patronage of the second generation of collectors of Impressionism, among them, Auguste Pellerin, Etienne Moreau-Nélaton, Paul Gallimard (father of the publisher Gaston Gallimard), Lucien Sauphar, and P. van der Velde.

32 Pierre-Auguste Renoir. *Mr. and Mrs. Gaston Bernheim de Villers*. 1910. Oil on canvas, 81 × 65 cm. (31¾ × 25⅝″). Musée d'Orsay, Paris (Gift of Mr. and Mrs. Gaston Bernheim de Villers, 1951).

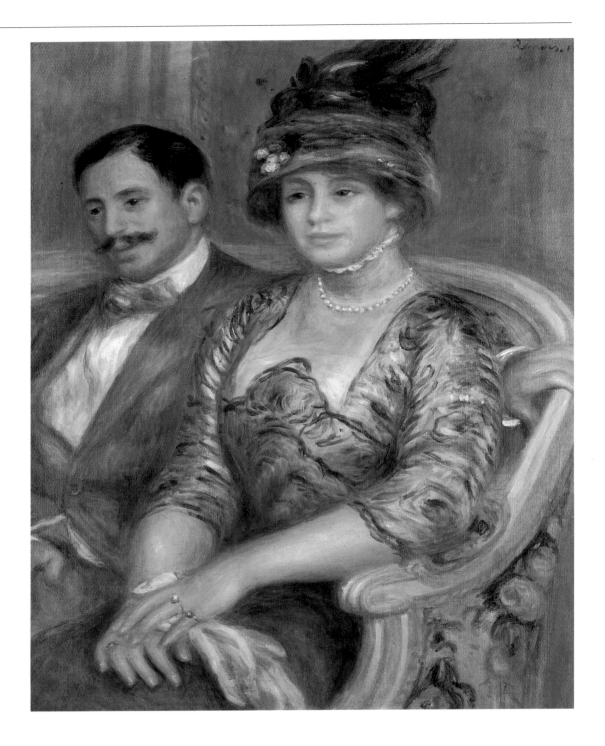

▷

33 Pierre Bonnard. *Portrait of the Bernheim-Jeune Brothers*. 1921. Oil on canvas, 165 × 155 cm. (65 × 61″). Musée d'Orsay, Paris (Gift of Mr. and Mrs. Gaston Bernheim de Villers, 1951).

"A sign of the times at the Bernheim brothers, picture dealers [on] Rue Laffitte, one of my canvases from 1882 in the shop window.... What a long time it has been since I've seen a canvas by me at a dealer other than Boussod and Valadon or Durand[-Ruel]. If it should sell a little, we might manage to escape from extreme poverty."

Camille Pissarro to his son, Lucien, May 14, 1891.

The Bernheim brothers' success preceded by very little the ascendancy of Ambroise Vollard, with whom the Bernheims often did business. Georges Petit sold shares in his firm to the Bernheim brothers. Even Durand-Ruel had to come to terms with them; he set up a partnership with the Bernheims to buy at the great auctions that broke up the collections formed twenty years earlier.

The Bernheim brothers also bought directly from artists, including Monet, Renoir (who apparently forgot to be anti-Semitic when it was to his advantage), and Pissarro's family. Like Vollard, the Bernheims bought up paintings by Cézanne, whose star had been steadily on the rise since 1895. They also foresaw fame for young, unknown artists such as Seurat and Van Gogh, and then the Nabis—especially Pierre Bonnard—and Félix Vallotton, who had married Josse's and Gaston's sister, Gabrielle. As a result, the Bernheim-Jeune gallery organized landmark exhibitions:

32

34 Paul Cézanne. *Portrait of Ambroise Vollard.* 1899. Oil on canvas 100 × 81 cm. (40¼ × 32½″). Musée du Petit Palais, Paris (Ambroise Vollard Bequest).

"Van Gogh" in 1901, "Bonnard" and "Vuillard" in 1906, "Cézanne" in 1907, "Cross" and "Seurat" in 1908, and lastly "Matisse" in 1910. Bernheim-Jeune also represented a group of artists who called themselves the Black Band *(bande noire)*, including Charles Cottet and Lucien Simon. The gallery widened its scope with a publishing house that secured the collaboration of critics such as Cézanne's friend, Joachim Gasquet, and Théodore Duret, and, among the younger generation, Félix Fénéon.

After 1900, by establishing branches first at 36 Avenue de l'Opéra, then at 25 Boulevard de la Madeleine and at 15 Rue Richepance, the Bernheim-Jeune gallery gave the signal for the Parisian art trade to shift toward the western part of the capital. The management of their branch on Avenue de l'Opéra was entrusted to one of their cousins, Jos Hessel.

While the Bernheim brothers conducted their trade with luxury and flourish, in the grand style modeled on Georges Petit, there was another important figure in the field who, little by little, stood out in quite a different style—Ambroise Vollard.

Vollard

The artist Maurice de Vlaminck described Vollard thusly: "Ambroise Vollard's shop was located on Rue Laffitte, a few yards from the Boulevard des Italiens. It was a rather big shop, painted brown, that looked somewhat sleazy. The faded paint was peeling off, and the two dusty shop windows did not display much of interest. In front of a vaguely colored velvet curtain, sometimes set on an easel, one could see a small painting of *Bathers* by Paul Cézanne, a Bonnard, or a Gauguin. But most of the time the windows were bereft of paintings; small bronzes or terra-cottas by Aristide Maillol lay about helter-skelter. During the day, the shop was dark. At night, a flickering gas burner gave feeble light. A table loaded with a lot of papers, catalogues, and incongruous objects and two straw-bottomed chairs constituted all the furniture; and one could catch sight of Vollard, sleeping with his head in his hands.... Not one of the canvases stacked up in front of, or behind the curtains, or piled up on the board shelves that ran all around the room was turned to show the painting. In 1905, there were ten or so canvases by Cézanne there, just as many by Degas and by Renoir, all bunched together [and] covered with a layer of dust." Vlaminck forgot to mention the ubiquitous cats that shared Vollard's fate.

Ambroise Vollard is the only one of all the dealers who turned his life into quite a story. It is very hard to find something to write about him after having read his *Recollections of a Picture Dealer* (published in English for the first time in 1936).

Ambroise Vollard was born on July 3, 1866, on Reunion, one of the Mascarene Islands in the Indian Ocean, and died at Versailles in an auto accident on July 22, 1939. His life extended far beyond the Impressionist era. Yet the same man who became Georges Rouault's and Pablo Picasso's dealer had originally been Cézanne's and Renoir's.

In his book, Vollard gives a voluble narration of his exotic childhood and adolescence, his law studies at Montpellier and then in Paris, where he received his law degree while already looking at the shop windows of picture dealers. Vollard was a frequent visitor at several artists' studios and finally made his first appearance in the trade—after Georges Petit had declined to employ him—as a shop assistant for a certain Dumas, who sold the works of the very academic Edouard Debat-Ponsan.

Vollard finally opened his own shop on Rue Laffitte, moving from Number 39 to Number 41 as early as April 1895, and then to Number 6 in June, 1896. At first he sold mostly the prints and drawings of artists such as Jean-Louis Forain, Adolphe Willette, Félicien Rops, and Théophile Steinlen rather than their more expensive paintings. Vollard was shrewd and managed to convince Manet's widow to give him drawings, with which he held a small exhibition. News traveled fast, for Camille Pissarro wrote to his son on January 21, 1894: "A young man whom I met at John Lewis Brown's, and whom Mr. [Georges] Viau recommends highly, has opened a

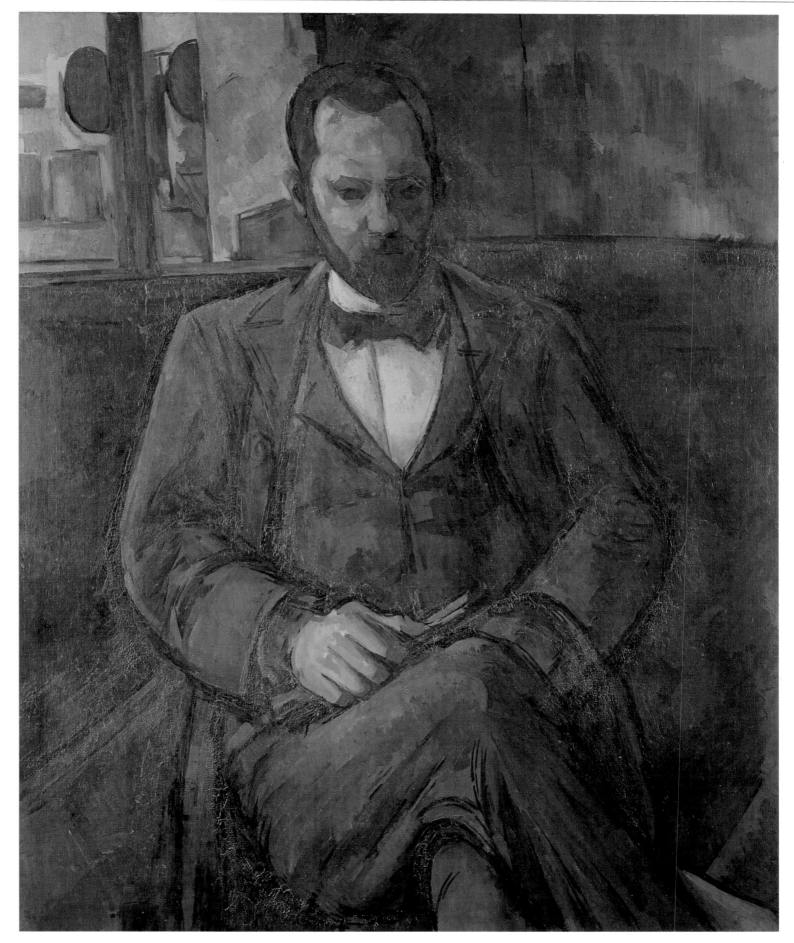

35 Pierre-Auguste Renoir. *Ambroise Vollard Holding a Maillol Statuette.* 1908. Oil on canvas, 82 × 65 cm. (31¾ × 25½″). Courtauld Institute Galleries, London.

"Vollard, the wealthiest dealer in modern pictures. He is a millionaire ten times over. The beginning of his fortune goes back to the day in Cézanne's studio when he found the artist depressed and bought about 250 canvases from him at an average of 50 francs apiece. He parted with some but kept the majority until the time he could sell them for 10,000 to 15,000 francs each."

René Gimpel, *Diary of an Art Dealer*, May 14, 1918 (translated by John Rosenberg), 1986, p. 23.

small shop on Rue Laffitte. He only has paintings by young artists; there are very beautiful old Gauguins, two extremely beautiful things by Guillaumin, and works by Sisley, Redon, Jean-François Raffaëlli, and De Groux.... He only likes things by our school.... he is very enthusiastic and a good judge; he has already begun to be of interest to certain collectors who like to rummage."

Among those collectors were Degas and Monet, who bought works by Manet from Vollard; but his customers also included the people who amassed the great collections of the end of the century: Count Isaac de Camondo, Dr. Georges Viau (a dentist), State councilor Olivier Sainsère, Eugène Blot (a collector turned art dealer), Denys Cochin, a member of the French parliament, and Paul Gallimard. There were also foreign collectors among Vollard's clients: the Russians were the very first, including Sergei Shchukin and the Morozov brothers. They were followed by the Germans: Von Seidlitz from Dresden, Ressler from Berlin, Count Kessler from Weimar; by a Dutchman, C. Hoogendijk, from The Hague; by an American living in Florence, Charles Loeser; and by Marczell de Nêmes from Budapest, among others.

Vollard's start was very unpretentious, but by being on good terms with Renoir and Degas—which enabled him to sell an important work from time to time—he made a name for himself. Vollard also took an interest in artists that are somewhat forgotten today such as De Groux and Maurin. His greatest achievement was clearly the Cézanne exhibition he organized at the end of 1895; from then on, he bought Cézanne regularly, thus assuring the artist's income until his death.

Vollard was not slow to acquire works by Van Gogh either; he systematically prospected in Arles and in Saint-Rémy, looking for lost canvases. In 1897, he held a Van Gogh exhibition.

Vollard also purchased works by Gauguin, agreeing to regular purchases in 1901, in order to secure for the artist a meagre subsistence in the tropics.

In 1900, Vollard's shop at 6 Rue Laffitte (his address until the World War I) was already one of the shrines of the avant-garde. Maurice Denis and his friends, Bonnard and Vuillard, depended on Vollard since the death in 1897 of their first dealer, Louis-Léon Le Barc de Boutteville. Denis made Vollard's shop the setting for his famous *Homage to Paul Cézanne* (Musée d'Orsay, Paris). His fortune secured by the Impressionists, Ambroise Vollard was able to devote himself to younger artists, both as a dealer and as a publisher.

As early as 1918, Vollard published a collection of photographs of works by Renoir, countersigned by the artist. That signaled the beginning of that master's historic ascendancy: Vollard's picture book was a Renoir corpus in embryo. In 1931, the Bernheim-Jeune gallery published another sumptuous collection of that artist's work, entitled *Atelier de Renoir (Renoir's Studio).*

To conclude our discussion of the pre-World War I Parisian art market—which was, by the way, sustained during the interwar years by the same leading spirits—we should mention the young Paul Rosenberg, who went from selling the Impressionists to the Cubists and Picasso.

Little by little, the artists themselves had been leaving the stage: Sisley was the first to die (in 1899), then Pissarro (in 1903), Cézanne (in 1907), Degas (in 1917), Renoir (in 1919), and lastly, Monet (in 1926). Most of them had enjoyed fame during their lifetimes. Now their posthumous fortune was secure.

36 M. Mouchot. *Auction at the Hôtel Drouot.* 1867. Print. Bibliothèque Nationale, Paris.

Chapter IV

The Parisian Art Market During the Impressionist Era: Auctions

In his preface to the sale of Count D'Aquila's collection at the Hôtel Drouot in Paris on February 21–22, 1868, Philippe Burty wrote: "In the past few years, thanks to unceasing changes at contemporary private galleries, the Hôtel Drouot has become a sort of permanent museum of the modern school." While underscoring the versatility of collectors, that remark also indicates that the French national collections at the Luxembourg Museum—created in 1818 and, until 1928, the National Museum of Contemporary Art—cut a sorry figure. Around 1850, the whole collection numbered less than two hundred paintings, whereas the auction rooms of the Hôtel Drouot, located since midcentury on the site it still occupies, played a very important role in circulating contemporary art.

The exhibitions held at the Hôtel Drouot in advance of public sales enabled people to see more works at one time than a dealer like Durand-Ruel could show in his gallery—let alone *père* Tanguy in his little shop. At the estate and studio sales held at Drouot after an artist's death, the artist's friends and collectors saw important works exhibited together for the last time, and sometimes they found a bargain. Because of the large quantity of works for sale on such occasions, prices were reasonable. The Delacroix (1864), Millet (1875), and Manet (1884) sales were exemplary. By 1920, this system would disappear.

The last great Impressionist auction was the sale of Degas's estate (a series of auctions, including the auction of his own collection in 1918–19). No auctions were held immediately after the deaths of Pissarro, Monet, or Renoir—although Renoir left a very large number of works. Those artists' dealers were there to collect their output and dispose of it little by little.

Almost all the collectors bought pictures at the Hôtel Drouot. All or part of many of their collections ended up in auction rooms themselves, fueling the desires of the next generation of collectors.

The Hôtel Drouot was also the scene of two Impressionist events: the auction organized by the artists on March 24, 1875 (auctioneer: Pillet, expert-appraiser: Durand-Ruel), and the one on May 28, 1877 (auctioneer: Tual, expert-appraiser: A. Legrand).

For a living artist to sell his work at the Hôtel Drouot was not unheard of; many resorted to it regularly, thereby supplementing their direct sales to dealers and collectors. Renoir, for example, wrote to Bazille in September, 1869: "I exhibited [the portraits of] Lise and Sisley at Carpentier's. I am going to try to stick him for about 100 francs, and I'm going to put my woman in white up for auction. I'll sell it for whatever price it goes for; it's all the same to me."

Reading the records of one of these auctions, one encounters both the names of dealers interested in Impressionism and those of collectors. In 1875, familiar names such as Durand-Ruel, Latouche, and a few other, less well-known brokers were listed, as well as collectors: Faure, Chesneau, Hoschedé, Rouart, Dollfus, Charpentier, the Hecht brothers, Arsène Houssaye, Petitdidier, better known by his pen name, Emile Blémont. Blémont was the table companion of Rimbaud and Verlaine in Henri Fantin-Latour's *A Corner of the Table* (Musée d'Orsay, Paris). Also among the buyers at the 1875 Impressionist auction was Gustave Arosa, a stockbroker. Arosa was interested in the collotype process, but, more importantly, he was the legal guardian

37 Official Record of the Hoschedé Auction, held at the Hôtel Drouot, Paris, on January 13, 1874. Archives of Paris.

of Paul Gauguin. Arosa's own collection was sold at auction on February 25, 1878. At least two collectors followed his example: his younger brother Achille and, of course, Gauguin. Finally, we can mention another buyer, Berthe Morisot's cousin, Gabriel Thomas, a director of the Eiffel Tower Company and future director of the company that owned the Théâtre des Champs-Elysées, as well as a patron of the Nabi artist Maurice Denis.

The rest of the Parisian art world poked fun at those "few worthy men, well equipped with colonial goods made of calico and flannel," probably referring to Ernest Hoschedé and the Hechts, who bought badly painted pictures. Even while disapproving of the uproar organized by Impressionism's detractors, a critic of *L'Art* found it necessary to state: "We call them paintings to be courteous."

Hagerman, Diot, and Petit were among the dealers at the Hoschedé auctions of 1874 and 1878—real "tests" for Impressionist painting, treated in more detail in Chapter VII. Among the collectors present were Théodore Duret and his cousin Etienne Baudry, De Bellio, Murer, Chocquet, De Rasty, May, and Mary Cassatt.

The same people also attended Manet's auction, along with others, including Chabrier, Deudon, Bernstein, Dr. Robin, and Dr. Blanche. This listing is enough to remind us, if need be, of the important role of auction rooms in circulating contemporary art during the Impressionist era. At the same time, with the support of dealers—as Durand-Ruel never tired of repeating—the commercial value of painting was strengthened at auctions. Hence the importance of auctioneers. The nineteenth century was not lacking in great master auctioneers, and luckily, several of them did not scorn the Impressionists.

The most renowned was certainly Charles Pillet, who conducted all the great auctions between 1855 and 1881, in particular, those of artists such as Delacroix and Millet, or of large collections such as Demidoff's. A journalist recalled Pillet's "agreeable though slightly haughty nature, reserved . . . but never refusing to do a favor and knowing how to be obliging with tact." In his letters, Camille Pissarro, remembering that Pillet had conferred his patronage upon the 1875 Impressionist auction, often wrote about the auctioneer with respect.

Paul-Louis Chevallier, Pillet's successor in November, 1881, maintained the same attitude and often chose Durand-Ruel as expert-appraiser. Chevallier was also associated with the auctions that aroused worldwide interest during his lifetime: Spitzer, Secrétan, Beurdeley, Meissonier, Rosa Bonheur, Count Doria, Sedelmeyer, and others.

Charles Pillet, the uncle of the Neo-Impressionist artist Albert Dubois-Pillet, died a pauper despite the millions he had earned. *Le Temps* said that, carried away by his weakness for works of art, he had launched into speculative purchases that swallowed up—in two years—the profits of his long career. So Pillet turned to journalism, contributing to *Le Journal des Débats* and *L'Art*, and he was named to the committee Jules Castagnary had established to supervise the conservation of paintings in the French national museums. (Castagnary, a critic and a friend of Courbet and the Impressionists, had become director of fine arts in 1887.)

Another auctioneer, Léon Tual—Boussaton's successor—active from 1876 to 1904, took an interest in the Impressionists from 1877, associating himself with Legrand or Martin as expert-appraisers. (Tual appraised Martin's property when he died.) Since Tual's archives have not survived, he is not well known. He maintained good relations with Monet, Sisley, and even Cézanne throughout his entire term of office. Tual liked artists and gladly offered his assistance—for free—when it came to organizing an auction to help a needy artist. Thus he presided at the auction for the benefit of the musician Cabaner on May 14, 1881. Emile Zola wrote the foreword to the catalogue; and Manet, Renoir, and Cézanne contributed works to be auctioned.

Far from being shunned by the general auction rooms at the Hôtel Drouot, the Impressionists, on the contrary, owed much of their success to that establishment.

38 James Abbott McNeill Whistler. *Arrangement in Flesh Color and Black: Portrait of Théodore Duret.* 1883. Oil on canvas, 194 × 90 cm. (76⅛ × 35¾"). The Metropolitan Museum of Art, New York (Wolfe Fund, 1913).

Private Collectors:
Théodore Duret, Etienne Baudry,
Albert and Henri Hecht

After beginning by quoting him, it seems only fair to mention Théodore Duret as our first collector. To think of Duret only as a collector would be a misconception. Journalist, critic, essayist, traveler to faraway countries, he also flirted with a political career in his youth. But it is primarily as a collector of Japanese art and a historian of Impressionism that his name has survived. We have a clear picture of how Duret looked. In 1868, when he was about thirty, Manet painted him as a dandy. Then, in 1882–84, Whistler portrayed a still-fashionable Duret in *Arrangement in Flesh Color and Black: Portrait of Théodore Duret*. Later, Edouard Vuillard depicted Duret, in 1912, as an aged man of letters in the quiet untidiness of his study.

1

38

48

A Republican from the Country

Born at Saintes in western France on January 19, 1838, Théodore Duret was the son of one of Saintes's leading citizens with republican sympathies. His father—a notary and a cognac merchant—had him travel for the family business. In 1862, Théodore was in London, a city he already knew well, during the International Exhibition. In his first articles as a journalist, which he sent to a local newspaper, Duret spoke admiringly of the Japanese and described the races at Derby. Then his articles moved toward politics—the future Liberal candidate at the local elections of 1863 and 1869 was already beginning to emerge. Duret was not elected either time; "thrift and peace," his hardly original slogan, failed to convince the voters.

Like all provincials, however, Duret dreamt of the capital. He moved to Paris during the last years of the Second Empire, between 1868 and 1870, working as a reporter for the republican rags *Le Globe* and *La Tribune*—which were regularly subjected to fines; Duret also invested some money in those newspapers. Little by little, he began to specialize as an art critic: his first review of an exhibition dates from 1867. In 1870, Emile Zola wrote to Duret: "I've read your second article on the Salon, which is excellent. You are a bit mild. To speak well of those one likes is not enough; it is necessary to speak ill of those one detests." (Since 1868, Duret had been friendly with Zola, who wrote for *La Tribune*; and the two would continue to be close friends.) That admonition from Zola, Manet's champion, places Duret once again on the side of the "good cause." It also shows clearly that, although Duret believed in "his" artists, he was by no means a wild polemist.

Duret and Etienne Baudry

By a stroke of fortune, Duret had already seen the great painting of his time in his native province. His cousin, Etienne Baudry, had been a schoolmate at Saintes of Jules Castagnary, the promoter of Realism and one of Courbet's earliest admirers. Baudry met Camille Corot and, especially, Gustave Courbet, who stayed with Baudry in 1862. Théodore Duret met Courbet for the first time at Baudry's; much later, Duret would write a book about the artist.

In the eyes of posterity, Etienne Baudry remains, above all, one of the first collectors of Courbet. The artist's *Les Demoiselles des bords de la Seine* had been at Baudry's since 1875; it was from there that the artist's sister handed it over to the Petit Palais Museum in Paris. Yet, although Baudry influenced Duret at first, Duret is the one who introduced Baudry to the Impressionists: first Pissarro, around 1872–73, then Monet. At the first Hoschedé auction on January 13, 1874, Baudry acquired Monet's *Blue House at Zaandam*, which the artist would have liked to buy back himself. This painting, which was recently (in 1988) auctioned for 3.85 million pounds in London, went for 405.25 francs, including the auction fees. Baudry lent that picture to the fourth Impressionist exhibition in 1879. Soon afterward, that artlover faded from sight, despite his efforts to find buyers in Saintes for the painters he appreciated.

Théodore Duret Encounters Manet

The second crucial event in Duret's career was his encounter with Edouard Manet in a Madrid hotel in 1865. To thank Duret for writing favorably—despite a few reservations—about the 1867 Exposition Universelle, Manet painted a portrait of his new friend in 1868. Duret's booklet was entitled *Les Peintres français en 1867*. In it he compared Bouguereau, Cabanel, Gérôme, and Winterhalter—extremely bad bourgeois painters—with Corot and Jean-François Millet. From Théodore Rousseau and Charles Daubigny, Duret went on to discuss Courbet and Manet. The same ideas are reiterated in his account of the 1870 Salon, where he also came to the defense of Eugène Boudin, Paul Guigou (from Provence), Henri Fantin-Latour, Camille Pissarro, and Degas.

When the war broke out, Manet asked Duret to safeguard his paintings. In a note, the artist specified that only the portrait of Duret and *A Matador Saluting*, which Duret would pay for shortly afterward with a check sent from New York, belonged to his friend at that time. Manet added that, if he should die, Duret could choose a work by him as a memento.

Duret was in the capital during the siege and Commune of Paris. Together with the banker Henri Cernuschi, he tried to organize relief for starving Parisians and to prevent summary convictions. The two men's departure for London and then Japan via the United States at the beginning of June, 1871, strongly resembled a flight from the "horror and terror" that Duret described to Pissarro, who had already taken refuge in London. It was probably through *père* Martin that Duret had met that artist before the Franco-Prussian War, after having met Manet and Degas—the latter, no doubt, thanks to Manet. Moreover, Martin had informed Duret that Pissarro was in London.

In London, Duret had the time to see a work by Pissarro at Durand-Ruel's, and he brought two friends to Pissarro's hoping they would buy something: Jules Berthet, a wine merchant, and one of the Hecht brothers who collected paintings by Manet. For, in addition to wanting to buy an English landscape by Pissarro, Duret was also actively trying to convert people to Impressionism, a cause he pursued during many years, when the artists had the greatest need for it.

Trip Through Asia

Duret was leaving for Japan: ten days to cross the Atlantic, seven for the United States, twenty-four for the Pacific, and he arrived in Yokohama in October, 1871. From there he visited the rest of Japan, then China as far as Mongolia in April, 1872. His companion Cernuschi began systematically purchasing works of art that would constitute the future collections of the Parisian museum that bears his name. In June, 1872, the two men were in Java, then they went on to India via Ceylon. On October 5,

1872, Duret wrote to Manet, announcing: "Cernuschi is bringing back a collection of bronzes from Japan and China, the likes of which no one has ever seen," and added, "give my regards to Zola, your brothers, and to Pizarro [sic]." On December 30, 1872, the two men started on the return trip via Suez.

Impressionist Artists

Just after he returned to France at the end of January, 1873, Duret told Pissarro that he needed "a large Pissarro ... before it becomes as expensive as Corots and [Meindert] Hobbemas." For although Duret was well off because of income from the family business in Cognac, he had to learn to limit his spending. In February, 1874, shortly before the famous first Impressionist exhibition, Duret wrote to Pissarro: "So here I am, owner of five of your paintings." In the same letter, he advised the artist to submit a work to the Salon and disapproved of the plans for an independent exhibition; obviously, he must have heard people talking about plans for the first Impressionist exhibition.

Pissarro had put Duret in contact with Monet; Duret does not seem to have met him in person before. In May, 1873, Duret bought *Fishermen's Shacks at Sainte-Adresse* (Private collection, Switzerland) directly from the artist for the healthy sum of 1,200 francs. Apparently there was trouble about the payment, and Pissarro acted as a mediator between the parties. In any case, Duret kept the painting and only parted with it when his collection was sold.

Duret's interests were not, however, confined to those artists. He had a lot of free time, having apparently eased up on his commercial activities during the 1870s in order to divide his time between Paris and his native province. Since 1869, Duret was living in a well-to-do bachelor's apartment, on the fifth floor, at 20 Rue Neuve des Capucines, near the Eglise de la Madeleine. In 1869, Duret was described as "a gentleman of independent means" and in 1876, as "man of letters"—a clear sign that he was taking his work as an art critic and writer seriously.

In December, 1873—again to Pissarro—Duret wrote: "I would not mind the opportunity to see something by Cézanne at your place. I am looking more than ever for the impossible in painting." There was nothing disparaging in that remark, for Duret had long been interested in Cézanne. In May, 1870, he had written to Zola: "I have heard people talking about an artist named, I believe, Cézanne or something like that, who is said to hail from Aix and whose paintings the [Salon] jury supposedly rejected. I seem to remember that, a while ago, you talked to me about a totally eccentric artist from Aix. Would that be this year's rejected artist? If so, would you please give me his address and a word of introduction so that I can become acquainted with this painter and his paintings?" Zola refused, pleading Cézanne's desire to remain apart.

It seems, however, that Duret knew Renoir before his trip to Japan. Nevertheless, he did not buy his first Renoir until 1873; that was *Summer* (Lise) (Nationalgalerie, Berlin), the painting exhibited at the 1869 Salon. Duret purchased it from a small, unknown dealer on the Rue La Bruyère, on Degas's suggestion. It was probably during the same period that Duret encountered Alfred Sisley.

Duret's main activity, from that time onward, was persuading people to buy paintings by those artists. He worked more through personal contacts and friends than through his writing as a critic: between Duret's review of the 1870 Salon and his booklet, *Les Peintres impressionnistes*, in 1878, he published nothing on the subject. For one thing, he was too busy writing his *Voyage en Asie* (1874) and then *Histoire de quatre ans*, devoted to what he had just witnessed during and after the Franco-Prussian War. That book meant a lot to Duret, and the first volume was published in 1876 by Georges Charpentier. Zola, whose relationship with the publisher is well known, introduced him to Duret. This was the beginning of a long friendship between Duret and Charpentier, both great collectors of Impressionism.

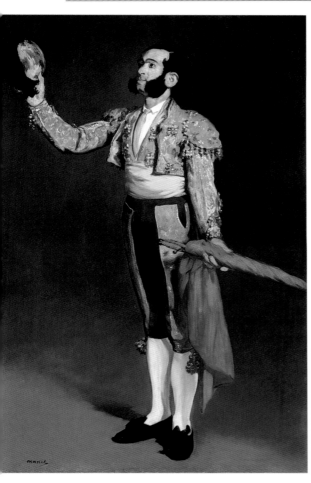

39 Edouard Manet. *A Matador Saluting.* 1866-67. Oil on canvas, 171 × 113 cm. (67⅜ × 44½"). The Metropolitan Museum of Art, New York (Bequest of Mrs. H.O. Havemeyer, 1929. The H.O. Havemeyer Collection).
In 1870, Manet sold this work to Théodore Duret, on credit, for 1,200 francs, paid the following year—a remarkable favor, since the artist explained that he would have sold it to anyone else for not less than 2,500 francs. Manet enjoined Duret to the strictest secrecy about the price. At the Duret sale in 1894, Durand-Ruel (with Faure as a partner) paid 10,500 francs for the picture and sold it to the Havemeyers in 1898, probably for more than twice as much.

Duret's correspondence is studded with references to introductions that he obtained for his artist friends with future collectors such as Cernuschi, Baudry, Deudon, or Ephrussi. Naturally, he himself continued to make purchases, and Duret was one of the people that Monet or Renoir thought of at the end of the month when they urgently needed to repay a debt. Duret made loans or paid in installments; sometimes even more intricate arrangements were found. For example, in 1875, Manet was upset by Monet's financial difficulties. Monet had asked him "to find someone who would take a selection of ten to twenty paintings at 100 francs each." Manet wrote to Duret, "Do you want the two of us to do it together, 500 francs each? Of course, no one—and first and foremost he—will be aware that we made the purchase."

On August 18, 1878, it was Sisley who asked Duret to find, among his "friends in Saintonge . . . an intelligent man with enough confidence in your knowledge of art for you to convince him that he would not be making a bad bargain by investing some money in paintings by an up-and-coming artist. If you know someone, this is the plan you could propose to him on my behalf: 500 francs per month for six months for thirty canvases. After the six months are over, since he might not want to keep thirty paintings by the same artist, he could set aside twenty of them, risk [selling them] at auction, thus recoup his out-of-pocket expenses, and have ten canvases for nothing. This last scheme was suggested to me by the auctioneer Tual, Boussaton's successor . . . to whom I sold a painting."

Duret found a patron who, though not exactly what Sisley was looking for, did purchase seven paintings. When, at the end of his life, Duret commented on the deal, he added mischievously that Jourde, the buyer, was the director of *Le Siècle*, a paper whose art critic was hard on the Impressionists. However Jourde had never intervened, being of the opinion that the journal's readership had to be satisfied above all. Jourde was not the only journalist to be won over by Duret, who had extensive professional contacts in the field. L. Panis, a man of letters and the business manager of *Le Rappel*, was also a potential customer whom Pissarro and Duret discussed.

Yet Duret was not a traveling salesman for Impressionism. To be sure, the correspondence between him and the artists often revolved around marketing strategies: Duret suggested to Monet, Pissarro, and Renoir that, at the Salon, which was open to the general public (rather than at group exhibitions that remained private), they exhibit paintings "where there is a subject . . . not too recently painted" with a costly frame. In a letter written to Pissarro in 1874, he wrote: "You have managed after quite a while to have an audience of selected connoisseurs, but who are not rich artlovers [capable of] paying high prices. In this small circle you will find buyers at 200, 400, and 600 francs. I believe that there are still a lot of years of waiting ahead before you will manage to sell easily at 1,500 and 2,000. Corot had to wait until he was seventy-five for his paintings to sell for more than a 1,000-[franc] note. . . . The public neither likes nor understands good painting. Medals go to [the likes of] Gérôme; Corot is passed over. People who are good judges of painting and who face the mockery and scorn are few and rarely ever millionaires. Which doesn't mean that we must lose heart. Everything, even fame and fortune, will come in the end; and in the meantime, the opinion of connoisseurs and friends compensates you for the oversight of fools."

Duret's activities were completely free from selfish motives: he had the run of the artists' studios and paid moderate prices, which was enough for him. If he went to Durand-Ruel's, it was to see paintings, not to buy them. Duret was enough of a rummager, should the occasion arise, to find a work cheap at an obscure little dealer's such as Widow Goblet's, Rue de Castiglione, or *père* Audry's, about whom we know nothing.

The same year that Duret published *Les Peintres impressionnistes*, however, his life changed: "Just imagine," he wrote to Emile Zola on September 6, 1878, "after a break of fifteen years, I have become a merchant again. I had no choice. My father is seventy-three and very debilitated; my young brother who, apart from me, is the only

one who could help him is only twenty-two. The firm to which the fortune of the entire family is attached was going to be in danger if I didn't come to its rescue. So here I am supervising a ton of [account] books, dictating business letters . . . tasting, buying, and shipping spirits." Thus Duret presided over the destinies of the house of Jules Duret and Company, brandy merchants.

At least that job often took him to London, a city of which he was very fond: Duret even tried to take Renoir there in spring, 1881, but Renoir left for Algeria instead. All of which did not prevent Duret from keeping abreast of what was happening in Paris, nor from popping into the capital from time to time. He was writing and publishing: in 1880, the foreword to Monet's exhibition, and, in 1883, the one for Renoir's exhibition at the gallery in the offices of *La Vie Moderne*, which belonged to Charpentier. In 1882 *L'Art japonais* was published, followed, in 1885, by a collection of Duret's articles, entitled *Critique d'avant-garde*, which he dedicated to the memory of Manet.

Duret was traveling too: in December, 1882, he was in Russia, at St. Petersburg and then Moscow.

Manet's Studio Sale

When Manet died, however, Duret was in France; he attended the funeral on May 3, 1883. In his will, the artist had explicitly requested that Duret step in: "An auction of the paintings, sketches, and drawings in my studio will be held after my death. I ask that my friend Théodore Duret be kind enough to undertake this task, for I rely entirely on his taste, and on the friendship he has always shown me, to know what should be put up for auction or destroyed." Manet's mother was not convinced that Duret (who seemed to prefer Georges Petit to Durand-Ruel) was altogether competent. However Duret took his task to heart, and a series of letters relates the preparations for the auction. "Going through the studio with Durand-Ruel, we found—apart from a dozen large, finished paintings—about a hundred studies that can figure in the auction, in addition to about twenty pictures in pastel, several of which are excellent, and about thirty drawings and watercolors to put under glass. Thus I hope we have the components of a good auction, and that apart from the big paintings, which are difficult to sell, we shall be able to make a rather large sum."

Just before the auction, a large exhibition containing Manet's essential works, including more than one hundred paintings, was adroitly organized at the Ecole des Beaux-Arts in Paris in January, 1884. This was made possible through the support of Antonin Proust, an old friend of Manet, who had been minister of fine arts in the Gambetta government. Zola wrote the foreword to the catalogue, which Duret reread and corrected. The exhibition drew crowds, friends as well as detractors. Thousands of visitors were able to see, or to see again, all the masterpieces by the artist arranged in groups.

A little later, in the first days of February, Duret took part in hanging Manet's works at the Hôtel Drouot, where the auction began on February 4, 1884. That evening, he took stock: "We made 71,000 francs at today's sale. Only *Argenteuil* [Musée des Beaux-Arts, Tournai] was withdrawn at 12,500 francs. As I expected, we were not able to push up [the prices] for the large paintings, which prevented us from grossing more. Tomorrow's sale is the one to fear, for almost all [our] friends and supporters bought today, and many probably won't be able to again tomorrow. Thus no help is to be disdained. If you want, you might buy a picture in pastel or a painted study for 5[00], 6[00], or 700 francs. No one would know anything. Therefore, it wouldn't affect your relationships and your role with regard to Manet; nevertheless, it would be an additional help to Madame Manet—who really needs it."

The next day, Duret wrote: "My fears fortunately did not come to pass, and the most difficult studies to place found a buyer. We made a total of 116,000 francs. Only *Olympia* at ten thousand and *Argenteuil* at twelve thousand five hundred were 61

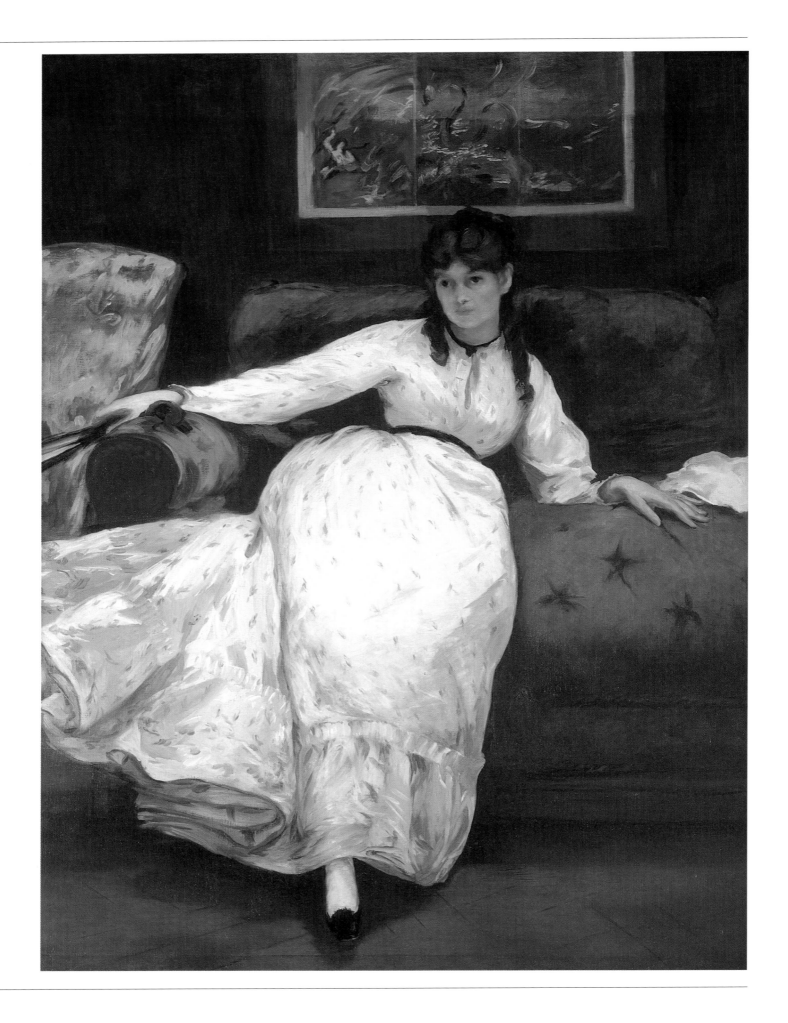

40 Edouard Manet. *Le Repos (Portrait of Berthe Morisot)*. 1870. Oil on canvas, 148 × 113 cm. (58¼ × 43¾″). Museum of Art, Rhode Island School of Design, Providence (Bequest of the Estate of Edith Stuyvesant Vanderbilt Gerry).

This painting (valued at 3,000 francs by Manet) was part of the lot Durand-Ruel bought from the artist in 1872. Duret acquired it in exchange for a Daumier in 1880, but he had to part with it in 1894. Berthe Morisot, who was Manet's sister-in-law, tried to buy it at the Duret sale, but she missed getting it due to an error on the part of the person she had sent to represent her. Faure was luckier: he bought it for 11,000 francs, before reselling it to Durand-Ruel. The dealer resold the painting to the American George Vanderbilt as early as 1898.

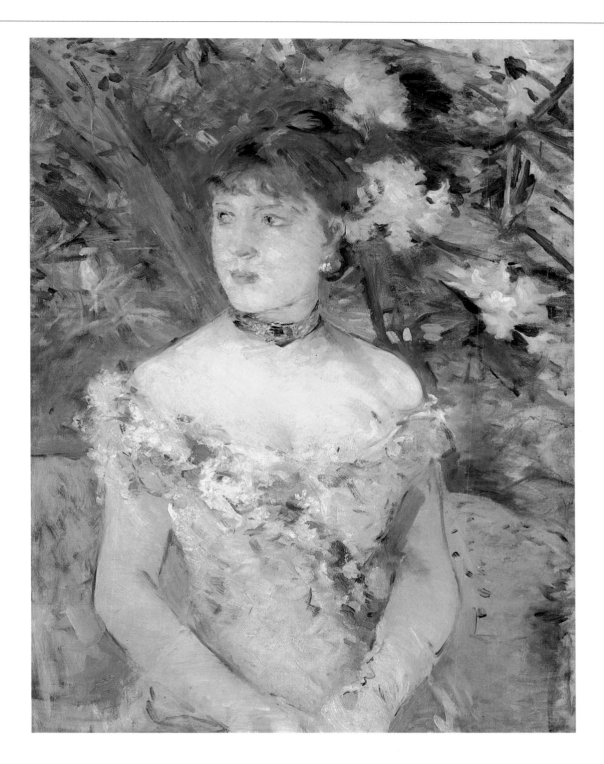

41 Berthe Morisot. *Young Woman in a Party Dress*. 1879. Oil on canvas, 71 × 54 cm. (33⅞ × 20⅞″). Musée d'Orsay, Paris.

bought back. For the public eye, this result is regarded as a great victory. Personally, I think there is reason to be satisfied."

Duret's assessment was corroborated by a specialist, Paul Eudel, the recognized chronicler of Parisian auctions: "It was a pleasure to see Messrs. Hecht, Faure, Caillebotte, De Bellio, Leenhoff (Madame Manet's son), Chabrier, Henri Guérard, Antonin Proust, Théodore Duret fanning the auction's fires with all their might. . . . So they stoked the auction, buying a great deal and inciting purchases. . . . But the Americans they expected did not appear. The owners of the large galleries, it is true, were very noncommittal; the museums were deaf or blind—whatever you prefer. And the Louvre, which establishes reputations and is a sort of Temple to Glory

for artists, the same Louvre which made purchases at the Courbet sale, gave no sign of life."

Meanwhile, in addition to trifles, Duret had purchased for himself *"Père"* 46 *Lathuile's Restaurant* for 5,000 francs, *Le Linge* for 8,000 francs, and *Young Lady in 1860* for a mere 120 francs.

During the following years, in spite of living far away, Théodore Duret remained perfectly well apprised of the Parisian art world. He is mentioned in the letter Camille Pissarro wrote to his son, Lucien, on March 17, 1887: "I ran into Duret yesterday; he said, 'Ah, ah! You are going to exhibit at Petit's this year. I am delighted, delighted; but you know you must consider it as a business affair—it's an absurd, idiotic milieu. Concessions, make concessions.'" And, making the following disclosure, Duret left Pissarro: "My dear fellow, I am retiring; I don't write anywhere anymore, and never shall. Newspapers have a ghastly fear of everything that isn't trite and foolish. I shall be content to work in silence far from Paris, in Cognac."

Duret actually took a small apartment in Paris once again, at 4 Rue Vignon, but he still retained his love of traveling. In June, 1891, he left for the Caucasus, using a visit to his brother-in-law (the French consul in Tbilisi) as a pretext. This enabled Duret, with artful playfulness, to congratulate Edmond de Goncourt from a distant country on De Goncourt's book *Outamaro*.

Duret and Whistler

Duret also corresponded with someone else about his trip: James Abbott McNeill Whistler. Duret probably met Whistler, whom he already knew in 1880, through Manet. In April, 1881, Duret published his first article about Whistler. Renoir brought up Duret's article when he dined with Whistler, who had come to see him at Chatou on Easter Sunday, 1881. Duret's frequent trips to London strengthened the two men's friendship. The clearest sign of this is the portrait of Duret that Whistler painted for 38 the 1885 Salon. When Whistler finally won the official recognition of a gold medal at the 1889 Salon, Duret wrote to him with humor: "I congratulate the medal that is lucky enough to be given to you." Duret was closely associated with the commission in which Stéphane Mallarmé, the art critic Roger Marx, and Georges Clemenceau (a member of the Chamber of Deputies at the time) made common cause to have Whistler's *Arrangement in Gray and Black: Portrait of the Artist's Mother* admitted to the Luxembourg Museum. Today it remains the only masterpiece by Whistler owned by the Musée d'Orsay, Paris.

As early as August 1902, after the publication of his monograph *Histoire d'Edouard Manet et de son œuvre*, Duret talked to Whistler about a book Duret wanted to write about him; however, the book was not published until 1904, after Whistler's death.

It is fitting to review in detail two major events in Duret's life: the breaking up of his collections at auction in 1893–94, and the Dreyfus affair in 1897.

The Duret Auction

At the beginning of March, 1893, Pissarro trumpeted: "Big news: Duret, that formidable lover of things Japanese, has sold his entire collection of prints and books to Boussod, as well as a good part of his paintings! He's buying Old Masters! . . . Duret doesn't want to look at prints any longer!" The big news was a bit premature, for the largest part of Duret's paintings were not sold at the Georges Petit Galleries until March 19, 1894.

The artists were furious: "What a shark Duret is, and will he ever fall on his face," Monet wrote in February, 1894; meanwhile Degas told Duret, "If you're ruined, if you have to sell your pictures, you should at least sell them regretfully. You boast of

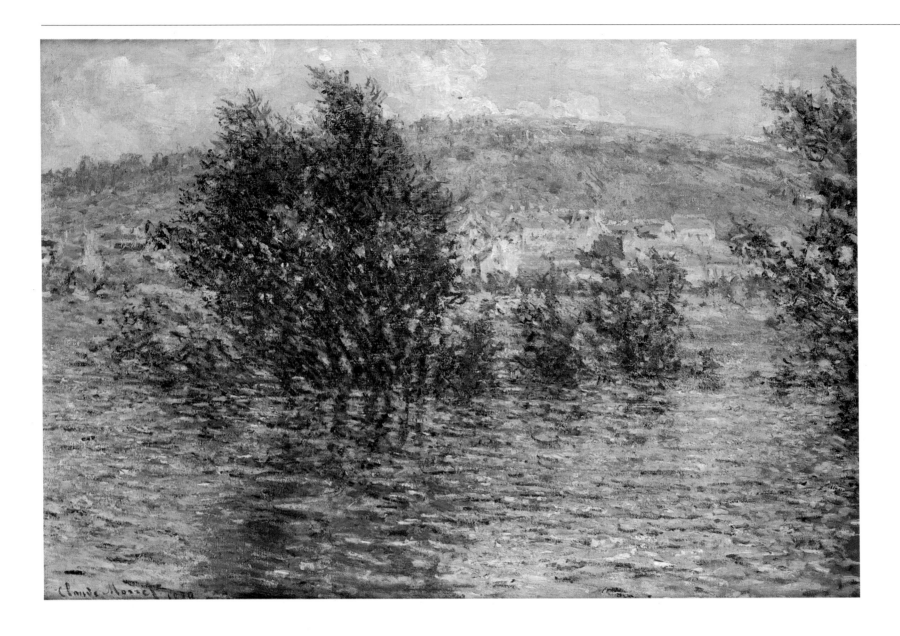

42 Claude Monet. *The Seine at Vétheuil After the Rain.* 1879. Oil on canvas, 60 × 81 cm. (23⅝ × 31⅞″). Musée d'Orsay, Paris (Isaac de Camondo Bequest, 1911).

having been our friend; all over Paris you have them post 'Duret Sale.' I wouldn't shake your hand. Besides, your auction will be a failure."

At the same time, the Impressionists were engaged in a battle for different, much higher stakes: Gustave Caillebotte had died in February, 1894, and had bequeathed his collections to the nation. Apart from two drawings by Millet, they were composed entirely of Impressionists, almost sixty items in all. Although the authorities at the French national museums had initially accepted the bequest, difficulties soon arose, the prelude to a controversy that will be discussed in Chapter XXII. Georges de Bellio, another collector who owned dozens of Impressionist canvases, had also died in January, 1894. These events were signs of an era coming to an end. By breaking up his collection, Duret was merely hastening an inescapable development.

Although Duret himself wrote the preface to the auction catalogue, the details of the event are not as clear as the catalogue—whose vertical format was as unusual as it was elegant—would lead us to believe. It is almost certain that Duret had to sell his collection as he himself implies, to make good the deficit in his business. Thus the sale was not purely speculative. It was natural for Duret to keep Manet's and Whistler's portraits of him and for him to try to buy back several works. It is also true, however, that Duret had already sold paintings that belonged to him, such as the famous *Lise with a Parasol* (Museum Folkwang, Essen), before 1894.

65

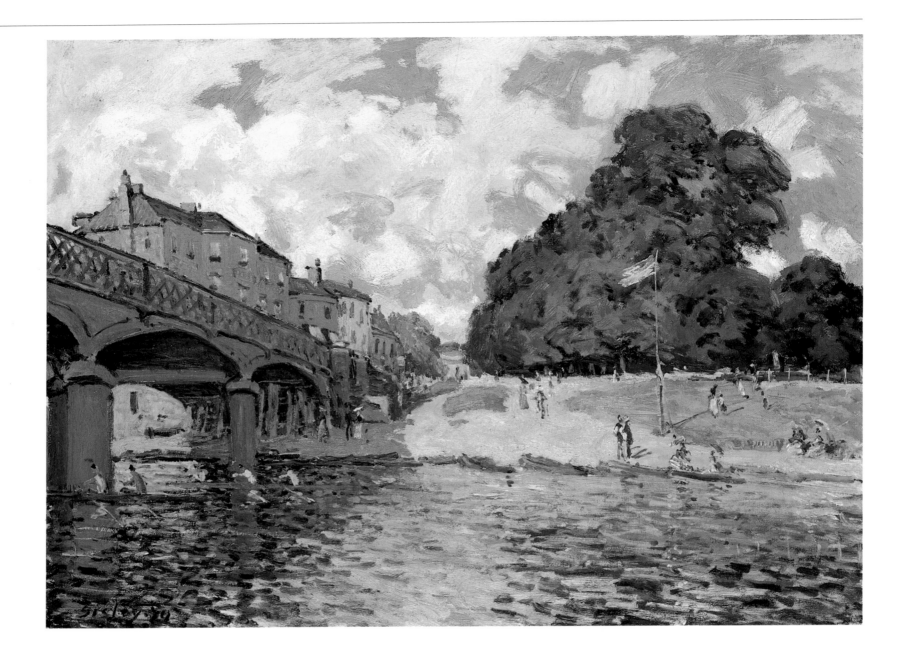

43 Alfred Sisley. *View of the Thames at Hampton Court.* 1874. Oil on canvas, 44 × 59 cm. (17¼ × 23¼″). Wallraf-Richartz-Museum, Cologne.

The Duret auction contained forty-two lots—a small number—but there were 1 Boudin, 1 Cals, 3 Cézannes, 1 Corot, 2 Courbets, 8 Degases, 1 Jongkind, 6 Manets, 6 Monets, 1 Berthe Morisot, 4 Pissarros, 1 Puvis de Chavannes, 3 Renoirs, 3 Sisleys, and 1 Whistler. Manet's *Le Repos (Portrait of Berthe Morisot)*—purchased by the opera singer Faure—and Monet's *Les Dindons (Turkey Cocks)*, which had belonged to Hoschedé and to the artist De Nittis, fetched the highest prices. The majority of the works at the auction were acquired by Durand-Ruel, who acted as expert-appraiser along with Petit. The prudent Petit bought nothing. The other well-known buyers were the Natanson brothers of *La Revue blanche* (for which Duret later wrote), Abbé Gaugain (a curious person and a customer at Durand-Ruel's with good but unorthodox taste for his calling; he purchased a *Still Life* by Cézanne), and the composer Emmanuel Chabrier.

Most of the works auctioned can be identified. Without going into detail, we can list among the most important: a pastel by Degas, *Conversation at the Millinery Shop*; by Manet *"Père" Lathuile's Restaurant, A Matador Saluting, The Port of Bordeaux*; by Monet *Fishermen's Shacks at Sainte-Adresse* (Private collection, Switzerland) and *Woman in the Grass*, which made headlines after an auction in London in June, 1988;

40
86

45
46, 39,
47

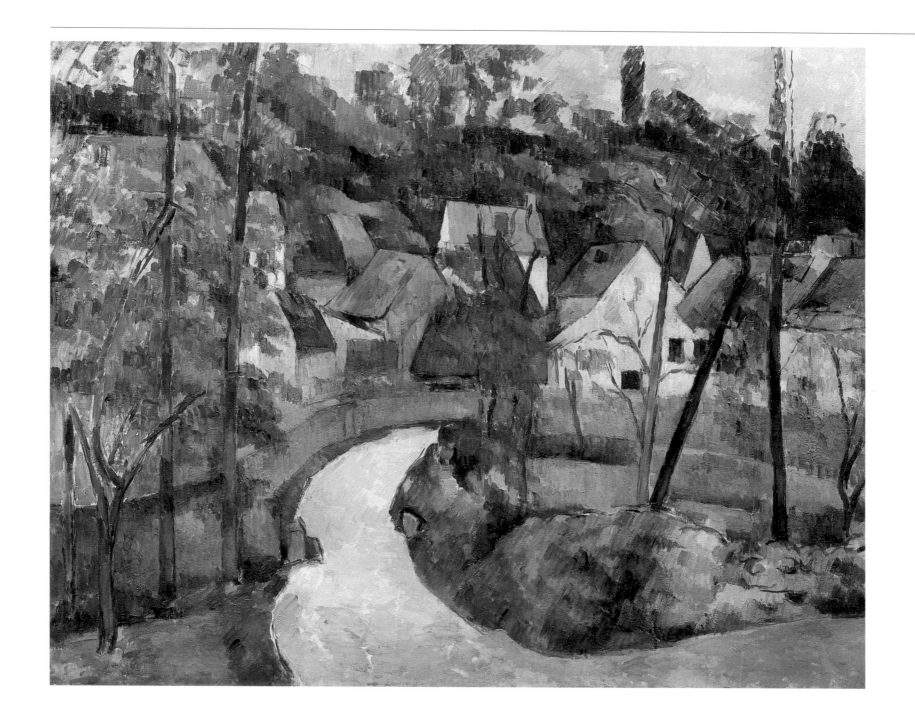

44 Paul Cézanne. *Turn in the Road.* c. 1881. Oil on canvas, 59 × 72 cm. (23⅞ × 28⅞"). Museum of Fine Arts, Boston (Bequest of John T. Spaulding).

by Berthe Morisot *Young Woman in a Party Dress*, purchased by the French national museums after the auction, and Puvis de Chavannes's *The Dream* (Musée d'Orsay, Paris).

Although Renoir said that Duret's auction had not "worked out," the amount that Duret raised was not insignificant. Furthermore, it was proof for the future that Impressionist works—previously worth a few hundred francs—now brought prices tenfold higher.

As for his Japanese collections, the Burty sales may have suggested to Duret that it was time to rid himself of them. Duret's collection of Japanese books was acquired cheaply by the Bibliothèque Nationale in 1899. Furthermore, at that time, most of the collections of Japanese art formed twenty or thirty years earlier were being broken up, either because their owners had died or because they spontaneously decided to take advantage of a new generation's infatuation with Japanese art.

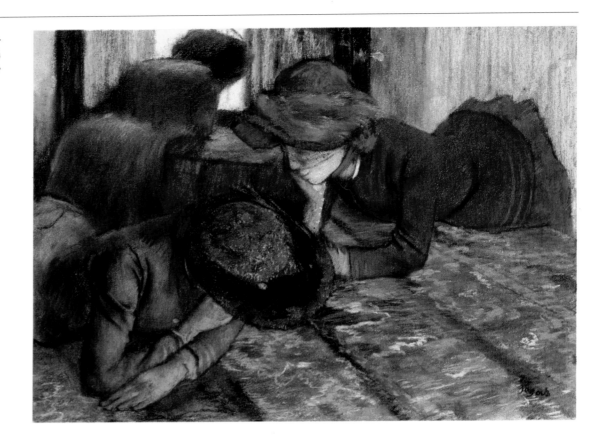

As for Henri Cernuschi, in 1896, he bequeathed to the city of Paris his town house and collections as a museum.

Duret kept a few paintings, as we have seen. However, he lacked the means necessary to form a collection comparable to the one he no longer owned, so he took up the new generation of artists—something rare for a collector of Duret's generation. Still as much of a rummager, Duret began going to Theo van Gogh's, Tanguy's, and Vollard's. He bought and convinced others to buy Gauguin, Toulouse-Lautrec, and especially Van Gogh. Duret acted as a go-between for dealers such as the Bernheim brothers, or for eminent individual collectors: the Havemeyers of New York, Sir Hugh Lane (who died in 1915, on the *Lusitania,* leaving his Impressionist paintings to museums in London and Dublin), and Wilhem Hansen (founder of the Ordrupgaard Museum, in Charlottenburg, near Copenhagen, inaugurated in 1918). Thanks to an apt twist of fortune for a former lover of things Japanese, Duret would be the main person responsible for introducing Vincent van Gogh's work into Japan, and the book Duret wrote about Van Gogh would be translated into Japanese in 1916.

The Dreyfus Affair

The end of the century for Duret, however, was also taken up with the Dreyfus affair. Without entering into all the details of what the "affair" meant to Duret's contemporaries, we can recall that, from the moment Emile Zola started his campaign (even before his famous open letter, *J'accuse,* of January, 1898), Duret took the part of Dreyfus and let Zola know it: "It's a good use of your talent and a splendid use of your great name to take up the cause of a downtrodden man in order to capture the attention of the crowd, in spite of itself. Reading you, I felt with keen pleasure that I was one of your old friends, and I took up my pen to tell you how much I approve of you and admire you" (December, 1897). Not content to write only to his friend,

46 Edouard Manet. *"Père" Lathuile's Restaurant*. 1879. Oil on canvas, 92 × 112 cm. (36¼ × 44″). Musée des Beaux Arts, Tournai (Guillaume Charlier Bequest, 1925).

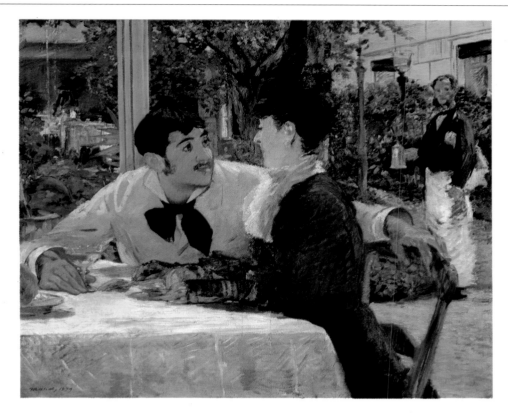

47 Edouard Manet. *The Port of Bordeaux*. 1871. Oil on canvas, 63 × 100 cm. (24¾ × 39⅜″). Private collection, Zurich.

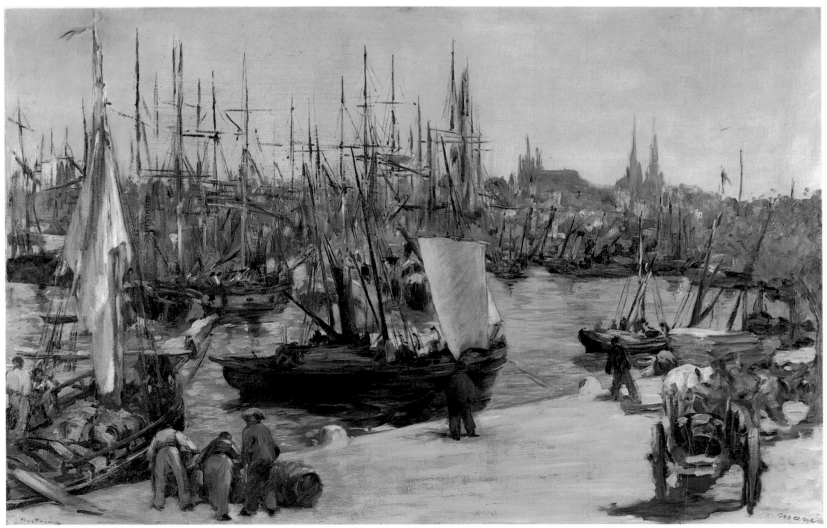

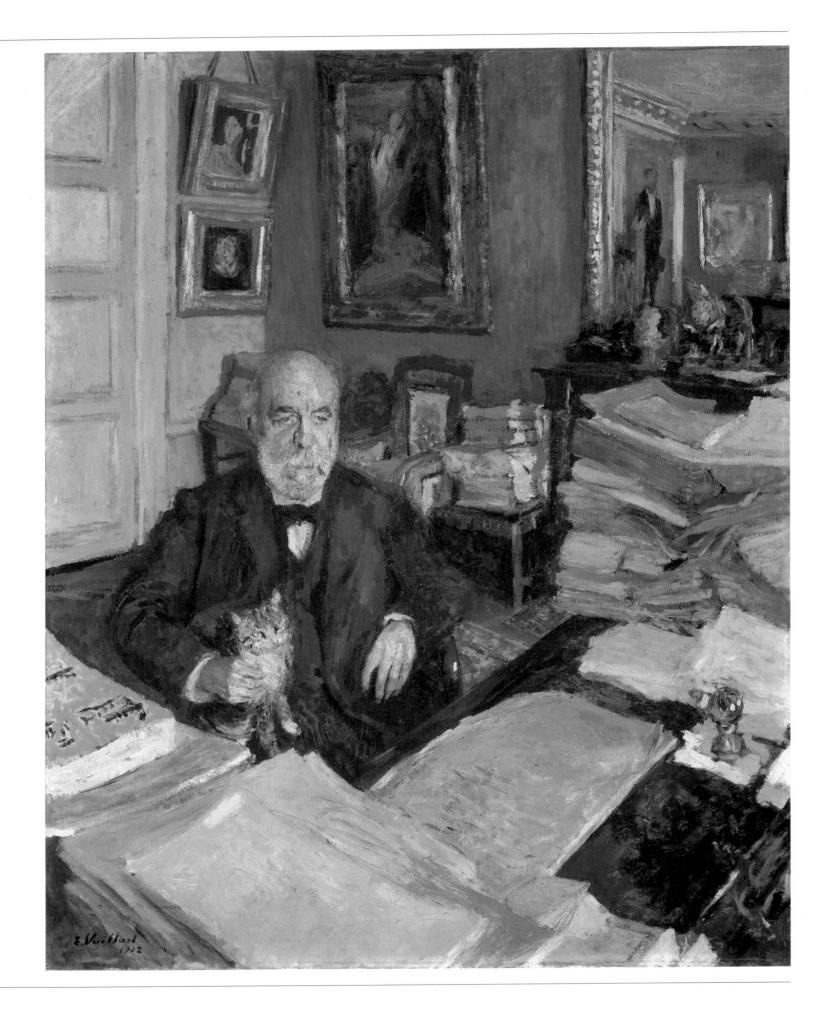

48 Edouard Vuillard. *Théodore Duret*. 1912. Cardboard mounted on wood, 95 × 74 cm. (37½ × 29½″). National Gallery of Art, Washington, D.C. (Chester Dale Collection).

Duret wrote several articles in *Le Siècle* and *La Revue blanche* defending the same ideas. He was one of the few people to visit Zola while the novelist was in exile in London in 1898. When Zola returned to Paris, Duret was among the first to see him. Once again Duret, the aloof dandy, the rich scholar, had not been reluctant to do battle, for he believed from the start in the ultimate success of Dreyfus's cause. In August, 1899, he wrote to Madame Zola: "I am suffering sorrowfully, sympathizing with the lowly fate of that unlucky Dreyfus," and in September, 1899, he welcomed the news of Dreyfus's pardon joyfully.

"Few Men Know How to Be Old"

At the beginning of the twentieth century, fighting old age and attacks of gout—although, he insisted, "that's not a sickness"—Duret published works that evoked his youth: *Manet, Whistler*, and *Histoire des peintres impressionnistes* (1906), followed by monographs on *Cézanne* (1914), *Van Gogh* (1916), *Courbet* (1918), *Toulouse-Lautrec* (1920), *Renoir* (1924).

In 1924, when he donated most of his remaining paintings to the Petit Palais Museum in Paris, Duret wrote to the curator: "I belong to the old generation and am trying to make use of a maxim by La Rochefoucauld, 'few men know how to be old,' knowing that I am old."

The crowning irony was that Duret never realized just how old he had become. He never suspected that, taking advantage of his bad eyesight, people had substituted for some of his paintings pitiful daubs, whose mediocrity tarnished to a certain extent the memory of the collector Duret. What a shame that, side by side with Manet's marvelous portrait of Duret, or Guigou's beautiful *Landscape in Provence*, and other quite respectable paintings, Duret would donate to the Petit Palais Museum a Van Gogh that dares not even bear the artist's name. In the months following January 16, 1928, when Duret died at his home, 44 Rue d'Amsterdam, the Parisian art world was all aflutter about the the fakes in Duret's collection. As soon as an inventory was made after his death (March 18, 1927), the secret was out, which led to a lawsuit.

A first series of unchallenged paintings was sold at the Hôtel Drouot on March 1, 1928. The fakes were auctioned—after the signatures had been scraped away—on November 25, 1931. A few people felt they had to protest, forgetting that, according to the chronicler for the *Gazette de l'Hôtel Drouot*, "everything is for sale at Drouot"; this included a *Print Collector* in the manner of Honoré Daumier, which might just resurface one day after suffering its time in purgatory.

But let's not finish on such a pessimistic note. It is certainly better, as the critic Yvon Bizardel suggests, to conclude this picture of Duret with a line from Marcel Proust, who may have had Théodore Duret in mind when he created his character Verdurin. Proust wrote that Verdurin had received "lessons in taste from Whistler, lessons in truth from Monet."

Albert and Henri Hecht

49 Henri Chapu. *Henri Hecht*. 1873. Terracotta, H. 47 cm. (18½″). Musée de Châlons-sur-Marne (Deposited by the Musée d'Orsay, Paris; gift of Ernest Hecht, nephew of the model, 1934).

We cannot leave Théodore Duret, however, without discussing at somewhat greater length Henri and Albert Hecht, both of whom were friends of Duret, as well as admirers of Courbet and Manet. Today, Albert is the better known of the two brothers (who were perhaps twins and, in any case, inseparable), because the book in which Albert listed his personal expenses has been preserved. But during his lifetime, Henri was probably most in the public eye. An obituary notice published after Henri's death on April 26, 1891, recalled that, at the auction of Courbet's studio in 1881, "H. Hecht, who was one of Gambetta's close friends, spontaneously guaranteed—until the necessary funds were voted—the purchase of the paintings by Courbet now

49, 50
41

in the Louvre, which Mr. Antonin Proust had made as minister." Thus, it is to some extent thanks to Henri Hecht that *The Spring Rutting Season, The Wounded Man,* and *Man with a Leather Belt* are now in the Musée d'Orsay, Paris.

The Hecht brothers were traders in precious wood, ivory, and colonial produce. Henri knew how to reconcile the demands of a prosperous business with his love of art. He had a preference for Old Master paintings (widely represented at the sale of his collection on June 8, 1891) and for Courbet, Corot, Rousseau, Dupré; but he also had a very high regard for Manet and Degas.

Of the two brothers, however, Albert seems to have been the most clearly attracted to Impressionism. He started by acquiring works by Corot and Jongkind. Albert was a customer at "small" dealers such as Latouche and a rummager at the Hôtel Drouot. Yet there were times when he was willing to spend: 5,000 francs to buy a Théodore Rousseau from Durand-Ruel in 1872, or 2,000 francs to purchase Manet's *Boy Blowing Bubbles,* which Hecht and his brother had coveted for several years. Albert Hecht was on very friendly terms with Manet, who did a portrait in pastel of Hecht's only daughter, Suzanne, in 1883. Later, Albert served on the committee in charge of organizing the Manet retrospective in 1884. Also in 1872, Albert bought a Pissarro, then his first Monet, a *View of the Thames,* in 1873. At the Hoschedé auction in 1878, Albert purchased 1 Sisley and 3 Pissarros, while his brother became the owner of Manet's *Woman with a Parrot.*

Both the brothers were also great admirers of Degas, who depicted at least one of them in his famous paintings, *The Ballet of "Robert le Diable,"* commissioned by the singer Faure. The Hecht brothers' passion for the opera, which they shared with Degas, brought the three men together. Degas asked Albert to request an introduction to watch a ballet audition at the Opéra, adding: "I have done so many of these dance auditions without having seen them that I am a bit ashamed."

Albert Hecht stopped buying paintings about 1886; he died young, on August 21, 1889, but not before having made a donation to the fund organized by

53

52

210

52 Edouard Manet. *Suzanne Hecht (Madame Emmanuel Pontremoli)*. 1883. Pastel, 49 × 39 cm. (19¼ × 15⅜″). Musée d'Orsay, Paris (Gift of Madame Trenel-Pontremoli in memory of her parents, 1957).

53 Edouard Manet. *Boy Blowing Bubbles*. 1867. Oil on canvas, 100 × 81 cm. (39¾ × 31⅞″). Calouste Gulbenkian Foundation, Lisbon.

Claude Monet at the beginning of that year to donate Manet's *Olympia* to the nation. In accordance with Albert Hecht's wishes, only his initials (like those of his brother) appeared on the list of contributors. A hundred years later, their spirits will surely not take offense at this disclosure, for it pays tribute to their good taste.

Jean-Baptiste Faure

54 Anders Zorn. *Jean-Baptiste Faure*. 1891. Oil on canvas, 83 × 66 cm. (32¾ × 26″). Present whereabouts unknown.
This portrait was probably painted to thank Faure for a Manet that he had given to Zorn (which the artist later donated to the Stockholm museum).

Jean-Baptiste Faure's story could almost have been a film script written for Hollywood. He was born on January 15, 1830, into a family of modest income in the provincial town of Moulins. His father became cantor at Notre-Dame in Paris, but died when his son was only seven years old. Little Jean-Baptiste's golden voice, first revealed in church and then in the chorus of the Italian Opera (Théâtre-Italien) in Paris, was the family's only source of income. When his voice changed, Jean-Baptiste took up the contrabass and played in suburban cafés. Luckily, once his adolescence was over, Faure was able to return to singing and enter, in 1850, the Music Conservatory. There Faure won prizes and made his debut at the Opéra-Comique in Paris in 1852. A journalist wrote about him at that time: "A well-built young baritone, with a good-looking figure and distinguished demeanor, knows how to sing well and enunciate properly, and who can sustain, if necessary, the part of a lover without seeming too unlikely. I believe we have found all that in Mr. Faure. . . ." From then on, Faure's renown never stopped growing.

54, 55, 56, 63, 73, 74, 75

In 1858, Faure married a young singer, Caroline Lefebvre; they had several children. Attending Faure's wedding was one of the most famous composers of the period—Giacomo Meyerbeer. Jean-Baptiste Faure went from rags to riches: he was earning 50,000 francs per year; Covent Garden was clamoring for him. It was the beginning of an international career.

A Triumphant Career

55 Reutlinger. *Jean-Baptiste Faure as Hamlet*. Photograph. Bibliothèque Nationale, Paris.

After the Opéra-Comique, Faure made his debut at the Paris Opéra. This marked the beginning of his grand period: Meyerbeer wrote the role of Nelusko in *L'Africaine*—one of Degas's and Bazille's favorite operas—especially for him (created on April 28, 1865). In 1867, Faure played Count de Posa in Giuseppe Verdi's *Don Carlos*; the composer considered Faure the only good singer at the Paris Opéra. Two other great roles sung by Faure were Hamlet in the opera of the same name by Ambroise Thomas, and Mephistopheles in Charles Gounod's *Faust*. In 1870, Faure sang "La Marseillaise" after each performance, kneeling on one knee and draped in the French flag: that was his contribution to the defense of the nation. During the following years, Faure divided his time between France and tours abroad. By then, he was earning up to 300,000 francs for ten months' work—a fortune by the terms of the day. In comparison, the young American artist J. Alden Weir, who was studying in Paris and far from poor, since he could manage to buy a ticket to the opera to hear Faure sing in *Don Giovanni*, planned to make both ends meet for a year with 3,230 francs.

63, 64

Faure retired in 1876, though he continued to give recitals all over Europe. In 1881, the same year as Manet, Faure was awarded the cross of the Legion of Honor. He wrote textbooks on singing as well as sentimental songs that are rightly forgotten. Faure had always been very pious, and after that, he could rarely be heard singing, except at the funerals of friends where his voice still moved listeners. It is astonishing that there should have been room in such a full life for anything other than singing, and yet Faure had another passion—collecting.

56 Marcellin Desboutin. *Jean-Baptiste Faure as Nevers in [Meyerbeer's] "Les Huguenots."* 1874. Oil on canvas, 40 × 32 cm. (15¾ × 12½"). Wheelock Whitney & Co., New York.
This painting appeared in the second Impressionist exhibition of 1876.

Faure's First Collection

A biography written during his lifetime stated that Faure had always been passionately fond of curios and second-hand goods, buying paintings, prints, faience, snuff bottles, miniatures, and small bronzes—all the knickknacks for which the rich middle class of the period had a predilection. The same source explained that Faure's taste was influenced, while he was still at the Italian Opera, by a fellow singer who had had to revert to singing in the chorus after some setbacks. Faure never breathed a word about another likely source of inspiration: the baritone Paul Baroilhet, whose portrait by Thomas Couture Faure owned. Baroilhet, a friend of the artist Jules Dupré, had assembled a very beautiful collection of works by the School of 1830 (notably by Rousseau). That collection, formed at a period when prices were lower, was dispersed at auction in March and April, 1860. The excellent results of that sale ensured financial success for that generation of artists and caused a great stir; it proved that money could be made with paintings. The idea that one could speculate on young talent and reap the fruit of shrewd speculation ten or twenty years later was not born with the Impressionists but with the preceding generation. With auctions of works by Rousseau, Millet, and the Barbizon School as well as, to a lesser extent, with works by Corot, collectors first noticed that nice profits could be made even as they gave themselves over to the joys of collecting.

Those were the artists on which Faure speculated at first. His first collection was auctioned on June 7, 1873. It was composed of works by Corot, Delacroix, Dupré, Millet, Roybet, Ribot, Rousseau, and Troyon. The auction earned him close to a half a

57 Edouard Manet. *Young Man in the Costume of a Majo.* 1863. Oil on canvas, 188 × 124 cm. (74 × 49⅛"). The Metropolitan Museum of Art, New York (The H.O. Havemeyer Collection).

58 Edouard Manet. *Mademoiselle Victorine in the Costume of an Espada.* 1862. Oil on canvas, 165 × 127 cm. (65 × 50½"). The Metropolitan Museum of Art, New York (The H.O. Havemeyer Collection).

million francs—certainly more than Faure spent to form the collection. As a reporter said, "the art of singing did not have much to find fault with in the art of painting." This particularly well-organized sale was conducted by the auctioneer Pillet. One noteworthy fact is that the catalogue was probably the first to contain photographs instead of engravings of the items being auctioned. Paul Durand-Ruel, who was the expert-appraiser, bought back a large part of Faure's collection. One may wonder whether he had a previous agreement with Faure, to whom Durand-Ruel happened to have sold the works. Faure had already embarked on a real adventure with Durand-Ruel: buying paintings by Manet.

Faure and Manet

Manet had been shocking the Parisian public for ten years, but he had not sold any important paintings before 1872. Faure bought his first two Manets on January 3, 1873: *The Port of Boulogne in the Moonlight* (Musée d'Orsay, Paris) for 3,000 francs and *The Spanish Singer, or Guitarrero* (The Metropolitan Museum of Art, New York) for 7,000 francs. A year earlier, Durand-Ruel had paid Manet 800 and 3,000 francs respectively for them, together with another series of works. Thus the dealer made a much-needed profit, which helped him to maintain his new establishment on Rue Laffitte.

59 Edouard Manet. *Le Déjeuner sur l'herbe.*
1863. Oil on canvas, 208 × 264 cm. (84½ ×
106¼"). Musée d'Orsay, Paris (Gift of Etienne
Moreau-Nélaton, 1906).

It is hard not to imagine that the choice of subjects echoed Faure's personality:
he liked things that were picturesque, theatrical, and reflected his own career. Bou-
logne was the port from which Faure so often embarked for England. *The Spanish
Singer* was, moreover, a key work in Manet's oeuvre and his first success at the 1861
Salon. Faure kept that painting until the end of his life, when, in 1906, he sold it to
Durand-Ruel.

Very shortly after having purchased those two paintings from Durand-Ruel,
Faure made contact with Manet himself. On November 18, 1873, according to
Manet's account books, Faure acquired several recent canvases from the artist:
Masked Ball at the Opéra, which reminded him of the old Opéra on Rue Le Peletier,
Le Bon Bock (The Engraver E. Bellot at the Café Guerbois) (Philadelphia Museum of
Art), a success at the 1873 Salon, as well as earlier works such as *Lola de Valence*

61

60 Edouard Manet. *The Fifer*. 1866. Oil on canvas, 160 × 98 cm. (63 × 38½″). Musée d'Orsay, Paris (Isaac de Camondo Bequest, 1911).

On November 18, 1873, Paul Durand-Ruel wrote to his partner Deschamps in London: "I just sold two Manets, *Alabama* and *The Fifer*, to Faure for the sum of 9,000 francs for both. It is just about the only business this month."

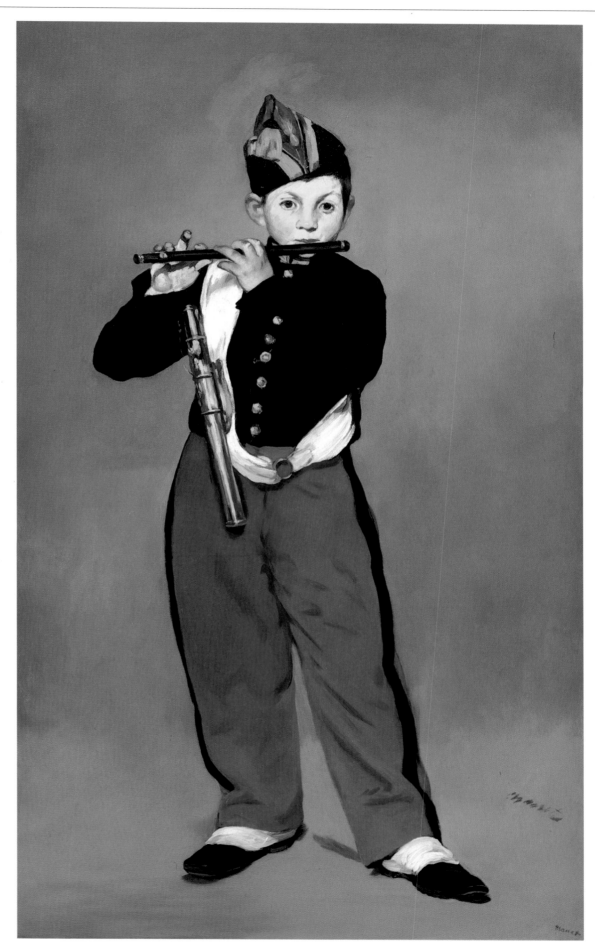

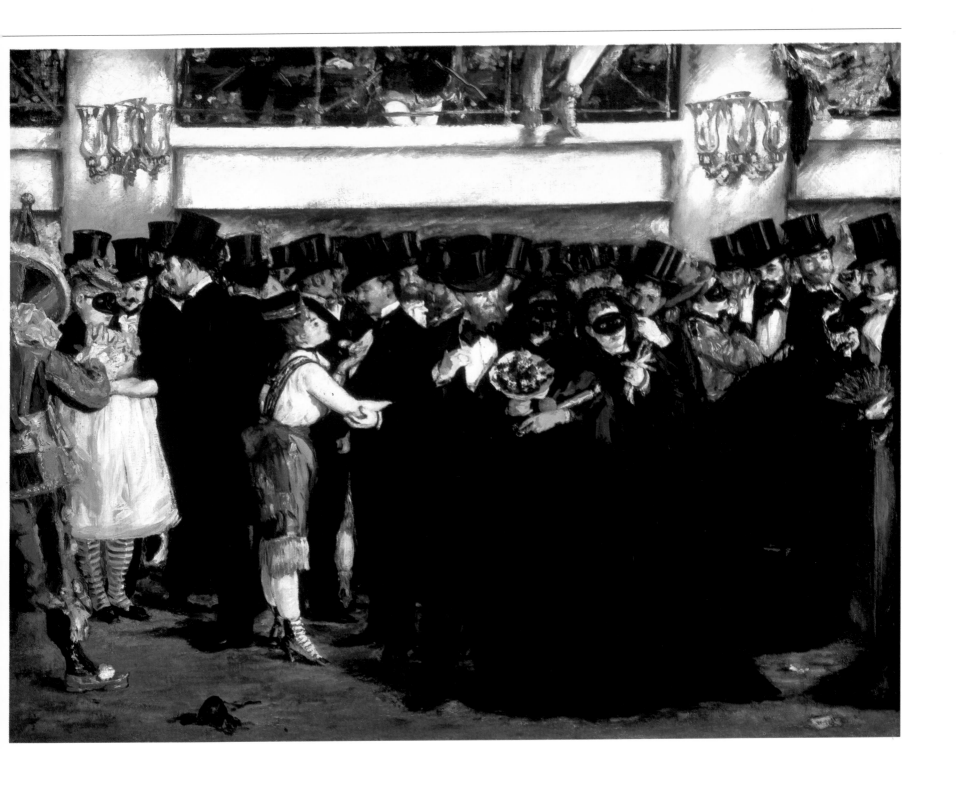

61　Edouard Manet. *Masked Ball at the Opéra.*
1873-74. Oil on canvas, 60 × 73 cm. (23¼ ×
28½″). National Gallery of Art, Washington, D.C.
(Gift of Mrs. Horace Havemeyer in memory of
her mother-in-law, Louisine W. Havemeyer).
According to Duret, Manet took the composer
Emmanuel Chabrier, Albert Hecht, and Duret
himself as models to pose for the people who
regularly attended the ball at the old Opéra on
Rue Le Peletier, which burnt down in 1873. This
was one of the first paintings that Faure bought
from the artist in November, 1873. Faure risked
putting it up for sale at his auction in 1878—it
did not sell—and finally sold it in 1894 to
Durand-Ruel, who resold it the following year to
the Havemeyers.

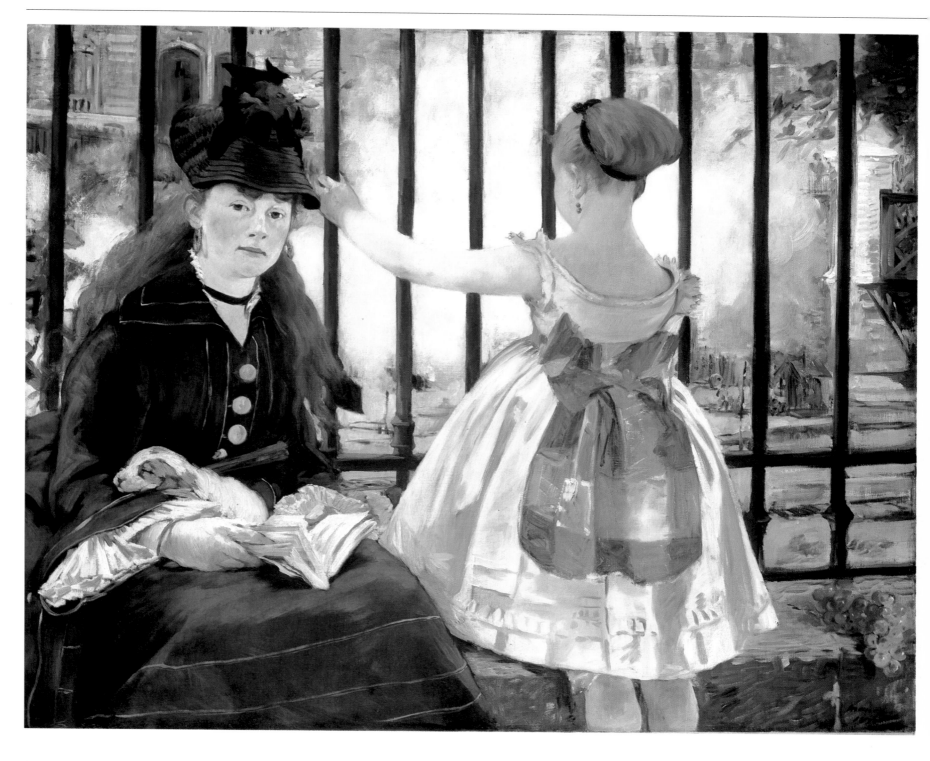

62 Edouard Manet. *The Railroad (Gare Saint-Lazare)*. 1872–73. Oil on canvas, 93 × 114 cm. (36½ × 45″). National Gallery of Art, Washington, D.C. (Gift of Horace Havemeyer in memory of his mother, Louisine W. Havemeyer).

This work already belonged to Faure when it was exhibited at the 1874 Salon. One of the many caricatures that greeted its appearance was accompanied by the following caption: "*The Railroad* by Mr. Manet, or Mr. Faure's departure for England, which explains the woebegone look of the figures. It's not very cheerful for Mr. Manet either."

(Musée d'Orsay, Paris) or *Luncheon in the Studio* (Bayerische Staatsgemäldesammlungen, Munich). This did not prevent Faure from buying from Durand-Ruel, at the same time, *The Fifer* (Musée d'Orsay, Paris) and *Combat of the "Kearsarge" and the "Alabama"* (John G. Johnson Collection, Philadelphia Museum of Art). Durand-Ruel was greatly relieved and wrote to his partner in London: "I just sold Faure two Manets, *Alabama* and *The Fifer*: at 9,000 francs for both. That's about the only sale this month."

That was only the beginning for Faure, however; the art historian Anthea Callen, who has meticulously studied this aspect of Faure's collection, listed sixty-seven paintings by Manet that the collector owned at one time or another. It is easier to mention the canvases he did not possess—*Olympia, A Bar at the Folies-Bergère* 81

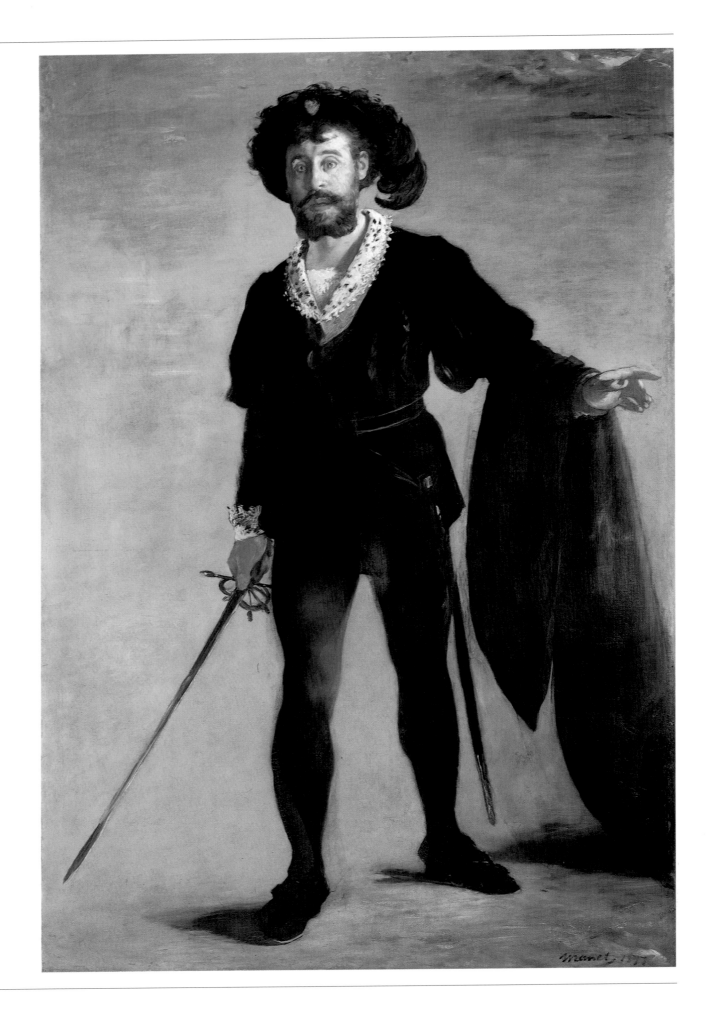

64 Cham. *Hamlet, Having Gone Mad, Has Manet Paint His Portrait.* Caricature in *Le Charivari*, May 19, 1877. Bibliothèque Nationale, Paris.

"After sitting about twenty times, I had to leave to sing, where I no longer remember. Manet continued working in my absence. When I returned, I found the portrait completely changed, in strange, flashing blues and with legs that weren't mine.

"'Those aren't my legs,' I told him, surprised by my picture that only half suited me.

"'What difference does it make? I took those of a model who had better-looking legs than yours.'

"After a rather tart exchange of letters, we once again became friends as before.... Because of him, I plunged into uncompromisingness in matters of painting. He sent me Degas, Pissarro, Sisley, [and] Claude Monet, from whom I acquired so many works."

Frédéric Gilbert, "J.B. Faure interrogé sur Manet" in *Le Gaulois*, 18th year, no. 538.

◁ 63 Edouard Manet. *Jean-Baptiste Faure as Hamlet.* 1877. Oil on canvas, 194 × 131 cm. (76⅜ × 51½"). Museum Folkwang, Essen.

(Pl. 191), or *The Balcony*—than those which he actually owned such as *Le Déjeuner sur l'herbe, Concert in the Tuileries Gardens* (National Gallery, London), *The Railroad (Gare Saint-Lazare)*, and *The Dead Toreador* (National Gallery of Art, Washington, D.C.). 214, 59 / 62

The most famous likeness of the baritone Faure—who loved to have himself portrayed in paintings or photographs—is Manet's painting, *Faure as Hamlet* (Museum Folkwang, Essen; sketch in the Kunsthalle, Hamburg). It was the only one of Manet's works accepted at the 1877 Salon. Nevertheless, Faure did not like the painting and was probably hurt by the caricatures to which it gave rise. 63 / 64

Manet caused him another mortifying setback shortly afterward. On April 29, 1878, Faure attempted another auction of his paintings, combining "safe" artists such as Corot, Diaz, and Dupré with the younger generation: Giovanni Boldini (who had done Faure's portrait), Jongkind, and above all Manet, with *Le Bon Bock* and *Masked Ball at the Opéra*. No doubt being prudent, Durand-Ruel did not put in an appearance. The expert-appraiser was Hector Brame, joined by Georges Petit who was making his debut. As a contemporary reporter wrote, the auction was "crowned with a complete lack of success, despite the most sumptuous advertising." He added that Faure "had a series of Manets that he probably hoped to sell at Drouot for prices as high as the artist's reputation is resounding. It was a very rude awakening, and most of the works up for auction had to be bought in by their owner. Only six of the forty-two paintings found purchasers." 61

Faure at least kept his paintings, however. That was not the case two months later with poor, bankrupt Hoschedé: two of his Manets, *The Street Singer* and *Young Man in the Costume of a Majo* were sold off for 450 and 650 francs respectively. They were purchased by Faure, who made a good buy. He would have the satisfaction of reselling the two to Durand-Ruel at the end of the century; he received 20,000 francs for *The Street Singer*. 88, 57

Faure remained on good terms with Manet, nonetheless, since he posed for him again, late in 1882 or early in 1883, in a morning suit (two versions in The Metropolitan Museum of Art, New York). Those were among Manet's last canvases. Quite naturally, Faure was a member of the committee that organized the Manet retrospective, to which the singer lent several works. Faure insisted on having the critic Albert Wolff—who had vilified the Impressionists, but whom Faure hoped to soften up—on the retrospective's honorary committee. That did not prevent Wolff from writing unpleasant things, however. 75

When the contents of Manet's studio were auctioned, reporters did not fail to notice the presence of "Monsieur and Madame Faure." But Faure hardly participated in the bidding. Apart from the purchases of the Manet family, the main items such as *The Balcony* or *A Bar at the Folies-Bergère* were taken away by Gustave Caillebotte or the composer Emmanuel Chabrier. As Manet's mother wrote before the auction: "Faure seems to be holding himself back... you know what a dealer he is... he makes his calculations and wants to get what he desires." 214, 191

Whence the term "dealer," which has stuck to Faure ever since. The Impressionists never forgave him for associating their work so closely with a market value. They were forgetting that Faure—who was born poor—had to put away money for his old age. They were also forgetting that Durand-Ruel and his allies (Martin or even Petit) were unable—or unwilling—to acquire the Impressionists' entire oeuvre. A man like Faure, with a lot of ready money, was necessary to relay those dealers. Knowing that the Manet family would buy certain canvases back, it is also quite possible that Faure thought he could always change his mind later. Indeed, in 1894, Faure bought several of the chief items at Duret's sale, which that collector had acquired at the sale of Manet's studio: *Le Repos (Portrait of Berthe Morisot)* and *"Père" Lathuile's Restaurant.* 40, 46

Although he was without a doubt the biggest collector of Manet, Faure also considered other artists, for example Monet.

83

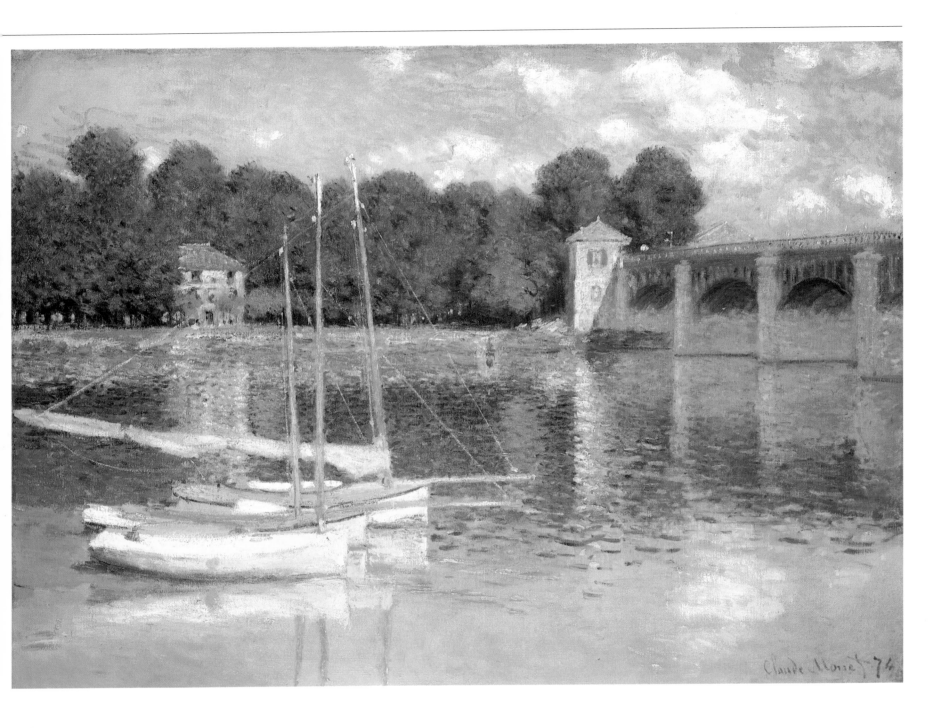

65 Claude Monet. *The Argenteuil Bridge.*
1874. Oil on canvas, 60 × 80 cm. (23⅝ ×
31½"). Musée d'Orsay, Paris (Antonin Per-
sonnaz Bequest, 1937).
This is one of the nine Monets that Faure
loaned to the second Impressionist
exhibition.

Claude Monet

In one of his account books, Monet summarized his sales from 1872 until 1877, and
he recorded that he had sold sixty-four canvases to Durand-Ruel and nineteen to
Faure—in reality a few more if the "rough sketches" are included. Faure is first
mentioned in Monet's accounts in June, 1874, immediately after the first Impression-
ist exhibition: the sale of four paintings for 4,000 francs is recorded, notably, *The
Argenteuil Bridge* (Musée d'Orsay, Paris) that Faure lent to the second Impressionist
exhibition and, possibly, the small version of *Le Déjeuner sur l'herbe*, from 1865—66
(now in the Pushkin Museum of Western Art, Moscow). This purchase took place
with Manet as broker, for he regularly contrived to help his fellow artists. Monet's
sales to Faure continued at a good rate until October, 1879, when they stopped
suddenly. Like other collectors such as Georges de Bellio, Faure was not pleased with
the canvases from Vétheuil, painted in a freer style, with loose patches of color.

66 Page from Claude Monet's Account Book. Musée Marmottan, Paris.
This list of dealers and collectors gives Faure's address between 1878 and 1886 as 5 Rue Neuve de Mathurins.

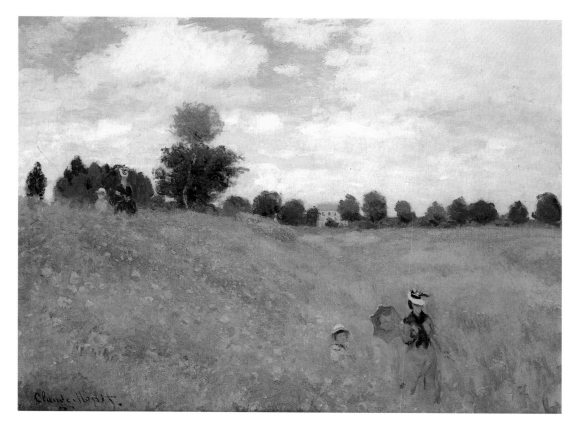

67 Claude Monet. *Wild Poppies.* 1873. Oil on canvas, 50 × 65 cm. (19⅝ × 25½″). Musée d'Orsay, Paris (Gift of Etienne Moreau-Nélaton, 1906).

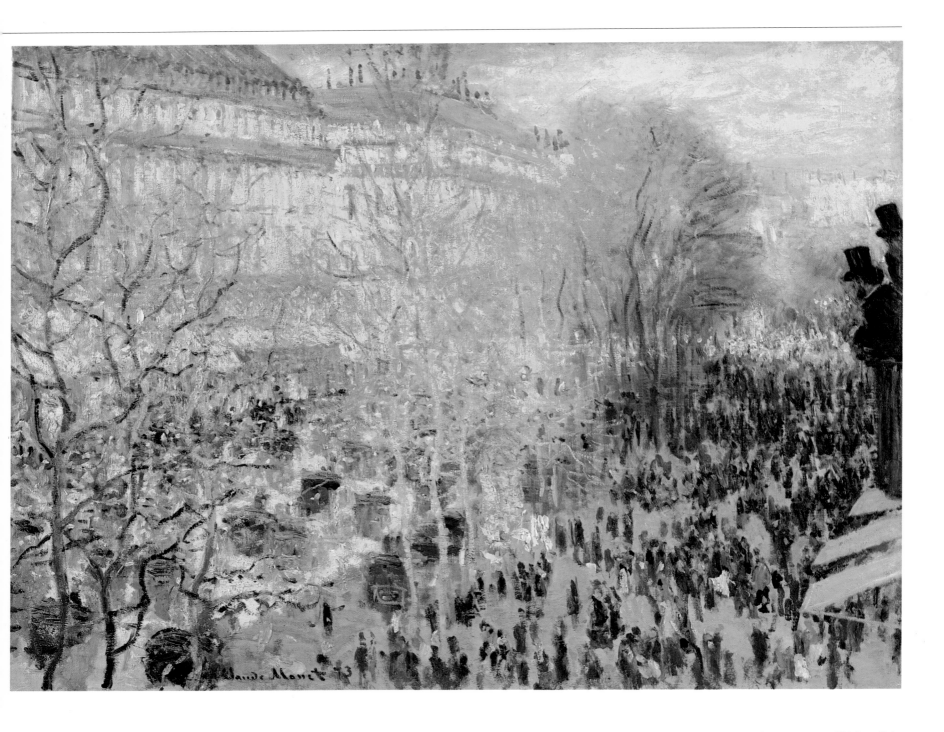

68 Claude Monet. *Boulevard des Capucines, Paris.* 1873. Oil on canvas, 61 × 80 cm. (24 × 31½″). Pushkin Museum of Western Art, Moscow (I. A. Morozov Collection).
This painting created a scandal at the first Impressionist exhibition in 1874.

Monet bore such a strong grudge against Faure for turning up his nose at *Vétheuil in the Fog* (Musée Marmottan, Paris) that, as late as 1913, he mentioned it to a reporter who came to interview him.

Still, in 1884 and 1885, when Monet was staying at Etretat, Faure—who had a house there—put himself out. Monet thought, perfidiously, that Faure hoped for "something good and cheap," but, the artist wrote to Durand-Ruel, "although I am terribly in need of money, I congratulate myself on having made this little appearance at Etretat without asking for the baritone's aid." That was not a bad tactic. Shortly afterward, following the Monet exhibition at Georges Petit's, Faure bought five recent paintings by the artist for 5,400 francs.

Faure owned between fifty and sixty paintings by Monet. In addition to those mentioned previously, among the most remarkable of those Faure purchased either from Monet, at auction, or from dealers were *Beach at Sainte-Adresse* (The Art Institute of Chicago), *Boulevard des Capucines* (Pushkin Museum of Western Art,

68

69 Alfred Sisley. *Boat Races at Hampton Court.* 1874. Oil on canvas, 45 × 61 cm. (17¾ × 24″). Private collection, Switzerland.

Moscow), *Meadow at Bezons* (Nationalgalerie, Berlin), *Dahlias,* from the estate of the unfortunate Hoschedé, *Cliffs at Dieppe* (Kunsthaus, Zurich), *Haystack, Evening* (Pushkin Museum of Western Art, Moscow), and *Le Printemps (Spring)* (Fitzwilliam Museum, Cambridge, England). Faure may have purchased this last painting directly from the artist in 1877. After 1890, the aging Faure began to resell his paintings. 84

Alfred Sisley

Another one of Faure's favorite artists was Alfred Sisley. A great traveler who was familiar with England, Faure had Sisley, who was of English ancestry, accompany him on a trip to London in spring, 1874. That trip, which was very much in the princely tradition of the past, resulted in a beautiful series of canvases painted by Sisley at and around Hampton Court. Faure owned several of those paintings, for 87

C. Pissarro.

70 Camille Pissarro. *The Hermitage at Pontoise.* c. 1867–68. Oil on canvas, 151 × 200 cm. (59⅛ × 78¾″). Solomon R. Guggenheim Museum, New York (The Justin K. Thannhauser Collection).

example, *Boat Races at Hampton Court*, as well as *The Bridge at Villeneuve-la-Garenne* (The Metropolitan Museum of Art, New York)—undoubtedly one of the artist's masterpieces—and a number of paintings of Saint-Mammes and of Moret-sur-Loing, the artist's last home. **69**

Camille Pissarro

More is known about Faure's relationship with Pissarro. In his correspondence, Pissarro often referred to the singer, with whom he dealt directly, although Faure had chosen his first works by Pissarro at Durand-Ruel's. For instance, in April, 1872 (well before Faure purchased his first Manets), he bought a *Snow Effect*, which Durand-Ruel had acquired from Pissarro during his stay in London in 1871. Durand-Ruel recorded that this sale and others that followed were made through the dealer Hourquebie.

Faure was not satisfied with just buying finished works; he apparently made suggestions. Pissarro, who wanted to please such a serious collector, took Faure's suggestions to heart: "I have done a small genre painting," he wrote to Durand-Ruel on June 12, 1875, "intended for Faure." A little while later, the collector Eugène Murer, who coveted the work, referred to "a Breton domestic scene that Faure refused as [being] too dismal."

Faure undeniably preferred paintings with figures, shepherdesses, sowers, washerwomen. He also owned important works such as *The Hermitage at Pontoise* **70** —which Cézanne particularly admired—and *The Plain of Epluches (Rainbow)*, exhibited at the third Impressionist exhibition. Like many of the earliest collectors, Faure did not "follow" Pissarro as he developed into his divisionist period. **80**

Edgar Degas

The last great artist in Faure's collection was indisputably Edgar Degas. The association between Degas, the opera, and Faure was inevitable. Nonetheless, this association turned into a tempestuous adventure, ending in a lawsuit or perhaps only the threat of a lawsuit. Despite research into this affair on the occasion of the large Degas exhibition of 1988–89, it remains largely obscure. What is clear is that, from 1870 to 1880, Faure was the first and most important collector of Degas: he owned ten of the artist's paintings. In spring of 1873, Faure bought the marvelous *Carriage at the Races* (Museum of Fine Arts, Boston) from Durand-Ruel's London branch (Faure sang in London more often than in Paris). Then, he probably bought *Before the Race* (National Gallery of Art, Washington, D.C.); later, in 1874, this time at Durand-Ruel's in Paris, Faure acquired *Jockeys at the Tribune*. **71**

In the meantime, Faure contacted Degas and commissioned a ballet scene from him, *The Dance Lesson* (The Metropolitan Museum of Art, New York). The collector **72** even agreed to buy back from Durand-Ruel the pictures with which Degas was not satisfied, so as to give them back to the artist. As a quid pro quo, Degas agreed to

89

71 Edgar Degas. *Jockeys at the Tribune*. c. 1866–68. Oil on canvas, 46 × 61 cm. (18⅛ × 24″). Musée d'Orsay, Paris (Isaac de Camondo Bequest, 1911).

72 Edgar Degas. *The Dance Lesson*. 1874. Oil on canvas, 83 × 79 cm. (32½ × 30″). The Metropolitan Museum of Art, New York (Bequest of Mrs. Harry Payne Bingham, 1986).

paint new pictures for Faure. But Degas dragged his feet: "I have had to earn my miserable living in order to be able to turn a little of my attention to you," he wrote to Faure in 1876. Degas delayed for so long that the matter was not yet settled in 1887. At that point, Faure threatened to sue Degas. Whether he actually went that far or not remains unknown, but the paintings were finally delivered.

Although we do not know when those paintings entered Faure's collection, they can be identified, since he resold them to Durand-Ruel in 1893, 1894, and 1898. They were *The Racecourse. Amateur Jockeys Beside a Carriage* (Musée d'Orsay, Paris), *Laundress Seen Against the Light* (National Gallery of Art, Washington, D.C.), *Laundresses*—sold at Christie's, London, on November 30, 1987, for 13.6 million dollars—and *The Ballet of "Robert le Diable"* (The Metropolitan Museum of Art, New York). Faure also owned the second version of that painting (Victoria and Albert Museum, London). These are some of the greatest masterpieces by Degas. Yet, in 1902, when Faure had the catalogue of his collection printed, there was not a single Degas left.

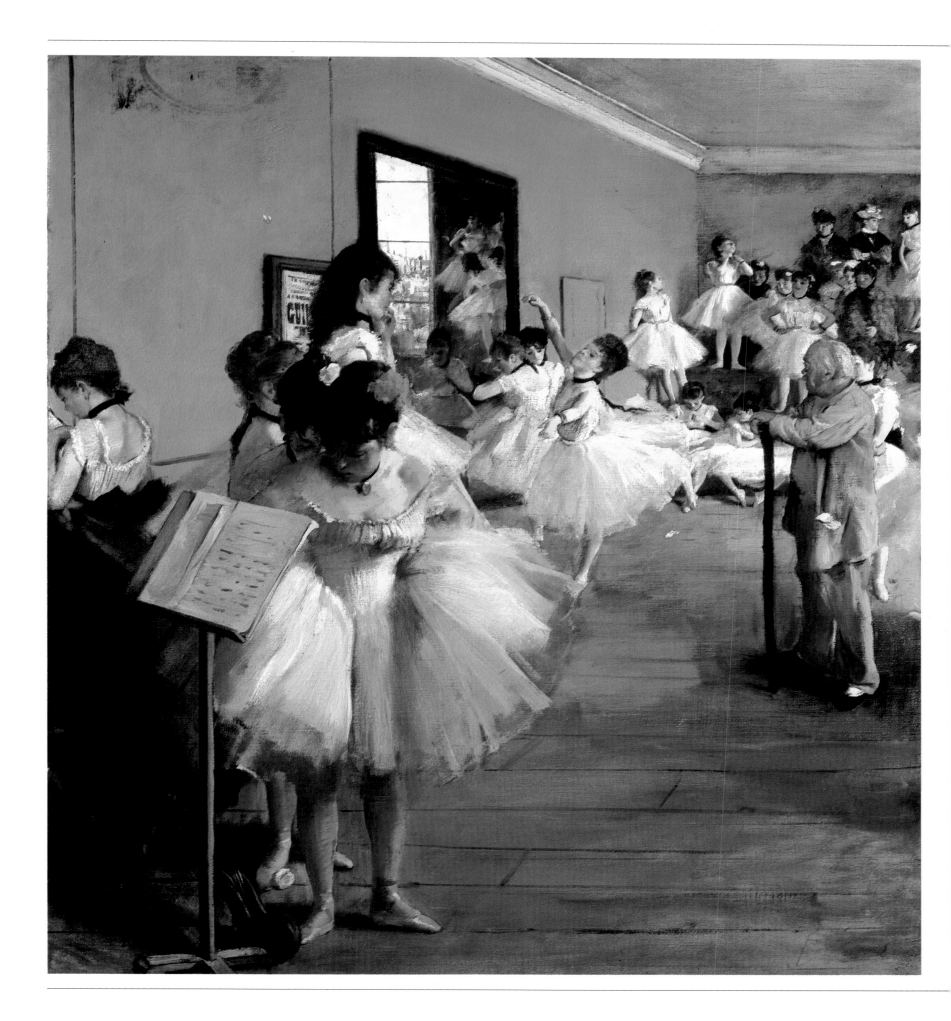

73 Anonymous. *Jean-Baptiste Faure.* Photograph. Bibliothèque Nationale, Paris.

74 Zacharie Astruc. *The Mask Dealer.* Reduced copy in bronze of the statue in the Luxembourg Gardens, detail with the mask of Faure. Musée Barbey d'Aurevilly, Saint-Sauveur-le-Vicomte (Deposited by the Musée d'Orsay, Paris).
The original plaster cast for this work was exhibited at the 1882 Salon; in that work, Faure is associated with Delacroix, Balzac, Corot, Berlioz, Carpeaux, Gounod, Gambetta, Barbey d'Aurevilly, Alexandre Dumas fils, Théodore de Banville, and Victor Hugo. Being placed in such a context undoubtedly flattered the baritone.

A Wager Won and a Collection Ended

Early in the 1890s, Faure started to sell again. He never explained why. The apartment at 52 A Boulevard Haussmann, right behind the Opéra, in which Faure had lived since 1887 (after having resided at 30 Rue Neuve des Mathurins from 1870, and at Number 5 on the same street from 1878), contained a formal gallery that the singer gladly opened for distinguished visitors—the Havemeyers for example. Faure clearly had trouble resisting the attraction of the profits he made with each resale. Even in his unsuccessful 1878 auction, he had already demonstrated a tendency to speculate.

Faure's son, Louis-Maurice, was an artist. Perhaps he was the one who introduced Faure to the Swedish artist Andreas Zorn, who painted Faure's portrait, or to Max Liebermann, the artist from Berlin; Faure owned several works by Liebermann. The 1902 catalogue mentioned above, which contained one hundred and twenty works, was only the last chapter in Faure's story. Although the Impressionists were still present in force (2 Caillebottes, 21 paintings and watercolors by Manet, 13 Monets, 24 Pissarros, 22 Sisleys), other names appeared as well: Jules Bastien-Lepage (whose *Gambetta on His Deathbed* was no doubt a politically motivated acquisition), Cormon, Corot, Couture, Daubigny, Decamps, Diaz, Dupré, Fortuny, Ingres, Jongkind, Meissonier, De Nittis, Raffaëlli, Raffet, Ribot, Roybet, and Ziem.

The death of Faure's wife on February 22, 1905, was perhaps one of the decisive factors in Faure's decision to part with his paintings. As Durand-Ruel wrote to the Havemeyers in March, 1905, at first Faure wanted to sell the whole collection outright; then—probably because no buyer came forward—he decided to make lots, for example all the Manets. Well-informed circles in Paris were abuzz with talk of astronomical prices. The dealers, especially the Bernheim brothers, outdid each other paying court to Faure. In March, 1907, Durand-Ruel bought almost all the Manets, which had been exhibited at Durand-Ruel's in Paris the previous year, as

75 Edouard Manet. *Head of Jean-Baptiste Faure.* 1882. Oil on canvas, 46 × 37 cm. (18⅛ × 14⅞″). The Metropolitan Museum of Art, New York (Gift of Mrs. Ralph J. Hines, 1959).

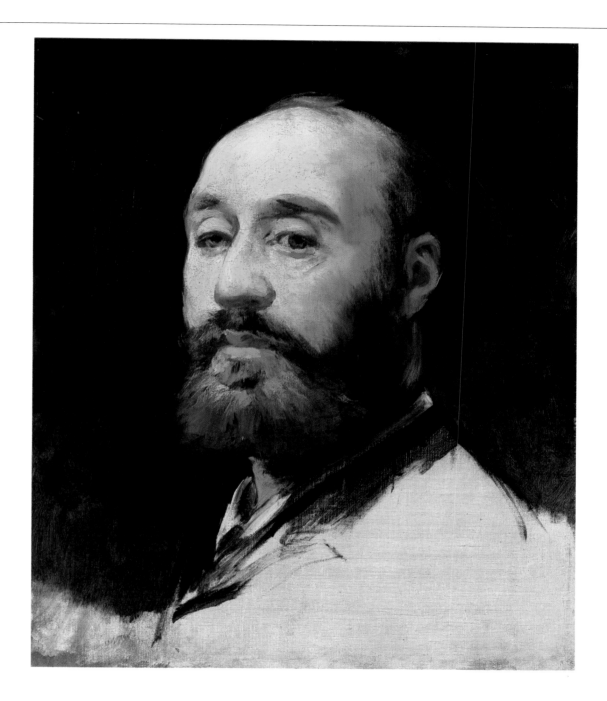

well as in London, Berlin, and Stuttgart, and the Monets for a little less than half a million francs. Faure appears to have preferred more tangible assets—buildings in Paris and Etretat, where he owned a series of houses—to a patrimony of paintings.

Faure kept the Pissarros and Sisleys, however, in addition to some minor works by Manet. In 1919, his daughter-in-law would sell to Durand-Ruel forty-eight paintings that correspond roughly to the 1902 catalogue for a little more than 300,000 francs.

Death and war had severely assailed the singer's family in the meantime. Jean-Baptiste Faure, suffering from growing deafness, died at his home on Boulevard Haussmann on November 9, 1914. His family had kept from him the fact that his house at Etretat, containing the other objects in his collection—particularly the faience—had burnt down. Faure's son, the artist Louis-Maurice Faure, died during World War I on February 7, 1915, at the young age of fifty-two, of an illness caught on the front line. Thus ends the story of the Faure collection which, one could say, died before the collector and by his own hand.

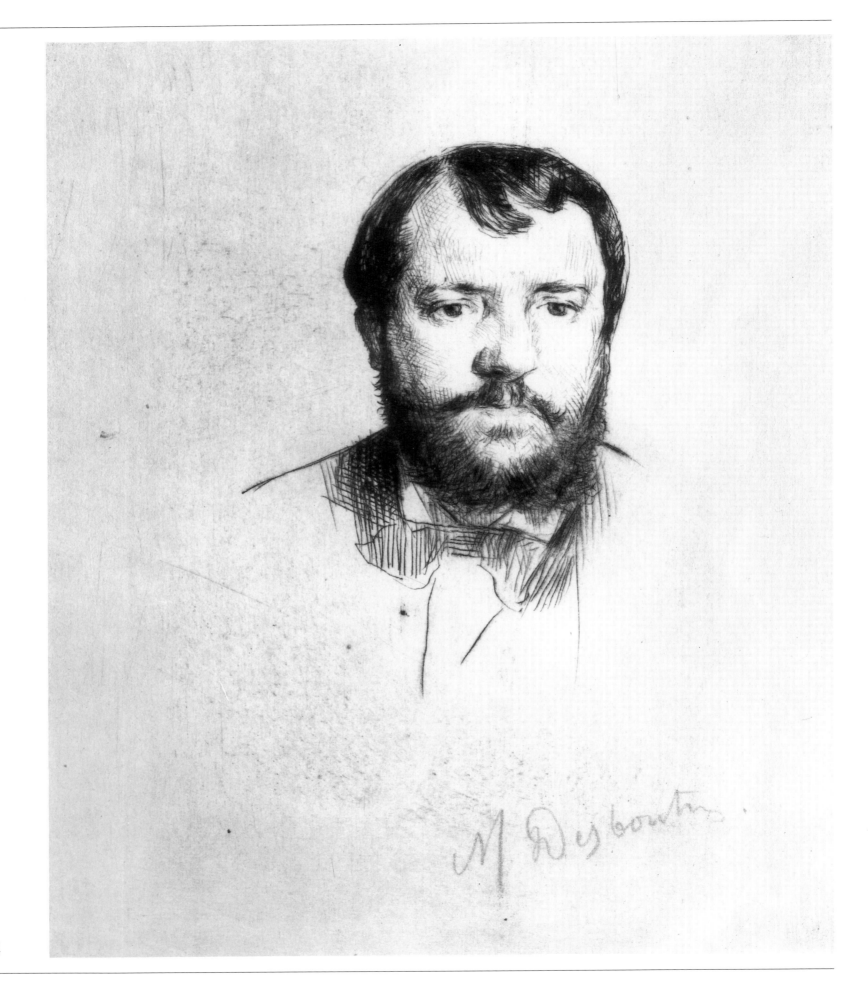

M. Desboutin.

94

Ernest Hoschedé

When Théodore Duret was drawing up his list of collectors in 1878, an important actor was just leaving the stage: this was Ernest Hoschedé, who was thus unjustly omitted from the honors list on which he should have been mentioned.

Recapitulating the paintings he had sold in 1874, Monet made the following note in his accounts: "May, impression 800 Mr. Hochedé [sic] via Durand," which means that in May, 1874, at the end of the first Impressionist exhibition, Monet sold his painting *Impression, Sunrise*, which had been in the limelight, to Ernest Hoschedé, through Durand-Ruel, for 800 francs. Monet should have spelled Ernest Hoschedé's name correctly, since it was in the catalogue of the Impressionist exhibition: Félix Bracquemond, the painter and a friend of Hoschedé, had exhibited an etched portrait of Hoschedé.

Ernest Hoschedé was a regular customer of Durand-Ruel. Starting in February, 1873, he had purchased several works from Durand-Ruel by Monet, Pissarro, and Sisley. Thus Hoschedé shared with the baritone Faure the first pickings obtained from the Impressionists by their dealer.

We do not know how Hoschedé met Durand-Ruel. Impressionist works were not the first paintings Hoschedé purchased. Before the Franco-Prussian War, he had lent a painting by Eugène Boudin to the 1870 Salon. Félix Bracquemond had engraved an invitation card for Hoschedé (dated April 27, 1870) and Hoschedé's portrait as a National Guardsman in 1871. A reporter from Brussels spoke of Hoschedé as one of the "principal French collectors," when Hoschedé bought a work by Corot, *Dance of the Nymphs*, at the Laurent-Richard sale in 1873. These dates mark the beginning of Hoschedé's career as a collector.

A Parisian Wholesaler

In 1874, Ernest Hoschedé (who was born in Paris on December 18, 1837) ran a large wholesale fabric firm on Rue du Sentier in the Parisian garment district. Ernest had actually succeeded his father, Edouard, in 1867. The elder Hoschedé had worked his way up from employee to managing partner of the important, old company, Cheuvreux-Aubertot.

An only son, Ernest Hoschedé was indulged financially in his youth, perhaps to inspire him with a taste for business, which he did not seem to possess naturally. Ernest's father set aside a considerable sum of money for him when he married Alice Raingo in April, 1863, although Ernest's mother did not especially welcome the marriage. Yet Alice was pretty, intelligent, and very rich. From her parents she received 100,000 francs, the customary dowry for young Parisian women of the upper middle class. (Of Belgian extraction, Alice's father had made a fortune speculating on real estate and died in 1870, a millionaire several times over.) Ernest's father also advanced him 400,000 francs to set up a new company, in which the older man was merely a sleeping partner.

Even without working much, Ernest Hoschedé was entitled to a large part of the business's profits. So he settled down to a life of luxury, dividing his time between his home in Paris at 56 Boulevard Haussmann and the castle of Rottembourg at Mont-

91

77

76, 77,
81, 83,
89

78 Page from Monet's Account Book. Musée Marmottan, Paris.
This page records Hoschedé's purchase of *Impression, Sunrise* in May, 1874, as well as purchases by Faure and by Durand-Ruel.

geron, which his wife had inherited. Hoschedé arranged the castle so he could entertain with ostentation. Although he already seemed to be living beyond his means—it was said that Hoschedé hired a special train to take his guests to Montgeron—nothing yet foretold the catastrophe in store for him.

Was It Possible to Speculate on Paintings in 1874?

Still, it might seem odd that Hoschedé, who had purchased paintings from Durand-Ruel in 1873, sold them a few months later, on January 13, 1874. Without giving a real reason for the sale, the foreword to the auction's catalogue—signed with the initials "E.C.," i.e. the critic Ernest Chesneau—is clear enough: "In addition to the established names of the highest rank in contemporary art (Diaz, Courbet, Vollon, Michel, Corot, C. Jacque), it will contain works by very young artists, facing the test of an auction for the first time. These artists belong to a group whose tendencies toward extreme simplicity and whose absolutely sincere naturalist interpretations are much discussed." (This auction took place before the first Impressionist exhibition.) What Chesneau failed to mention was the fact that the work of most of these young artists had been rejected by the Salon jury. Showing them with their elders, by now successful, suggested that tastes evolved quickly. It was the first time that that truth was proclaimed outside the walls of Durand-Ruel's gallery.

79 Alfred Sisley. *Flood at Port-Marly*. 1876. Oil on canvas, 60 × 81 cm. (23⅝ × 32″). Musée du Jeu de Paume, Paris (Isaac de Camondo Bequest, 1911).

80 Camille Pissarro. *The Plain of Epluches (Rainbow)*. 1877. Oil on canvas, 53 × 81 cm. (20⅝ × 32″). State Museum Kröller-Müller, Otterlo.

The auction catalogue contained one hundred lots: these included 1 Degas (*The False Start*, Yale University Art Gallery, New Haven, Connecticut), 3 Monets, including the famous *Blue House at Zaandam* (auctioned in London on June 27, 1988), 6 Pissarros, and 3 Sisleys. Other artists such as Boudin, Lépine, Mauve, and Piette were linked to the same category of painting.

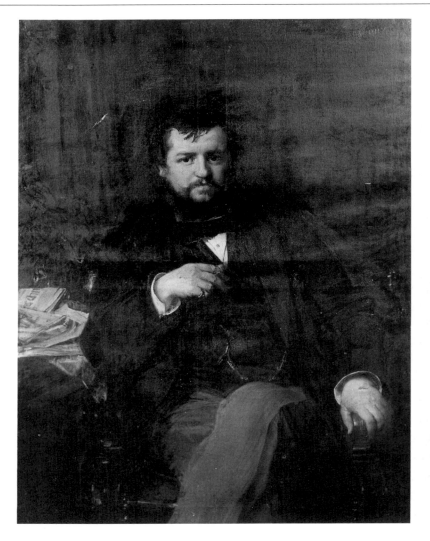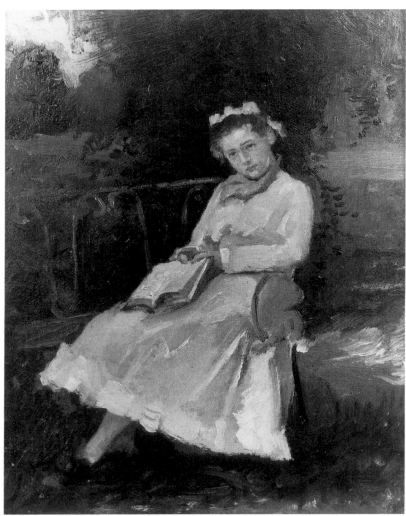

81 Paul Baudry. *Ernest Hoschedé*. 1876. Oil
on canvas, 13 × 98 cm. (5⅛ × 38½″). Jean-
Marie Toulgouat Collection, Giverny.

82 Carolus-Duran. *Marthe Hoschedé (Ma-
dame Theodore Butler)*. c. 1876. Oil on can-
vas, 35 × 27 cm. (13¾ × 10⅝″). Jean-Marie
Toulgouat Collection, Giverny.

The prices these works brought were not very high, with the exception of the
1,100 francs paid by Henri Rouart for the Degas. The average price was between 200
and 400 francs. The entire auction brought in less than 35,000 francs, somewhat less
than what Hoschedé had paid at Durand-Ruel's. For the artists, the prices were
respectable, since they corresponded to what their dealer was paying them.

People were astonished that a work by Pissarro went as high as 950 francs;
according to the artist the news could be heard as far away as Pontoise. In fact, it had
been bought back for Pissarro by Durand-Ruel on behalf of that worried artist.
Durand-Ruel bought seventeen paintings himself. Be that as it may, Duret believed
that the Hoschedé auction was the Impressionists' first step on the road to public
recognition.

Without denying Hoschedé's love of painting, it must be acknowledged—as his
creditors would argue later—that this sale was motivated by thoughts of speculation.
No doubt Hoschedé felt it was more attractive to make money with paintings than
with his fabrics. After all, the example of Faure's auction (in June, 1873), had proven
that a private collector who was not a dealer could nonetheless make nice profits.

The difference was that, at his auction, Faure was getting rid of paintings by
Delacroix and the Barbizon School. These were works by artists who had achieved
success at last among the prosperous middle class, not works by young artists known
for their uncompromising stance as *refusés*. Hoschedé had tried his luck too soon.
Though he was much more careful, Faure would make the same mistake in 1878.
Hoschedé's only excuse may have been that he already needed money to pay his

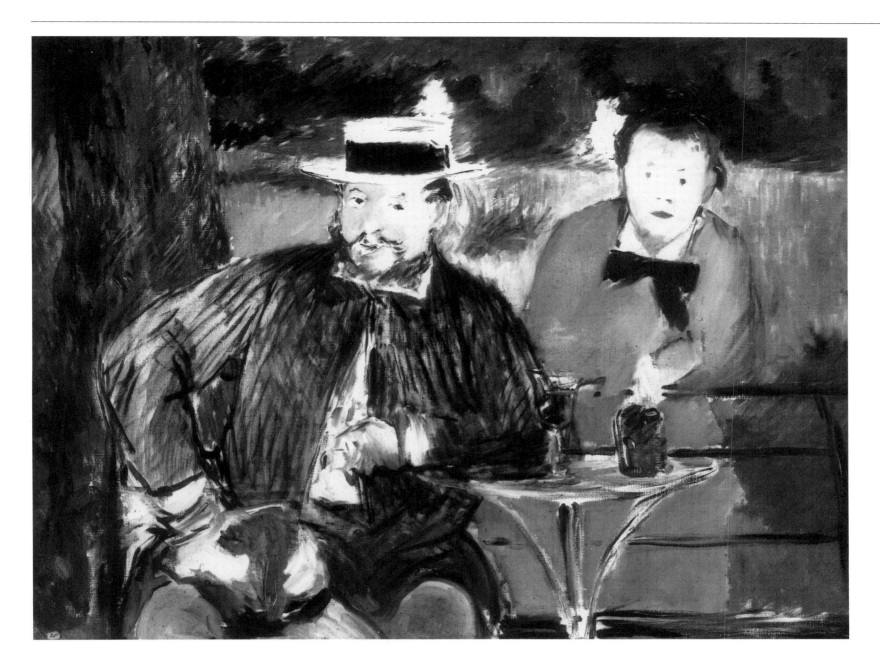

83 Edouard Manet. *Ernest Hoschedé and His Daughter, Marthe*. 1876. Oil on canvas, 86 × 130 cm. ($33\frac{5}{8}$ × $51\frac{1}{4}$"). Museo Nacional de Bellas Artes, Buenos Aires.

debts. No doubt the inheritance from his father (who died on May 29, 1874) solved his financial problems for the time being.

Hoschedé continued buying from Parisian dealers and from the artists, whom he now knew. Then Hoschedé's financial situation worsened; this time he was evidently obliged to sell the most "marketable" works in his collection. The catalogue of Hoschedé's second auction on April 20, 1875, is noteworthy for the 16 Corots, 11 Courbets, the works by Daubigny, Millet, Lépine, and Stevens. The auction brought in more than 200,000 francs. In her studies of Hoschedé, Hélène Adhémar has pointed out that, when the collector had achieved his financial goal, he began buying back as many of the works as possible. Even though he was hard pressed— later, the judgment in bankruptcy backdated Hoschedé's insolvency to September 5, 1875—Ernest Hoschedé did not change his life style.

The year 1876 was particularly rich in artistic events for the collector. Paul Baudry, the highly esteemed artist who had worked on the new Opéra by Garnier, sent a portrait of Hoschedé—definitively established as a patron of art—to the 1876 Salon. During that summer, Manet painted Hoschedé with his daughter, Marthe (Pl. 83), while the artist was staying at Montgeron. At the same time, the fashionable

81

84 Claude Monet. *Dahlias.* 1877. Oil on canvas, 173 × 193 cm. (68¼ × 76″). Hermitage Museum, Leningrad (I.A. Morozov Collection).
A decoration for the castle of Rottembourg.

academic artist Carolus-Duran was also a guest of the collector. Manet and Carolus-Duran painted each other (Musée d'Orsay, Paris, and Barber Institute of Fine Arts, Birmingham). Monet also arrived at Montgeron and began painting large (almost 6 ¼ feet) decorative panels: *Les Dindons (Turkey Cocks)*, *Dahlias, Pond at Montgeron*, and *Hunting*.

In January, 1877, Hoschedé bought from Durand-Ruel twenty-seven paintings for which he never paid. Among them were works by Manet, Monet, Sisley, Pissarro, and Berthe Morisot. It is interesting to see that Ernest Chesneau (a former *Inspecteur des Beaux-Arts*, who resigned at the fall of the Second Empire, and who had written the foreword to the catalogue of the first Hoschedé auction) received two paintings— by Pissarro and by Monet—from Durand-Ruel as a fee for that "sale."

86, 84, 85, 87

85 Claude Monet. *Pond at Montgeron.* 1877. Oil on canvas, 173 × 193 cm. (68¼ × 76″). Hermitage Museum, Leningrad (I.A. Morozov Collection).
Another decoration for the castle of Rottembourg.

In spring of 1877, Hoschedé, whose loans were concealed by using the initials "M.H.," could congratulate himself on being the most important lender at the third Impressionist exhibition. As far as official art was concerned, the portrait of Hoschedé's daughter, Blanche, by Paul Baudry figured in the 1877 Salon. For Hoschedé, however, this was the end.

Bankruptcy

In spite of having formed a new company in 1876, Hoschedé was declared bankrupt on August 24, 1877. The balance sheet drawn up a year later showed debts of more

86 Claude, Monet. *Les Dindons (Turkey Cocks)*. 1877. Oil on canvas, 170 × 170 cm. (67 × 67″). Musée d'Orsay, Paris (Winnaretta Singer Bequest, Princess Edmond de Polignac, 1943).
Another decoration for the castle of Rottembourg.

▷
87 Claude Monet. *Hunting*. 1876. Oil on canvas, 170 × 137 cm. (67 × 54″). Private collection.
Another decoration for the castle of Rottembourg.

than 2,000,000 francs. Among the approximately one hundred and fifty creditors, we find picture dealers (Brame, the widow Cadart, David, Durand-Ruel, Luquet, Petit, Legrand, Reitlinger, Thomas, and others) as well as artists (Delpy, Detaille, Pelouse). But those debts amounted to less than 100,000 francs. The biggest creditors were financiers from whom Hoschedé, "for his personal use," had "entered into large financial obligations necessitating heavy borrowing." Everything had to be sold: the furnishings in Paris and at Montgeron during the summer of 1877, the castle of Rottembourg in May, 1878, and finally, the collection of paintings at the Hôtel Drouot.

The catalogue of the June 6, 1878 auction contained more than one hundred lots, half of which were Impressionist works. The catalogue, which documented Hoschedé's final downfall, also remains as an incomparable tribute to the memory of a collector who, with the exception of Faure, was unrivaled in his time.

Unfortunately, the auction took place at a very bad time. The Impressionist exhibitions had made works by the group appear unsaleable. The highest prices were paid for paintings by Manet: 800 francs for *The Ragpicker* (The Norton Simon Museum, Pasadena, California), 700 francs for *Woman with a Parrot*, 650 francs for *Young Man in the Costume of a Majo*, and 450 francs for *The Street Singer*. Manet was dismayed by these prices, however, because the same paintings had been sold to his dealer a few years earlier for more. On the other hand, Faure, who won the bidding for the last two paintings mentioned, made an excellent buy; as did his friend Henri Hecht who acquired two other Manets. Murer bought the first lot—a landscape by Sisley—for 21 francs! For just under 700 francs, Faure bought 3 Sisleys, 3 Monets, including *The Thames and the Houses of Parliament* (National Gallery, London), and 3 Pissarros. Victor Chocquet treated himself, for only 157 francs, to the two Monets that would reappear at his posthumous sale. Georges de Bellio became the owner of the famous *Impression, Sunrise* for 210 francs, as well as another Monet and a Renoir. De Bellio led another Romanian, his friend Constantin de Rasty, to acquire Renoir's *Woman with a Cat* (National Gallery of Art, Washington, D.C.). Among the other buyers were Mary Cassatt or her brother, Jean Dollfus, Théodore Duret, and Ernest May.

As for the dealers, Durand-Ruel bought only a single Pissarro, *The Plain of Epluches (Rainbow)*, because he was not the expert-appraiser at the auction: Georges Petit—not as intimately acquainted with Hoschedé as Durand-Ruel, though one of the collector's creditors—had been appointed expert-appraiser. Petit purchased several canvases, some of them Monets bought on behalf of the artist.

The total sales fell short of 70,000 francs; a little more than 7,500 francs had been paid for works by Manet and the Impressionists. Pissarro summarized the situation: "The Hoschedé auction killed me." Even though Pissarro certainly came away the worst, none of his fellow Impressionists could feel optimistic.

210

57, 88

91

80

192

Survival of a Dethroned Nabob

Hoschedé was ruined, and yet—however absurd it may seem—in July, he bought *National Holiday, Rue Saint-Denis, Paris* from Claude Monet for 100 francs. Hoschedé's possession of that work was even more short-lived than that of his previous collections, since Monet himself negociated its sale to the composer Emmanuel Chabrier shortly afterward for twice the original price. Still, it is true that henceforth the fates of Monet and his collector were bound together.

When Monet, his wife Camille, and their two sons went to live at Vétheuil, the entire Hoschedé family—Ernest, his wife Alice, and their six children—shared two houses in succession with the Monets. It is possible that Ernest Hoschedé's admiration for the artist extended to Monet's ability to live without money—a talent Hoschedé was sorely lacking.

At first, the Hoschedés were aided by Ernest's mother, but she died in December, 1880. Settling the bankruptcy swallowed up her estate. Alice had man-

88 Edouard Manet. *The Street Singer.*
c. 1862. Oil on canvas, 175 × 108 cm.
(67⅜ × 41⅝"). Museum of Fine Arts,
Boston (Bequest of Sarah Choate Sears,
in memory of her husband, Joshua
Montgomery Sears, 1966).

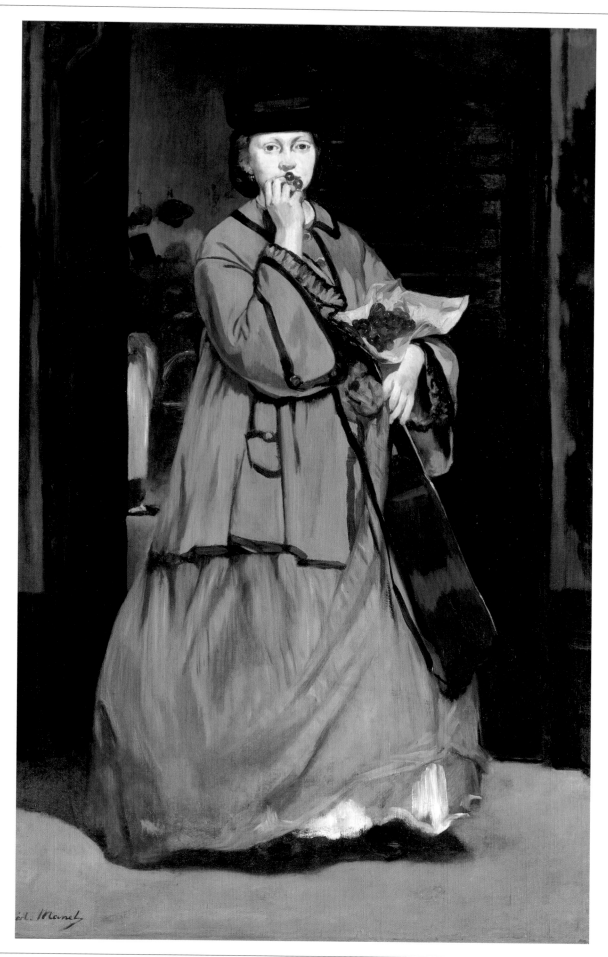

aged to save a few scraps of her personal fortune from the disaster. The Hoschedés and their friends could hope for a simple but decent future. However, Monet's loss of heart at the most difficult times, and the illness and then death of Camille Monet in September, 1879, saddened their community life at Vétheuil. Alice took care of Monet's children, who no longer had a mother, while her husband—no doubt carrying out an old dream—became a journalist. The initially confused situation became very clear when, leaving Vétheuil, Alice Hoschedé decided, in December, 1881, to settle at Poissy with Claude Monet. They remained together and were officially married in July, 1892, a year after Ernest Hoschedé died.

We cannot fail to mention the fact that Jean-Pierre Hoschedé, Alice's youngest son (born in August, 1877), has been thought to be Claude Monet's son. Whether he was or not, this suspicion only emphasizes the fact that—in the absence of Ernest Hoschedé—Monet was the real educator of all the Hoschedé children, and not just of Jean-Pierre, who was almost the same age as Monet's son Michel (born in March, 1878). Monet was the head of the family, the man who made a success of his life and, at the end, achieved fame. Blanche Hoschedé married Monet's son Jean; she took care of her father-in-law at Giverny until he died.

Are we, then, to come to the same conclusion as Zola's friend, the critic and novelist Paul Alexis, who, writing under the alias Trublot, declared in his annoying jargon to the readers of *Le Cri du peuple* on August 15, 1887: "For two or three summers, your colleague Hoschedé, the ex-millionaire, turned art critic for *L'Evenément*, has been staying in the country at Auvers. A merry companion, radiating goodness, and in much better spirits since he began living by his pen instead of being hampered by twelve or fifteen bowler hats like before."

Yet, separated from Alice, Ernest Hoschedé was not in a very enviable situation. The accounts of the bankruptcy mention an "emergency fund" given to the bankrupt Hoschedé in February, 1882; and he was harried at his successive Parisian domiciles by official legal documents. The liquidation was not closed until November, 1887—and Hoschedé's bankruptcy was labeled "fraudulent."

Nevertheless, it is true that Hoschedé did not give way to despair. A news item in the Brussels newspaper *Journal des Beaux-Arts* had named Hoschedé as an owner of the *Gazette des Beaux-Arts* in 1873, along with two other great collectors, Edouard André and Maurice Cottier. Although he had to give up ownership of the periodical, Hoschedé wrote reviews of the Salon or exhibitions for several Parisian newspapers.

Hoschedé was even involved in a very funny Parisian scandal at the end of 1885. There were rumors at the time that a nightclub named "L'Abbaye de Thélème," in honor of Rabelais, was going to open in Paris; the rumors said the serving girls would be dressed as nuns. Hoschedé was mentioned as the instigator of the project. The "Thélémites" inaugurated their abbey at 1 Place Clichy on May 22, 1886, "presided over by their venerable prior, Alexis Bouvier," a Parisian man of letters who died poor in 1892. Still, Hoschedé was mentioned again by Emile Goudeau, who, in June, 1886, went to visit artistic cabarets for the readers of *La Revue illustrée*, and reassured well-meaning people, with descriptions of the abbey's "genuine luxury, English comfort, plenty of linen, and good cooking"; the customers, "seated near artistic masterpieces, will dine in a superb manner in a pleasant setting."

There is no denying that the formula has been tried successfully elsewhere in the meantime. In any case, Hoschedé was known as a bon vivant. He frequently visited the Café Riche, or, as Pissarro noted in May, 1887, "drank to the honor of old Impressionism" at the independent artists' dinner. However, Pissarro added, "he seems to criticize Monet, Sisley, and Renoir. Hang it, I'm afraid there is something other than art in his criticism, for he is generally quite eclectic."

Hoschedé did not enjoy that bohemian way of life for long, however. In spite of Dr. Gachet's care, his health took a turn for the worse. Ernest Hoschedé died at 45 Rue Laffitte on March 18, 1891; he was fifty-three years old. Alice, still his wife, watched over his final hours. Hoschedé was buried in the cemetery at Giverny. Alice would be placed in the same burial vault, as well as most of the Hoschedé and Monet

89 Commandant Bourgeois. *Ernest Hos-chedé*. c. 1890. Pencil, 15 × 10 cm. (6 × 4″). Department of Graphic Arts, The Louvre, Paris (Gift of Paul Gachet, 1951).

children, and Claude Monet himself. Whether a consolation after death or a final, fateful irony, the fact remains that Ernest Hoschedé is linked in death to the triumph of Impressionism.

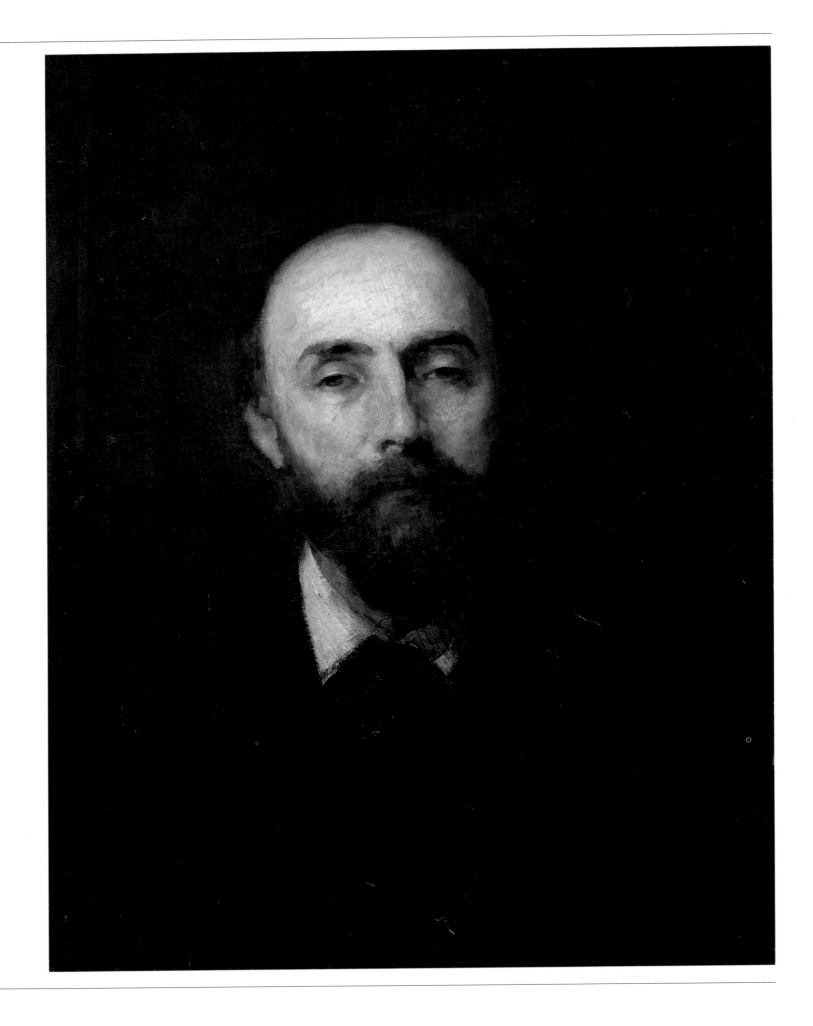

Georges de Bellio and Constantin de Rasty

90 Nicolas Jan Grigorescu. *Georges de Bellio.* c. 1877. Oil on canvas, 71 × 54 cm. (28 × 21¼″). Musée Marmottan, Paris (Donop de Monchy Bequest, 1957).

"Every time one of us had a pressing need for 200 francs, he ran to the Café Riche at the lunch hour. There one was sure to find Mr. De Bellio, who would buy, without even looking at it, the painting one brought him."

P. A. Renoir in: A. Vollard, *Renoir,* 1919, p. 71.

On October 27, 1985, armed robbers burst into a little museum located on a quiet street in a residential district of Paris and made away with a number of paintings, including a "star": *Impression, Sunrise* by Claude Monet, which gave Impressionism [91] its name. The theft of those works of art, still unsolved at the time these lines were written, emphasizes what an extraordinary symbol an initially overlooked painting became within a century.

On June 6, 1878, Georges de Bellio, a Romanian collector who was a Parisian by choice, had paid 210 francs for *Impression, Sunrise* at the Ernest Hoschedé auction, for there was no one else to bring the bidding up to the 800 francs that Hoschedé himself had paid for the picture in May, 1874. De Bellio never parted with the canvas; he handed it down to his daughter and his son-in-law, Mr. and Mrs. Eugène Donop de Monchy. In 1957, they bequeathed it to the Musée Marmottan in Paris, together with a group of works important enough to make Georges de Bellio's name famous for evermore.

This bequest was only part of a group of more than one hundred and fifty paintings (only about twenty of which predated the nineteenth century) and as many drawings; it represented the collection Georges de Bellio amassed from the mid-1860s until his death in 1894. Monet was the star of the De Bellio collection, which included more than thirty of his works. There were about ten paintings each by Pissarro and Renoir, as well as works by Cézanne, Degas, E. Gonzalès, Guillaumin, Manet, Morisot, Sisley, and others. That list alone is enough to make Georges de Bellio a collector beyond compare. Théodore Duret was right to give De Bellio a place of honor on his list as early as 1878.

Yet Georges de Bellio revealed little about himself apart from what is contained in the letters he exchanged with artist friends. There is enough, however, to depict De Bellio as an unpretentious, educated man. He was curious about everything, passionately fond of art, and very generous. The art historian Remus Niculescu has done a lot to make De Bellio better known.

A Romanian Gentleman and Homeopathic Physician

According to one of his handwritten notes, Georges de Bellio was born on February 20, 1828, in Bucarest. Duret called him a "rich Romanian gentleman." De Bellio [90, 103, 105] kept his Romanian citzenship all his life. It is true that the Bellu family (as the name is written in Romanian) numbered among its members landed proprietors, politicians, and several barons of the Austrian Empire married into princely families. Georges and his brother, Constantin, left the management of their fortune to their two older brothers, who remained in Romania, and settled in Paris shortly after 1850. The family fortune was sufficient to enable Georges de Bellio as he now called himself, adding a handle to his name as he entered Parisian society, to live comfortably without ostentation and without having to worry about pursuing a livelihood. Yet Georges de Bellio studied medicine and earned his doctor's degree; and as a convinced advocate of homeopathy, he treated Manet, Pissarro, Monet, Sisley, Renoir, and their families and friends over the years, all free of charge.

91 Claude Monet. *Impression, Sunrise.* 1872. Oil on canvas, 48 × 63 cm (17¾ × 21¾″). Musée Marmottan, Paris (Donop de Monchy Bequest, 1957).

Generous and unselfish, Georges de Bellio was also very meticulous. He set out to assemble documentation on art from prints cut out of *L'Art pour tous, L'Illustration,* and other magazines. De Bellio established a card index (now lost) of his collection. He prepared a list of 105 objects necessary when leaving on a trip: toiletries, photography equipment, implements for writing and for drawing as well as a homeopathic kit and a Smith and Weston revolver! Although De Bellio wrote French perfectly, he put together a collection of formal endings used in French correspondence. The only other noteworthy fact known about Georges de Bellio's private life is his acknowledgment of the child that Catherine-Rose Guillemet bore him on April 17, 1863—a daughter named Victorine, who later became Mrs. Eugène Donop de Monchy.

Art was the ruling passion of Georges de Bellio's life. The first known milestone in his career as a collector was his acquisition of a copy by Delacroix after Rubens at the sale of Delacroix's studio in 1864. At the time, De Bellio lived on Rue Grange-Batelière, a few steps from the Hôtel Drouot, where he was a regular customer. It was there that De Bellio purchased old drawings, many from eighteenth-century France,

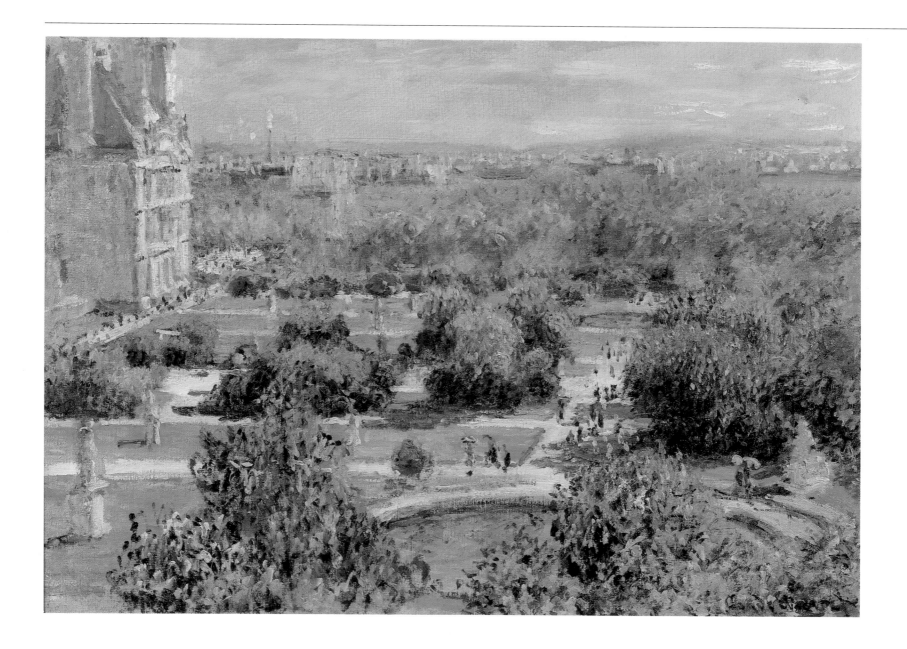

92 Claude Monet. *The Tuileries Gardens.* 1876. Oil on canvas, 53 × 72 cm. (20¾ × 28½″). Musée Marmottan, Paris (Donop de Monchy Bequest, 1957).
This canvas was painted from the balcony of Victor Chocquet's apartment on Rue de Rivoli.

in keeping with contemporary taste. He also amassed a jumble of curios that found a place in his home. 104

A Friend of Claude Monet

The second important event in De Bellio's career as collector took place in January, 1874, at the first Hoschedé auction, and thus before the first Impressionist exhibition. This was his purchase of a canvas by Monet, *The Seine at Argenteuil.* It has not been ascertained whether De Bellio already knew the artist at that time. Be that as it may, in April and June, 1876, De Bellio bought five paintings directly from Monet. The letters they exchanged confirm that they were friends. In 1877, Georges de Bellio loaned three Monets to the third Impressionist exhibition: *The Tuileries Gardens* 92 (Musée Marmottan, Paris), *The Parc Monceau, Paris* (probably the one in the Metropolitan Museum of Art, New York), both canvases acquired in June, 1876, and *The Pont de Rome, Gare Saint-Lazare* (Musée Marmottan, Paris).

From that time onward, Georges de Bellio was Monet's good angel, especially during the dismal year 1878. The artist wrote to De Bellio at the end of that year: "I 111

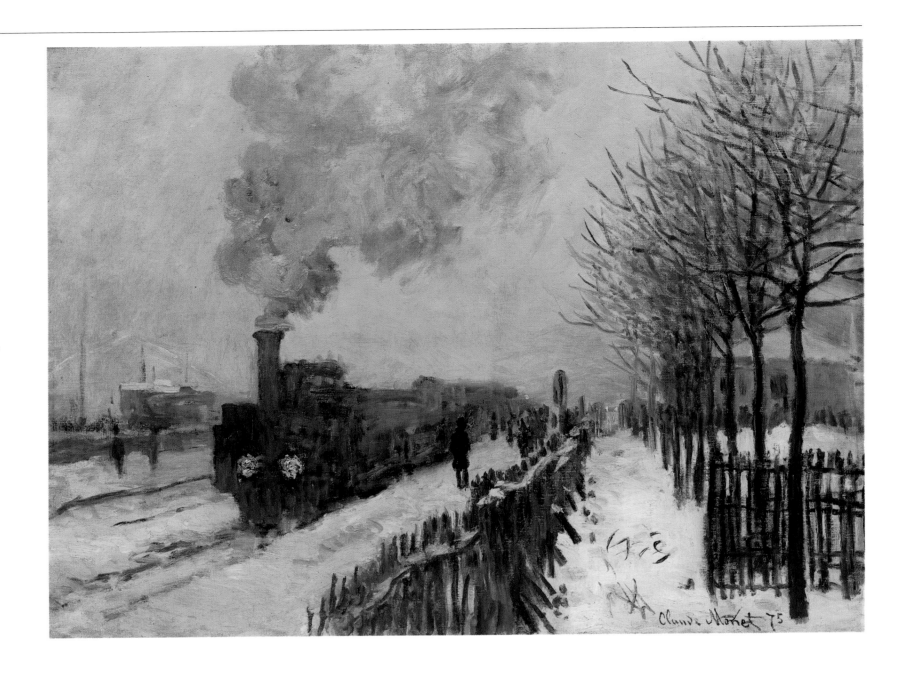

93 Claude Monet. *Train in the Snow. The Locomotive.* 1875. Oil on canvas, 59 × 78 cm. (23¼ × 30¾"). Musée Marmottan, Paris (Donop de Monchy Bequest, 1957).

am more than a beginner, and at my age it is sad to be in that situation: always forced to ask, to solicit commissions." Somewhat later, in March, 1879, Monet wrote: "I am absolutely disgusted and demoralized by this life I've been leading for such a long time.... Consequently I am completely giving up the fight and all hope of success, nor do I feel strong enough to work under such conditions. I hear that my friends are having a new exhibition this year; I must forgo participating in it, not having anything that is worth exhibiting." Yet there were twenty-four Monets listed in the catalogue of the fourth Impressionist exhibition, all loaned by Monet enthusiasts, who included Baudry, Duret, Caillebotte, Chabrier, Murer as well as the pleasant, fashionable artist Ernest Duez; Antoine Guillemet, another artist who was a friend of Manet; Mr. Lecadre, a cousin from Le Havre; Mr. Frat, a collector from Montpellier whom Bazille once brought; and Charles Hayem, a Parisian merchant whom Monet called a "ribbon dealer." Hayem did indeed combine the business of selling shirts in the garment district of Paris and art: he was one of the first collectors of Gustave Moreau. With his six works, Georges de Bellio was the main lender of Monet at that exhibition.

94 Claude Monet. *Woman with a Parasol— Madame Monet and Her Son.* 1875. Oil on canvas, 100 × 81 cm. (39⅜ × 31⅞"). National Gallery of Art, Washington, D.C. (Collection of Mr. and Mrs. Paul Mellon).

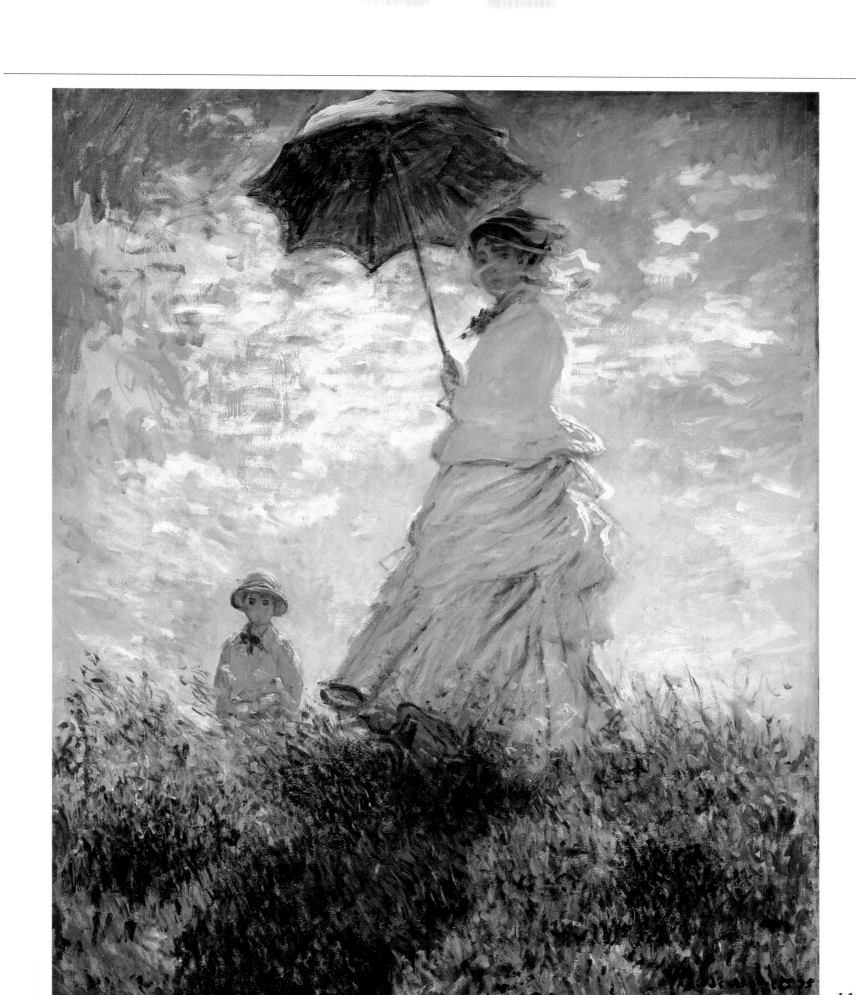

113

95 Claude Monet. *Rue Montorgueil Decked with Flags.* 1878. Oil on canvas, 80 × 50 cm. (24¼ × 13″). Musée d'Orsay, Paris.

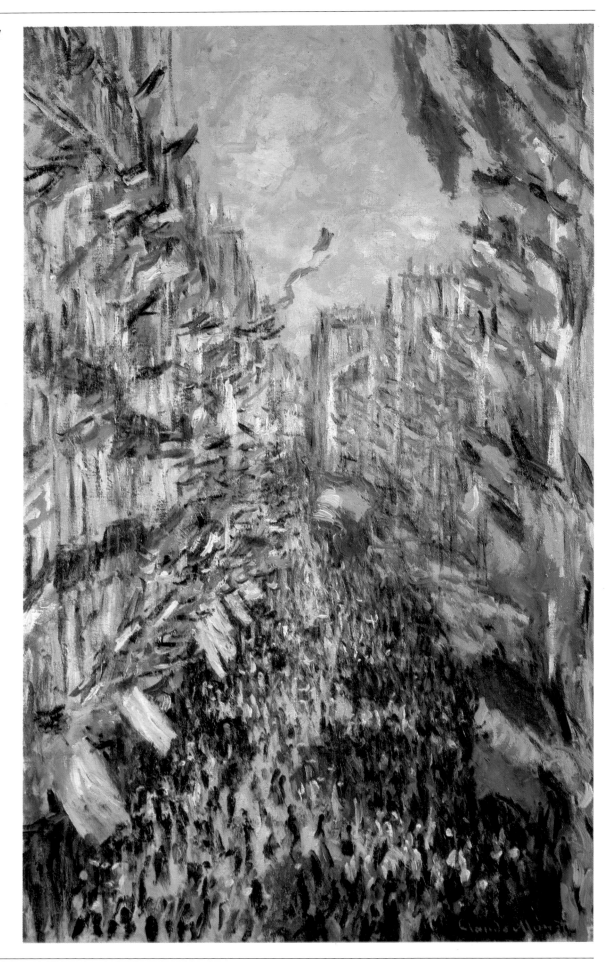

96 Rough Draft of a Letter from Georges de Bellio to Monet. Musée Marmottan, Paris. The paintings to which Georges de Bellio refers are now in various museums: *The Tuileries Gardens*, *The Europe Bridge*, *The Train*, and *Impression, Sunrise* (stolen—one must hope to see it hanging in the museum again one day) are in the Musée Marmottan, Paris; *The Flags*, or *Rue Montorgueil Decked with Flags*, is in the Musée d'Orsay, Paris; *The Parc Monceau, Paris* is in the Metropolitan Museum of Art, New York (however, De Bellio owned several versions of this). Of the two versions of *Gare Saint-Lazare* that come from the collector, one is in the Fogg Art Museum, Cambridge, Massachusetts, and the other in the Art Institute of Chicago. *The Promenade*, or *Woman with a Parasol—Madame Monet and Her Son* is in the National Gallery of Art, Washington, D.C.

My dear Monet,
You see that in all of this there is nothing to make such a fuss about [and I understand *crossed out*] and everything comes down to [I believe *crossed out*] a simple misunderstanding. I understand your surprise at hearing from that fool that I was getting rid of your canvases without explaining to you [under what conditions *crossed out*] my objectives nor under what conditions I was doing it. (The tone makes a difference) and all this fretting [on both our parts *crossed out*] for both of us could have been avoided if I could have seen you and explained (set forth) the matter to you myself in its true light. Set your mind at rest, my dear Monet, none of your important canvases will *ever*, and I repeat it, leave my collection, and in particular
The Tuilleries [sic]
Monceau Park
The Europe Bridge
Impression, [Sunrise]
Gare Saint-Lazare
The Train
Véteuil [sic], sunset
Véteuil, winter
The Flags (July 14 Holiday)
The Boat
The Promenade [Woman with a Parasol] and many more, whose titles I do not know and that it would take too long to add here. It would really have been sad and perfectly ridiculous for us to let ill feeling come between us for such a trivial incident. Therefore, as in the past, and more than ever, my dear Monet, I sign.
 Your very sincere friend,
 Georges de Bellio

After the death of Monet's wife, Camille, in an episode unfortunately worthy of contemporary melodrama, the artist begged De Bellio to take out of pawn a medallion that he "wanted to put around her neck before parting."

Yet very quickly, Monet experienced a sudden change of fortune: on January 8, 1880, the artist blithely told Georges de Bellio that Georges Petit had paid him 500 francs for a still life and that, under those circumstances, he could no longer sell to De Bellio at bargain prices: "You have a nice enough collection of my canvases so that, in the future, you can buy a few less of them from me but pay a bit more for them. Besides, you will always be the first to whom I show my canvases, since I shall never forget all the times you helped me out of a difficulty."

Georges de Bellio did not take offense and still bought several paintings from Monet up to May, 1881—but always for less than 500 francs! Then, though he still remained on the best of terms with Monet, De Bellio stopped buying. It is true that he already owned very many works by Monet. Moreover, he maintained a preference for the artist's earlier style and told Pissarro, in spring, 1891, that he was surprised that Monet was preparing an exhibition at Durand-Ruel's consisting only of *Haystacks*. Nonetheless, De Bellio was always ready to loan his paintings to exhibitions and reassured Monet, denying the rumors that he intended to sell his collection. In 1889, De Bellio was one of the first to respond to the subscription that Monet organized in order to give Manet's *Olympia* to the French national museums.

96

Dr. De Bellio Takes Care of Manet

Georges de Bellio attended Manet during his last illness. De Bellio owned several works by the artist. One, a portrait of *Berthe Morisot with a Fan*, was given to him by Madame Manet to thank De Bellio for the care he had lavished on the sick artist. De Bellio had purchased three others at the auction of Manet's studio in 1884. The most important, however, was a pastel, *Woman Wearing a Garter* (Ordrupgaard Museum, Charlottenlund), which De Bellio acquired after the exhibition at the offices of *La Vie Moderne* in 1880. As early as 1878, Georges de Bellio advised his nephew, John Campineanu, governor of the National Bank of Romania, to have Manet paint his little girl; this is the *Portrait of Lise Campineanu* (Nelson-Atkins Museum of Art, Kansas City, Missouri).

97

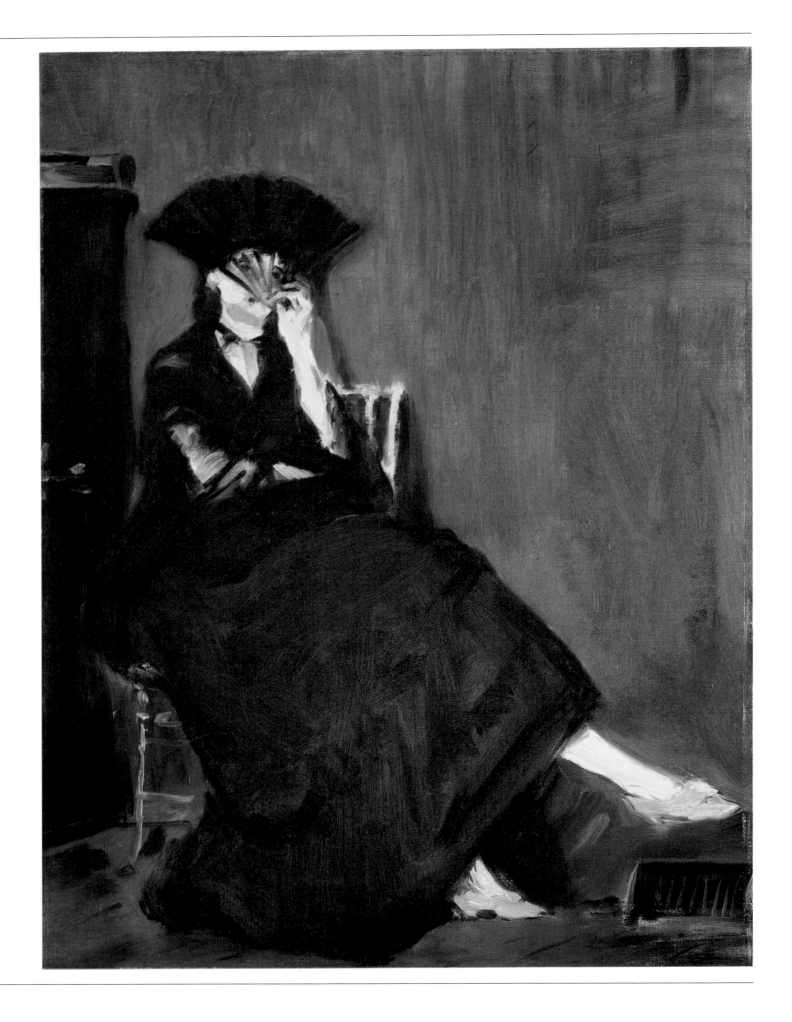

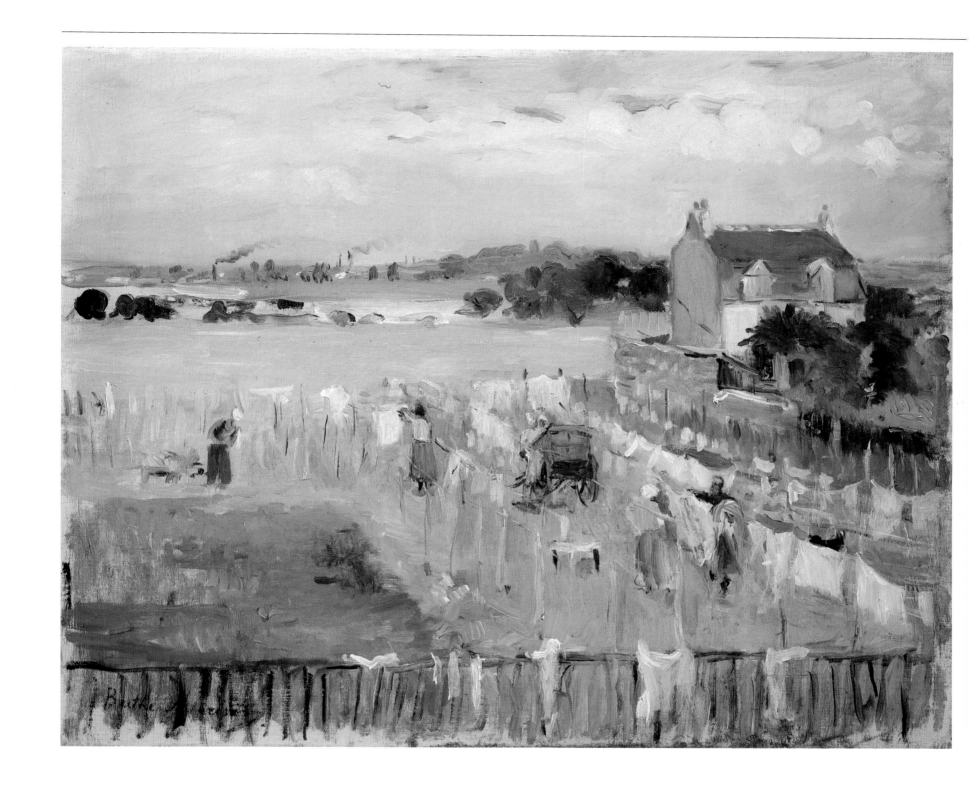

97 Edouard Manet. *Berthe Morisot with a Fan.* c. 1872. Oil on canvas, 60 × 45 cm. (23⅝ × 17¾"). Musée d'Orsay, Paris (Gift of Etienne Moreau-Nélaton, 1906).

98 Berthe Morisot. *Hanging the Laundry Out to Dry.* 1878. Oil on canvas, 35 × 41 cm. (13 × 16"). National Gallery of Art, Washington, D.C. (Collection of Mr. and Mrs. Paul Mellon).

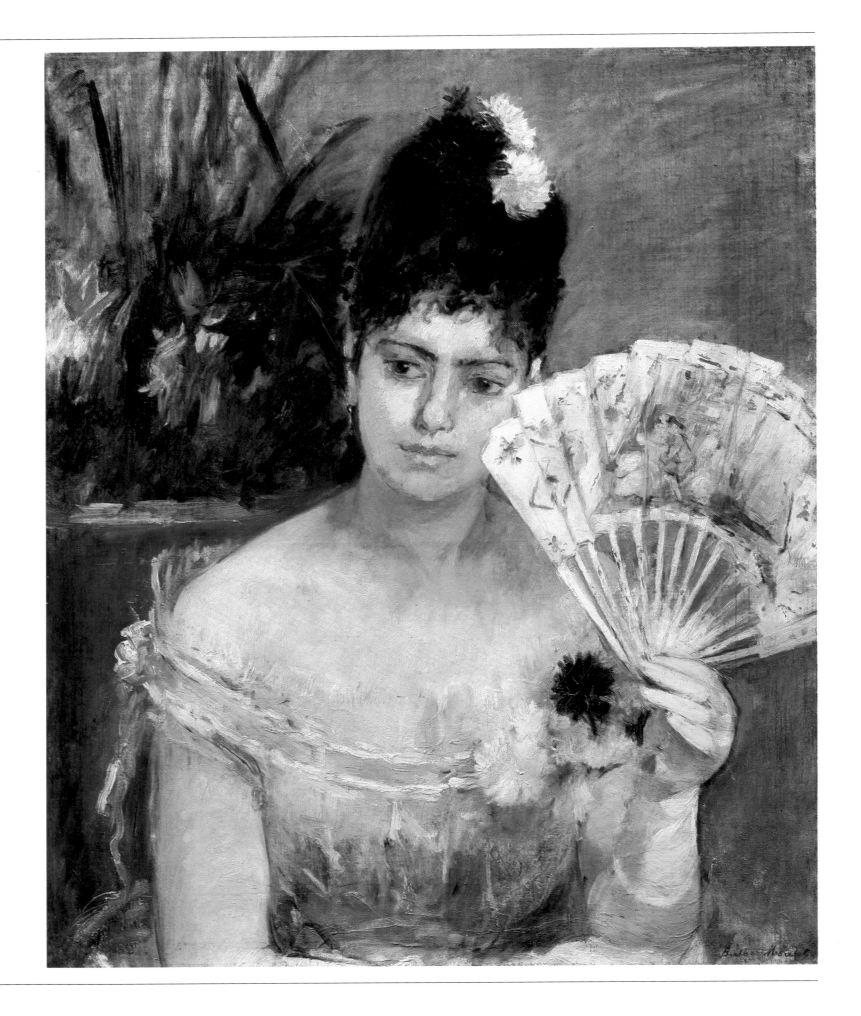

99 Berthe Morisot. *Young Woman at a Dance*. 1875. Oil on canvas, 62 × 52 cm. (24½ × 20½″). Musée Marmottan, Paris (Donop de Monchy Bequest, 1957).

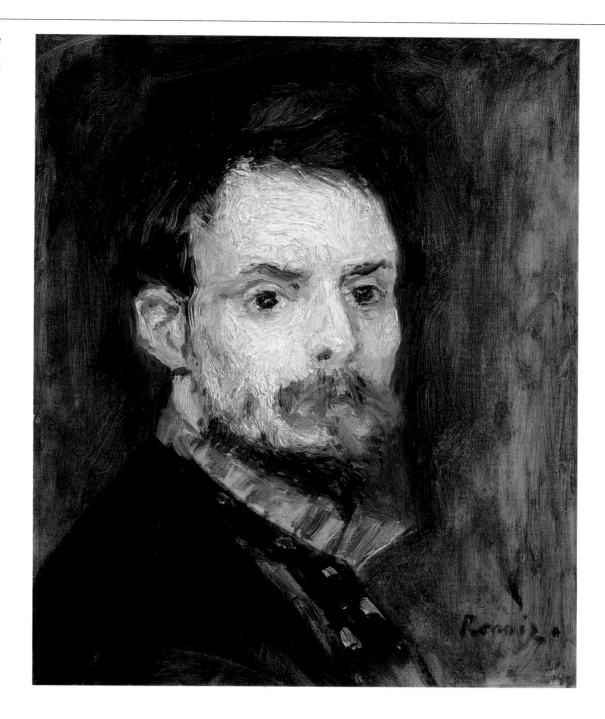

100 Pierre-Auguste Renoir. *Self-Portrait*. c. 1875. Oil on canvas, 38 × 31 cm. (15¾ × 12½″). The Sterling and Francine Clark Art Institute, Williamstown, Massachusetts.

Georges de Bellio and Renoir

De Bellio might also have recommended Renoir as a portraitist, for he was one of De Bellio's favorite artists. However, it is true that Renoir was deluged with commissions at that time, in particular (as he wrote to De Bellio) those for the Charpentiers. If we are to believe another story taken up by Ambroise Vollard, it was through Victor Chocquet that De Bellio acquired a self-portrait by Renoir. R. Niculescu correctly suggests that Renoir may have been introduced to Georges de Bellio by his compatriot, Prince Gheorghe Bibesco. Indeed, in 1868, Renoir had painted ornamentation in Bibesco's town house, which the prince had had built by Renoir's friend, the architect Charles Le Cœur. In any case, it is sure that De Bellio bought a *Still Life with Melon* by Renoir at Durand-Ruel's in 1876. In 1878, at the Hoschedé auction, De Bellio bought a Renoir landscape, *Railroad Bridge at Chatou* (The Sterling and 119

101 Alfred Sisley. *Pit Sawyers.* 1876. Oil on canvas, 51 × 65 cm. (20 × 25½″). Musée du Petit Palais, Paris (Gift of Ferdinand Blumenthal, 1908).

Francine Clark Art Institute, Williamstown, Massachusetts). The collector also owned Renoir's portrait of *Madame Henriot in Costume* (Columbus Museum of Art, Columbus, Ohio), a *Bather* (present location unknown), *The Seamstress* (Collection Oskar Reinhart, Winterthur, Switzerland), and Renoir's view of the *Place de la Trinité* (Private collection).

In 1892, Renoir painted a portrait of Victorine de Bellio (Musée Marmottan, Paris) on the occasion of her marriage; it was a sign of the uninterrupted friendship between the artist and his collector, a friendship dating back to 1880, when Renoir invited De Bellio to lunch at Chatou while the artist was painting his large *The Luncheon of the Boating Party.*

Georges de Bellio and Sisley

Georges de Bellio also knew Alfred Sisley well; De Bellio had taken care of Sisley's wife in 1883. Of the works De Bellio owned, however, only *Pit Sawyers* and the

102 Camille Pissarro. *The Climbing Path, L'Hermitage, Pontoise.* 1875. Oil on canvas, 54 × 65 cm. (21¼ × 25½"). The Brooklyn Museum, New York (Gift of Dikran G. Kelekian).

landscape now in the Musée Marmottan, Paris, have definitely been identified. As late as 1889, Sisley asked De Bellio to "sell" some paintings to his nephew at a low price—700 francs for five canvases—because he preferred, Sisley said, to have friends benefit from such distress prices, being sure that they would not gloat aloud about their luck.

Georges de Bellio and Pissarro

Among the approximately ten paintings by Pissarro in De Bellio's collection, *The Climbing Path, L'Hermitage, Pontoise* and the large *Garden of Les Mathurins at Pontoise* (Nelson-Atkins Museum of Art, Kansas City, Missouri) are especially worthy of note. Pissarro and his numerous offspring were the privileged patients of

102

Georges de Bellio, all the more so since Pissarro was an enthusiastic adept of homeopathy. Apparently, like many other people, De Bellio did not see the point of Pissarro's divisionist experiments around 1887. However, in 1893, Pissarro repeated with pleasure to his son, Lucien, that De Bellio had declared: "that I have gone further than Monet, that my art is more serious, and that I have surpassed Monet's *Poplars.*" That was a reasonable opinion at that time, but De Bellio had not seen—and would never see—Monet's *Cathedrals*, exhibited in 1894, after the collector's death.

We may add that, like his friend Chocquet, De Bellio liked Berthe Morisot—he owned several of her works—and especially Paul Cézanne, although it is hard to identify the half dozen paintings by him that De Bellio owned.

98, 99

One of the First Collectors of Gauguin

At the sixth Impressionist exhibition in 1881, Georges de Bellio alone with Degas—several of whose works De Bellio owned—was the only other avowed lender of Gauguin. De Bellio lent a still life. Pissarro had probably introduced his "pupil" to De Bellio. The collector also made purchases at the famous 1891 sale that enabled Gauguin to leave for Tahiti. However, according to Pissarro, De Bellio had an unfavorable opinion of the Gauguin exhibition of 1893.

A Permanent Collection

Thus, Georges de Bellio played an active role in artistic circles until he died on January 26, 1894, at his home on 2 Rue Alfred Stevens, at the top of the Rue des Martyrs (where he had lived for a long time at Number 66). The simple apartment

103 Anonymous. *Georges de Bellio.* Photograph after a document published by R. Niculescu.

104 Anonymous. *Georges de Bellio's Apartment.* Photograph after a document published by R. Niculescu.

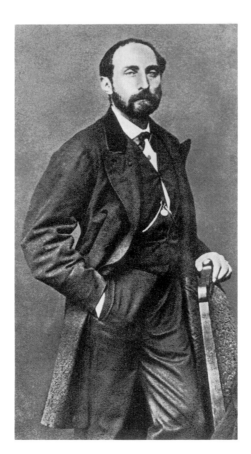

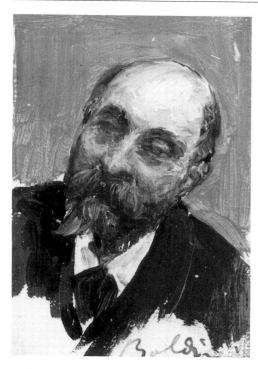

105 Giovanni Boldini. *Georges de Bellio.* c. 1890. Oil on canvas, 6.5 × 4.5 cm. (2½ × 1¾″). Musée Marmottan, Paris.

on the mezzanine floor in which De Bellio lived (because, according to Duret, he was lame in one leg and could not go up the stairs) was open to anyone—artist or collector—who wanted to see his paintings. The critic Gustave Geffroy, one of Monet's friends and a champion of Cézanne, went to see them with the artist Eugène Carrière.

Although De Bellio talked of building a real "gallery," he stored part of his collection in a nearby shop. Pissarro met Monet there whenever the older members of the group did not get together at the Café Riche (for a long time the habitual restaurant of that true Parisian, Georges de Bellio). The famous Café Riche, located at the start of Rue Laffitte, was, of course, a strategic spot for enthusiasts of the art of painting.

Georges de Bellio passed away almost at the same time as Gustave Caillebotte. At the time, Pissarro said, "For a while now, I have been very sad about the loss of my old friends." The contemporary press was right to emphasize that the disappearance of those two collectors of Impressionism marked the end of an era. The fact that Caillebotte had bequeathed his collection to the nation became known very rapidly, and the difficulties that ensued are well known. Monet, writing to the dealer Maurice Joyant, stated that the heirs of Georges de Bellio did not intend to hold an auction that would have been a catastrophe at a period when Duret was also selling off his Impressionist works. Monet added that dealers were "throwing out feelers to the son-in-law," Eugène Donop de Monchy. The latter, a bookloving military man, obviously liked painting, for he resisted the dealers' blandishments for almost half a century. His wife's bequest to the Musée Marmottan, though smaller in number than De Bellio's original collection, was still extensive. From 1895, however, Donop de Monchy did give in to Vollard; later he also sold important works to Prince de Wagram. This is how one of most remarkable collections of the time was broken up gradually over the years.

Constantin de Rasty, a Friend of Georges de Bellio

We cannot leave Georges de Bellio without mentioning quickly an almost unknown collector who, being Romanian too, was most probably De Bellio's friend. This was Constantin de Rasty. Duret gave De Rasty a place on his list of collectors of Impressionism. One of the first purchases De Rasty is known to have made is Renoir's *Woman with a Cat* (National Gallery of Art, Washington, D.C.), acquired at the Hoschedé auction in 1878. Oddly enough, two years earlier, in November, 1876, when Monet was staying at Hoschedé's at Montgeron, the artist wrote to De Bellio, asking him to convince De Rasty's mother-in-law to buy one of his works: proof, if that is necessary, of De Bellio's proselytizing.

In any case, De Rasty was interested enough in Monet's painting to make a further purchase at an auction at the Hôtel Drouot on April 19, 1877: Monet's *La Japonaise (Camille Monet in Japanese Costume)*, a very large painting listed as *Japonnerie* in the catalogue of the second Impressionist exhibition, and now in the Museum of Fine Arts, Boston.

Little is known about Constantin de Rasty's private life. In 1879, in Romania, De Rasty married Gabrielle-Marie-Zoé Riquier, the Frenchwoman who had given him a son, Jean. Born on December 8, 1876, in Paris, Jean de Rasty would become an artist and a collector of Old Master painting.

As for Constantin de Rasty, he died on September 1, 1923, at the age of eighty-three, at Biarritz, where he was staying temporarily. The dealer Paul Rosenberg had already resold *La Japonaise* for the collector, and De Rasty's own personality has remained a secret.

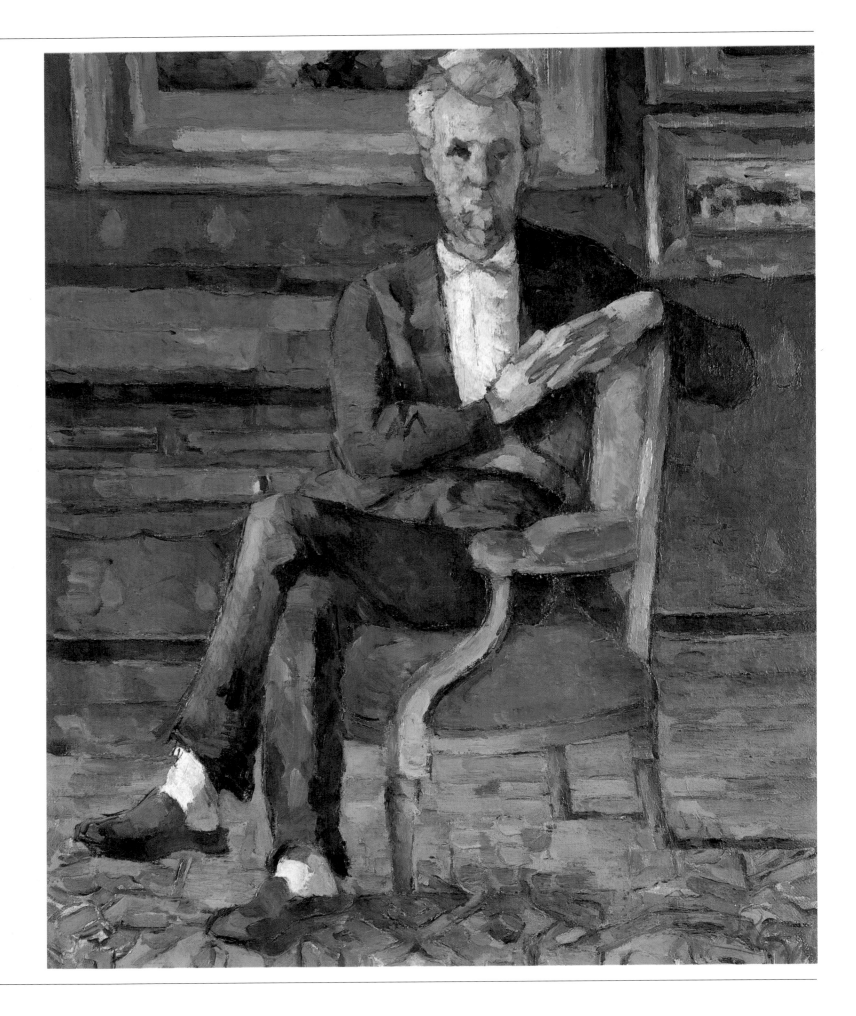

Victor Chocquet

106 Paul Cézanne. *Victor Chocquet in an Armchair*. c. 1877. Oil on canvas, 45 × 38 cm. (17¾ × 14½″). Columbus Museum of Art, Ohio (Museum Purchase, Howald Fund).

Emile Zola, also an art critic, was among the first to champion Manet and the Impressionists. As a novelist, in the characterizations in *The Masterpiece*, Zola depicted the artists—independent or official—and their dealers. Among the collectors in Zola's novel, Monsieur Hue is the only one whose character is somewhat fleshed out. A "former head clerk," Hue collected works by Delacroix, but also by Claude Lantier (alias Manet, Monet, Cézanne, and the other Impressionists). Here is what Zola wrote: "An independent exhibition, at which he [Claude Lantier] had shown a few paintings with some fellow artists, had just finished him off with private collectors: the public had made such fun of those paintings splashed with colors in all the shades of the rainbow. The dealers were on the run. Only Monsieur Hue, making the trip to Rue Tourlaque, stood there going into raptures over the extravagant pieces, the ones that exploded in unexpected flares, giving way to despair at not being able to buy them for their weight in gold. And it was useless for the artist to say he would give them to Hue, to say he begged Hue to accept them. The little middle-class man was extraordinarily scrupulous about it: after a long interval of squirreling [money] away from his bread and butter, he would manage to amass a sum. Then, piously carrying away a frenzied canvas, he hung it up next to his pictures by the masters of painting." (Emile Zola, *The Masterpiece*, Chapter IX).

Zola's descriptions are sufficient for us to identify his model as Victor Chocquet, "*père* Chocquet," as Renoir always called him. In an outburst of enthusiasm, the artist did not hesitate to describe Chocquet as "the greatest French collector since the kings, perhaps in the world since the popes." Renoir's opinion expresses an artist's gratitude but does not take into consideration the specific character of a man such as Victor Chocquet, who owned fifty Cézannes at a time when no one bought them and who was convinced that the young artists exhibiting on Rue Le Peletier were equal to Delacroix. The first historians of Impressionism—Théodore Duret and Georges Rivière, a friend of Renoir—mentioned the role Chocquet played. Since then, John Rewald has made extensive use of the available documents that enable us to reconstruct Victor Chocquet's story.

An Employee Earning 50 Francs a Month

Victor Chocquet was born in Lille on December 19, 1821. He was the tenth in a family of thirteen children. His father was a yarn manufacturer. Victor, however, would follow quite a different course. In 1842, he became an employee at the Customs House, first at Dunkerque, then as chief supervisor at the general headquarters in Paris. Rivière said that Chocquet's career "had been confined to that modest level, because he had never agreed to leave Paris to go into exile—even temporarily—in a district on the border so as to be promoted." Rivière also implied that Chocquet was not a submissive pen-pusher. Chocquet's superior, in full dress for the New Year's ceremony at which Chocquet presented himself dressed in his shabbiest clothes, is supposed to have demanded: "What is the meaning of those clothes, Sir?" To which Chocquet is said to have replied: "Sir, they are those befitting a man who earns 50 francs per month." While it is impossible to verify that story, it is

106, 107,
110, 112,
117

107 Pierre-Auguste Renoir. *Portrait of Victor Chocquet.* c. 1875. Oil on canvas, 46 × 37 cm. (18 × 14¼"). Fogg Art Museum, Harvard University, Cambridge, Massachusetts (Grenville L. Winthrop Bequest).

true that Chocquet was earning 800 francs per year at his start in Paris. When he retired at fifty-six in 1877, Chocquet was only earning 4,000 francs annually.

Victor Chocquet loathed his job. His outlet was collecting. Paintings, drawings, antique furniture, china, silverware—everything interested him. Furthermore, Chocquet had, by instinct, an excellent eye as well as the necessary patience. He was a permanent fixture at the Hôtel Drouot from the early 1860s. At the auction of Delacroix's studio in 1864, for example, Chocquet bought a painting and a watercolor, no doubt unable to afford more. Perhaps at that time he did not manage to acquire the watercolor of flowers specially singled out by Delacroix in his will to be included in his posthumous sale and for which the bidding went up to 2,000 francs. No matter, a year later Chocquet got the watercolor for 300 francs at the estate sale of the person who had purchased it at the Delacroix auction. Chocquet was among the

108

108 Eugène Delacroix. *Bouquet of Flowers.*
c. 1850. Watercolor and gouache with pastel
over a pencil sketch on gray paper, 65 ×
65 cm. (25½ × 25½″). Musée d'Orsay, Paris
(César Mange de Hauke Bequest).

109 Paul Cézanne. *Copy After Delacroix's
"Bouquet of Flowers."* c. 1902. Oil on canvas,
77 × 64 cm. (30¼ × 25¼″). Pushkin Museum
of Western Art, Moscow (I.A. Morozov Col-
lection).
At Chocquet's estate sale, Vollard bought
Delacroix's watercolor and gave it up to
Cézanne—a gift or an exchange? The artist
hung it in his room and made a copy of it.

collectors listed in the specialist gazettes: for instance, as attending the Laurent-Richard auction, which created a great stir in 1873.

Although Chocquet had limited resources, he did have a little more than his salary. His personal income was about 1,000 francs per year; his wife, Augustine-Marie-Caroline Buisson, had received an annuity of the same amount as a dowry. That was rather scanty, however, considering that the rent for Chocquet's four-room lodgings at 198 Rue de Rivoli, adjacent to the rooms for servants on the fifth floor, cost him 960 francs annually. 113

118

The Legacy

However, Chocquet had, as they said then, "prospects." Several members of his wife's family were leading citizens at Yvetot in Normandy. In March, 1882, Madame Chocquet's mother died, leaving a large estate consisting of land, farms, and various buildings at Yvetot, Hattenville, and Fécamp. Madame Chocquet was her mother's only heir. In March, 1890, the Chocquets were rich enough to purchase a building in Paris at 7 Rue Monsigny, near the Avenue de l'Opéra, for 150,000 francs. By way of comparison, at the same time, Claude Monet and subscribers gave Manet's widow a little less than 20,000 francs for *Olympia*, which entered the French public collections.

Chocquet, unfortunately, hardly had time to arrange his collections on the four floors of his new residence before he died on April 7, 1891. His widow closed the house and went to live in Yvetot until her death on March 24, 1899. Since the Chocquets had no children, all they owned had to be sold on behalf of distant nephews after her death.

The Chocquet Estate Sale

The announcement of the Chocquet estate sale stirred up Paris: "Great artistic event in view," Pissarro wrote to his son, "*père* Chocquet as well as his wife having died, his collection is going to be sold at auction. There are thirty-two first-rate Cézannes, Monets, Renoirs, and only one thing by me. The Cézannes will sell for high prices; they are already being quoted at 4,000 to 5,000 francs."

After everything that was to be sold on July 1, 3–4, 1899, had finally been transported into the red-draped rooms of the Galerie Georges Petit, it made quite an effect. Théodore Duret, who had known Chocquet well, wrote the preface to the sumptuous illustrated catalogue that listed 30 Cézannes (some sold in grouped lots under the same number), 1 Corot, 8 Courbets, 1 Daumier, 3 Dehodencqs, 23 paintings and about sixty drawings and watercolors by Delacroix, 5 Manets, 10 Monets, 3 Morisots, 1 Pissarro, 10 Renoirs, 1 Sisley, 5 Tassaerts, etc. Also up for auction were eighteenth-century Sèvres porcelain and old faience, jewelry, clocks, bronzes, eighteenth-century furniture, and—in keeping with the taste of the time—so-called Renaissance furniture.

A year later, the English critic Winford Dewhurst, devoting an article to Claude Monet in *The Pall Mall*, was still struck with admiration for Chocquet's collection and for the unusual personality of the collector. After the successive deaths of the great collectors, the Parisian public was suddenly discovering the existence of their collections and the success of artists, the Impressionists, whom no one had wanted to take seriously. In 1896, the Caillebotte Bequest had finally been put on display at the Luxembourg Museum. Victor Desfossés's estate sale had been held in April, 1899, and Count Doria's in May, 1899, shortly before the Chocquet estate sale. Besides Gustave Courbet's *The Painter's Studio* (Musée d'Orsay, Paris), Desfossés's sale also included Impressionist paintings. Furthermore, although Manet, Monet, or Degas were ordinarily worth several 1,000-franc bills, it was a great surprise to discover that

110 Paul Cézanne. *Portrait of Victor Chocquet*. c. 1877. Oil on canvas, 35 × 27 cm. (13⅞ × 10¾"). Virginia Museum of Fine Arts, Richmond (Collection Mr. and Mrs. Paul Mellon).
Edgar Degas bought this painting at Chocquet's estate sale.

Cézanne fetched comparable prices, for at the Tanguy sale in June, 1894, Cézanne's paintings had barely sold for 200 francs.

As Duret noted, Chocquet's estate sale established the market value of Cézanne: Durand-Ruel paid 4,400 francs for *Mardi Gras* and 2,200 francs for *The Bridge at Maincy*. The highest price (6,200 francs) was paid, on Monet's advice, for *The House of the Hanged Man, Auvers* by Durand-Ruel on behalf of Count Isaac de Camondo. Vollard's proselytism had been working too.

Nonetheless, such prices were still low in comparison to those paid for works by Manet (*Claude Monet in His Floating Studio [Argenteuil]*, 10,000 francs), Monet (*Meditation: Madame Monet on the Sofa* [Musée d'Orsay, Paris], 5,700 francs), Renoir (small version of *Dancing at the Moulin de la Galette* [Pl. 114], 10,500 francs), or Delacroix, whose works were considered by many people to be the only interest-

116
111
149

119

129

111 Paul Cézanne. *The Bridge at Maincy.*
c. 1879-80. Oil on canvas, 58 × 72 cm. (23 ×
28½″). Musée d'Orsay, Paris.

ing part of Chocquet's collection. Degas paid 6,700 francs for a Delacroix sketch for *The Battle of Nancy.*

The Chocquet estate sale was an unquestionable success: the auction receipts for paintings, drawings, and furniture amounted to 452,635 francs. The collections, however, only accounted for a third of the entire Chocquet estate, which consisted of buildings and land in Paris and in Normandy, ready money, and assets. All the big dealers (Durand-Ruel, Bernheim-Jeune, Boussod-Valadon, Camentron, Haro, Rosenberg, Vollard, Tedesco, etc.) measured their position on the market against the results of the Chocquet sale. All the collectors who mattered (Degas, Moreau-Nélaton, Pellerin, Koechlin, Chéramy, the Natansons, and the Rouarts) were there. And, as we have seen, Durand-Ruel represented Count Isaac de Camondo.

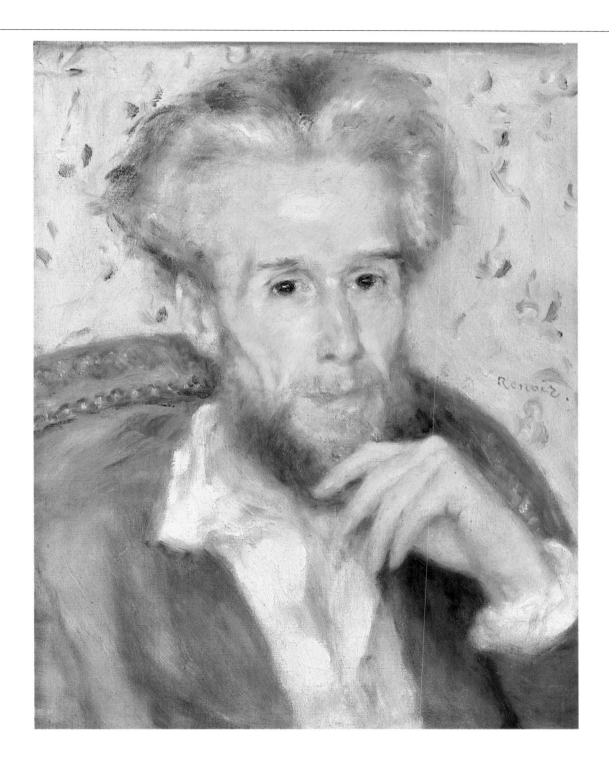

112 Pierre-Auguste Renoir. *Victor Chocquet.* 1876. Oil on canvas, 46 × 36 cm. ($18\frac{1}{8}$ × $14\frac{1}{8}$″). Collection Oskar Reinhart, Winterthur, Switzerland.

The Chocquet Collection: Delacroix, Renoir, Cézanne, and the Others

Now let us look at when and how Victor Chocquet amassed his treasures. Eugène Delacroix was indisputably the artist whom Chocquet liked first. In spring, 1862, he had asked Delacroix to paint a portrait of Madame Chocquet. The artist courteously refused, with the excuse that his eyes prevented him from doing portraits. Chocquet, nonetheless, went to great pains to pick up Delacroix's paintings and watercolors.

Chocquet also admired Gustave Courbet. The collector owned several secondary works by Courbet; the ones whose provenance we know were acquired after 1880 in auction rooms.

131

113 Pierre-Auguste Renoir. *Madame Chocquet*. 1875. Oil on canvas, 75 × 60 cm. $(28\frac{3}{4} \times 23\frac{1}{8}'')$. Staatsgalerie, Stuttgart.
The study by Delacroix that can be seen behind Madame Chocquet recalls her husband's passion for that artist.

It is the Impressionists who are important here, however. Chocquet was not satisfied with merely buying their works. With Monet, Renoir, and especially Cézanne, he maintained the same ties of friendship and trust as Georges de Bellio or Gustave Caillebotte. People always said that Chocquet had "missed" the first Impressionist exhibition in 1874. He was not the only one! However Chocquet lent 6 Renoirs as well as works by Monet and by Pissarro to the second Impressionist exhibition in 1876. We are certain of one thing: Renoir dates a first portrait of Madame Chocquet to 1875. He depicted her in the apartment on Rue de Rivoli, with a sketch by Delacroix in the background—a discreet homage to the artist preferred by both Renoir and the collector. According to Renoir's recollections as reported by Vollard, Chocquet (who had attended the Impressionist sale of 1875 without purchasing anything, according to the auction record) wrote to the artist afterward, asking him to paint a portrait of his wife.

113

114 Pierre-Auguste Renoir. *Dancing at the Moulin de la Galette* (small version). 1876. Oil on canvas, 78 × 114 cm. (31 × 44¾"). Collection Mrs. John Hay Whitney, New York.

Renoir was to paint several other portraits for Chocquet: two of the collector's wife (one of which is in an American private collection; the other, having belonged to the Bremen museum, was destroyed during the war), two of the collector himself, and finally, after a photograph, a portrait of Chocquet's little girl, born in 1861, who died in 1865 (formerly Collection Florence Gould). This confiding of a great sorrow—the Chocquets had no other children—reveals the bond of friendship between Renoir and Chocquet.

Among the other Renoirs that Chocquet owned were *The Seine at Asnières* (National Gallery, London), *Alphonsine Fournaise* (Musée d'Orsay, Paris), and in particular, the small version of *Dancing at the Moulin de la Galette*, dated 1876. Now in the collection of Mrs. John Hay Whitney, New York, that picture is probably a version painted especially for Chocquet, as John Rewald suggests. The large version of the painting (now in the Musée d'Orsay, Paris) had been exhibited in 1877, and was acquired by Caillebotte. Unfortunately, no document giving precise information about Chocquet's purchases of his paintings exists. The few letters Renoir wrote to Chocquet show that their uninterrupted relationship was cordial: Renoir wrote a little note of condolence to Madame Chocquet when her husband died.

Quite often too, in the correspondence between Chocquet and Renoir, there was talk of Cézanne. It was Renoir, once again questioned by Vollard, who said: "As soon as I became acquainted with Mr. Chocquet, I thought of having him buy a

107, 112

114

213

133

115 Paul Cézanne. *Three Bathers*. c. 1875.
Oil on canvas, 22 × 19 cm. (8½ × 7½″). Mu-
sée d'Orsay, Paris.
This painting may possibly be the small study
of nudes that Renoir convinced Chocquet to
buy from Tanguy.

▷

116 Paul Cézanne. *Mardi Gras*. 1888. Oil on
canvas, 102 × 81 cm. (40¼ × 31⅞″). Pushkin
Museum of Western Art, Moscow
(S. Shchukin Collection).

Cézanne! Therefore, I took him to *père* Tanguy's, where he purchased a small
[painting], *Nude Studies.*" That encounter with Cézanne's work in 1875 was the start
of a long friendship between Chocquet and the artist, a friendship all the more
remarkable since Cézanne was known for his unpredictable behavior.

Cézanne painted six portraits and made several drawings of Chocquet that are
dated between 1876 and 1889. The last was probably painted while Cézanne was
staying with the Chocquets in Hattenville. In his *Histoire des peintres impression-
nistes*, Théodore Duret wrote that, after Chocquet struck up a friendship with
Cézanne, the artist "spent a part of his time, from that moment onward, painting for
him in the city and the countryside." That is correct, for as early as July, 1876,
Cézanne wrote to Pissarro from Estaque: "I started two small sketches with the sea

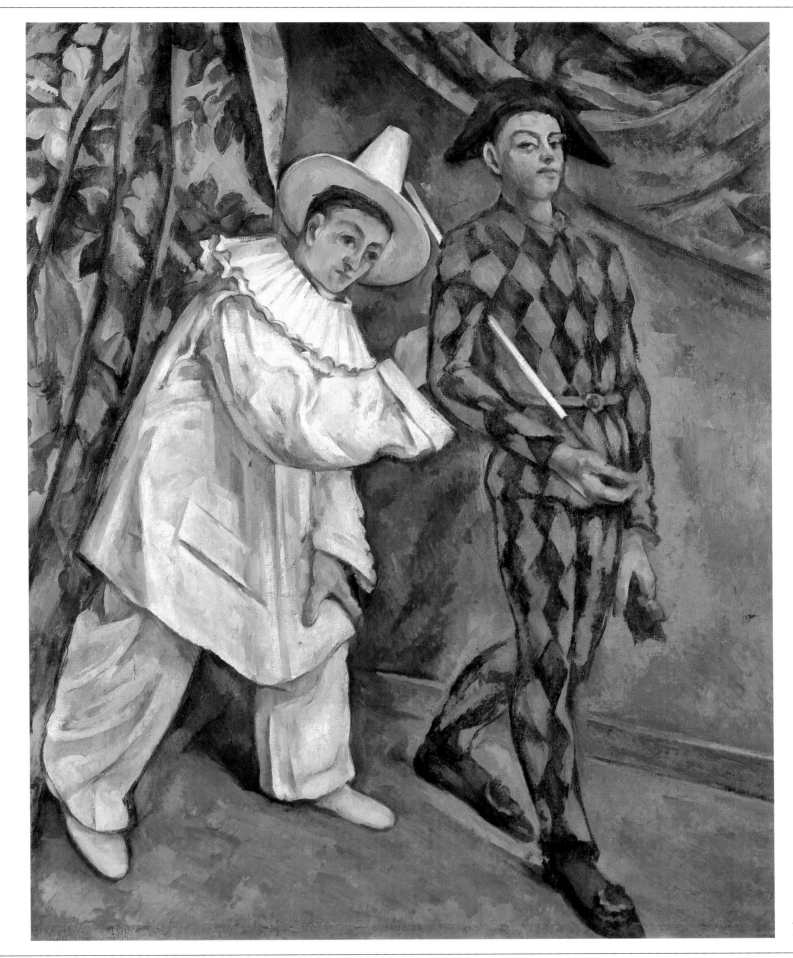

118 Claude Monet. *The Tuileries Gardens.* 1876. Oil on canvas, 50 × 75 cm. (19¾ × 29½″). Musée d'Orsay, Paris (Gustave Caillebotte Bequest, 1894).
Although Monet put 1875 on the canvas, it must be dated 1876, for that was the year Cézanne introduced Monet to Chocquet. The subject is the view that one has from the balconies of Chocquet's apartment on Rue de Rivoli. This sketch was exhibited at the third Impressionist exhibition and purchased by Caillebotte. Another version, with a different composition, belonged to Georges de Bellio at one time; but Chocquet does not seem to have owned one.

◁ 117 Paul Cézanne. *Victor Chocquet.* 1876. Oil on canvas, 46 × 36 cm. (18¼ × 14″). Private collection, New York.
This portrait was exhibited at the third Impressionist exhibition in 1877 and gave rise to very harsh remarks about the artist and the model. Today, in view of his article in the 1874 *Le Charivari* that pokes fun at *Impression, Sunrise,* among others, the critic Louis Leroy wins the prize for writing baloney about the Impressionists. Leroy repeated the offense in 1877: "If you visit the exhibition with a woman in an interesting condition [i.e., pregnant], pass quickly by the portrait of a man by Mr. Cézanne.... That head the color of boot tops is such a strange sight that it might make too sharp an impression on her and give the fruit [of her womb] yellow fever before it comes into the world." (*Le Charivari,* April 11, 1877)

for Monsieur Chocquet, who had spoken of it to me. It is like a playing card, red roofs against a blue sea." About 1890, Cézanne was working on overdoors for the new Chocquet residence on Rue Monsigny. They were probably never put up because of the collector's death. (One is in the Musée de l'Orangerie, Paris.) Chocquet had been extremely attached to Cézanne, so he certainly deserved such faithfulness on his friend's part.

In 1877, at the third Impressionist exhibition, Cézanne had been the target of criticism. A portrait of Chocquet provoked particularly sarcastic remarks, and it is 117 likely that, although his name did not appear, the collector was the lender of a great number of works the artist exhibited. Entirely free to do as he liked since he had rid himself of his duties at the ministry, Chocquet never left Rue Le Peletier where the Impressionist exhibition was taking place. Like Duret, Rivière did not forget the fact: "He [Chocquet] was something to see, standing up to hostile crowds at the exhibitions during the first years of Impressionism. He accosted those who laughed, making them ashamed of their unkind comments, lashing them with ironic remarks.... Hardly had he left one group before he would be found, farther along, leading a reluctant connoisseur, almost by force, up to canvases by Renoir, Monet, or Cézanne, doing his utmost to make the man share his admiration for these reviled artists.... He exerted himself tirelessly without ever departing from that refined courtesy that made him the most charming, and the most dangerous, adversary."

Champion of Cézanne and of Renoir, Chocquet was also a supporter of Monet. He met Monet in February, 1876, at a "very simple luncheon" in Monet's home at Argenteuil, which Cézanne probably attended too. When it was over, Monet noted in his accounts that Chocquet had purchased a sketch for 100 francs and a pastel for 20 francs. In return, Monet went to Rue de Rivoli many times and painted the splendid view of the Tuileries Gardens from the Chocquets' small balconies off the 118 attic, like his friend Renoir. Several of those views were on display in 1877. Oddly enough, the collector does not seem to have owned any of the paintings in that series, whereas Caillebotte and Georges de Bellio both bought some.

Monet often thought of Chocquet when he needed money: "I am writing to ask you to take one or two daubs that I will let you have for whatever price you want to give me: 50 francs, 40 francs—whatever you can manage, for I cannot wait any 137

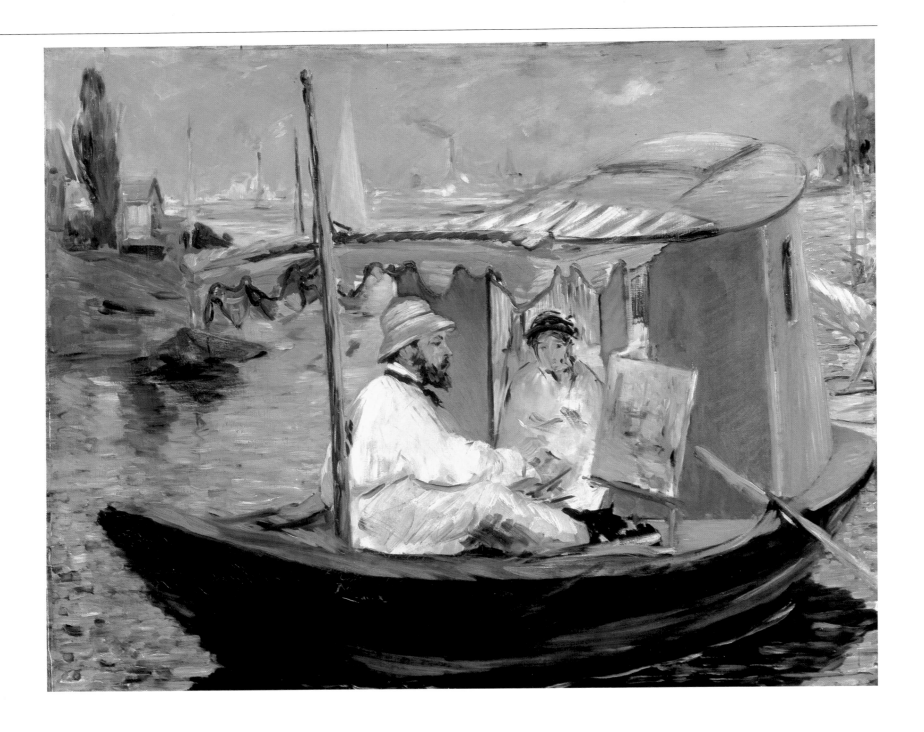

119 Edouard Manet. *Claude Monet in His Floating Studio (Argenteuil)*. 1874. Oil on canvas, 80 × 98 cm. (32 × 39¼"). Bayerische Staatsgemäldesammlungen, Munich (Neue Pinakothek).

longer." Monet must have had complete confidence in Victor Chocquet, because he preferred requesting a loan rather than relinquishing a painting at a low price to other collectors, even when he was needy and entreating.

Chocquet owned twelve paintings by Monet. Two came from the Hoschedé auction in 1878, "bargains" at less than 100 francs each. It is obvious that price was not of prime importance to the collector; it was, at the most, a necessity, since Chocquet did not have more to spend. In 1888, however, Chocquet, whose inheritance dates from 1882, paid more than 1,500 francs at the general auction rooms for a *Haystack* by Monet. The artist was grateful to him, because the good price added to Monet's notoriety. At that time, however, Monet had to ask Duret for Chocquet's address in order to thank him, for he seems to have lost touch with his admirer.

Chocquet also owned several works by Manet. The most important had been purchased at the sale of Manet's studio: this was the portrait of *Claude Monet in His*

119

120 Paul Cézanne. *Apotheosis of Delacroix*. 1891–94. Oil on canvas, 27 × 35 cm. (10⅝ × 13¾″). Musée d'Orsay, Paris.

Floating Studio (Argenteuil), for which Chocquet paid 1,150 francs—a high price and a reminder that Chocquet now had the means to choose the paintings he wanted.

Pissarro hardly appealed to Chocquet, and the artist himself was aware of it. After the show of his divisionist pictures at Petit's in May, 1887, Pissarro wrote to his son, Lucien: "As for Chocquet, his compliments to me were overdone; he can't stand them, I feel that clearly; [but] I am not worrying about it."

Chocquet probably did not own anything by Degas. However, at the Chocquet estate sale, Degas bought a portrait of Chocquet by Cézanne. 110

It has often been said that Chocquet seemed to lose the desire to enlarge his collection once he was rich. If Chocquet bought less in the 1880s, it may have been because he thought he owned enough paintings for his pleasure and for the extent of his walls. Chocquet continued, nonetheless, to acquire work by Cézanne, notably *The House of the Hanged Man, Auvers* from Count Doria, in exchange for another 149 landscape.

Cézanne provides a fitting conclusion for this chapter on Victor Chocquet. When the artist was conceiving his *Apotheosis of Delacroix* in homage to that artist, a long- 120 planned project that was left unfinished after Chocquet's death, Cézanne included only one non-artist, Victor Chocquet, among the group of painters—Pissarro, Monet, and Cézanne himself—looking up at the clouds into which the master is ascending. As John Rewald emphasized, Chocquet was the only collector Cézanne considered worthy to accede to that pantheon.

121 Anonymous. *Georges Charpentier*. c. 1875. Photograph. Private collection.

122 Anonymous. *Marguerite Charpentier*. c. 1875. Photograph. Private collection.

Georges and Marguerite Charpentier

Georges Charpentier (publisher of Flaubert, Zola, the Goncourt brothers, and others) and his wife, Marguerite, were true artlovers rather than just collectors. They took up the Impressionists' cause, each in a distinctive way, with shared enthusiasm. This was unusual enough to be noteworthy. Not that the collectors' wives had been systematically kept in the background—Madame Chocquet and Madame Berard, for example, encouraged their husbands' collecting—but all the other collectors were men acting alone. With the exception of Louisine Havemeyer, there was hardly a woman among them with a strong personality comparable to Marguerite Charpentier. Indeed, it is amusing to note that Renoir's portrait of *Madame Charpentier and Her Children*, one of the most famous paintings in the Metropolitan Museum of Art, New York, stands side by side with so many Impressionist and other masterpieces that entered the museum's collections thanks to Louisine Havemeyer. Although that is as close as the two women came to encountering each other, when one discusses them, one cannot help noticing how much they had in common.

Marguerite Lemonnier, the future Madame Charpentier, was born in Paris on March 1, 1848; she was the daughter of Gabriel Lemonnier, jeweler to the crown during the Second Empire, with a shop located on Place Vendôme. Among other things, Gabriel Lemonnier made Empress Eugénie's crown (The Louvre, Paris). Marguerite spent a happy, protected childhood in an environment where she was exposed to music and literature. On August 24, 1871, at a moment that was historically inauspicious for rejoicing, Marguerite married the publisher Georges-Auguste Charpentier. The wedding took place at Gometz-le-Châtel, where the Lemonniers owned an estate. Théophile Gautier, star author of Charpentier's publishing house, was Georges Charpentier's bestman.

Born on December 22, 1846, Georges Charpentier was twenty-five when he married. Although Charpentier called himself a man of letters, until then, he had created little apart from debts. Gervais Charpentier, Georges's father, had died a month earlier, and his death would determine his son's future.

A bookseller and publisher, Gervais Charpentier had a strong personality. Having started out with little and grappled with the vicissitudes of fortune, Gervais had actually invented the low-priced book in France. In 1838, Gervais had created the so-called Charpentier Library: specially sized books, priced at 3.50 francs—a quarter of the usual price—which was equivalent to one day's salary for a good workman. Gervais Charpentier published Chateaubriand, Balzac, Gautier, George Sand, Alfred de Musset, Alfred de Vigny, and Victor Hugo as well as Homer, Muhammad, Dante, Goethe, Shakespeare, and Schiller. The Charpentier Library contained four hundred titles in all. It held its own despite the competition.

Gervais Charpentier was neither as wealthy nor as ostentatious as some of his fellow publishers, although he was prosperous. But he was famous for his bad temper, and not even his own family was exempt from his outbursts. Legally separated and living apart from his wife, Gervais barely tolerated his son and seems to have done everything to ensure that young Georges, who was living the pleasant life of a bohemian writer, was kept away from his business.

Yet after Gervais died, Georges Charpentier took up the reins of the Charpentier Library, backed by a new partner, Maurice Dreyfous. Georges's first move—and

something for which succeeding generations would envy him—was to enter into relations with Emile Zola, who was just beginning to attract attention. Charpentier not only became friends with Zola, he also made him a sort of literary director for the firm. Then, after 1873, Charpentier attracted Gustave Flaubert and became the publisher of the Naturalists: Louis-Edmond Duranty, Alphonse Daudet, Edmond and Jules de Goncourt, Joris-Karl Huysmans, Léon Hennique, and Henri Céard.

Madame Charpentier's Salon

Right after her marriage, Madame Charpentier began holding a salon at 28 Quai du Louvre (then at 11 Rue de Grenelle); her at-home day was Friday. At her salon, people were Republicans and would later be Dreyfusites, and politicians such as Georges Clemenceau and Léon Gambetta, whose works Charpentier would publish, rubbed shoulders with the publisher's authors and with actors and artists. There were also musical evenings at the Charpentiers'; the composer Emmanuel Chabrier was often seen playing the piano there. Later Madame Charpentier would invite the music-hall singer Yvette Guilbert, whom Henri de Toulouse-Lautrec immortalized. Sarah Bernhardt performed at the theatrical evening the Charpentiers held in honor of Edmond de Goncourt's *Faustin* in 1881. Among the painters present during the

123 Pierre-Auguste Renoir. *Menu* for Madame Charpentier, with the name of her sister, Isabelle Lemonnier. Print. Private collection.

124 Pierre-Auguste Renoir. Excerpt from a Letter to Georges Charpentier. 1878. Department of Graphic Arts, The Louvre, Paris. Renoir flings his arms, from pure joy, around the neck of the mailman who is bringing him a money order.

years 1875 to 1880, were Jean-Jacques Henner from Alsace, Giuseppe de Nittis, and Carolus-Duran. Manet, Monet, and Renoir were frequent guests and were sometimes joined by Degas, Sisley, or Caillebotte. Théodore Duret (whom Charpentier would publish) also came to Madame Charpentier's salon, as did Charles Ephrussi, Charles Deudon, Paul Berard, and Hoschedé. These last men, all collectors, were perhaps mostly attracted by the Charpentiers' pictures. In fact, the collection was rather small: the Charpentier residence, reached by climbing up a rather steep and narrow staircase, and located above the publisher's offices, was not enormous, but Impressionist works predominated in the collection.

1875—The Start of a Collection of Impressionists

Georges Charpentier seems to have taken the initiative in starting their collection. He bought Renoir's *Fisherman* for 180 francs at the famous Impressionist auction of 1875. (The painting would eventually be auctioned at Sotheby's in London in July, 1979, for 610,000 pounds.) Charpentier also bought two other Renoirs at the same time. Apparently, he did not yet know Renoir personally: in the extensive correspondence between Renoir and the Charpentiers, the artist's first (undated) letter mentions a portrait of the publisher's daughter that was painted in 1876. The letter's greeting ("Dear Sir") is still very formal, which leads us to believe that the two men hardly knew each other.

There is also a letter from Monet to Charpentier, dated July 2, 1876; it starts as follows: "Sir: You talked to me of how you had wanted to acquire, at my sale at the Hôtel Drouot, a certain canvas depicting a locomotive in the snow," and probably refers to the painting in the Musée Marmottan, Paris, purchased by Georges de Bellio. Ten days later, Monet was waiting for a visit from Charpentier: "I should be very happy," he wrote, "to show my studies to Madame Charpentier if, as she gave me reason to hope, she should decide to undertake this little trip with you." Zola had probably introduced the collectors to Monet, for a letter (unfortunately, undated) from Monet to Zola states: "Thank you very much for having thought of me.... At the moment, I am worried about [having] very little money. If Mr. Charpentier buys a painting, it would spare me a lot of anxiety."

Manet, too, was a member of this small circle. Even though he was less needy than his fellow artists, he was not about to ignore an artlover ready to give in to

125 Anonymous. *Paul Charpentier and His Dog*. c. 1880. Photograph. Private collection.

126 Pierre-Auguste Renoir. *Madame Charpentier and Her Children*. 1878. Oil on canvas, 154 × 190 cm. (60½ × 74⅞"). The Metropolitan Museum of Art, New York (Wolfe Fund, 1907, Catharine Lorillard Wolfe Collection).
Represented here with their mother are Georgette Charpentier (who married the writer Abel Hermant before becoming Madame Chambolle, and the Madame Tournon) and Paul Charpentier. Paul was the godson of Emile Zola. Gustave Flaubert wrote to Madame Charpentier that he was bent on attending the baptism in order to "grace your religious celebration with my presence and to see the face that Zola will make in front of the altars."

temptation: "If you want something, I shall sell you all I can, at the most moderate prices. I would just as soon that it be my friends who derive benefit from [my paintings]," Manet wrote to Charpentier. As for Madame Charpentier, Manet did for her the sort of little things that were particularly pleasing to a woman holding a salon: for example, he secured the help of Lorenzo Pagans, the renowned guitarist painted by Degas, for one of her musical evenings. Manet was also very fond of Madame Charpetier's younger sister, Isabelle Lemonnier, whose portrait he painted several times between 1878 and 1880—a particularly noteworthy one is in the Dallas Museum of Fine Art. Manet occasionally wrote verses for her on a sheet of paper on which he painted a plum in watercolor:

129

A Isabelle	("To Isabelle
Cette mirabelle	That mirabelle [plum]
Et la plus belle	And the fairest belle
C'est Isabelle.	Is Isabelle.")

Georges Charpentier had also been known to take advantage of an auction: he bought Manet's *Combat of the "Kearsarge" and the "Alabama"* (The John J. Johnson Collection, Philadelphia Museum of Art) on March 23, 1878, for 700 francs.

In the late 1870s, when they needed financial help, Monet, Renoir, and Sisley too, were rarely disappointed when they appealed to Georges Charpentier.

Madame Charpentier's "Resident Artist": Renoir

More personal letters, especially from Renoir, were sent to Marguerite Charpentier. Renoir, the son of a tailor, was grateful to that intelligent, educated, upper middle-class woman for valuing his work and for graciously welcoming him as her "resident artist," as Renoir jokingly dubbed himself. Madame Charpentier commissioned portraits of her children from Renoir: in 1876, a portrait of Georgette, and in 1878, one of Paul. In 1876, Renoir painted his first half-length portrait of Madame Charpentier, which he exhibited at the third Impressionist exhibition in 1877, with those of Madame Alphonse Daudet, Deputy Spuller, a member of the French parliament, and the actress Jeanne Samary—all regular visitors at the Charpentiers' salon. That series of paintings was a sort of prelude to Renoir's large portrait of 1878, which depicts Marguerite Charpentier with two of her children and their big dog in a cosy drawing room, against a colorful, softly blurred background of Japanese art and bamboo. Because the main model was so well known, the picture aroused a lot of talk when Renoir exhibited it at the 1879 Salon. That painting marked Renoir's return to the forefront of the Parisian art scene. Pissarro was able to write to Eugène Murer that Renoir, "was a big success at the Salon. I believe he is launched. So much the better; poverty is so hard." Renoir remained grateful for the Charpentiers' support, keeping his friends informed by letter of the discoveries he made during his artistic travels through North Africa and Italy. The Charpentiers continued to help Renoir and his fellow Impressionists in other ways besides buying their works.

130

126

A New Magazine: *La Vie Moderne*

In 1879, Georges Charpentier launched a new illustrated literary and artistic weekly, *La Vie Moderne*. The managing director was Theophile Gautier's son-in-law, Emile Bergerat; he was assisted by contributors such as Armand Silvestre, Théodore de Banville, Alphonse Daudet, Edmond Duranty, and Edmond Renoir, the artist's youngest brother, who was becoming a journalist. Charpentier intended it to be a luxurious magazine—though Pissarro considered it "bad"—and a "bold periodical, free [of constraint], eager for any innovation... a vigilant, lively, youthful, and

126a

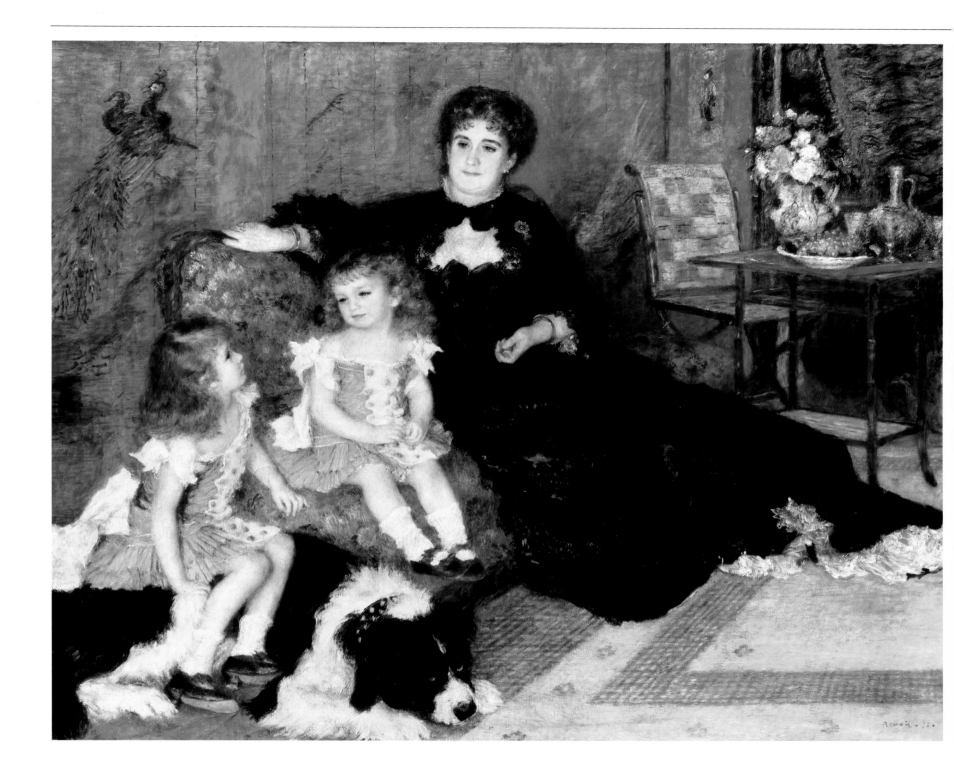

passionately truthful periodical." In his first article, Armand Silvestre already mentioned the Impressionists, as well as Henner, Puvis de Chavannes, and Baudry. No one was to be left out, and illustrations by Vierge, Detaille, Meissonier, Leloir, and Forain also appeared in the magazine. The publishers had to try to please everyone.

La Vie Moderne also had a feminist side to it, and here we can discern the influence of Marguerite Charpentier. The periodical proclaimed, for instance: "Perhaps it is time, too, to prove that all elegant women are not necessarily adventuresses, [nor] all great ladies loose women, and that a liking for domestic life is not the exclusive prerogative of the poor." Thus, issue No. 4 of the weekly, dated May, 1879, announced that Degas had added two paintings to the Independent Artists' exhibi-

126a A.G. *Housewarming Party [Literally, Putting Up the Pothanger] at the Offices of "La Vie Moderne."* March 3, 1879. Print. Private collection.

tion (i.e., the fourth Impressionist exhibition) and went on, with no transition, to a physician's study advocating daily baths for babies—"above all, cleanliness!" Naturally, articles favorable to the Impressionists were forthcoming. Furthermore, Georges Charpentier put the offices of *La Vie Moderne* at the disposal of the Impressionists. The premises were tiny but admirably situated for exhibitions: at the entrance to Passage des Princes on the Boulevard des Italiens.

In June, 1879, a Renoir show inaugurated the series of exhibitions held there; then Monet had one in June, 1880, and Sisley in 1881, at Renoir's suggestion. An exhibition of tambourins (long, narrow drums used in Provence) and decorated ostrich eggs was also held in the offices. Manet participated in both exhibitions, but his own exhibition took place in April, 1880. Monet's exhibition at *La Vie Moderne* was the artist's first one-man show; it even took place before the one Durand-Ruel organized. Although, financially, the results of Monet's exhibition were modest, the *succès d'estime* gave the artist courage at a difficult time. There are several documents that mention the active participation of Théodore Duret and Ernest Hoschedé in organizing Monet's show. When the exhibition was over, Marguerite Charpentier purchased one of Monet's canvases, *The Floating Ice*—on credit!—for 1,500 francs, planning to give it to her husband. Monet would borrow the picture from him in 1882, for the seventh Impressionist exhibition, because he thought it was one of his "good things."

The Charpentiers must have heard Zola talk about another artist: Cézanne. A small Cézanne of 1866, *Marion and Valabrègue Setting Out, for the Motif* (a sketch for a large picture that was never completed) appeared after Georges Charpentier's death, at the 1907 auction of the Charpentier collection. Charpentier had asked Renoir to take him to Chocquet's. At that early date, Victor Chocquet was the only true Cézanne enthusiast. Charpentier was not really ready to let himself be won over by Cézanne's art, however.

The End of an Era

In the early 1880s, Georges Charpentier experienced great financial difficulties: apparently, he had borrowed more than he was able to reimburse. The publisher Michel Lévy suggested that they go into partnership together, but Charpentier, making sacrifices, selling land and paintings, preferred to repay his debts rather than risk his independence. In 1883, however, Charpentier was obliged to come to terms with the publishers Marpon and Flammarion. In 1885, the success of Zola's novel *Germinal* revitalized the Charpentier Library, but the most brilliant period of the Charpentiers' salon had come to an end.

The Charpentiers' relationship with Zola remained just as close as it was in the past. In 1888, Zola received the Legion of Honor in the Charpentiers' drawing room. Their estate at Royan was even named "Le Paradou" in memory of Zola's novel, *La Faute de l'abbé Mouret.* During the Dreyfus affair, Charpentier was unequivocal in his support of Zola. As the musician Alfred Bruneau related in his memoirs, Charpentier was one of the few close friends who accompanied Zola to the trial at Versailles. In the automobile that took them, along with Georges and Albert Clemenceau, there were two young picture dealers, the Bernheim brothers, whose business was growing.

The Charpentiers had to endure an irreparable loss: the sudden death of their only son, Paul, who died of typhoid fever at twenty, in 1895, during his military service. Marguerite Charpentier's social life was supplanted by an increasing interest in "La Pouponnière" at Porchefontaine, an institution she had founded to help young single mothers and their children. Georges Charpentier sold his business to Eugène Fasquelle, with whom he had worked for many years. Charpentier's bonds with the Impressionist artists took on a more distant character, although he was always ready to lend the paintings in his collection when he was asked.

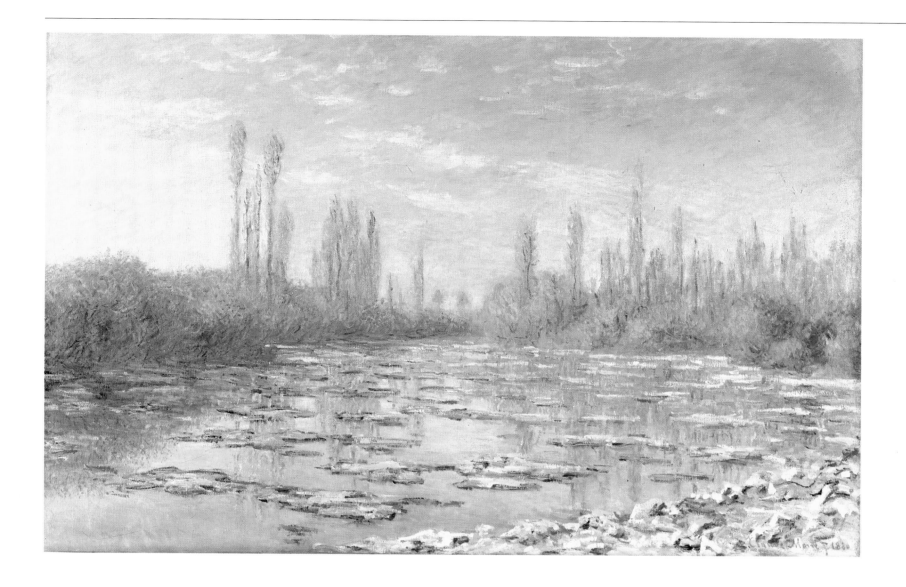

127　Claude Monet. *The Floating Ice*. 1880.
Oil on canvas, 97 × 150 cm. (34¼ × 58¼").
Shelburne Museum, Shelburne, Vermont.
Madame Charpentier, who wanted to buy the
work, wrote to Monet on June 22, 1880: "Sir,
I know that my husband wants your large
painting of the breaking up [of drift ice] very
much. I would like to make him a present of
it out of my savings; and although I hate to
bargain, especially with a man of your talent,
I do not have the means to pay 2,000 francs
for it. Since you haven't sold it yet, perhaps
you may want to agree to my conditions:
1,500 francs, payable in three installments:
500 francs on October 14, 500 francs on Jan-
uary 14, and 500 francs on April 14, 1881.
You will forgive me, Dear Sir, for seeming to
bargain with you, and I would ask you to
accept the pledge of my ladylike sentiments
[= Yours truly], Marg. Charpentier."

As Alice Hoschedé wrote shortly after-
ward, that offer "provided hardly any money."
Therefore, before reaching an agreement
with Madame Charpentier, Monet tried to sell
the picture to other private collectors. In the
end, Madame Charpentier got her painting.

The Charpentiers left Rue de Grenelle and moved to 3 Avenue du Bois de
Boulogne (now Avenue Victor Hugo). Marguerite Charpentier died there on
November 30, 1904 at fifty-six years of age, and Georges Charpentier, in turn, on
November 15, 1905.

The two Charpentier daughters, Georgette (Madame Tournon) and Jane
(Madame Dutar), were obliged to break up their parents' collection. The notice of
the auction including the large portrait by Renoir stirred up collectors and dealers;
Durand-Ruel strongly urged the English critic and painter Roger Fry to purchase the
portrait of *Madame Charpentier and Her Children* for the Metropolitan Museum of 　126
Art, New York, while warning him that there would be serious competitors: rumors
said that Madame Charpentier had once refused 100,000 francs for it, that German
museums (Dresden or Berlin) were interested, that Count Isaac de Camondo was
going to buy it for the Luxembourg Museum, and so forth. In the end, the Metropoli-
tan Museum, via Durand-Ruel, won out over competitive bidders for 84,000 francs,
while most of the other paintings were bought back by the family.

There was one consolation for the French museums: Mesdames Tournon and
Dutar wanted to donate Renoir's half-length portrait of Madame Charpentier to the
Louvre. However, in 1907, the Louvre's regulations prevented living artists from
gaining admission to that holy of holies. Despite his own willingness to accept the
donation, the curator Léonce Bénédite was unable to circumvent the existing regula-
tions. The Charpentiers heirs kept the work, therefore, until the painting was finally 　**147**

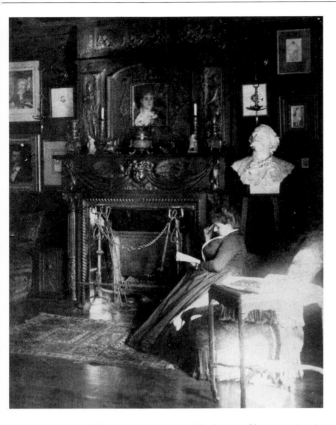

128 Anonymous. *Madame Charpentier in Her Drawing Room.* c. 1895. Photograph. Private collection.

129 Edouard Manet. *Portrait of Isabelle Lemonnier.* 1879–82. Oil on canvas, 82 × 73 cm. (36 × 28¾″). Museum of Art, Dallas (Gift of Mr. and Mrs. Algur H. Meadows and the Meadows Foundation Incorporated).
Madame Charpentier's young sister was one of the models Manet preferred at the end of his career. This portrait, which remained in Manet's studio, later became a part of the collection of N.A. Hazard, a friend of Count Armand Doria.

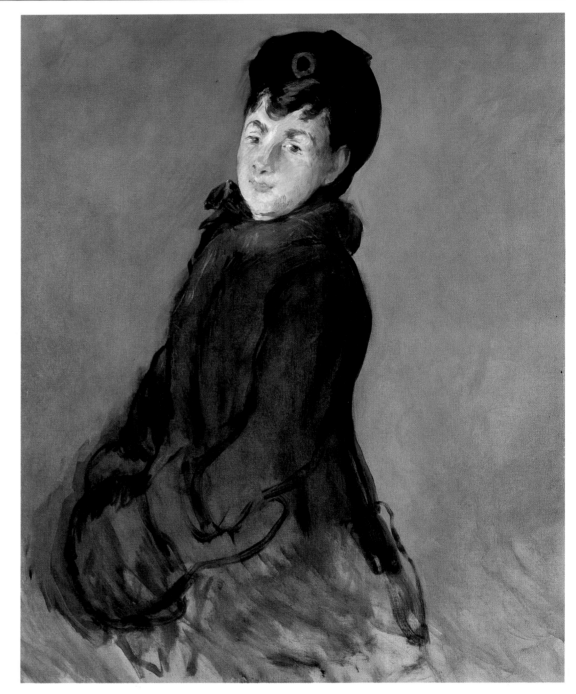

130 Pierre-Auguste Renoir. *Portrait of Madame Georges Charpentier.* c. 1876–77. Oil on canvas, 46 × 38 cm. (17⅞ × 15″). Musée d'Orsay, Paris. (Gift of the Society of Friends of the Luxembourg Museum with the participation of Madame Tournon, née Georgette Charpentier, 1919).

purchased—with Madame Tournon's participation—by the Friends of the Luxembourg Museum in 1919. Now it is in the Musée d'Orsay, Paris.

We shall let Marcel Proust have the last word here, as he did in the chapter on Théodore Duret. Even though Proust was cruel and surely unjust toward Marguerite Charpentier, whom he met when she was no longer very young and labeled a "ridiculous, philistine bourgeois," the writer had to admit that Madame Charpentier's portrait by Renoir "gives the greatest impression of elegance since the great paintings of the Renaissance." In *Time Regained*, Proust wrote: "Will the generations of the future not feel that the poetry of a fashionable home and the beautiful clothes of our times are to be found rather in the drawing room of the publisher Charpentier by Renoir than in the portraits of the Princess de Sagan or the Countess de La Rochefoucauld by Cot and Chaplin?"

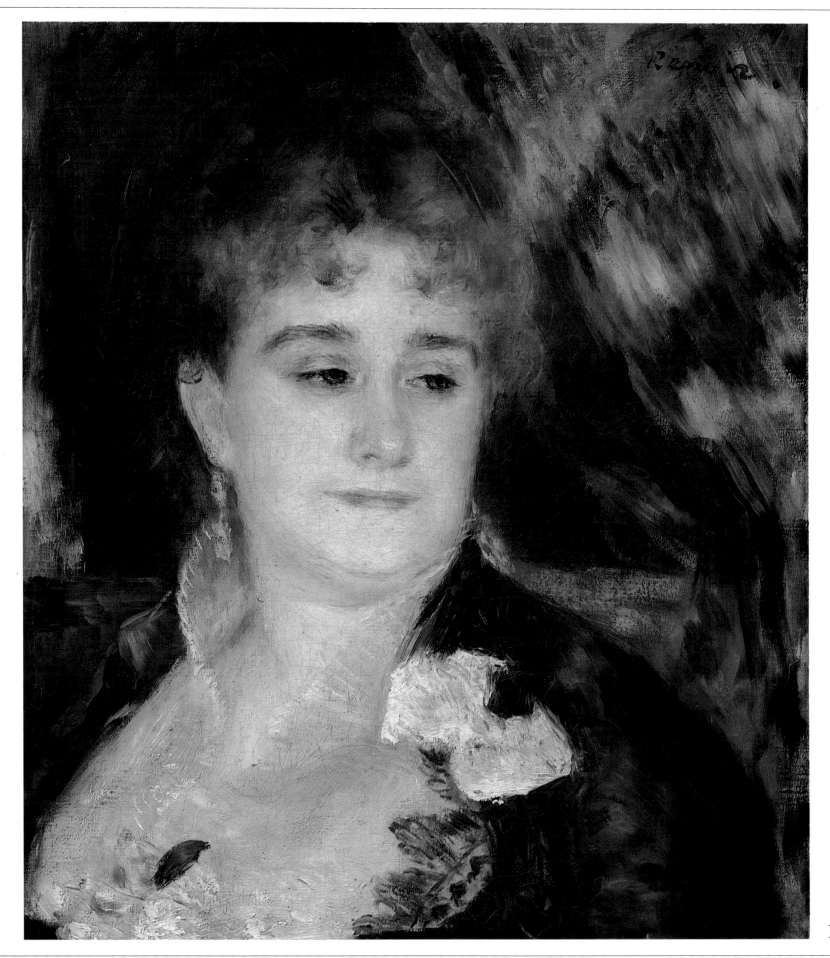

149

Jean Dollfus

131 H. Humbricht. *Jean Dollfus*, after the frontispiece in the catalogue of the first Dollfus auction.

As is often the case, not until after Jean Dollfus had died and his collections were put up for auction in 1912 was the general public able to appreciate the extremely high quality—and abundance—of works that Dollfus had assembled.

During the Dollfus auctions, regular customers of Georges Petit's or of the Hôtel Drouot's salesrooms could ascertain that Dollfus had been a collector, at one and the same time, of modern French painting, the so-called Primitives of the fifteenth century, Dutch or Flemish painting of the seventeenth century, and French painting of the eighteenth century, in addition to being a first-class collector of Japanese objets d'art.

In order to understand why Duret counted Jean Dollfus among the first collectors of Impressionism in 1878, we must go back to the first auction of modern paintings owned by this artlover and held at Georges Petit's on March 2, 1912. The seventy-seven lots in that auction can be broken down as follows: 20 by Corot, 6 by Delacroix, 4 by Géricault, 1 by Millet, 5 by Georges Michel, 7 by Théodule Ribot, 5 by Théodore Rousseau, along with works by Bonington, Constable, Isabey, Roybet, Ingres, Fortuny, Français, and Monticelli. The lots also contained works by Courbet, Daumier, Daubigny, Jongkind, and finally, 6 Renoirs, 2 Sisleys, and 1 Pissarro. Many of the main questions that might arise about the collector are answered in the luxurious catalogue published on that occasion. In it, the historian André Michel wrote a detailed study of Jean Dollfus's career, using information from Dollfus's son, Adrien, who was himself a scholar and a collector. Such biographical data was rare enough at that period to be noteworthy.

Jean Dollfus, son of the economist and Alsatian manufacturer Jean Dollfus and grandson of Daniel Dollfus Mieg of the textile manufacturers Dollfus Mieg and Company (D.M.C.), was born at Mulhouse on December 2, 1823. Dollfus had connections with the family business early and traveled for it in Europe and in the United States. He bought his first paintings as early as 1846. When Dollfus became the son-in-law of Baron Huyssen de Kattendyke, Holland's secretary of state (a collector, who bequeathed several Dutch paintings to Dollfus in 1854), his own collection had already been started.

In 1860, Jean Dollfus relinquished his actual participation in the business of the firm of Dollfus Mieg. His personal wealth provided an income that enabled him to devote himself to his collections. Dollfus lived at Geisbuhl, near Mulhouse, in a house built according to plans by Viollet-Le-Duc and by Boeswillwald. The house already contained a picture gallery for his paintings, which were primarily Dutch. Yet on the advice of the Alsatian artist Clément Faller and of Moureaux, a dealer on Rue Laffitte in Paris, Dollfus began to take an interest in Corot and Jongkind.

Dollfus probably came into contact with Manet before 1870; he would own several works by that artist. However his collections of Old Masters had priority, and in order to add to them, Dollfus traveled in the Germanic countries as well as in Italy.

The upheavals caused by the Franco-Prussian War of 1870 determined the future of Jean Dollfus: he left Alsace and decided to settle in Paris. At first Dollfus lived on Avenue Montaigne; then he had a private residence built at 35 Rue Pierre Charron (called Rue de Morny at the time), where he could display his collections. The pictures of the nineteenth century gradually found a place in the main drawing

132 Payment by Jean Dollfus for Two Paintings by Renoir. June, 1876. Documents, Musée d'Orsay, Paris.

133 Pierre-Auguste Renoir. *Portrait of Claude Monet*. 1875. Oil on canvas, 85 × 60 cm. (33¾ × 24"). Musée d'Orsay, Paris.

room and in the small room next to the large entrance hall, where Jean-Baptiste Carpeaux's *Flora* occupied the place of honor. Jean Dollfus's heirs donated it to the Louvre; it is now in the Musée d'Orsay, Paris. From that time onward, Dollfus organized his life around his daily visits to the Hôtel Drouot. In his account books, the notations concerning the works he purchased take up as much room as those dealing with his financial transactions and the management of his estate.

In 1875, within the space of a few weeks, Dollfus purchased his most beautiful Corots, in particular *Woman with the Pearl,* for which he paid 4,000 francs at the artist's sale; and he acquired the small version of Renoir's *La Loge, Stage Box,* knocked down for 220 francs at the Impressionists' auction. At the sale of the Dollfus estate, the Corot was purchased by the Louvre for 150,000 francs and the Renoir knocked down for 31,200 francs. This proves that the Renoir was a much better buy from a financial point of view. Dollfus had to face derision in 1875, however, and keep the work an entire lifetime!

In 1876, after he acquired a small Géricault, *Race of the Riderless Horses,* for 6,230 francs, which the Louvre also bought at the Dollfus sale for 38,000 francs, Jean Dollfus bought two paintings by Renoir that had been loaned to the second Impressionist exhibition: *Portrait of Claude Monet* and a small *Head of a Young Woman*; he paid 300 francs for the two. Compare that price with, respectively, 20,200 francs and 10,550 francs, the prices for which those works were auctioned at the sale of the Dollfus estate. While it is not always possible to establish such comparisons, they are sufficiently striking to speak for themselves. Any attempt to establish a correspondence between the franc of 1912 and today's franc, by multiplying the latter by thirteen, only confirms what everyone knows: Impressionist art was a better bargain before World War I than it is now. The very same *Head of a Young Woman,* for example, brought 157,000 pounds at auction in London on July 3, 1973.

134

133

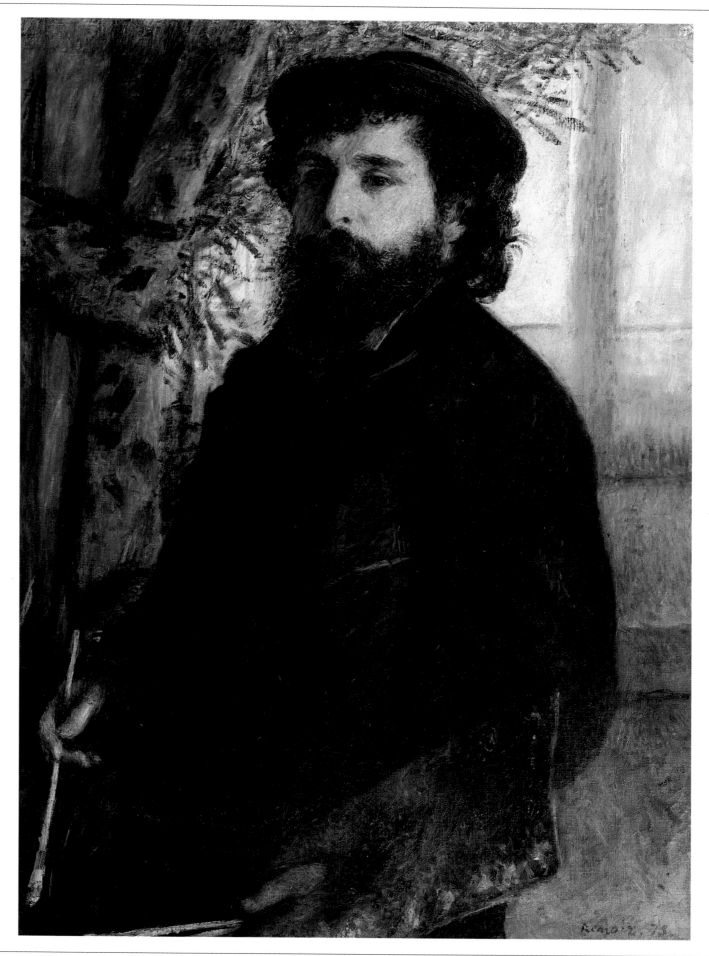

153

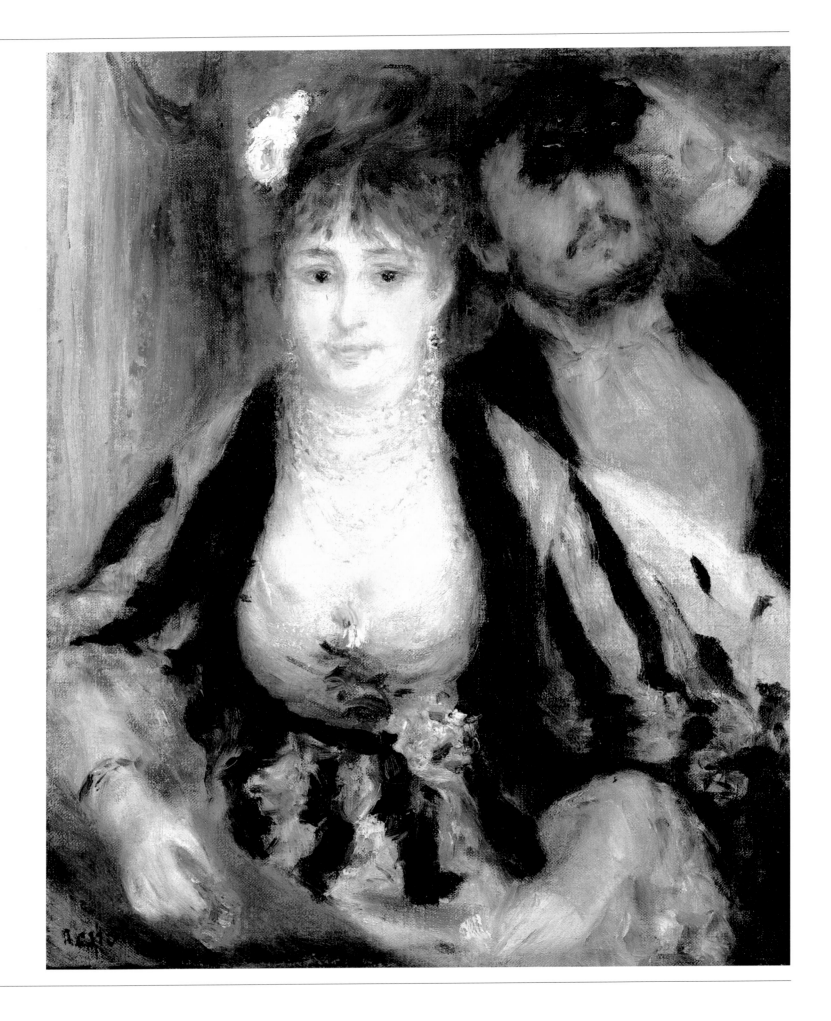

Dollfus no doubt rediscovered the accents of Delacroix in Renoir, for he commissioned Renoir to copy that artist's *Jewish Wedding in Morocco* in the Louvre (copy in The Worcester Art Museum, Massachusetts).

In 1876, Dollfus, who was a regular customer at *père* Martin's, bought from him a landscape by Sisley, which was not sold at the 1912 auction; and on May 2, 1876, Dollfus purchased Monet's *Hoar Frost* from Poupin for 110 francs (knocked down for 5,200 francs at the Dollfus sale). Finally, in June of the same year, Monet noted in his account books that he sold Dollfus, for 150 francs, a *Snow Effect* that is hard to identify because it was not in the 1912 auction. Thus, from 1876, Dollfus already had a small, representative collection of Impressionist art.

It is conceivable that Pissarro's *Big Pear Tree at Montfoucault*, dated 1876—the only work by that artist we are certain that Jean Dollfus owned—was acquired at the Hôtel Drouot at the sale organized by the Impressionists on May 28, 1877. As a regular visitor to the Hôtel Drouot, Dollfus could not have missed the Hoschedé auction in June, 1878: he bought three more landscapes by Sisley there.

At the sale of Manet's studio, Dollfus only bought small things: one was a watercolor, *The Barricade* (Szépmüvéstzeti Múzeum, Budapest). It would turn up again at the posthumous sale of the collector's watercolors and drawings.

Although he kept what he had acquired, Dollfus did not continue purchasing works by the Impressionists beyond the mid-1880s. This was the case for many of the collectors of that generation, as we have seen. Dollfus, it must be added, had many other fields to explore: the art of Japan and the Far East as well as Old Master painting. In number, the Impressionist works were always a small part of Dollfus's collection. However, as was the case with Duret in 1878, when the Dollfus collection was broken up at auction in 1912—by which time, the six Renoirs claimed as much attention as the works by Corot, Delacroix, and Millet—those few Impressionist works greatly contributed to the way succeeding generations judged this collector.

It is worth noting that the Henri Rouart sale also took place in 1912. Although the Rouart and Dollfus sales consecrated the success of Impressionism, the Louvre purchased only works by Delacroix and Corot at both those auctions. As for the Luxembourg Museum, whose collections were taken over by the Musée d'Orsay, Paris, it acquired a work by Ferdinand Roybet at the Dollfus auction and would have to rely on private donations to build its collection of Impressionist art, which had become too expensive for the French national museums' meager acquisitions budget.

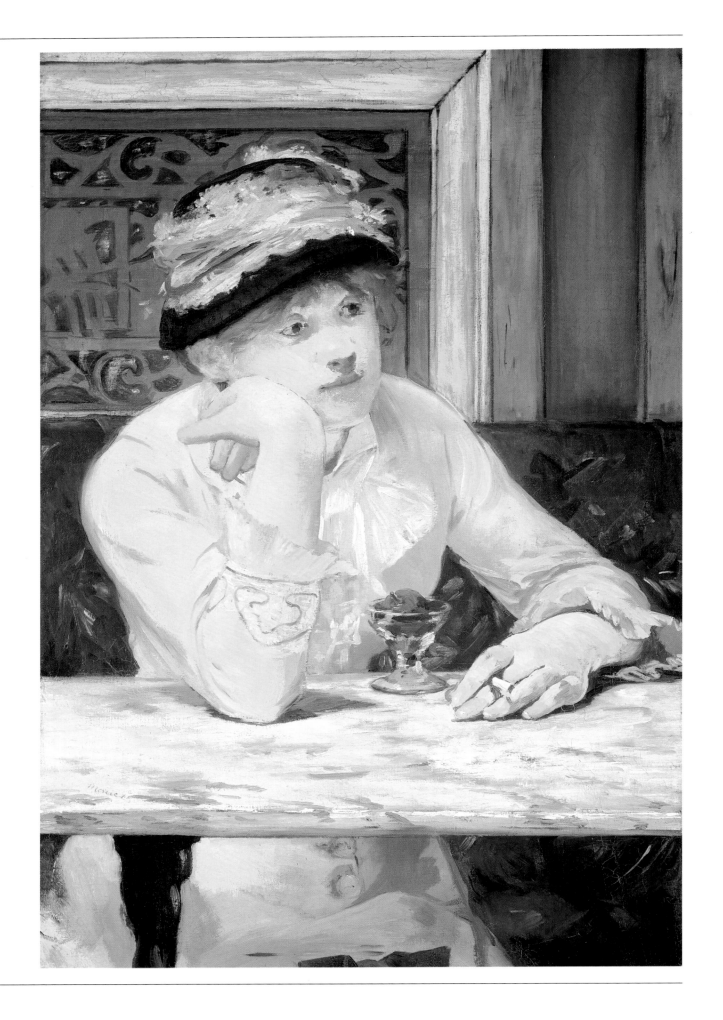

Charles Deudon, Charles Ephrussi, and Paul Berard

135 Edouard Manet. *The Plum*. 1878. Oil on canvas, 73 × 50 cm. (29 × 19¾"). National Gallery of Art, Washington, D.C. (Collection of Mr. and Mrs. Paul Mellon).

When Théodore Duret published his booklet in May, 1878, one of the collectors he mentioned, Charles Deudon, had just bought Renoir's *The Dancer* from Durand-Ruel 136 for the considerable sum of 1,000 francs. It is a historic painting, since it was shown at the first Impressionist exhibition in 1874. Moreover, it was not the first Impressionist canvas Deudon acquired. A year earlier Monet had sold him a landscape of Argenteuil that Deudon had exchanged in the meantime for another painting. It was most probably through Duret that Deudon, also a friend of Henri Cernuschi, became acquainted with Monet, Renoir, and also Pissarro. However, little is known about when and how Charles Deudon initially entered into this social sphere.

A Stylish Young Man

Charles Deudon was born on September 23, 1832, at Le Cateau in northern France. His father, a military man in a family that usually embraced the profession of notary public, had married an English heiress. Her possessions—coal mines and the workers' housing belonging to them—would enable her son to lead a life free from financial worries. Deudon studied law and took his doctorate. We next come across him as a stylish young man living in Paris, a member of the very exclusive club, "Cercle de la Rue Royale," where his British origins worked in his favor. It is unfortunate that he was not included in the group portrait that James Tissot painted of the founders of that club in 1867. Deudon's family wanted him to marry, but he preferred to live the unfettered life of a bachelor. He traveled, took care of his health by visiting spas, and occasionally contributed to English newspapers. During the Commune of Paris in 1871, Deudon prudently retired to his property in Saint-Clair-sur-l'Elle in the department of La Manche.

Charles Deudon Discovers Manet and the Impressionists

Charles Deudon did not begin to take an interest in painting until after the Franco-Prussian War. It seems that the first work he bought, in 1875, from a small dealer on Rue Le Peletier, was a landscape with windmill attributed to Meindert Hobbema. It is easy to imagine that Deudon also went into Durand-Ruel's during his outings.

In July, 1876, Deudon leased an apartment at 13 Rue de Turin, which he kept until 1894 at least. The apartment was in the newly developed Europe district and just a stone's throw from Edouard Manet's studio at 4 Rue de Saint-Petersbourg. In 1881, at a time when Manet had left that studio, Charles Deudon purchased a pastel study from him and, more importantly, *The Plum* for the considerable sum of 135 3,500 francs. In the meantime, Deudon had acquired works by Renoir, Monet, Pissarro, and Sisley. He himself only bought a few paintings, but he had exclusive taste and was fervently militant. Deudon's friend, Paul Berard, was an important recruit. Renoir owed Berard's patronage to Deudon. Won over by Renoir's portrait of Madame Charpentier that Deudon had taken him to see at the publisher's home in November, 1878, Berard ordered his first painting from Renoir in 1879. Berard was not alone:

Charles Ephrussi had also accompanied Deudon and Renoir on their visit to Madame Charpentier's.

Deudon belonged to that sparkling, lively social set that moved from Paris to Trouville or Saint-Moritz in the summer months. In the 1880s Deudon was at the height of his career as a collector. He made loans to the Japanese exhibition held at Petit's in 1883, Japonism and Impressionism being on an equal footing at the time. Deudon was on the committee for the Manet exhibition in 1884 and bought several works at the artist's sale. In May, 1886, Pissarro met Deudon, again with Duret, at a dinner for the Impressionists at which Zola's novel, *The Masterpiece*, was the topic of conversation. Pissarro listed the guests: Philippe Burty, critic and an early collector of Japanese objets d'art; George Augustus Moore, the Irish critic and writer immortalized by Manet, whom Pissarro called an "English Naturalist"; the poet Stéphane Mallarmé, the novelist Joris-Karl Huysmans, and Berard. At the last minute, Monet arrived on the train from The Hague, where he had gone to see the tulips in flower.

In the years that followed, Deudon seemed to lose interest in painting. His name is not mentioned among the subscribers who were responsible for Manet's *Olympia* entering the Luxembourg Museum in 1890. Charles Deudon married in 1894 and took up residence in Nice. Rich and esteemed, Deudon died there on May 9, 1914. There is a street named for him in Nice, testifying to the city's gratitude for his donations to the hospital.

Who Will Get Deudon's Paintings?

We cannot leave this account of Deudon's life without mentioning the fate of his paintings. In February, 1899, Paul Durand-Ruel, attentive to his old customers who, inevitably, were providers of new collectors, sent Renoir to visit Deudon in Nice. "Deudon still has," Renoir said, "a small seascape and a Woman with plum brandy by Manet, and a veiled woman. A Train Station by Monet, a Dutch and an Argenteuil landscape, one Sisley, four heads by me, and a large landscape from Wargemont." A little later, he stated: "There is only one interesting Manet. It is a woman sitting at a café table with a glass of plum brandy in front of her. The two others: a very ugly veiled woman, and another of very little significance—a seascape with one or two little boats in the background. Very artistic. A pretty little Sisley, *La Machine de Marly*[a seventeenth-century pump that brought water to Versailles] *(Morning)*." Renoir added: "His cousin has my dancer." Durand-Ruel was not the only one interested in this affair, however. The Bernheim brothers, informed by Théodore Duret, who asked Paul Berard to get them an introduction, were gaining in importance at the time as dealers for the Impressionists. They had decided to make a dramatic move and to carry off the prize: they offered Deudon 100,000 francs for the Manet he had bought for 3,500 francs. That was a spectacularly high price, especially in view of the fact that the value of the franc had not changed much. Renoir said, "it is very funny to see Deudon's joy." He added, however, that Deudon did not seem to be ready to sell yet and only wanted to know, as did his wife, the approximate value of his collection.

Durand-Ruel's only business transaction at the time was to purchase from Charles's cousin, Eugène Deudon, who was not even a collector, Renoir's famous *The Dancer* as well as a pastel by Manet and a Monet. Charles Deudon kept his other paintings and even wrote to Monet for details of titles and dates in 1907.

Manet's *The Plum*, Monet's magnificent *The Gare St-Lazare, Paris: Arrival of a Train* that the bankrupt Hoschedé had to give up to Deudon, through the artist, in October, 1877, Renoir's figure paintings, including the Art Institute of Chicago's *Young Woman Sewing* and the Collection Paul Mellon's *Dreamer*, Renoir's landscape (none other than *The Rose Garden at Wargemont*), and a still life, *Bouquet in Front of a Mirror*, were purchased outright after Deudon's death by Paul Rosenberg, the

135, 137

136 Pierre-Auguste Renoir. *The Dancer*. 1874. Oil on canvas, 142 × 94 cm. (56⅛ × 37⅛″). National Gallery of Art, Washington, D.C. (Widener Collection).

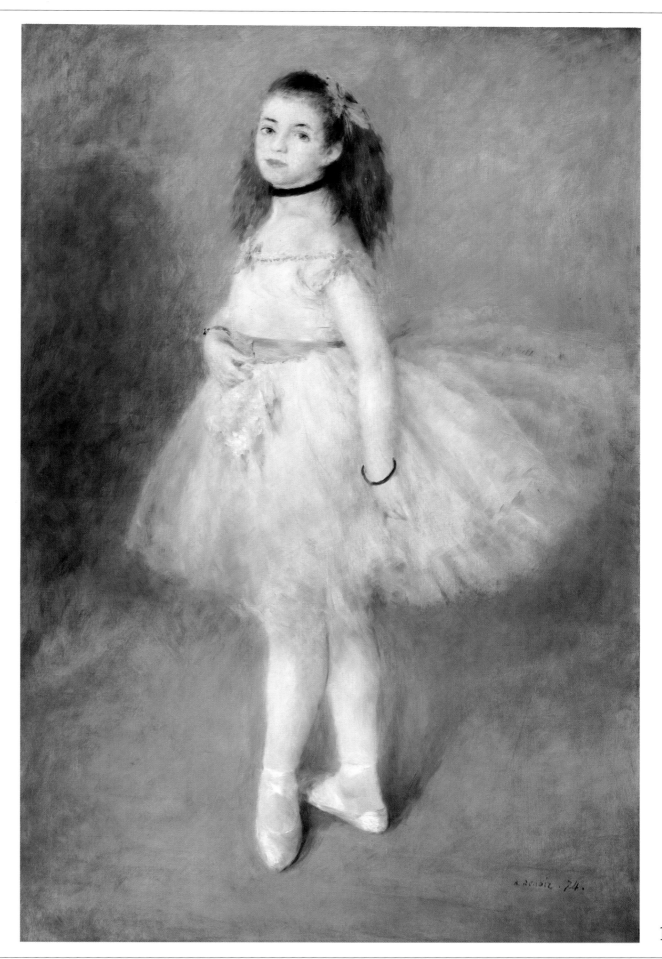

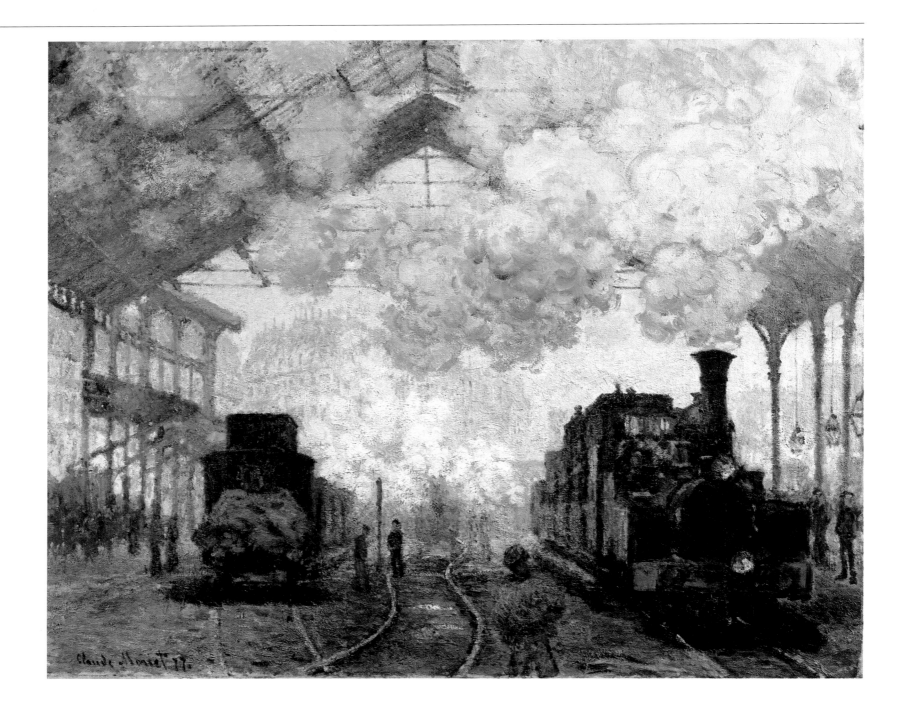

137 Claude Monet. *The Gare Saint-Lazare, Paris: Arrival of a Train*. 1877. Oil on canvas, 82 × 101 cm. (32¼ × 39¾"). Fogg Art Museum, Harvard University, Cambridge, Massachusetts (Bequest: Collection of Maurice Wertheim, Class of 1906).

third competitor, who won out over Durand-Ruel and the Bernheim brothers. Rosenberg exhibited the paintings in his gallery in May and June, 1922.

Deudon, pampered "like a big baby" by his wife, as Renoir mockingly observed, outlived his two closest friends by almost ten years. Charles Ephrussi and Paul Berard who, thanks to Deudon, were also collectors of Impressionist art, both died in 1905.

Charles Ephrussi

Charles Ephrussi, the descendant of a family of bankers who had settled in Vienna, was content with the profits from his great wealth and lived like a "Benedictine dandy," the term his private secretary, the poet Jules Laforgue, used when referring to him. Ephrussi devoted himself to doing research in art history, at first in Italy. Later, 138

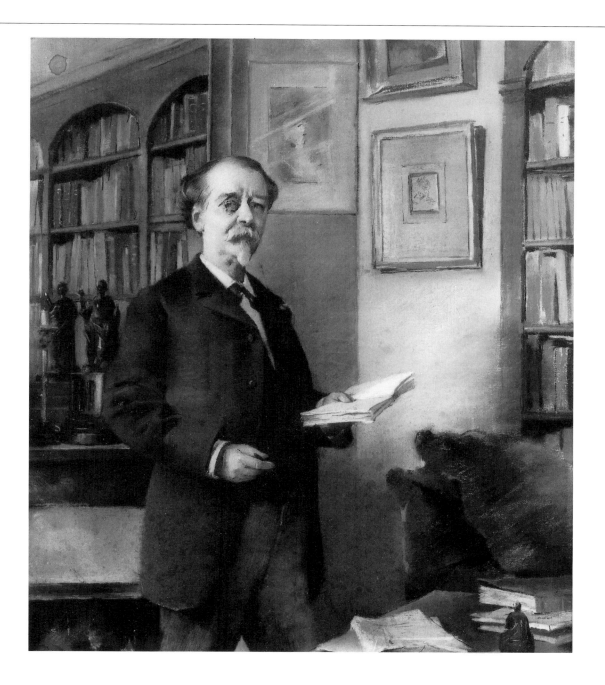

he became interested in Albrecht Dürer; he wrote a study on Dürer in 1876. Besieged by Duret and by Deudon, who was his close friend, as well as by his own brothers, Ignace and Jules, and by Jules's wife, Fanny, Ephrussi let himself be won over by the most progressive elements in the Parisian art world. Ephrussi wrote the review of Duret's booklet in 1878, for the supplement of the *Gazette des Beaux-Arts.* It was a serious magazine but also, thanks to Ephrussi, who became its owner in 1885, very popular with cultured women: "Without sharing Mr. Duret's rather excessive enthusiasm for the new school, it must be admitted that certain pictures at Rue Le Peletier [an allusion to the Impressionist exhibition of 1877] are worthy of favorable attention." A considerable breakthrough had been made since a disillusioned Manet had written to Duret: "Leave the children to their mother and Ephrussi to Bonnat." The artist Léon Bonnat, the pride of the Academy of Painting and Sculpture and future portraitist of the presidents of the French Republic, was, as Renoir himself said, as much Deudon's friend as Ephrussi's.

Thus, in the early 1880s, Charles Ephrussi developed a passion for Impressionism, the new painting. He bought works by Manet from Durand-Ruel was well as 161

139 Pierre-Auguste Renoir. *Paul Berard.* 1880. Oil on canvas, 81 × 65 cm. (31⅞ × 25½"). Private collection.

directly from the artist. Having paid a hefty price for a still life depicting a *Bunch of Asparagus* (Wallraf-Richartz Museum, Cologne), Ephrussi received from Manet a small painting depicting *one* asparagus, with this note: "There was one missing from your bunch." Ephrussi was also interested in Monet, who recorded his purchases and his address (81 Rue de Monceau) in his account books in 1880. Not satisfied with bestowing especial praise on Degas in the *Gazette des Beaux-Arts* on the occasion of the Impressionist exhibitions of 1880 and 1881, Ephrussi bought several of Degas's pictures of dancers from Durand-Ruel.

Finally, Ephrussi used his influence—particularly on Renoir's behalf—to obtain commissions for portraits from his immediate family and distant relatives as well as from fashionable acquaintances such as the Foulds and the Cahens d'Avers. In 1881, Renoir stated airily as he left for Algiers, "I've let Ephrussi take my Salon in hand." And, in fact, Renoir, like many academic painters, was represented by two society portraits at the 1881 Salon. Tradition holds that Renoir portrayed Charles Ephrussi in a top hat, lost among the boatmen in undershirts in his great *The Luncheon of the Boating Party* (The Phillips Collection, Washington, D.C.). Renoir's latent anti-Semitism, which intensified later at the time of the Dreyfus affair, doomed this friendship to failure; Ephrussi had the same trouble with Degas for the same reason.

John Rewald relates that, in May, 1881, Ephrussi exchanged a Monet landscape with Chocquet for four Sisleys. There is, on the other hand, no trace of any interest in Cézanne. Ephrussi also knew Hoschedé, but he did not take advantage of the latter's auction. Nor was Ephrussi among the artist's supporters at the auction of Manet's studio.

Ephrussi encouraged his circle of friends to buy works by the Impressionists, in particular his cousin Carl Bernstein, a professor of law in Berlin. Thanks to Ephrussi, the Impressionists Degas, Monet, Pissarro, Berthe Morisot, and Mary Cassatt were launched with the public in Berlin from the early 1880s. Ephrussi's other cousin, Marcel Bernstein, had Manet paint a portrait of his five-year-old son, Henry, in 1881. The playwright Henry Bernstein would later become a great collector of Impressionist art himself.

Charles Ephrussi, very much a man about town, entertained and "attended six or seven receptions every evening in order to become a director of the Fine Arts Administration [equivalent to a secretary of state for cultural affairs] one day," said Edmond de Goncourt maliciously. Ephrussi was never appointed to such a position and, until the end of his life, was satisfied with managing the *Gazette des Beaux-Arts*, in which, among other things, he promoted the fledgling career of young Marcel Proust. Proust had Ephrussi in mind when he created his famous character, Swann. On September 30, 1905, Ephrussi died at fifty-five, a "Russian subject, man of property, officer of the Legion of Honor, and bachelor," in the town house he shared with his brother, Ignace, at 11 Avenue d'Iéna.

Paul Berard

A few months before Charles Ephrussi's death, in May, 1905, one of the most remarkable collections of works by Renoir and the Impressionists was sold at auction: Paul Berard's, which was especially noteworthy for containing one of Renoir's masterpieces, *Children's Afternoon at Wargemont.* 141

With his portrait of *Madame Charpentier and Her Children* in 1878, Renoir had 126 ushered the spectator into the muted drawing room of Marguerite Charpentier. Six years later, he depicted the interior of the home of one of her friends, Madame Paul Berard, this time much more casually—though it should be noted that the house in question was in the country. *Children's Afternoon at Wargemont* portrays the Berard 141 girls: Marguerite, intent on her picture book; Marthe, her older sister, engrossed in her sewing; and Lucie, the youngest, with her doll. This is not the first portrait of the members of the Berard family that Renoir painted; but it is the one in which, having

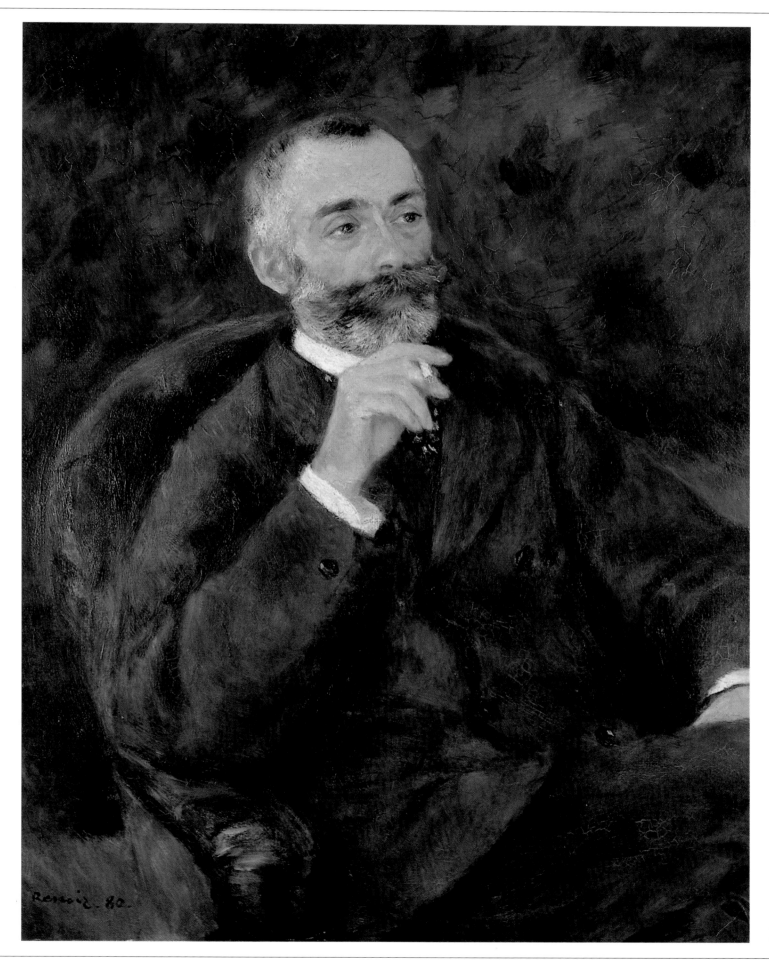

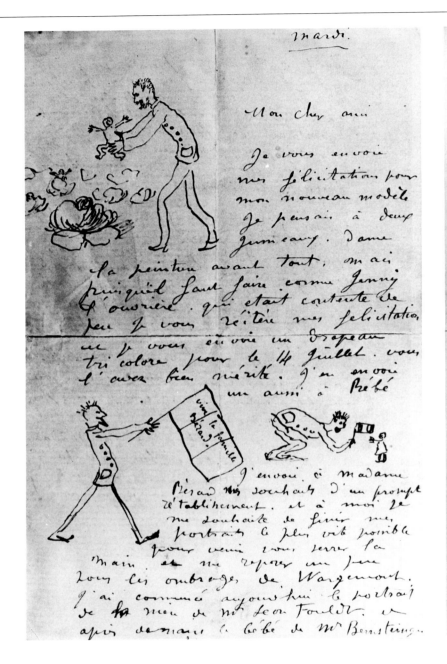

140 Renoir's Letter to Paul Berard for the Birth of Lucie Berard in July, 1880. Private collection.

finally made his models tractable, he went beyond the details of direct likeness in order to create a painting. It is also unquestionably one of the most beautiful tributes that Renoir ever paid to one of his most faithful and attentive collectors.

Like the Charpentiers, the Berards were instruments of Renoir's success. With their connections, they helped the artist become known in wealthy circles, where commissions for portraits were numerous and where, in addition, the models became actual champions of the new art of painting. At the Berards', Renoir was accepted as he was and entertained kindly in spite of his breaches of fashionable good manners, for which others reproached him. How far apart, nonetheless, were Renoir, a workman's son, and Paul Berard.

Paul-Antoine Berard was born in Paris on May 11, 1833. From his parents he had inherited a vast estate in Normandy, near Dieppe; he resided on his property at Wargemont a good part of the year. Berard's declared occupation was foreign affairs' attaché. He was a Protestant and had ties with the banking world like his brother, Edouard, who had also taken an interest in contemporary painting. Although Paul

139, 145

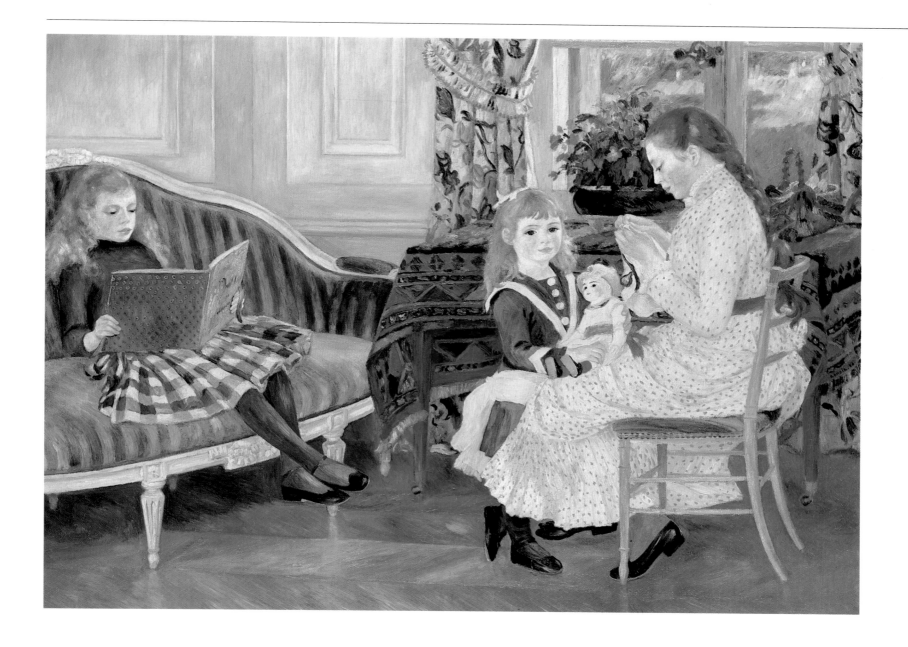

141 Pierre-Auguste Renoir. *Children's Afternoon at Wargemont*. 1884. Oil on canvas, 127 × 173 cm. (50 × 68″). Staatliche Museen Preussischer Kulturbesitz, Nationalgalerie, West Berlin (Gift of Elise König, 1906).
Marthe, who is sitting at the right and sewing, was born in 1870; Marguerite, reading at the left, was born in 1874, and the youngest child, Lucie, in 1880.

Berard owned works by Monet and Sisley, purchased for the most part from Durand-Ruel in April, 1882, his favorite painter was Renoir.

The two men met in the late 1870s at Madame Charpentier's salon through Charles Deudon. In spring of 1879, Paul Berard commissioned a portrait of his eldest daughter Marthe, born in 1870, from Renoir (Museu de Arte, São Paolo); the composition is very sober. The painting pleased the Berards, and Renoir was invited to Wargemont, where he painted various decorative motifs—flowers, game, and so 142
forth—on the doors or above the fireplaces of this Louis XIII-style castle. Over the 143, 144
following years, Renoir painted portraits of the rest of the Berard family (often several of each): André, Marguerite (The Metropolitan Museum of Art, New York), and the youngest, Lucie (The Art Institute of Chicago). For that matter, all the Berard children appear together on an 1881 canvas, on which sketches have been juxtaposed, creating a particularly lively effect (The Sterling and Francine Clark Art Institute, Williamstown, Massachusetts).

While he was staying at Wargemont, Renoir's hosts did not monopolize him. The artist Jacques-Emile Blanche, a neighbor and friend, recalls having seen Renoir working in the park at Wargemont on the painting that he would send to the 1880 Salon, *Mussel Fishers* (The Barnes Foundation, Merion, Pennsylvania). *Gypsy Girl* 165

142 *The Castle of Wargemont.* Photograph.

143 *Inside the Castle of Wargemont,* showing a panel painted by Renoir. Photograph.

(Private collection, Canada) from 1879 was also painted at Wargemont, as well as the sinuous landscape now in the Toledo Museum of Art, Ohio. None of those works, however, belonged to Paul Berard. In Paris too, Renoir was frequently invited to the Berards' town house at 20 Rue Pigalle, an elegant eighteenth-century building (now destroyed) surrounded by a garden on the far side of the vault leading to the house from the street. As in the case of Chocquet's apartment, Impressionist painting harmonized with the furniture and collections of objects from the eighteenth century. Another interesting note: when Renoir traveled or could not see his friend, he wrote dozens of letters to Berard; the correspondence extended over a quarter century, from 1880 to the death of Paul Berard on March 31, 1905.

Berard did not "hoard" paintings like Faure, Hoschedé, or even Chocquet or De Bellio. His intelligent sympathy for, and fair appreciation of, Renoir's experiments were as important to the artist as Berard's commissions for portraits or those he procured for Renoir through his connections. Why, otherwise, would Renoir write to him in August, 1885: "I have started a bunch of things and not one is finished. I rub out, start again; I believe the year will go by without a canvas, which is why I turn down the visit of any artist whatsoever.... I prevented Durand-Ruel from coming to see me.... I want to find what I am looking for before revealing myself. Let me search...."

Of course their correspondence was not always so serious. Renoir liked to cheer up his correspondent when he felt Berard was worried. The artist sent enthusiastic letters from Italy to Berard, as he did to the Charpentiers. From Venice, he proclaimed: "I am in love with the sun and the reflections in the water and, in order to paint them, I would go around the world. But when I am there, I feel my inability"—as always, a pessimistic note. Renoir also counted on Berard to manage his savings as well as his consignments for the Salon. In spring of 1902, as he was preparing to leave for Algiers and recovering in the south of France from pneumonia, Renoir told Berard to choose for him either "the little Yvonne Grimprel, or your portrait, or whatever you want from your home.... You need only pick up a form at an art-supply shop, fill in the blanks, and sign 'Renoir, Pierre-Auguste.'"

On December 12, 1883, Paul Berard wrote to his friend Charles Deudon: "As for Renoir, he is having a bout of discouragement. His immense studio scares him, and he can do nothing there. Except for the portrait of Madame Clapisson, I have seen nothing new, and he has no commissions. He admitted to being worried about paying so much rent, and now he regrets having left his small studio on Rue Saint-Georges. For that matter, I am appalled by the difficulties encountered trying to get his painting accepted. I paid for a beautiful frame for the portrait of Lucie. I hung it in a good place in my study, and Marguerite and I are rapturously content with it. But, unfortunately for Renoir, we cannot bring people to share our satisfaction, and this portrait—so different from the Hencker [sic]-type of portrait—frightens people." This portrait of Lucie Berard is certainly the one in the Art Institute of Chicago, where Renoir's portrait of Madame Clapisson is also kept.

It should be noted that, thanks to Berard, Léon Clapisson, a bank broker and the son of a composer famous at the time, was a new adherent of Renoir's work. In May, 1881, Clapisson bought paintings Renoir had brought back from his trip to Algeria from Durand-Ruel; however, he sold them back to the same dealer as early as 1892.

As for Paul Berard, even if he hardly bought anything after 1885, his friendship for Renoir did not fade. In 1900, Renoir received the Legion of Honor, and he asked Paul Berard to hand over the emblems to him. This detail fully proves that, for Renoir, Berard was always a guarantee of respectability and of success in society.

Age was leaving its mark on both men, however. Berard became increasingly worried, disgusted with himself and others. Renoir tried to reason with him, finding him "unfair to society, which is still quite interesting when one reaches that shrewd age where one gives up the role of actor to become a spectator. To watch the trumps being counted without participating in the game—what a darn day...." Sometimes Renoir could not prevent his own discouragement from showing, as in September,

Inside the Castle of Wargemont, showing a panel painted by Renoir. Photograph.

1903: "The weather, my painting, nothing has worked out this year.... I write badly; my hands hurt horribly." Renoir was referring to the rheumatism from which he was already suffering.

Early in March, 1905, Durand-Ruel suddenly learned that Paul Berard had decided to auction his paintings along with some faience and furniture. Berard wanted to leave his Parisian town house: now that his wife was dead and his adult children had left home, he found the place too big. Sensing that his time was almost up, Paul Berard had decided to dispose of his paintings. Durand-Ruel was embittered at being excluded from the sale and wrote to Renoir that Berard had been indoctrinated by the Bernheims, Rosenberg, and Petit. Renoir, amazed that even a "multi-

145 Eugène Pirou. *Paul Berard Advanced in Years*. Photograph. Private collection.

millionaire" collector sold his paintings, wrote a note to Berard in Durand-Ruel's favor. When the auction finally took place on May 8–9, 1905, however, only Georges Petit and Bernheim-Jeune were expert-appraisers. The latter acquired *Children's Afternoon at Wargemont* for 14,000 francs, one of the high prices after Monet, but the reserve price had originally been set at 20,000 francs. Shortly afterward, that painting left for Germany: in 1906, it was donated to the Berlin museum.

141

146 Adolphe-Félix Cals. *Count Armand Doria.* 1859. Oil on canvas, 41 × 32 cm. (16⅛ × 12½"). Private collection.

Count Armand Doria and Nicolas Hazard

In 1874, Cézanne, the artist who had been systematically rejected by the official Salon, exhibited three paintings with the Impressionists on Boulevard des Capucines. *A Modern Olympia*, lent by Dr. Gachet, drew the most scathing ridicule: "Mr. Cézanne appears to be no more than a sort of troubled lunatic, painting from *delirium tremens*." 178

Nevertheless, a private collector came forward and purchased one of the two other paintings: *The House of the Hanged Man, Auvers*. The collector's name was Armand-François-Paul Desfriches, Count Doria. A wealthy landowner, Count Doria resided chiefly at his castle at Orrouy, where he was mayor of the village, near Crépy-en-Valois in northern France. The count was a scholar, an earnest Christian, enlisting the famous Abbé Dupanloup as a private teacher, curious about everything, and fond of writing. 149
146, 148
147

Although the general public was not aware of Count Doria, he was well known to Parisian picture dealers and to regular attendants at the Hôtel Drouot. The count visited Durand-Ruel's frequently, but *père* Martin's shop on Rue Mogador was his headquarters. From 1856, the count bought works by Jongkind, by Corot—there were sixty-nine paintings and twenty-seven drawings by Corot at the sale of the Doria collection in 1899—and by Millet, who was far from popular with the general public. After collecting works by those artists, Count Doria enlarged his collections with paintings by Rousseau, Daubigny, Daumier, including Daumier's renowned *Third-Class Carriage* (The National Gallery of Canada, Ottawa), Antoine-Louis Barye, A.F. Cals, Gustave Colin, Stanislas Lépine, and Victor Vignon. Finally, the count discovered the Impressionists.

After the Cézanne, purchased almost certainly during the 1874 exhibition, Count Doria acquired three paintings by Renoir from Durand-Ruel in July, 1876; he would own ten when he died. He also had several works by Manet, by Pissarro, Guillaumin, Sisley, and Berthe Morisot, one Monet, and one Degas (*Dancer Posing for a Photograph* [Pushkin Museum of Western Art, Moscow]), the exact provenance of which is unknown. Many works were probably acquired directly from the artists, for the count had a reputation for studio-crawling as well as for offering hospitality at his apartment in Paris or his castle at Orrouy.

These few purchases made prior to 1878, when Duret's booklet *Les Peintres impressionnistes* was published, were enough to ensure Count Doria's inclusion as one of those "bold collectors" described. The otherwise unknown reference "d'Auriac" was probably just a mistake, though we do not know whether the printer or Duret was responsible for it. All that remains in Duret's booklet of the count's social status is the "d'," signifying that he belonged to the nobility; otherwise, the name is unrecognizable.

When Count Doria died at Orrouy on May 7, 1896, he left an enormous collection: all techniques taken together, it contained almost seven hundred items, at least forty of which were Impressionist. The Doria collection was sold on May 4–5, and 8–9, 1899, at Georges Petit's in Paris. Petit published a lavishly illustrated catalogue for the sale; and financially, it was a big success, for sales amounted to almost a million francs. The prices paid for Corot or Delacroix were hardly surprising, and those for Manet, Monet, or especially, Renoir only a little less so: his *Young Woman* 171

147 *The Castle of Orrouy.* Photograph. The castle of Orrouy and its outbuildings saw many artists pass through: Millet, Cals, Vignon, and Gustave Colin. Musical evenings were also held at Orrouy, for the count's brother, Marquess Arthur Doria, was a musician.

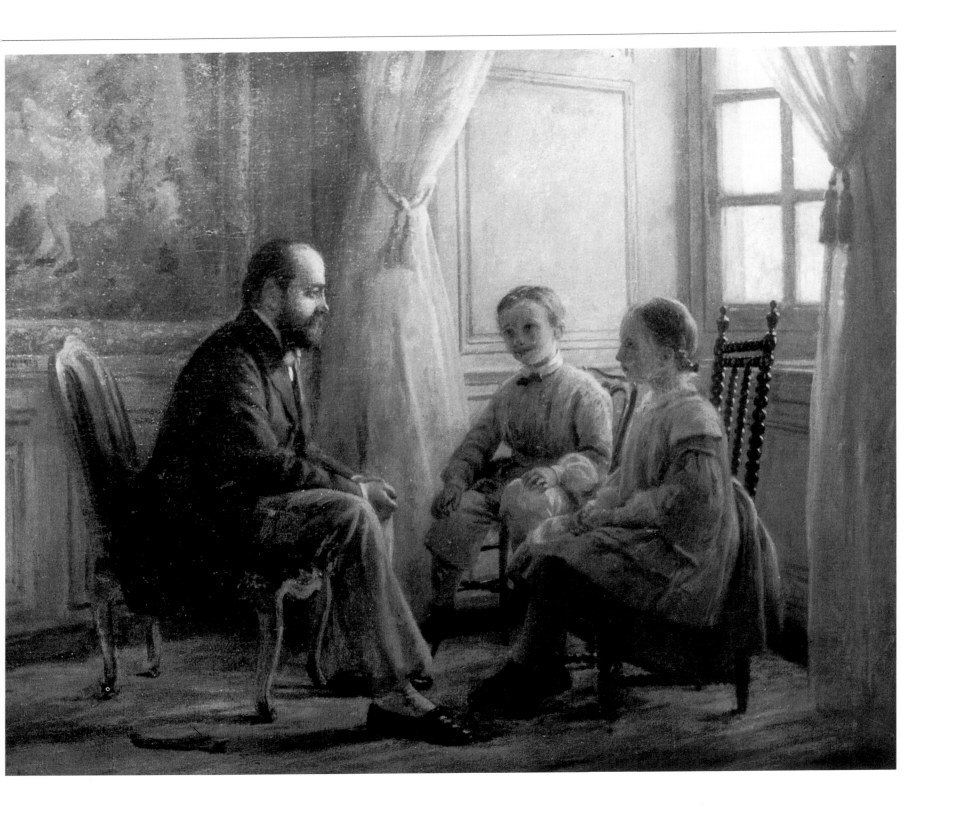

148 Adolphe-Félix Cals. *Count Doria and His Children.* 1859. Oil on canvas, 61 × 50 cm. (24 × 19¾"). Private collection.

Count Doria was born in Paris, on Rue de la Perle, on April 14, 1824. He married in 1851, but his wife died in 1855, leaving him with two young children: Marie-Luce (who died in 1878) and François, who would also become a remarkable collector. A. F. Cals, whom the count sheltered and fed at Orrouy, was the devoted chronicler of the Doria family. (The count wrote the foreword to the catalogue of the Cals sale in 1881, and to the catalogue of the artist's posthumous exhibition in 1894.)

149 Paul Cézanne. *The House of the Hanged Man, Auvers.* 1873. Oil on canvas, 55 × 66 cm. (22¼ × 26¾″). Musée d'Orsay, Paris (Isaac de Camondo Bequest, 1911).

Seated (La Pensée), which now belongs to the English nation (The Barber Institute of Fine Arts, The University of Birmingham), was sold for 22,100 francs. There was, however, total amazement when Claude Monet won the bidding at 6,750 francs for a Cézanne, *Melting Snow: Study in Fontainebleau Forest.* Never, within the memory of a collector, had such a sum been paid for a canvas by Cézanne. The work came from an exchange Count Doria had made with Victor Chocquet. In 1889, Chocquet traded Cézanne's landscape of Fontainebleau for his famous *The House of the Hanged Man, Auvers* (which Cézanne called *Cottage at Auvers*), at the time when Chocquet was acting as a go-between to have the canvas exhibited at the Exposition Universelle.

149

150 Edouard Manet. *Café, Place du Théâtre-Français, Paris.* 1877-81. Black-lead pencil and India-ink wash on graph paper. 14 × 18 cm. (5½ × 7″). Department of Graphic Arts, The Louvre, Paris.

Thus the Doria sale, more than those of Duret, Chabrier, or Ernest May, marked the advent of a new generation of artists and collectors. Two months later, the Chocquet sale merely confirmed this tendency before the century was over.

Nicolas Hazard

Among Count Doria's close friends was one man who was a direct emulator of the count: Nicolas-Auguste Hazard. Born in Paris on December 6, 1834, Hazard died on April 22, 1913, at Orrouy, where his collections were housed in a "gallery" that had been specially designed for them.

Little is known about this collector, except that his taste for painting came from his friend and neighbor, Count Doria. Hazard apparently painted too, since there were works signed with his name in his posthumous sale. On the other hand, it is possible to form a very exact idea of Hazard's collection: since the Hazards had no direct heir, after Madame Hazard's death the collection was sold at auction at the Galerie Georges Petit (on December 1–3, 1919) and at the Hôtel Drouot

151 Pierre-Auguste Renoir. *The Pont Neuf, Paris*. 1872. Oil on canvas, 75 × 94 cm. (29⅝ × 36⅞"). National Gallery of Art, Washington, D.C. (Ailsa Mellon Bruce Collection).

(December 10–11 and 29, 1919). It is amusing to note that, by the choice of artists — from Corot to Cals, from Manet (Hazard bought at Manet's studio sale in 1884) to the Impressionists—Hazard's collection was an exact reflection of Count Doria's. Moreover, Hazard had made many purchases at the Doria sale. That is not a criticism, especially when one considers that the Hazard sale included works such as Renoir's *The Pont Neuf, Paris*, which had been knocked down to Durand-Ruel for 300 francs at the Impressionist auction in 1875. Ironically resold on the same day that Renoir died, its price soared to over 100,000 francs.

151

In 1894, the Hazards had donated four paintings by Cals, (now in the Musée d'Orsay, Paris) to the French national museums. When Madame Hazard died, there were rumors that the national museums would inherit the collection. Alas, only a portrait of Nicolas Hazard by Cals had been designated by name as a bequest. Since it was not an important work of art, the Louvre did not keep it. Therefore, even the likeness of that bold collector Nicolas Hazard has been lost. Today, children from a holiday camp play in Hazard's empty museum on rainy days, totally oblivious to its glorious past.

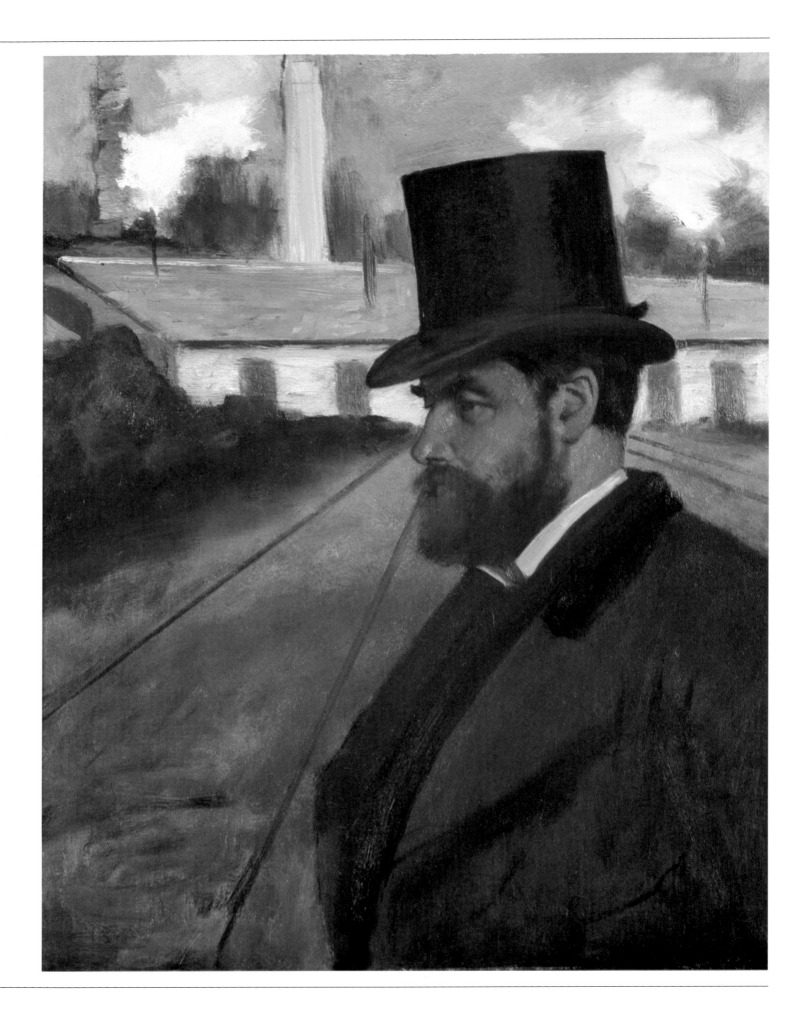

Henri Rouart

152 Edgar Degas. *Henri Rouart.* c. 1875. Oil on canvas, 65 × 50 cm. (25⅞ × 19⅞″). The Carnegie Museum of Art, Pittsburgh (Acquired through the generosity of the Sarah Mellon Scaife family, 1969).
This portrait has a frame line reminiscent of a photograph; Henri Rouart is represented with a picture of his factory, as a symbol. It might be the factory at Montluçon, or simply the 35-yard-high chimney stack that rose above the machine shop of the works at 137 Boulevard Voltaire in Paris, which were destroyed by shelling on June 15, 1918.

At the 1878 Exposition Universelle in Paris, the visitors to the Metallurgy Section could observe a large coil, 302 feet high, on top of the colonnade of big pipes that towered over the hall. This technical feat was the product of the Montluçon factory of the firm of Mignon and Rouart, the first French firm to specialize in metal tubes which, until then, had been the privileged domain of British manufacturers. The mechanical engineer Stanislas-Henri Rouart was awarded the cross of a Knight of the Legion of Honor in October, 1878.

An Engineer and an Impressionist Painter

It is quite probable that Rouart's business acquaintances did not know that the engineer was also an accomplished artist, a regular exhibitor at the official Salons from 1868 to 1872, and then—even more extraordinary at the time—at every Impressionist exhibition from 1876 to 1886, except for the one in 1882. No doubt few of those businessmen had been shown into Rouart's beautiful town house at 34 Rue de Lisbonne, where works by Corot and Delacroix were already giving way to those by Renoir, Monet, and Degas. If Duret did not mention Rouart in his booklet, it was because he thought of him—like Caillebotte—as one of the artists of the group, and therefore not to be considered according to the same terms.

168

153 Henri Rouart. *Terrace on the Banks of the Seine at Melun.* c. 1880. Oil on canvas, 46 × 65 cm. (18¼ × 25½″). Musée d'Orsay, Paris.

154 Edgar Degas. *Henri Rouart and His Daughter, Hélène.* c. 1877(?). Oil on canvas, 63 × 74 cm. (24¾ × 29¼″). Private collection, New York.

155 Edgar Degas. *Hélène Rouart in Her Father's Study.* c. 1886. Oil on canvas, 161 × 120 cm. (63⅜ × 47¼″). The National Gallery, London.
The model for this unfinished portrait has been placed in her family surroundings, suggested by the objects around her: the armchair by Jacob (his mother's maiden name was Jacob-Desmalter), the Chinese wall hanging, the Egyptian objects from her father's collection. Corot's landscape, *Bay of Naples with the Castel dell'Ovo*, and the drawing by Millet, *Little Peasant Girl Sitting Against a Haystack*, also belonged to Henri Rouart and provide an indication of his taste.

Henri Rouart was the perfect model of an intelligent and successful man. He came from a relatively modest family; his father made passementerie. At a time when decorated soldiers abounded, Rouart's father was prosperous enough to become a "landed proprietor." This enabled his son, born on October 2, 1833, to receive a good education at the Lycée Louis-le-Grand and to be admitted to the Ecole Polytechnique in 1853. Henri Rouart, who was better at mechanics than at German composition, graduated as a lieutenant in the artillery but resigned very quickly: he had decided to make a career as an engineer in the private sector. From 1860, Rouart entered into partnership with Jean-Baptiste Java Mignon, concerning himself with such diverse fields as military equipment and refrigeration—he built the cooling units for the Paris

152, 154, 169, 170

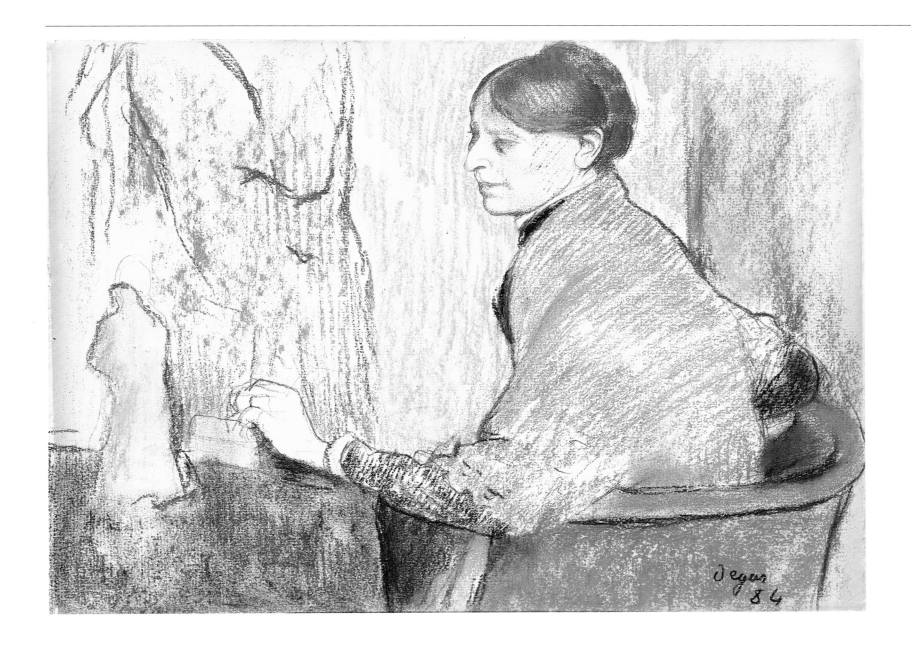

156 Edgar Degas. *Madame Henri Rouart.*
1884. Pastel, 26 × 36 cm. (10¼ × 14⅛″).
Staatliche Kunsthalle, Karlsruhe.
Traces of the illness to which Madame Rouart
would succumb on July 18, 1886, can be
seen on the model's face. Originally Degas
had planned to add a picture of Hélène
Rouart to her mother's portrait. (The skirt of
Hélène's dress can be made out on the upper
left.)

Morgue—pneumatic telegraphy, and electricity. As an engineer, Henri Rouart was a
precursor, and thus he was not simply a man of leisure enjoying his income.

Degas's Friend

The Franco-Prussian War, and especially the siege of Paris during which Henri
Rouart served as captain of a company of volunteer gunners, gave the young
engineer the opportunity to meet once again with an old schoolmate: Edgar Degas,
whose influence on, and friendship for, Rouart would be lasting. Henri Rouart the
artist—"pupil of Messrs. Levert, Véron, and Brandon," a Corot enthusiast (he would
eventually own more than fifty of Corot's works), a great admirer of Delacroix, as
well as of Daumier, Millet, whom he knew personally, and the artists of the Barbizon
School—became a convert to Impressionism. Rouart was a regular customer at *père*
Martin's shop; he even wrote Martin's obituary. Like his friend Count Doria, Rouart
was a patron of Cals and admired Jongkind and Lépine. By participating, from 1876,
in the Impressionist exhibitions as one of the organizing artists and as a lender,
Rouart got to know all the artists in the group and bought works from them. There is

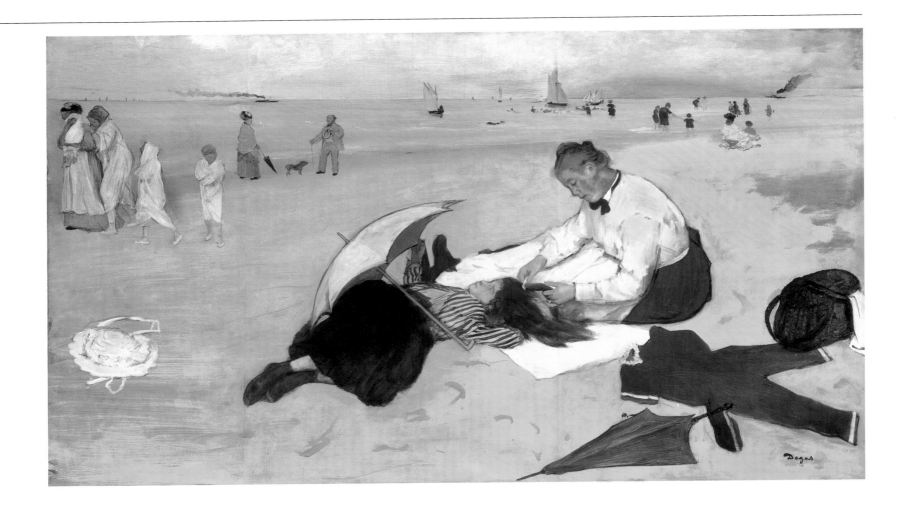

157 Edgar Degas. *Beach Scene.* c. 1876-77. Mixed technique on paper mounted on canvas, 47 × 82 cm. (18½ × 32¼″). The National Gallery, London (Lane Bequest, 1917).
This painting already belonged to Henri Rouart when it was exhibited at the third Impressionist exhibition in 1877.

158 Edgar Degas. *At the Café Concert: "The Song of the Dog."* 1876–77. Pastel and gouache over monotype, 57 × 45 cm. (22½ × 17¾″). Private collection.

no known correspondence between him and his fellow artists, except with Degas; but it is easy to imagine ties similar to those that Caillebotte, rich like Rouart, maintained with the impecunious Impressionists.

Henri Rouart was a regular buyer at the Hôtel Drouot. At the first Hoschedé auction, he acquired a Degas. Rouart was also present at the auction on March 24, 1875, and bought 2 Monets, 1 Renoir, and 2 Berthe Morisots, making him one of the principal bidders. In January, 1875, Rouart had purchased *Snow Effect*; it was the first painting by Monet that Rouart bought directly from the artist, to whom he made loans regularly. Likewise, Rouart owned several paintings by Pissarro. His most beautiful Manet, *The Music Lesson* (Museum of Fine Arts, Boston), had been purchased for Rouart by Durand-Ruel at the auction of Manet's studio. Rouart also took an interest in Renoir. The painting refused by the 1873 Salon, *A Morning Ride in the Bois de Boulogne*, and then *The Parisienne* were hung on the walls of his town house on Rue de Lisbonne. To someone who asked him the reason for his choice, Rouart replied simply, "Because I like it very much."

However, these years seem principally occupied by a sort of continuous dialogue between Rouart and his friend Degas. Their close ties were not confined to the numerous portraits that Degas painted of various members of the Rouart family. Even Henri Rouart's collection—by the very choice of the works—reflects the collection of his friend Degas. How can one explain, except by Degas's influence, the presence at the Rouart sale on December 9–11, 1912, of a Toulouse-Lautrec or the magnificent Gauguin, *Nava nave mahana (Delightful Days)* from 1896, which the Musée des Beaux-Arts, Lyons, hastened to buy? Almost blind, Degas visited the exhibition held before Rouart's estate sales; moreover, it was—symbolically—one of

159
160

161

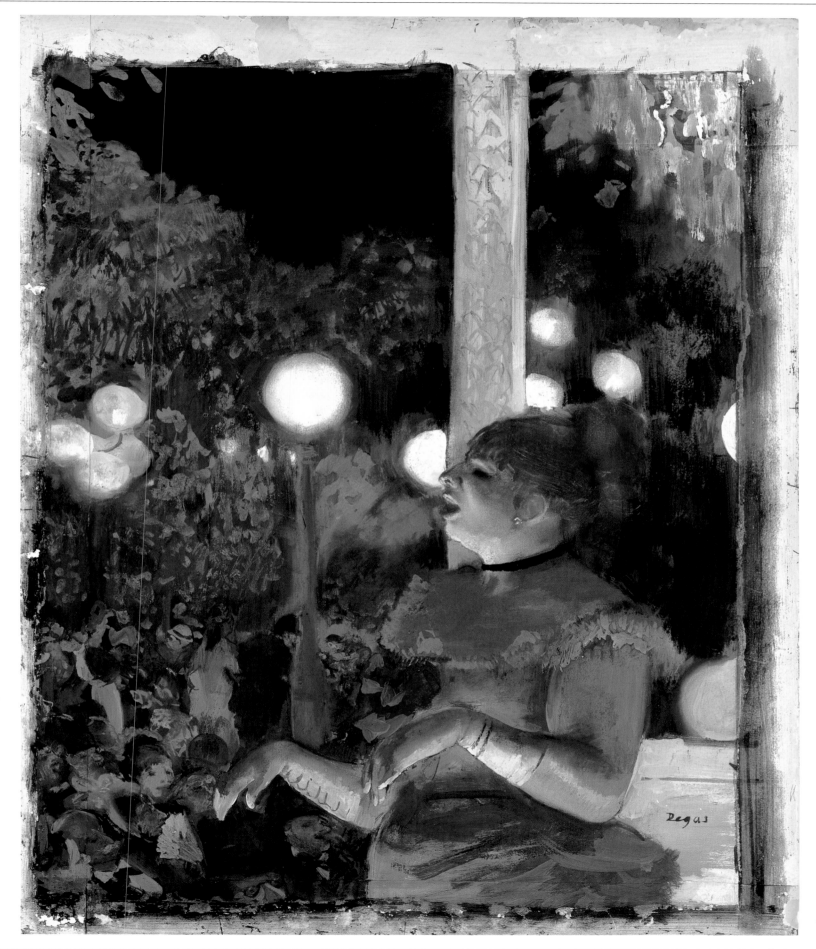

181

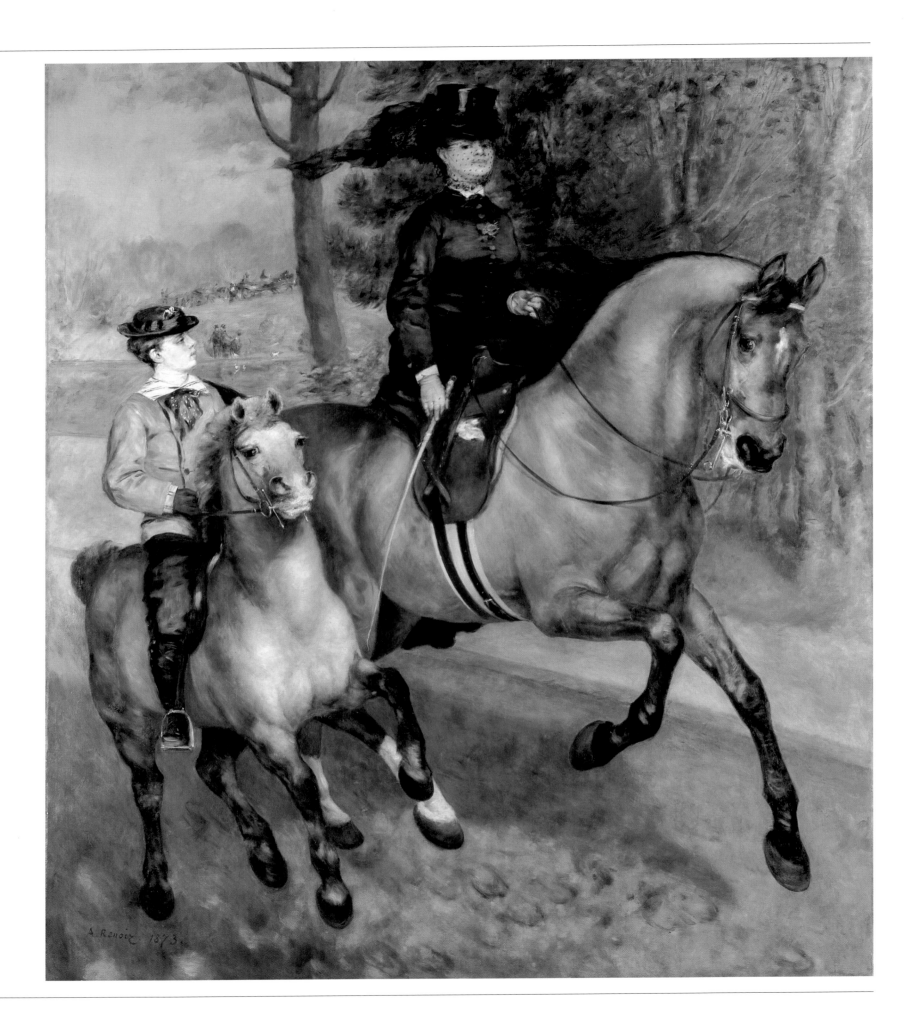

159 Pierre-Auguste Renoir. *A Morning Ride in the Bois Boulogne.* 1873. Oil on canvas, 261 × 226 cm. (102¾ × 89″). Kunsthalle, Hamburg.

160 Pierre-Auguste Renoir. *The Parisienne.* 1874. Oil on canvas, 160 × 106 cm. (61 × 41¾″). The National Museum of Wales, Cardiff (Miss Gwendoline E. Davies Bequest, 1962).

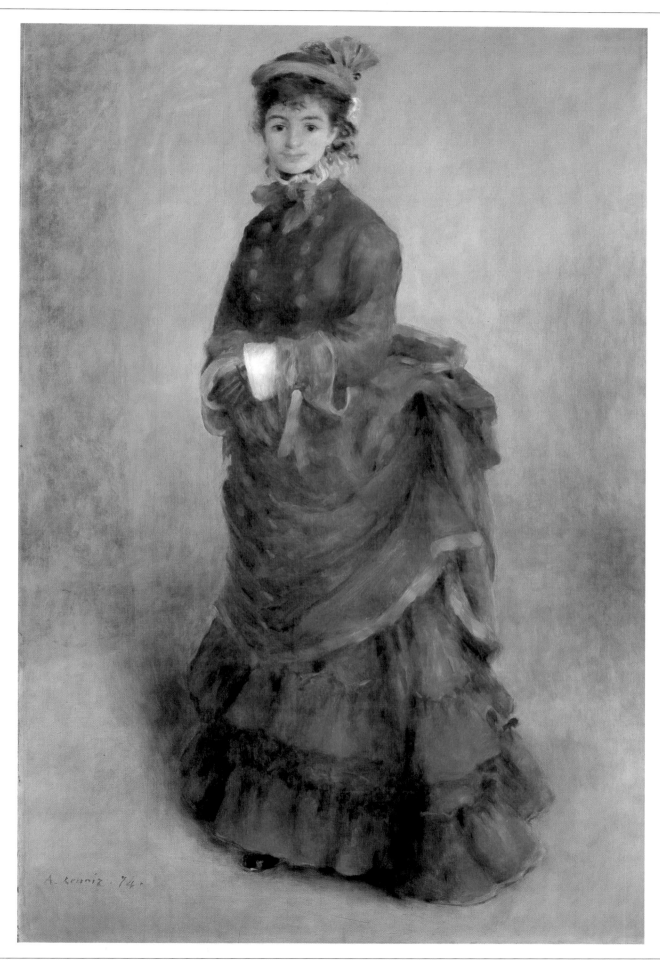

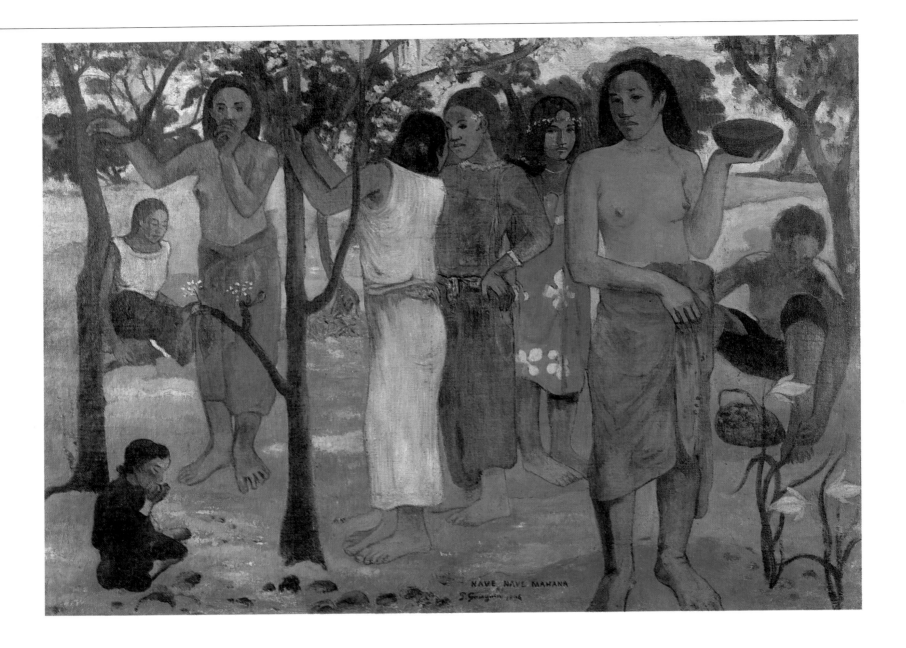

161 Paul Gauguin. *Nave nave mahana (Delightful Days)*. 1896. Oil on canvas, 95 × 130 cm. (37½ × 51¼"). Musée des Beaux-Arts, Lyons.

At the Rouart estate sale, the Lyons museum paid 31,500 francs for this painting, the same price the Louvre paid for Delacroix's *The Stove* (which Monet had asked Durand-Ruel to try to acquire for him up to a maximum of 10,000 francs). As a comparison, a simple copy by Degas after Nicolas Poussin's *Rape of the Sabine Women* (The Norton Simon Museum, Pasadena, California) was sold for 55,000 francs.

his last conscious acts before he was overcome by extreme senility. This good-bye to his best friend, "my only family in France," as Degas said, marked the end of an era.

The Rouart Estate Sales

Henri Rouart died at his Rue de Lisbonne residence on January 2, 1912. His five children—Hélène, the wife of the engineer Eugène Marin; Alexis, a music publisher; Eugène, who had agricultural property in southwestern France; Ernest, an artist who married Julie Manet, the daughter of Berthe Morisot and Eugène Manet; and Louis, also a publisher who later applied himself to the revival of religious art—kept some family portraits for themselves and put up the rest of their father's collection for auction, although they bought back many lots themselves. The sale of the paintings was followed by one for drawings and pastels on December 16–18, 1912. The two days' sales took place at Galerie Manzi-Joyant, probably because of the stake Henri Rouart's brother, Alexis (who had died a year earlier), had had in that firm. On April 21–22, 1913, the last auction at the Hôtel Drouot sold off some old and modern paintings of lesser importance by Boudin, Cals, Brandon, Colin, Ribot, Lepic.

154, 155, 169

166

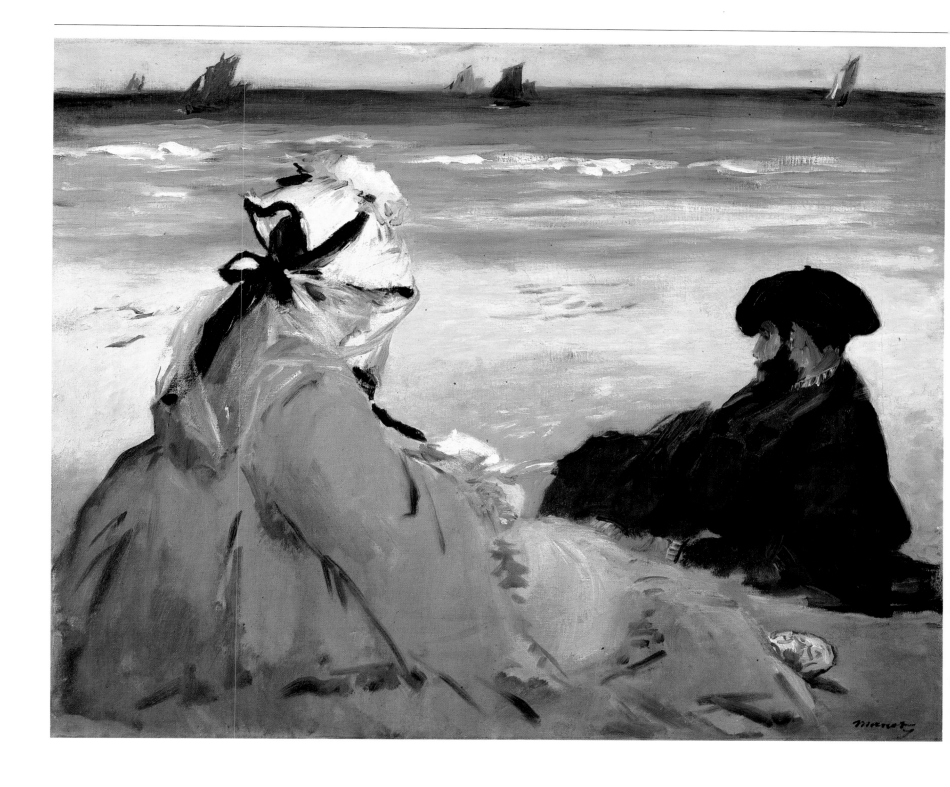

162 Edouard Manet. *On the Beach*. 1873. Oil on canvas, 59 × 73 cm. (22½ × 28⅜"). Musée d'Orsay, Paris (Gift of J.T. Dubrujeaud, 1953, with a life interest in favor of his son, M. Angladon-Dubrujeaud; acquired in 1970).

The first Rouart estate sale was quite an event. The Louvre bought Corot's *Woman in Blue* for 162,000 francs, Daumier's *Crispin and Scapin* for 60,000 francs, and Delacroix's *The Stove* for 30,000 francs. However, the real sensation of that sale was the 435,000 francs Durand-Ruel paid on Louisine Havemeyer's behalf for *Dancers Practicing at the Bar* by Degas. The fashion designer Jacques Doucet, who had just sold off his collections of French eighteenth-century art, making almost 14 million francs—the absolute record at the time for an auction—paid almost 100,000 francs for Manet's *On the Beach*. As a comparison, the Rouart estate sales, comprising some nine hundred paintings and drawings, only made a total of just under 6 million francs, which was sensational enough.

164

162

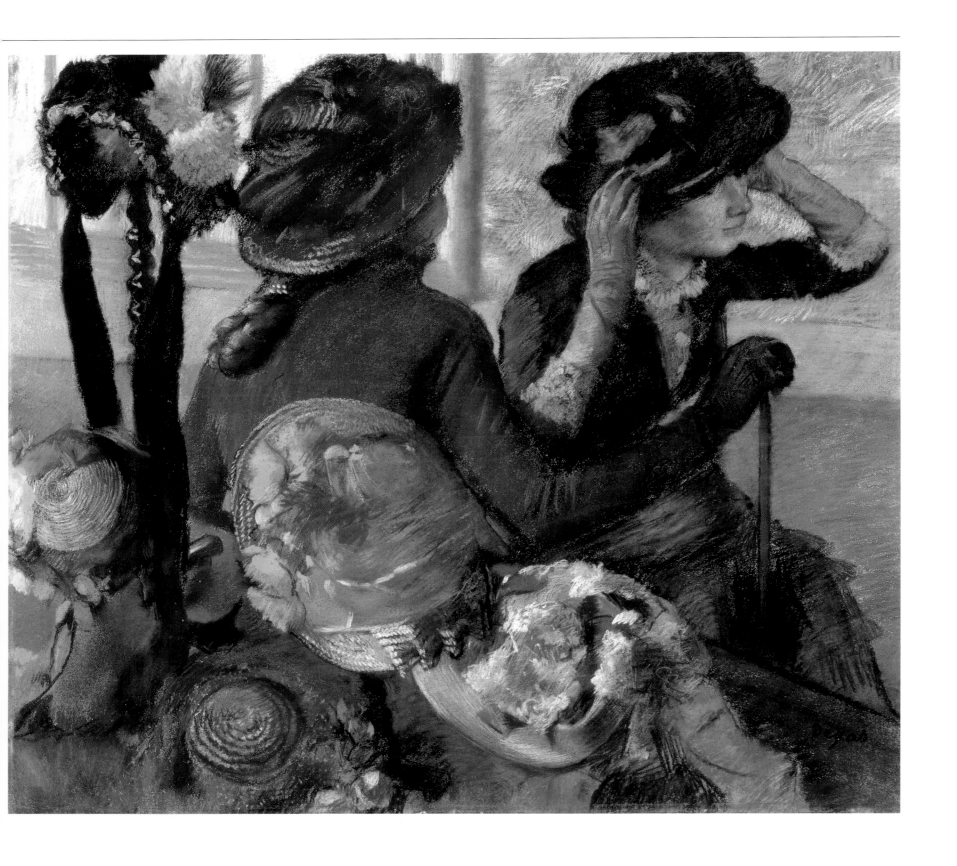

163 Edgar Degas. *At the Milliner's*. 1882.
Pastel, 75 × 84 cm. (29½ × 33½"). Thyssen-
Bornemisza Collection, Lugano, Switzerland.

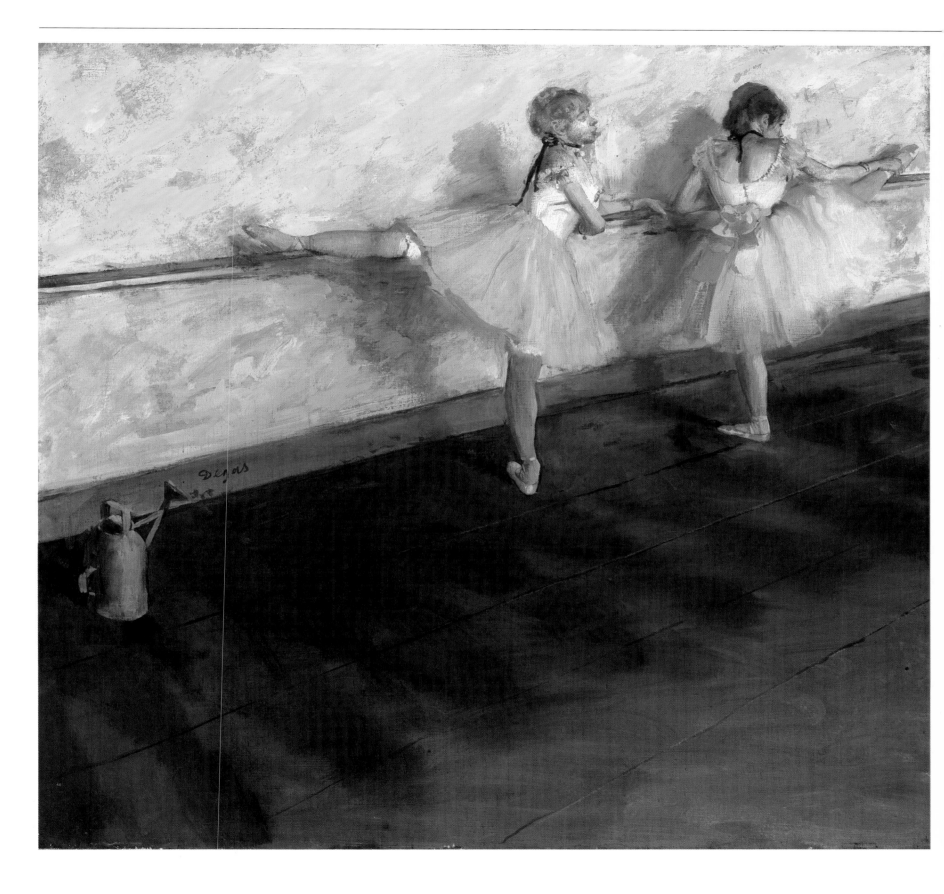

164 Edgar Degas. *Dancers Practicing at the Bar*. 1876-77. Mixed technique on canvas, 75 × 81 cm. (29¾ × 32″). The Metropolitan Museum of Art, New York (Bequest of Mrs. H.O. Havemeyer, 1929. The H.O. Havemeyer Collection).

Degas probably gave this work to Henri Rouart in exchange for another work that he wanted to retouch and is said to have irretrievably lost. At Rouart's estate sale in 1912, the present work was sold for 435,000 francs, the highest price ever paid at the time for a work by a living artist. It became known very quickly that the purchaser was Mrs. Louisine Havemeyer.

165 Camille Pissarro. *Peasant Woman Pushing a Wheelbarrow, Rondest House, Pontoise.* 1874. Oil on canvas, 65 × 51 cm. (25½ × 20″). Nationalmuseum, Stockholm.

166 Anonymous. *Alexis Rouart.* c. 1895. Photograph. Private collection.

Alexis Rouart

Henri Rouart's personality cast a shadow over his less brilliant younger brother, Alexis. Like Henri, who was his partner, Alexis was an engineer, but not a graduate of the Ecole Polytechnique. Before he took over the family residence at 36 Rue de Lisbonne, Alexis Rouart lived at the Mignon and Rouart factory on Boulevard Voltaire in Paris. He was clearly under his elder brother's influence. This was manifest in his appreciation of Degas; among others, Alexis owned *The Little Milliners* (Pl. 167).

166

189

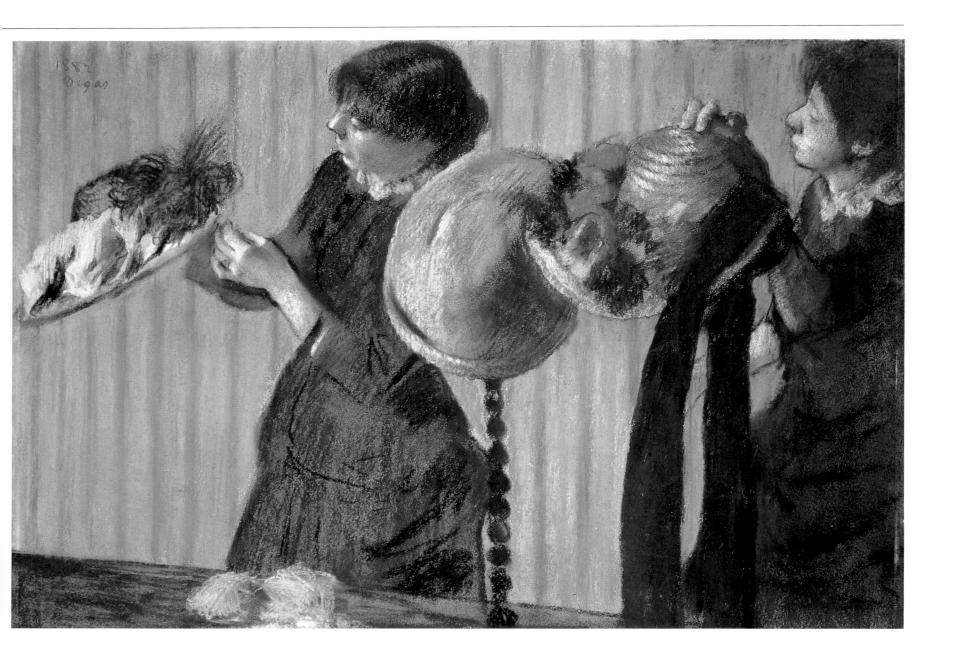

167 Edgar Degas. *The Little Milliners.* 1882. Pastel, 48 × 70 cm. (18⅞ × 27½"). The Nelson-Atkins Museum of Art, Kansas City, Missouri (Anonymous Fund).
On July 10, 1883, Alexis Rouart bought this pastel for 3,000 francs from Durand-Ruel, not from the artist. Later Rouart loaned it to the eighth, and last, Impressionist exhibition in 1886. The highlight of the Alexis Rouart sale in May, 1911, the picture was sold for 51,000 francs.

Yet his stylistic interests led Alexis Rouart to collect engravings by the artists of the so-called 1830 School as well as Japanese prints and Chinese, Hindu, Greek, and Egyptian objets d'art.

Alexis probably took an interest in the Société Manzi-Joyant as a result of his taste for prints. The engraver Manzi, a friend of Degas, lived at 20 Rue Pigalle as Berard's tenant. Among others, Manzi published Toulouse-Lautrec's work. Alexis also belonged to the Union Centrale des Arts Décoratifs, which included many collectors of Japanese art among its members; Lerolle, his father-in-law, was one of the Union's founders.

Paul Jamot reported an amusing episode that provides a good illustration of the atmosphere at Alexis Rouart's: "Every other week, Tuesday, he [Degas] dined at Alexis Rouart's. The usual guests were the brother of the master of the house, Henri Rouart; Dr. Descouts, forensic pathologist for the city of Paris; Abbé de Kergariou; Delavaud, drawing teacher at an educational institution; Gaston Caze, head of a large furniture factory on Rue Charles V—all men of taste and, more or less, artists. . . . Abbé de Kergariou, who had made some attempts at pottery, brought up the question of dinner services and their decoration at one of these friendly meetings. A kind

of contest was opened, in which each one was supposed to make a dozen dishes. . . . Degas decorated a platter and six dishes." By becoming a porcelain painter to please his friends, Degas ended up trying his hand at what Renoir had started his career doing!

Henri Rouart's Friends

Henri Rouart not only introduced his brother to Impressionism; he was also responsible for steering other collectors toward the movement. Some were temporary converts, like Gustave Mühlbacher, a Protestant and a carriage builder in Paris, who ran a firm of 250 employees. Mühlbacher did indeed loan a Degas to the first Impressionist exhibition in 1874; but when he died, his collection (sold at

168 Anonymous. *In Henri Rouart's Studio* in Paris, 34 Rue de Lisbonne. c. 1900. Photograph. Private collection.
The architect Henri Fèvre, Degas's brother-in-law, built Henri Rouart's town house in 1871, in a wealthy, elegant new quarter of Paris, not far from Monceau Park.

Among the paintings visible, we can recognize, in particular, Renoir's *A Morning Ride in the Bois de Boulogne* (Pl. 159), Degas's *Beach Scene* (Pl. 157) at the left, and in the back, a showcase with Egyptian objects recalling Degas's portrait, *Hélène Rouart in Her Father's Study* (Pl. 155).

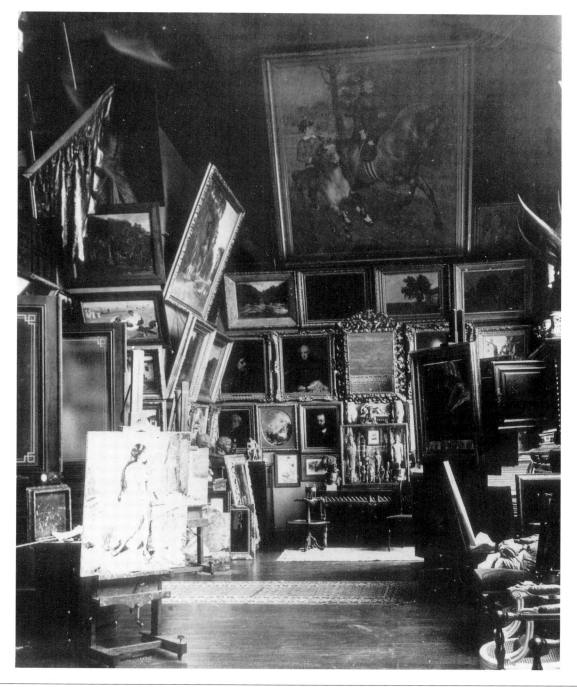

169 Edgar Degas. *Henri Rouart and His Son, Alexis.* 1895–98. Oil on canvas, 92 × 72 cm. (36¼ × 28⅜"). Bayerische Staatsgemäldesammlungen, Munich (Neue Pinakothek).

Alexis-Stanislas Rouart—who should not be confused with his Uncle Alexis—published music scores for a living.

"I admired, I revered in Mr. Rouart the fullness of a career in which almost all the qualities of character and spirit came together. Neither ambition, nor envy, nor a craving for showing off ever tormented him. He loved only genuine values, which he was able to appreciate in more than one domain. The very same man who was one of the leading collectors of his time, who enjoyed and who acquired, early, works by Millet, Corot, Daumier, Manet as well as by El Greco, owed his wealth to his mechanical engineering, to his inventions, which he conducted from pure theory to technology, and from technology to the state of manufacturing.... I would merely say that I place him among the men who made an impression on my mind."

(Paul Valéry, *Degas, danse, dessin,* Paris, 1934. The writer Paul Valéry married Jeanne Gobillard, Julie Manet's cousin. Julie was the daughter of Berthe Morisot and married one of Henri Rouart's sons, Ernest Rouart—Degas strongly encouraged the marriage.)

170 Anonymous. *Henri Rouart Advanced in Years.* Photograph. Private collection, Paris.

This outdoor photograph was probably taken at the Rouarts' country estate at La Queue-en-Brie.

the Galerie Georges Petit on May 13–15, 1907) was noteworthy only for the French eighteenth-century art it contained.

Other collectors were actually Degas's friends as well as collectors of Impressionist painting, yet were associated with Henri Rouart through their work. One, Charles Jeantaud, was a pioneer in automobile research; another, Edouard Lainé, specialized in casting faucets. Contrary to Rouart, their businesses were in a bad way, and their collections remained modest. Sometimes too, the collector did not take the "bait": Henri Rouart's partner, Java Mignon, only kept his portrait of *Madame Gaugelin* by Degas (The Isabella Stewart Gardner Museum, Boston) for a few years.

Dr. Paul Gachet

171 Vincent van Gogh. *Dr. Paul Gachet.* 1890. Oil on canvas, 68 × 57 cm. (26¾ × 22½″). Musée d'Orsay, Paris (Gift of Paul and Marguerite Gachet, 1949).

A printed letter found its way to the Louvre early in 1909, announcing the death at Auvers-sur-Oise on January 9, of Paul-Ferdinand Gachet, "doctor of medicine, physician for the Railroad Company of the North, honorary medical inspector of schools for the City of Paris, artist, and engraver." Dr. Paul Gachet was the modest donor of a single painting to the French national museums: Norbert Goeneutte's portrait of himself, donated in October, 1892, to the Luxembourg Museum. It is more than likely that Gachet's own work (exhibited under the pseudonym of Paul van Ryssel at the Salon des Indépendants from the beginning of the 1890s) passed almost completely unnoticed by his contemporaries, even those in well-informed circles. And yet the more than eighty-year-old man who had just died had known and appreciated, before anyone else, the greatest artists of his time: Cézanne and Pissarro, Renoir and Monet. In May, 1890, on Pissarro's recommendation, Dr. Gachet had welcomed with kindness Vincent van Gogh, who had come to Auvers-sur-Oise to board in an inn. Neither as a friend nor as a physician was Gachet able to prevent Vincent from committing suicide in July, 1890. On the other hand, Vincent gave Dr. Gachet lasting fame by painting two versions of his portrait: one in the Musée d'Orsay, Paris; the other, belonging to the S. Kramarsky Trust Fund (on loan to the Metropolitan Museum of Art, New York). In a letter to his brother Theo, Vincent van Gogh commented in his unique way on his first visit with the doctor: "I have seen Dr. Gachet, who impressed me as being rather eccentric, but his experience as a physician must keep him balanced while fighting the nervous disorder that certainly seems to affect him at least as seriously as it does me."

171, 172

173

171

The term Van Gogh employed, "eccentric," would henceforward be associated with the tormented features he had depicted; and although Van Gogh's excessive opinion still prevails, it must be moderated somewhat. Dr. Gachet's son, who was named Paul too and was also an artist—painting under the pseudonym of Louis van Ryssel—dedicated his life to his father, whom he worshiped, and to the artists his father had admired. Until he died on April 29, 1962, Paul Gachet, Jr. was a sort of living prolongation of a myth—the solemn guardian of his father's collection. Only a few of the major works had been sold off, and he would show the collection but would not loan pictures to any exhibition nor allow the collection to be photographed. Paul Gachet, Jr. was also the chronicler of his hero and of the whole artistic circle at Auvers-sur-Oise at the end of the last century. The books written by Dr. Gachet's son, in a prose as out-of-date as the meticulous penmanship in his manuscripts, his attire, his manners, and his elocution—all described by those who had known him—provide a trove of facts about Dr. Paul Gachet and his social sphere.

172 Amand Gautier. *Dr. Paul Gachet.* 1856. Pencil drawing. Department of Graphic Arts, The Louvre, Paris (Gift of Paul Gachet, 1951).

A Painting Enthusiast and a Physician

The son of the owner of a spinning mill, Paul-Ferdinand Gachet was born in Lille on July 30, 1828. Later, he would take his pseudonym, "Van Ryssel," from the Flemish name for Lille. Gachet nearly became an artist but finally chose medicine and left to study in Paris. He lived on the Rive Gauche, and thanks to his friend, the artist Amand Gautier, also from Lille, who joined him in 1852, Gachet took part in the bohemian

A MON AMI LE DOCTEUR GACHET NORBERT GOENEUTTE

Realist group that revolved around Courbet and the critic and novelist Champfleury. Paul Gachet completed his medical studies in Montpellier and received his doctorate there on June 21, 1858, submitting a thesis entitled "Study Concerning Melancholy"—early evidence of his interest in all types of insanity. In 1857, Gachet's Parisian friends suggested that he take the opportunity, in Montpellier, to visit the famous collector and museum donor Alfred Bruyas, Courbet's patron. In his papers, Gachet even kept a photograph of Bruyas with the dedication, "in memory of shared interests." According to Paul Gachet, Jr., his father came into contact with Adolphe Monticelli and Paul Guigou, artists from southern France, then. It was also in 1858 that Dr. Gachet met Cézanne's father in Aix-en-Provence, when Paul Cézanne was still a teenager.

Having returned to Paris, Dr. Gachet opened an office at 9 Rue Montholon in January, 1859; then, in 1863, he moved to 78 Rue du Faubourg Saint-Denis—an apartment in a building of very modest appearance, where his son still lived after World War II. On his letterhead, Dr. Gachet mentioned that the poor could consult him free of charge and that he specialized in "nervous disorders, women's and children's diseases." An advocate of hydrotherapy, Dr. Gachet became a consulting physician at the spa Evaux-les-Bains in the Creuse department. He was also a partisan of homeopathy. Gachet was definitely not a society doctor, but rather a devoted, compassionate man: as early as 1854, he was awarded the Contagious Disease Medal for his work during a cholera epidemic.

Dr. Paul Gachet had not completely forgotten about art; as a physician, he gave courses in anatomy for artists at the local drawing school in his district. This type of activity led him to publish a review of the 1870 Salon in *Le Vélocipède illustré*, a paper founded by his friend Richard Lesclide, who was friends with Victor Hugo. In the article, Gachet had some rather harsh things to say about Manet, though shortly afterward he changed his mind.

In 1868, Dr. Gachet married. His daughter, Marguerite, was born on June 21, 1869. Gachet spent the siege of Paris in the capital and, a true physician, was always ready to sacrifice himself for his fellow men. In spring, 1872, Dr. Gachet bought a home at Auvers-sur-Oise, which he considered healthier for his family. His son, Paul, was born there on June 21, 1873. Two years later, Madame Gachet died. The doctor never remarried, and his children were raised by a housekeeper.

Cézanne, Pissarro, and Guillaumin at Dr. Gachet's at Auvers-sur-Oise

When Dr. Gachet settled in Auvers, a small colony of artists was already residing in that small village on the Oise River 20 miles from Paris: Daubigny had a house in the village; Daumier lived not far away. The physician was moved by the poverty of that old artist, whom he had known for a long time, and who was almost blind. Gachet wrote to his neighbor at Pontoise, Camille Pissarro, in March, 1874, in order to organize a benefit auction on Daumier's behalf. It was probably thanks once again to Amand Gautier that Gachet had met Pissarro several years earlier. It seems that Dr. Gachet had treated the artist's mother completely by chance. Gachet would later be consulted as a friend, and free of charge, by Pissarro, his wife, and his numerous—unavoidably and frequently ill—offspring.

With the arrival of Paul Cézanne and Armand Guillaumin in Auvers in 1872–73, Gachet found himself caught up in the history of the Impressionist group in its infancy. All of them made engravings in the attic that Gachet had turned into a studio. At that time, Cézanne painted the around thirty paintings that became Dr. Gachet's property. Cézanne's still lifes evoke the curios the doctor collected and the gloomy atmosphere of his house; the landscapes were taken from Auvers itself. Two copies—one a landscape of Louveciennes after Pissarro, the other *Hamlet* after Delacroix—provide a key to Cézanne's preoccupations at that pivotal point in his career. A

174

175 Camille Pissarro. *The Road at Louve-ciennes*. 1872. Oil on canvas, 60 × 73 cm. (23⅝ × 28¾″). Musée d'Orsay, Paris (Gift of Paul Gachet, 1951).

Modern Olympia, exhibited at the first Impressionist exhibition in 1874, is formally imbued with memories of Delacroix, while offering a half-serious, half-facetious challenge to Manet's great painting. Since this painting belonged to Dr. Gachet, who loaned it to the 1874 exhibition, we are able to make out exactly what caught the interest of that collector.

Gachet met Manet through his friend Lesclide. First, Lesclide had asked Frédéric Régamey for an etched reproduction of Manet's *Le Bon Bock*, a success at the 1873 Salon, for his *Paris à l'eau-forte*. A little later, Lesclide asked Manet to illustrate Mallarmé's translation of Edgar Allan Poe's *The Raven and Other Poems*, and Manet dedicated a sheet with a portrait of *Courbet* (Musée Gustave Courbet, Ornans) to Gachet. The two men were drawn together not only by their mutual interest in

176 Camille Pissarro. *Chestnut Trees at Louveciennes*. c. 1872. Oil on canvas, 41 × 54 cm. (16¼ × 21¼″). Musée d'Orsay, Paris (Gift of Paul Gachet, 1951).

painting, but also by their love of cats. Later, Gachet was called to the dying Manet's bedside as a physician. In spite of his admiration for the artist, Gachet did not own an important work by Manet, probably because he could not afford one.

Apart from Cézanne, the two artists with whom Gachet was the most intimately acquainted were Armand Guillaumin and Camille Pissarro. Gachet owned more than thirty canvases by Guillaumin, only six of which are now in the Musée d'Orsay, Paris—but those six are top-quality paintings. One, *Sunset at Ivry*, is famous for 177 having appeared in the first Impressionist exhibition. There is an anecdote connected with another, Guillaumin's *Reclining Nude*: Vincent van Gogh, who was particularly fond of the painting, reproached its owner—he is purported to have pointed a gun at Dr. Gachet—with not having made the effort to have it suitably framed.

From Pissarro, with whom he corresponded quite regularly, Gachet collected about twelve, rather early works: views of Louveciennes (Pls. 175, 176) and England 199

177 Armand Guillaumin. *Sunset at Ivry.* 1873. Oil on canvas, 65 × 81 cm. (25½ × 31⅞″). Musée d'Orsay, Paris (Gift of Paul Gachet, 1951).

as well as landscapes painted at Montfoucault at the home of the artist Ludovic Piette, a friend of Pissarro.

Dr. Gachet, Monet, and Renoir

Dr. Gachet seems to have owned only Monet's *Chrysanthemums* (Musée d'Orsay, Paris) and a landscape in pastel. Their relationship, while cordial, was not really close; it was limited to an appeal for help from Monet in February, 1878, a dismal year for the artist just before the birth of his second son. Monet, to whom Gachet had already loaned money, immediately received the modest sum of 50 francs. It is likely

178 Paul Cézanne. *A Modern Olympia.* 1873. Oil on canvas, 46 × 55 cm. (18⅛ × 21⅝″). Musée d'Orsay, Paris (Gift of Paul Gachet, 1951).

that *Chrysanthemums,* dated 1878, was exactly the balance due on the artist's debt. Nonetheless, it is quite clear from Monet's letter of December 16, 1878, to Eugène Murer that the artist was afraid of being forced to sell his canvases too cheaply to the doctor; Monet preferred to pay back 100 francs rather than to relinquish a painting for that price.

Finally, thanks to a few letters dated January and February, 1879, we can outline the thoroughly romantic story, true to the Naturalist tastes of the era, of Gachet's relations with Renoir. Renoir had a model—perhaps she meant more to him than that—who was only designated as Mademoiselle L. in the letters. She lived at 47 Rue Lafayette. Making use of an author's prerogative, Paul Gachet, Jr. calls her "Margot." Using various cross-checks, including the documented testimony of her great grandson, we can now be sure that she was the young seamstress Alma-Henriette (known as Anna) Leboeuf. It was this young woman, who had fallen gravely ill, whom

201

179 Charles Léandre. *Dr. Paul Gachet.* c. 1878. Caricature in pencil, 22 × 15 cm. (8¾ × 6″). Department of Graphic Arts, The Louvre, Paris (Gift of Paul Gachet, 1951).

180 Pierre-Auguste Renoir. *Portrait of a Model*, sometimes known as *Portrait of Margot.* c. 1878. Oil on canvas, 46 × 38 cm. (18⅛ × 15″). Musée d'Orsay, Paris (Gift of Paul Gachet, 1951).

Dr. Gachet treated at Renoir's insistent request. The sick woman was already dying, however. Another physician, Georges de Bellio, also visited her and could only confirm that there was no hope of her surviving. Anna was twenty-three years old when she died on February 18, 1879. According to Paul Gachet, Jr., Renoir gave his father the delightful portrait of a model (not the dark-haired Anna Leboeuf) now in the Musée d'Orsay, Paris, after Anna died. 180

Although it seems that Gachet did not greatly increase the number of Renoirs in his collection, he had occasion to see the artist again often until the end of the century. Gachet also owned a painting of *Bathers*; it might be the sketch from life that Renoir was considering offering to the doctor in a letter to Murer dated October 30, 1890.

A Familiar Figure in Artistic Circles

It is too bad that Paul Alexis, alias Trublot, reporter for *Le Cri du peuple*, who made some nice remarks about the collector from Auvers-sur-Oise in an article on August 15, 1887, did not list the doctor's riches in detail as he did for Eugène Murer. Since there was no estate sale after Dr. Gachet's death, all we know about the doctor's collection comes from the notes compiled by his son. They at least have the advantage of referring to the confused mass of old paintings, Flemish for the most part, side by side with a pleiad of works by obscure contemporary artists—except for Amand Gautier—and by friends who frequented the vicinity of Auvers. Also noteworthy are the portfolios of prints, reflecting Dr. Gachet's interest, as Van Ryssel, in that medium. Paul Gachet, Jr. emphasized the fact that his father usually bought directly from the artists, although the doctor had been known to do business with *père* Martin.

Like all collectors, Dr. Gachet attempted to make converts to Impressionism. At the beginning of this century, a grocer from Pontoise, Jean-Baptiste-Armand Rondest, still owned 3 Cézannes, 3 Pissarros, and 1 Guillaumin that he had accepted on the doctor's advice in exchange for food.

As an "independent" artist, Gachet/Van Ryssel met the younger generation of artists. He owned works by Emile Bernard. A news item in the November 15, 1887 issue of *Le Cri du peuple* referred to Dr. Gachet as a table companion of Seurat, Signac, Lucien Pissarro, and their friends at the "Rouge et Bleu" dinners held at Restaurant Philippe's at the Palais Royal. Dr. Gachet, however, owned no works by those artists. The doctor was fond of such literary-artistic gatherings, and he was an influential member of the Eclectics' Society, founded in 1872 by that jack-of-all-trades Aglaüs Bouvenne and by Alexis Martin, an eminently minor poet.

Dr. Gachet attended their merry meetings regularly from 1873 until they stopped in 1904. The main function was the monthly dinner, where, said Paul Gachet, Jr., "you eat, drink, smoke, tell stories. You make jokes about serious things; you take nonsense seriously. You laugh: everyone is happy and anxious to outdo each other" with his literary and artistic works. Among the society's most famous members were the artists and engravers Frédéric Régamey and Norbert Goeneutte, who was close friends with Dr. Gachet and died at Auvers-sur-Oise. Being an engraver, Dr. Gachet prepared the invitation cards to the Eclectics' dinners several times.

What emerges from all that we have said is the picture of an "eccentric"; the nineteenth century produced them in profusion. Dr. Gachet's only difference is that fate and an undeniable flair led him to encounter exceptionally creative artists. The last of these was Vincent van Gogh. 181

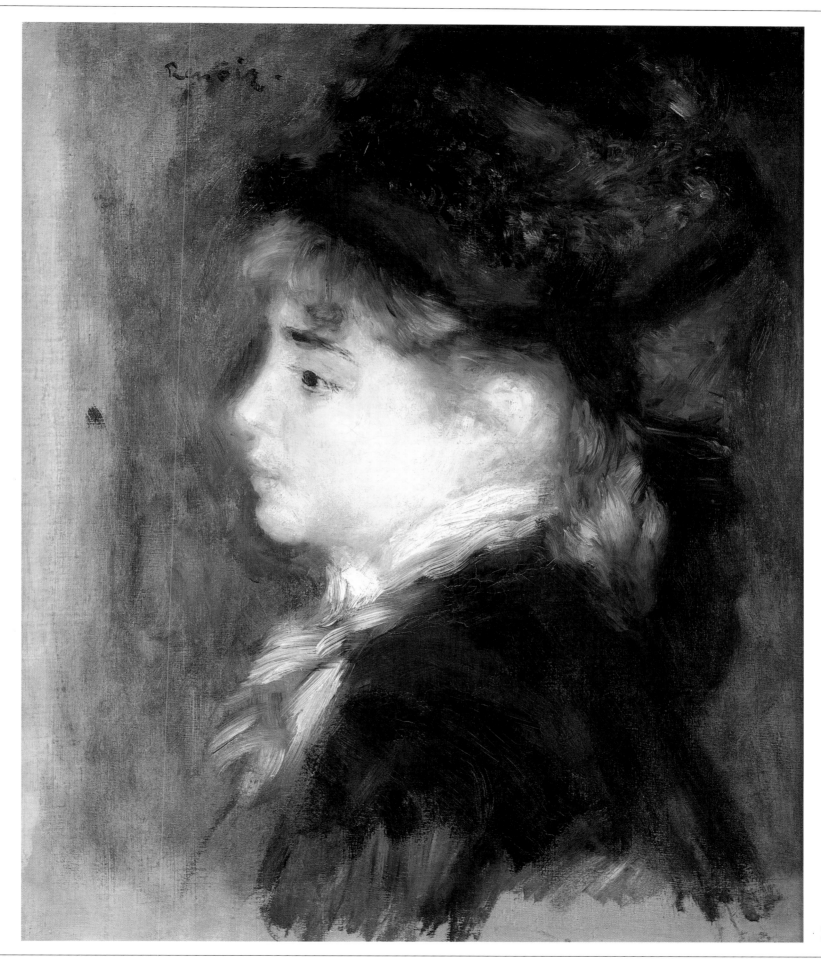

203

Dr. Gachet and Van Gogh

Vincent van Gogh, confined at Saint-Rémy, absolutely wanted to leave the asylum. His brother Theo, being a picture dealer, knew Pissarro well, and asked the artist for advice. Pissarro recommended Dr. Gachet, who agreed to see Vincent. As the latter said, an inn would suffice for his lodgings, "the main thing is to know the physician so that, in case of an attack, you do not fall into the hands of the police to be transported forcibly to an asylum."

Vincent van Gogh arrived in Auvers on May 20, 1890, without having taken advantage of Dr. Gachet's consulting hours in Paris. Van Gogh saw the doctor immediately, and Gachet recommended a first inn. Vincent only stayed there one day, then took a room at Ravoux's on Place de la Mairie, where room and board cost only half as much. The following Sunday—Pentecost Sunday—Van Gogh lunched at the doctor's and, according to Gachet's son, made the etching *Man with a Pipe,* the first portrait of his host. Van Gogh came back to Dr. Gachet's often. Vincent's brother, Theo, Theo's wife, and their small son were also invited there. Everything seemed to be going well. The only alert was the scene Vincent made about the frame for Guillaumin's painting. His fit of anger made him threatening. But Gachet, who had often visited mental hospitals, did not get excited and forgot the alarming episode for the time. Vincent had formed his own opinion of Dr. Gachet: "He certainly seems as sick and bewildered as you or me ... but he is very much a physician, and his profession and his faith still have a hold on him. We are already very friendly."

Van Gogh did not like the "old Flemish" interior of Gachet's house in Auvers, which was littered with curios. He got bored during provincial lunches "of four or five courses." However, he appreciated Dr. Gachet: "That man is a good judge of painting and likes mine a lot; he gives me strong encouragement, and two or three times a week he spends a few hours with me to see what I am doing." As Paul Gachet, Jr. emphasized, the physician was certainly not able to separate the artist from the patient, and a part of Dr. Gachet's interest in Van Gogh's works was surely derived from observing his madness. Gachet had once collected the letters of madwomen in the Salpêtrière asylum in Paris and had visited the engraver Charles Meryon, who died insane.

On the evening of July 27, Dr. Gachet was informed that Van Gogh, a bullet wound near the heart, lay dying at Ravoux's boarding house. The physician went to his bedside, but did not stay until Van Gogh died at one o'clock in the morning on July 29. He was buried at Auvers-sur-Oise. There were sunflowers planted on his tomb, for which Theo van Gogh thanked Dr. Gachet.

Little by little, Theo himself gave way to insanity. His wife and his brother-in-law asked Dr. Gachet for medical advice, knowing that Theo liked him. They even thought of asking Dr. Gachet to write a book about Vincent. Neither Dr. Gachet nor the renowned Dr. Blanche was able to help: Theo van Gogh died in Holland six months after his brother. Later, his body was reburied next to Vincent's in the country cemetery at Auvers.

As for Dr. Gachet, he is buried in Père Lachaise Cemetery in Paris. Today, people who make the pilgrimage to Vincent's grave in Auvers-sur-Oise might fail to remember Dr. Paul Gachet. However, his children donated some of the most beautiful paintings in his collection to the French national museums—a permanent reminder to visitors to the Musée d'Orsay, Paris, of his role.

205

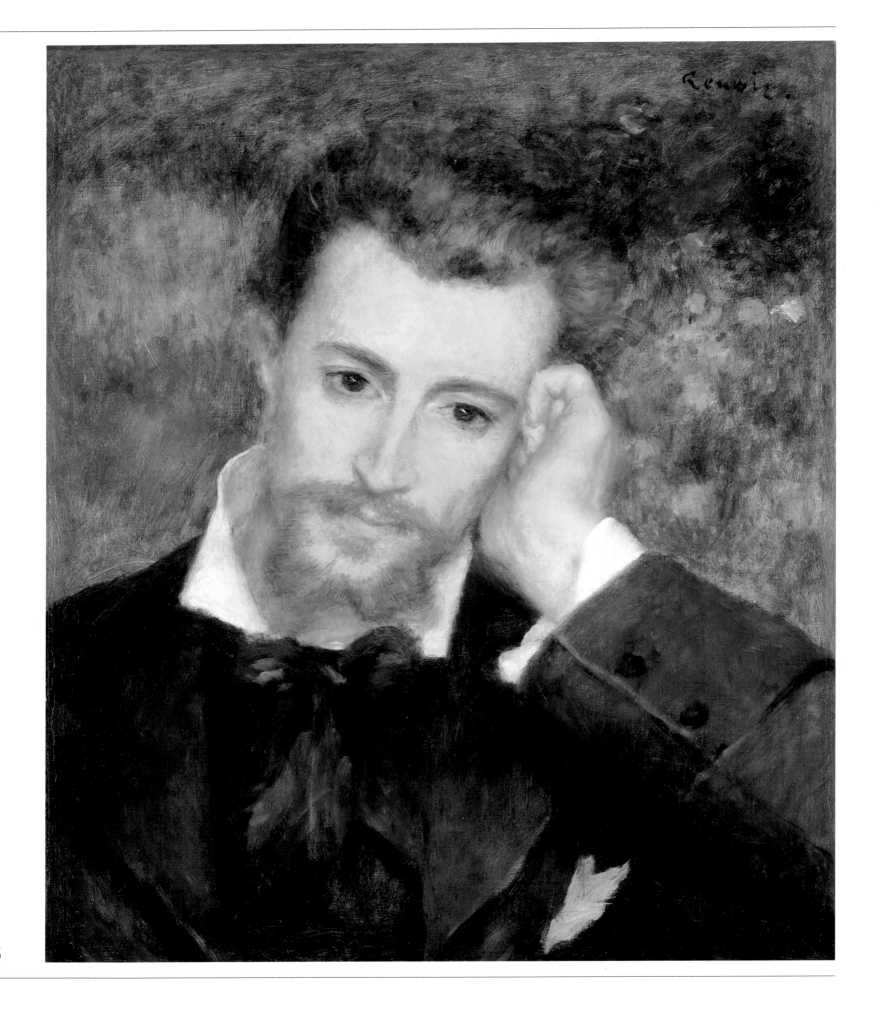

Eugène Murer

183 Pierre Outin. *Eugène Murer.* 1864. Charcoal with white highlights on buff-colored paper, 22 × 18 cm. (8¾ × 7″). Department of Graphic Arts, The Louvre, Paris (Gift of Paul Gachet, 1951).

◁ 182 Pierre-Auguste Renoir. *Portrait of Eugène Murer.* 1877. Oil on canvas, 46 × 38 cm. (18½ × 15¼″). Collection Mr. and Mrs. Walter H. Annenberg, Rancho Mirage.

Not content with memorializing his famous father, Paul Gachet, Jr. sought also to bring to light recollections of an old family friend and an author ill-treated by succeeding generations—Eugène Murer.

A Man of Letters and a Pastrycook

Gachet confessed that it was rather difficult to discuss the beginning of his hero's life: Murer had always lied about his birth! The key to Murer's behavior can be found in the fact that Hyacinthe-Eugène was an illegitimate child, born in Poitiers on May 14, 1841, "mother, undesignated." His parents, Antoine Meunier and Marie-Thérèse Pincan, did not acknowledge him and finally give him the surname of Meunier until 1872. In the meantime, he had made a name for himself in literature as Eugène Murer—the name by which he should rightfully be known. Illegitimacy a hundred years ago, painfully endured, was the subject of Murer's first novel, *Comment se vengent les bâtards (How Bastards Are Avenged)*, published in 1866, when he was twenty-four. Writing under the pseudonym of "Gene-Mur" this time, Murer took up the same subject again in 1876, with *Les Bâtards*, Volume I: *Fremès esquisse*, which was no more than a repetition of his first, despairing essay. Victor Hugo wrote Murer a short, grandiloquent note after his first novel was published. As Paul Alexis would say later, Murer's novels were "neither Naturalist, nor Symbolist, nor Romantic, nor Classic. But they could not be accused of being trite," the opinion of a friend, which while somewhat noncommital, avoided saying that Murer's books were extremely bad.

182, 183, 185, 189

Murer was brought up in the country by one of his grandmothers, then sent to a boarding school in Moulins. This friendless child had only one teacher from whom to learn about literature: a pastrycook on Rue du Faubourg Poissonnière in Paris, Eugène Gru, author of the now-forgotten *Morts violentes*, which enjoyed a certain success as a curiosity when it was published. In addition to his modest sponsorship in the literary world of Parisian Realists, Gru gave Murer a profession: pastrycook.

On July 1, 1870, Murer signed a lease for a pastryshop with a small apartment on the first floor at 95 Boulevard Voltaire in Paris. Two weeks later, France declared war on Prussia. Murer went through the war, the siege of Paris, and the Commune unscathed. In order to estimate the size of Murer's business, we can compare his annual rent of 2,500 francs for the shop and apartment with the 30,000 francs that Durand-Ruel paid when he set up his business on Rue Laffitte at the same time, or with Latouche's annual rent of 6,000 francs. Everything leads us to believe that the novelist did well for a small shopowner.

Murer had married, but his wife died young, leaving him with a son, Paul, born in 1869. Murer's sister, Marie Meunier, came to live with him; she provided the feminine presence—charming according to everyone—in their home. Over the next ten years, Murer would gather together in his undistinguished residence works by Renoir, Monet, Sisley, Guillaumin, and Cézanne.

184 Pierre-Auguste Renoir. *Mademoiselle Marie Murer*. 1877. Oil on canvas, 67 × 57 cm. (26⅝ × 22½″). National Gallery of Art, Washington, D.C. (Chester Dale Collection).
There is another version of this picture in the Barnes Foundation, Merion, Pennsylvania.

Murer as a Collector

In 1872, according to Paul Alexis, Murer had a chance meeting in Paris with a childhood friend, Armand Guillaumin. Murer bought a painting from Guillaumin. Alexis added, "Guillaumin introduced him to his comrades little by little. One picture after the other quickly snowballs." Alexis, writing under the pseudonym Trublot in the *Le Cri du peuple*, then enumerated a list of comical titles meant to spice his story; they included 8 Cézannes, 25 Pissarros, 15 Renoirs, 10 Monets, 28 Sisleys, 22 Guillaumins, and at the end, 4 Vignons, 2 Van Ryssels (Gachets), and 8 watercolors and drawings by Delacroix and Constantin Guys. Unfortunately, it is very difficult to identify the approximately one hundred works, although there were surely some masterpieces among them. Murer himself gave Duret the chronology of his various introductions to the Impressionists: "It was through Guillaumin, a fellow student at the private secondary school in Moulins, that I met, first of all, Paul Cézanne, Guillaumin's neighbor on Quai d'Anjou: 1875. Guillaumin brought Pissarro next.... Then came Sisley ... Renoir.... As for Monet, he turned up later, following the trail left by his comrades. Degas held himself more aloof. I met him at the [time of the] first Impressionist exhibitions, with Caillebotte and Vignon. The last later became my neighbor in the country at Auvers[-sur-Oise]; [I also knew] Gauguin and Van Gogh, who killed himself in July, 1890, behind the village church, on Montcel hill." (July 18, 1905)

This late statement fits well with the dates of the letters the artists sent to Murer. The main contacts took place between 1877 and 1880. For their part, Renoir, Monet, and Pissarro all expressed a certain annoyance with the collector, though each in his own way. Renoir always found a good excuse not to attend the famous "Wednesdays" held in Murer's back shop on Boulevard Voltaire, to which Murer invited "his" artists and literary friends. This did not prevent Renoir from accepting Murer's commissions for portraits, however. Renoir must have had a certain amount of faith in Murer, for he entrusted him with his project for reorganizing the 1880 Salon. Murer, promoted to art critic for the occasion, had the project published in *La Chronique des Tribunaux*, a publication as unknown as it was short-lived. No doubt Renoir, who used to work as a porcelain painter himself, was prepared to be more indulgent toward the autodidactic pastrycook than the other, middle-class Impressionists.

Monet, for instance, had no respect for Murer's critical talent; in a letter to Duret in July, 1880, Monet alluded to "a long, rambling piece by [the] pastrycook [enveloped] in cream puffs." Moreover, Monet was the curtest of all his comrades, especially when it came to money. He became angry when Murer, possibly with good reason, pressed for "delivery" of a painting. But Monet was not in a position to break off with Murer, for Murer was both a customer and a creditor. We get the impression that, in fact, all the Impressionists found this ineffectual pen-pusher quite absurd: to anyone who would listen, Murer would tell how Balzac had given him a 5-centime piece as a tip one day, when he was still a pastrycook's assistant; or he would show the framed letter, signed by Victor Hugo, congratulating him on his first novel. Later, Murer began to paint and exhibit his work, putting forward the names of his former "protégés," who had finally made good. That would complete the split between Murer and the Impressionists.

Yet Murer did indeed commission portraits of himself, his sister, and his son from Renoir and from Pissarro. He also did quite a lot to help artists in distress. He organized a lottery, for it was not unusual at the time to raffle paintings, especially for charity. First prize was a painting by Pissarro. Murer invited his friend Dr. Gachet to the drawing and invited Sisley, Pissarro, and Guillaumin to lunch at the same time. At that lunch in November, 1877, Murer referred to canvases by Sisley that he had "to show to Mr. Laurent-Richard."

Laurent-Richard was an important collector. A former tailor turned perfumer on Rue Laffitte and very prosperous, Laurent-Richard had monopolized the attention of

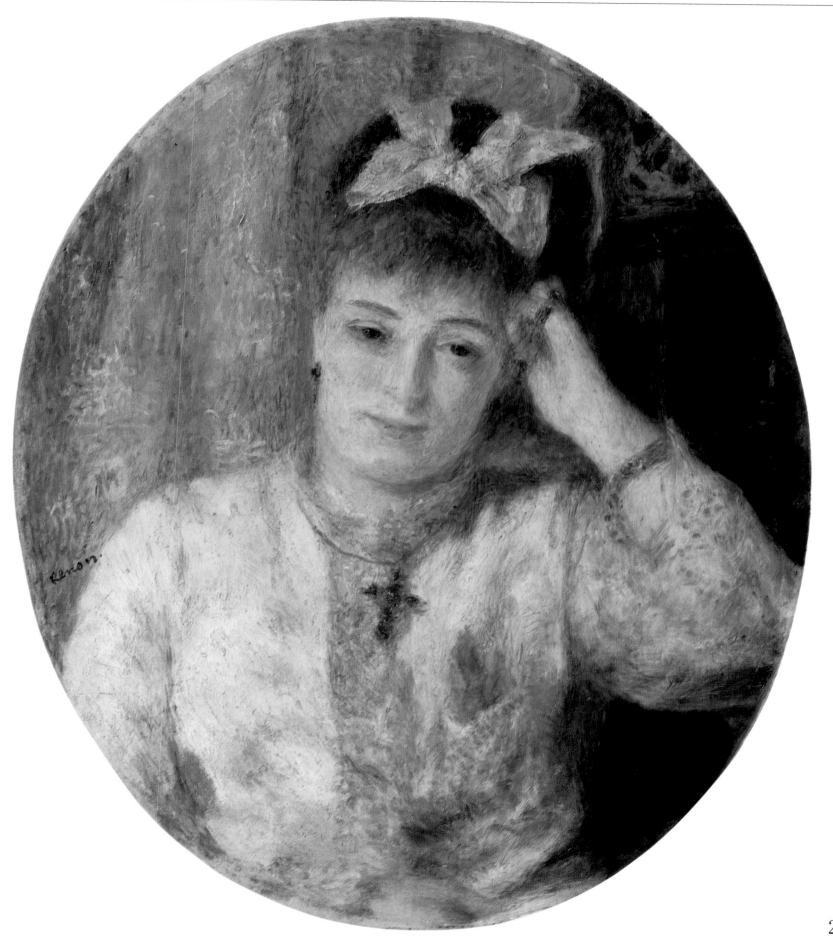

185 Camille Pissarro. *Portrait of Eugène Murer*. 1878. Oil on canvas, 67 × 56 cm. (26⅞ × 22″). Museum of Fine Arts, Springfield, Massachusetts.

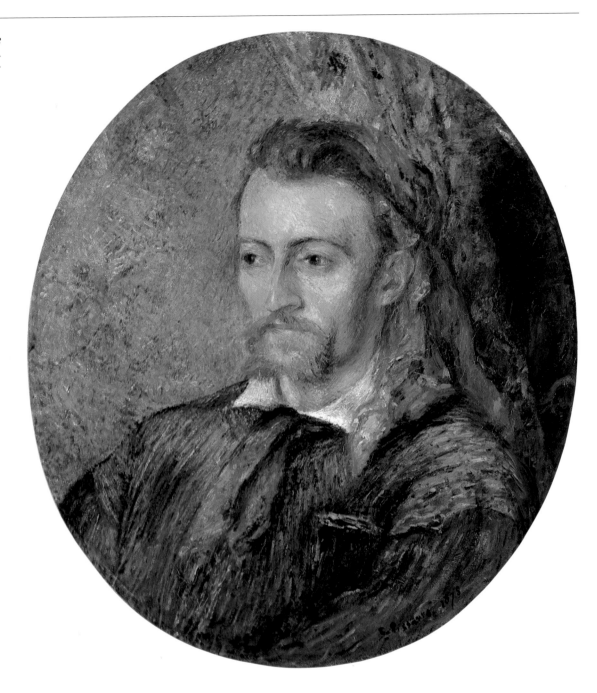

the fashionable Parisian art world by selling his collection in May, 1873. Then, Laurent-Richard set about buying works by the Impressionists; he made purchases at the first Hoschedé auction in January, 1874: two landscapes by Sisley.

Murer liked Sisley too: he paid 21 francs for *Aqueduct at Marly* at the Hoschedé auction in 1878, but he also bought directly from the artist. Their relations soured, however. In 1880, Sisley wrote to Murer: "You have gotten good enough bargains from me to leave me a little peace today." Murer retorted: "If being moved by other people's extreme poverty and alleviating it to the best of one's ability is what you call getting good bargains, you may well be right from an ethical point of view," but it seemed to him, "that he had only taken, as it were, been forced [to take] ... sometimes putting himself to quite an inconvenience, a painting from an artist in order to help him in a different way than by the offensive offer of monetary assistance." Murer added that he firmly intended to recover the money Sisley owed him, more than 1,000 francs.

186 Pierre-Auguste Renoir. *Young Women Talking*. 1878. Oil on canvas, 61 × 50 cm. (24 × 19¾″). Collection Oskar Reinhart, Winterthur, Switzerland.

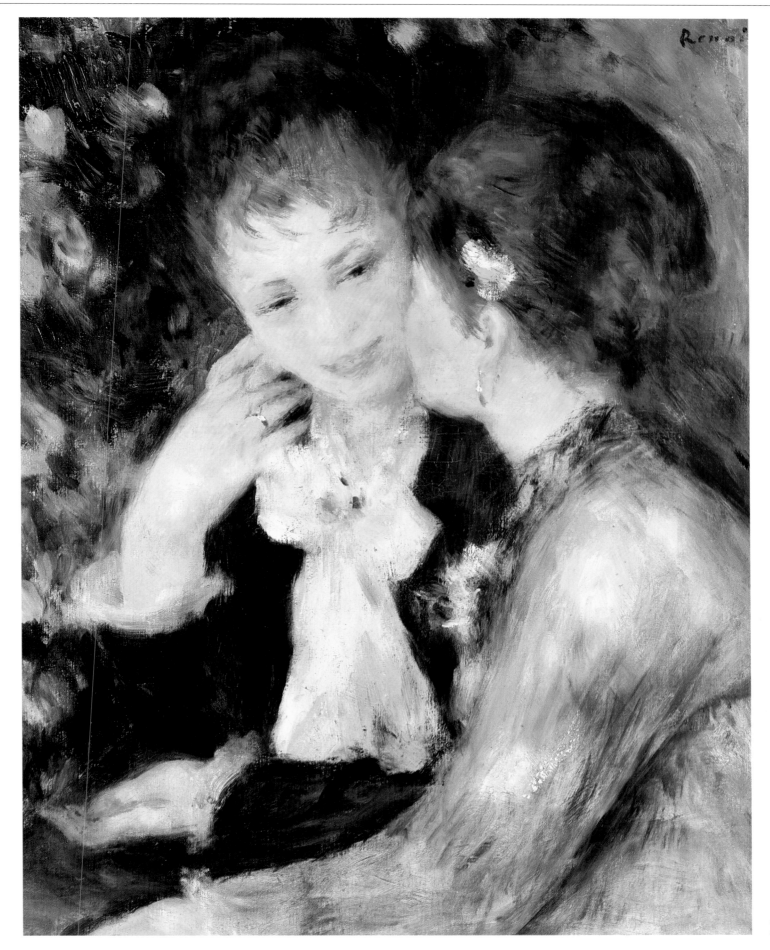

Murer was also, beyond question, one of the first Pissarro enthusiasts; he would own more than twenty of the artist's works. Murer was a rather obliging collector, as proven by a letter dated June 27, 1878, quoted by the critic and art historian Adolphe Tabarant: "So much the better if you have sold the hillside that I had chosen," Murer wrote to Pissarro, "in its place you will give me a figure painting, your scene of Breton domestic life, refused by Faure because it was too dismal; it doesn't scare me."

Murer haggled over prices persistently, apparently never wanting to pay more than 200 francs for a picture. In 1883, Murer offered to build a house for Pissarro and rent it to him, but Pissarro was reluctant to agree. Nevertheless, he had a high enough opinion of Murer to suggest that Murer show his collection to the Florentine critic Diego Martelli, who had well-known ties with Degas, and to the artist Serafino de Tivoli, who was friends with the *Macchiaioli* group of painters. Pissarro is the one who suggested that Murer visit Victor Chocquet. Murer, who was a close friend of Dr. Gachet, also knew Georges de Bellio well. Thus Murer was able to compare his own acquisitions with those of other collectors. Murer's career as a collector culminated in 1879, with his loan of a work by Pissarro and one by Monet to the fourth Impressionist exhibition.

When he left Paris after having sold his business on Boulevard Voltaire in 1881, Murer's collecting slowed down. He settled in a pretentious house he built in Auvers-sur-Oise, which Dr. Gachet christened "Oven Castle." Although he owned a business in Rouen run by a manager, Hôtel du Dauphin et d'Espagne, which soon gave him trouble, Murer wanted to devote himself to the fine arts. He painted and worked in pastels, fished and gardened.

Murer also continued to write: his novel *Pauline Lavinia* was finally published in 1887, with an illustration by Lucien Pissarro; *La Mère Nom de Dieu*, a collection of short stories, was published in 1888. It was quite in keeping with the spirit of Murer's friend, Paul Alexis, to whom the author dedicated one of the short stories. It is likely that Murer's fame at the time never went beyond the circle of the readers of *Le Cri du peuple.* In October, 1877, Alexis gave those readers details of the Murer collection, adding: "This collection measures up to that of the historian and art critic Théodore Duret, of *Père* Choquet [sic], of Mr. Doria, a descendant of the doges of Genoa no less, and of Count de Bellio, a Bulgarian gentleman."

Today, the Renoirs are unquestionably the most famous paintings from Murer's collection: the portraits of Murer, of his sister Marie, and of his son Paul (Private collection, Baden), *Young Women Talking, Portrait of Alfred Sisley* (The Art Institute of Chicago), *The Arbor, The Artist's Studio, Rue Saint-Georges,* (The Norton Simon Museum, Pasadena), and probably *Parisian Women in Algerian Dress* (National Museum of Western Art, Tokyo), which Paul Signac would see at Camentron's, a dealer on Rue Laffitte, in 1898. There were fewer Monets in Murer's collection, for the artist seemed to want to keep the collector at arm's length; none of the Monets were really important works. Among the twenty-five Pissarros, in addition to the portrait of the collector and the pastels depicting *Marie Murer* and *Murer in Front of His Oven, Piette's House at Montfoucault* (The Sterling and Francine Clark Art Institute, Williamstown) is noteworthy.

Breach of Friendship

Although the article by Alexis fixed the Murer collection at its high point in people's memory, the split between Murer and the Impressionists was already almost complete at that time. On March 12, 1888, Pissarro refused to have one of the short stories in *La Mère Nom de Dieu* dedicated to him. Pissarro was even more annoyed at the end of 1895, when—during an exhibition of Murer's own work in Paris at the Théâtre de la Bodinière, 18 Rue Saint-Lazare—Murer put up an advertisement, announcing for May, 1896, at the Hôtel du Dauphin et d'Espagne, which he owned, a "magnificent collection of Impressionists, including thirty paintings by Renoir, on view daily, free

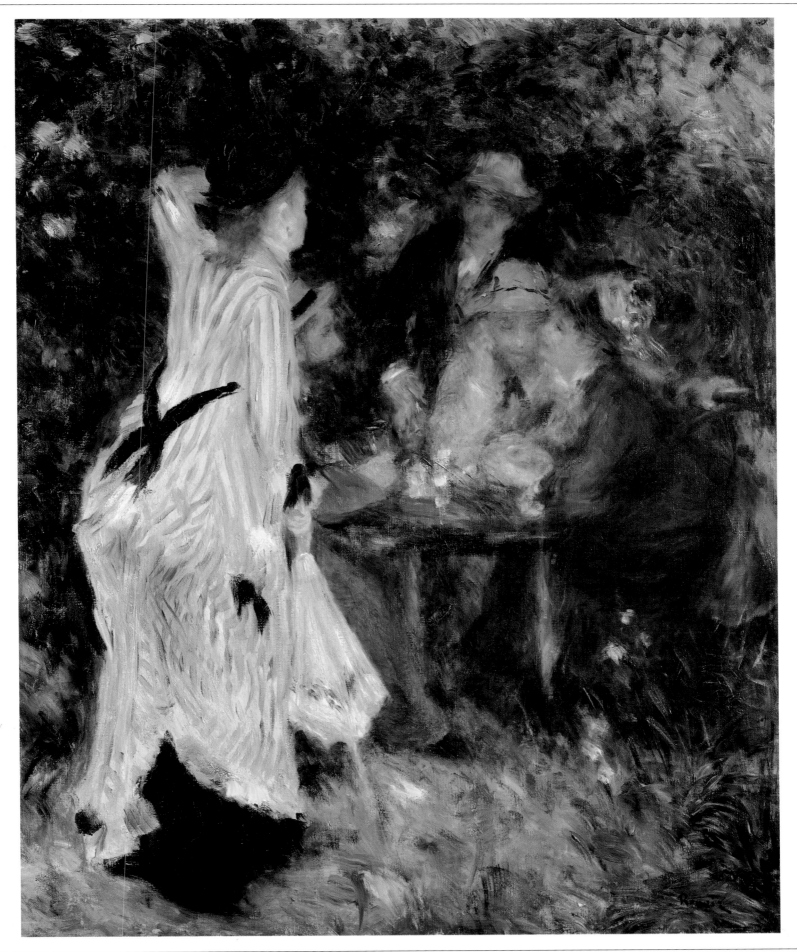

188 Catalogue of the Fifth Murer Exhibition: "The Flowers' Song," at Galerie Laffitte, Paris, 1900. Library of the Musée d'Orsay, Paris.

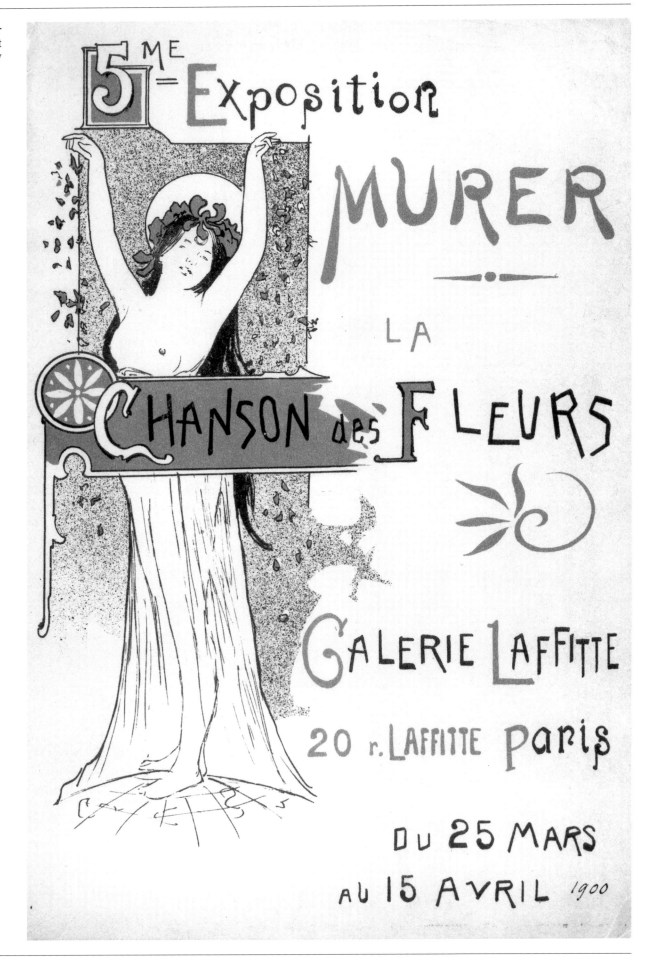

189 Mariani Picture Book. *Murer*, installment published between 1900 and 1903. Library of the Musée d'Orsay, Paris.

of charge, from 10 a.m. to 6 p.m." This publicity was repeated by Charles Oudart, who went the rounds of the art dealers in Rouen in July, 1896, for the *Gazette de l'Hôtel Drouot*: "I suppose that we have lunched, for example, at the Hôtel du Dauphin et d'Espagne, across from the Pierre Corneille Bridge, which I do not recommend for its cooking or its wines, neither of which is part of my program, but because the owner is both an artist and a collector, and because the dining room of that hotel is decorated on all sides with old and modern paintings, faience, clocks, and objets d'art that charm the eye. I must admit that the Impressionists are the predominating school, yet one sees with pleasure there a few well-chosen Claude Monets, works by Monticelli, and by a number of less well-known names." Oudart was obviously not a great fan of the Impressionists. In 1896, Pissarro worked in Rouen for a long time, but he stayed at the Hôtel d'Angleterre or the Hôtel de Paris, carefully avoiding Murer.

A family matter would hasten the end of Murer's collection. Late in life, in February, 1897, Murer's sister, Marie, married the poet Jérôme Doucet, who had published a biography of Murer in *Les Hommes d'Aujourd'hui*. Marie asked her brother for a reckoning, and Murer had to sell the hotel in Rouen and, above all, his collection. The dealers in Rue Laffitte negociated the sale of his paintings: Lucien Moline, who would hold an exhibition of works by Murer in 1900; Camentron, and Vollard, who had organized a Murer exhibition in 1897—probably to get into Murer's good graces.

It is interesting that works by the younger artists had also found a place in Murer's collection: Gauguin, who had met Murer in Rouen in 1884, and Van Gogh, whose painting, *Fritillaries* (Musée d'Orsay, Paris), found a choice buyer in Count Isaac de Camondo. As Paul Gachet, Jr. pointed out, apart from them, Murer associated with rather minor artists: Frédéric Cordey, Léon Giran-Max, Emile Giran, Joseph Delattre, Ernest-André Andreas, and Adolphe Clary-Baroux. The most interesting were the painter Norbert Goeneutte, a close friend of Murer, and the sculptor Rupert Carabin, whose extravagant furniture would find a place in the Musée d'Orsay, Paris.

Among the Impressionists, only Renoir still maintained cordial relations with Murer after 1890, giving him information about North Africa, where Murer actually went to paint, or advising him to go to "Pont-Aven, a center for painters, where you will have all the tips on Brittany."

It seems that Murer stopped having success as an artist at the same time as he stopped collecting. His exhibitions were not successful, although he laid siege to the 188 critics; the last one took place in his studio, at 39 Rue Victor Massé, at the foot of the Butte Montmartre in April, 1903. When Murer died at Auvers-sur-Oise on April 22, 1906, Paul Gachet, Jr. went to declare his death at the town hall. The obituaries mentioned only the man of letters.

Eugène Murer died alone; a disagreement had kept his only child, Paul, apart from him. Pissarro referred to it in 1890–91, when discussing with his wife the problems they had with their own children: Pissarro was opposed to "placing them in factories, where they will be exploited, where they will learn nothing or badly, like young Murer," or to "throwing them out like . . . Murer."

Murer's son, Paul Meunier, who had shown a stray artistic impulse by doing some wood carving, became a garage keeper in Beaulieu-sur-Mer. In 1907, he offered the big Parisian dealers one of the rare paintings his father had left him, Renoir's portrait of Murer, aged thirty. But no one wanted it: Eugène Murer was dead 182 indeed.

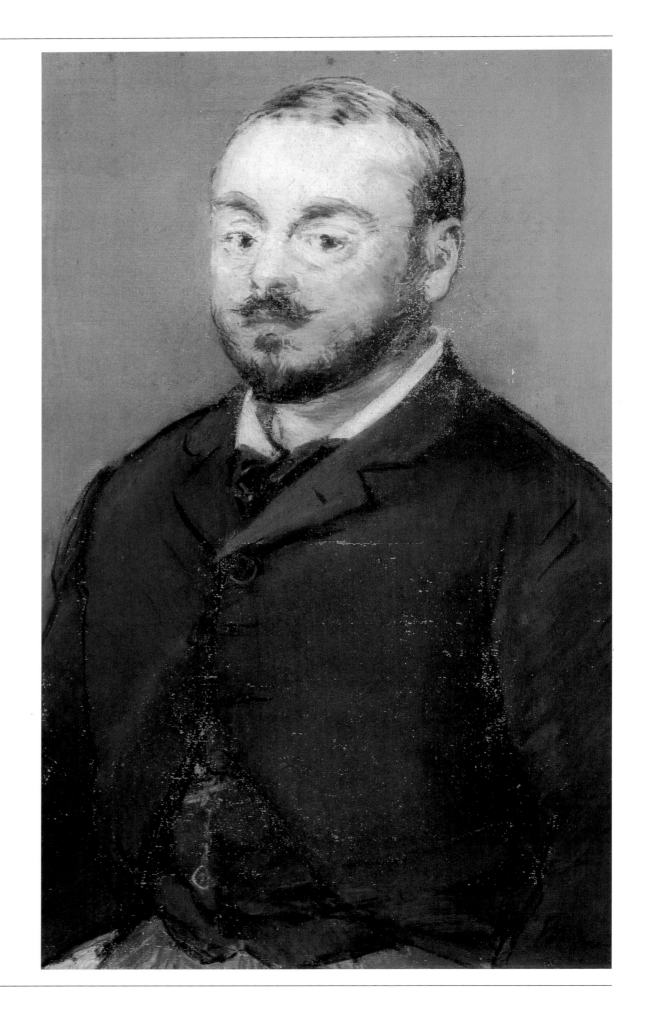

Emmanuel Chabrier

190 Edouard Manet. *Emmanuel Chabrier.* 1880. Pastel, 55 × 35 cm. (21¾ × 13¾″). Ordrupgaard Museum, Charlottenlund.

"About [his] physique: short but very stout, a Bourbon nose, prominent, lively eyes, a very high forehead; about [his] temperament: readily kind to all and sundry, gay, agreeable, with a loud, good-natured laugh, often spiced with a hint of irony."

Hugues Imbert, *La Revue illustrée*, II, 1887.

If Emmanuel Chabrier is famous today, it is not because, in 1884, at the auction of the contents of his friend Manet's studio, Chabrier bought the artist's *A Bar at the Folies-Bergère* and hung it above his piano. Although Emmanuel Chabrier died when he was only fifty-three years old, he has an acknowledged place among the founders of modern music as the composer of the operas *L'Etoile* (1877)—in which some of the most whimsical songs are said to be due to his friend, the poet Paul Verlaine—and *Gwendoline* (1886), and of the orchestrated work, *España* (1883). 191

The critic and musician Roger Delage has stressed, with deep insight, the affinities between Chabrier and his artist friends on the level of creative genius. For our purposes, it is sufficient to point out that the composer Chabrier was more than just an intimate friend of Manet from the early 1870s until the artist died in 1883. They had many character traits and tastes in common: their conspicuous cheerfulness hiding an extremely sensitive nature, their love of Wagner and Spain, their equally intense determination to break with the triumphant academism of their era without repudiating the great art of the past. If Manet represented the avant-garde in painting, Chabrier had a similar place in music. Maurice Ravel was one of the first to emphasize the correspondences between one of Chabrier's *Pièces pittoresques* for the piano and Manet's *Olympia*.

Chabrier, who was born in 1841, belonged to the same generation as Monet, Renoir, Sisley, Cézanne, and Degas, whose works the composer liked. The son of a provincial judge, Chabrier came to Paris to study law and then entered the Department of the Interior. Between 1862 and 1879, his job there left him enough free time for music and other aesthetic pastimes. Chabrier had always liked painting and associated with artists. The painter James Tissot did a portrait of Chabrier in pencil in 1861. Tissot was a friend of Degas and met Manet in 1862. However, Chabrier's ties with Degas would be closest about 1870, when Degas put a small portrait of the composer in a corner of *The Orchestra of the Paris Opéra* (Musée d'Orsay, Paris), which he painted for the bassoonist Désiré Dihau. Chabrier, who had a reputation for paying low prices, owned nothing by Degas, whose work was rare and expensive, even for his contemporaries. For that matter, Chabrier's preferred painter was not Degas but Manet. 190, 194, 195

Chabrier and Manet

We do not know under exactly what circumstances Manet met Chabrier, but the composer dedicated an *Impromptu* to Madame Manet, an accomplished pianist, in 1873. Tradition holds that, the same year, Chabrier posed for Manet's *Masked Ball at the Opéra*, although no one can identify him with any certainty today among all the men in black tails. Manet's portrait in pastel of Chabrier was not done until 1880; it was followed by an oil-painted portrait, with a different composition. At Chabrier's estate sale, there would be seven canvases and a drawing by Manet. All of them, except *Fishing Boat* (Private collection), were bought at one time—in 1884, at the auction of the contents of Manet's studio. We know that, at that time, Madame Chabrier came into an inheritance that the couple decided to invest in paintings. It 61 190 195

191 Edouard Manet. *A Bar at the Folies-Bergère.* 1881–82. Oil on canvas, 96 × 130 cm. (37¾ × 50"). Courtauld Institute Galleries, London (Courtauld Collection).

"I forgot to write to you about the Manet [studio] sale that did much better than anyone hoped.... Luckily, there was an enthusiastic pack of friends to get things going. Even Chabrier, who never pays more than 20 francs, spent 5,000 francs for the Bar [at the Folies-Bergère]."

P. A. Renoir to Monet, February, 1884.

was not a bad idea, because ten years later, the value of the paintings had increased almost fourfold.

Chabrier and the Impressionists

Chabrier's collection did not contain works by Manet alone. In spring, 1878, shortly after Manet and Chabrier had signed as witnesses at the birth of Monet's second son, Michel, Monet noted in his accounts that he had sold three paintings to Chabrier for 300 francs, a moderate price in what was a bad year for the artist. A little later, in August, Monet mentioned that Chabrier had bought *The Flags*, which the unfortunate Hoschedé had reserved earlier, for 200 francs. That painting, entitled *National Holiday, Rue Saint-Denis, Paris*, was shown in the fourth Impressionist exhibition in 1879, with no mention of the lender's name. However, Chabrier's name appeared on another Monet, *Banks of the Seine, near the Island of Saint-Denis*, which the composer lent to that exhibition. These works would be knocked down at the Chabrier estate sale for prices more than ten times as high. No one knows who put Chabrier in

192

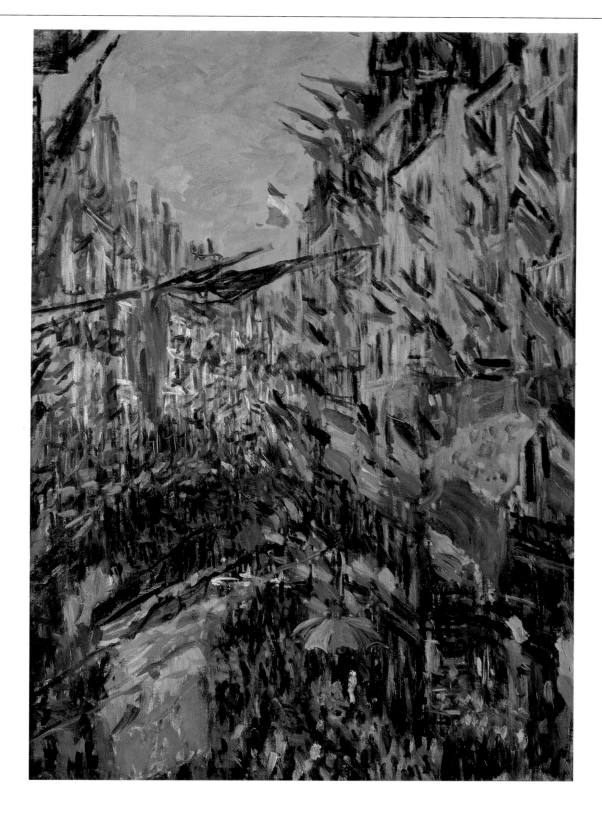

192 Claude Monet. *National Holiday, Rue Saint-Denis, Paris.* 1878. Oil on canvas, 76 × 52 cm. (30 × 20½"). Musée des Beaux-Arts, Rouen.

contact with Monet, Manet, and Renoir, whom the composer appreciated greatly too. If we are to believe Georges Rivière, Pierre-Eugène Lestringuez—one of the models for *Dancing at the Moulin de la Galette*—took Chabrier to Renoir's and was behind the composer's purchase of *Nude (Nana)*. Chabrier also bought *Leaving the Conservatory* and *Woman Crocheting* (The Barnes Foundation, Merion, Pennsylvania) as well as three pastels by Renoir.

193

It seems that Chabrier could never bring himself to buy a canvas from Pissarro, although the artist had strongly hoped to sell him a work during the summer of 1878.

193 Pierre-Auguste Renoir. *Nude (Nana)*. 1876. Oil on canvas, 92 × 73 cm. (36¼ × 28¾″). Pushkin Museum of Western Art, Moscow (S. Shchukin Collection).

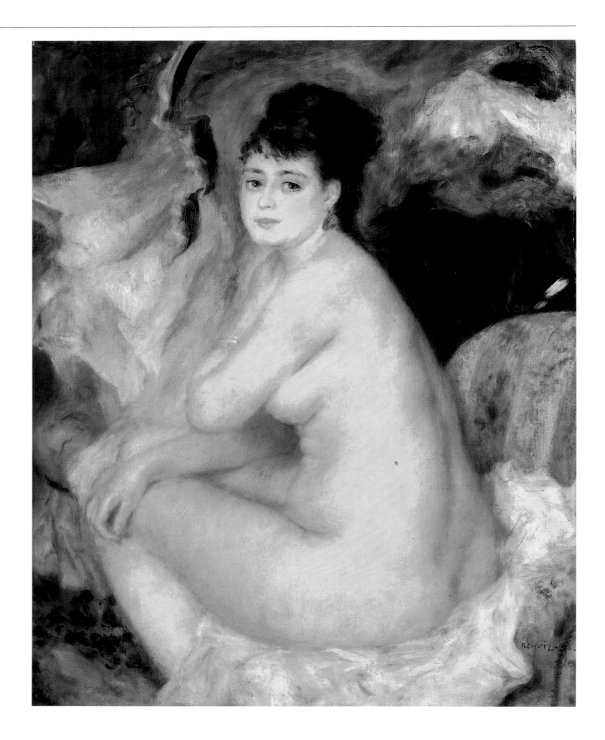

When Chabrier died though, he owned two Sisleys from the artist's best period (*Boatmen at Hampton Court*, 1874, and *The Seine at Point du Jour*, 1878, Private collection); their exact provenance is still unknown.

Chabrier did make one purchase that was wildly extravagant for that time: at the Duret auction, just a few months before he died, Chabrier bought a small painting by Cézanne, *Harvesters*, for 650 francs. It would be knocked down for 500 francs at the Chabrier auction in 1896.

Thus Chabrier's collection was small, but the right size for a Parisian apartment; in it, Manet and the Impressionists played the leading roles. Several other artists were represented in Chabrier's collection, reputable complements found in a number of contemporary collections owned by men of taste: Jean-Charles Cazin, John Singer Sargent, Paul-César Helleu, François Flameng, Georges Clairin, and Jules Chéret as well as the composer's friend, the sculptor Constantin Meunier.

194 Edouard Detaille. *Chabrier at the Piano*. Drawing, published in *La Revue illustrée*, II, 1887.

195 Edouard Manet. *Portrait of the Composer Emmanuel Chabrier*. 1881. Oil on canvas, 65 × 53 cm. (25½ × 20¾″). Fogg Art Museum, Harvard University, Cambridge, Massachusetts (Grenville L. Winthrop Bequest).

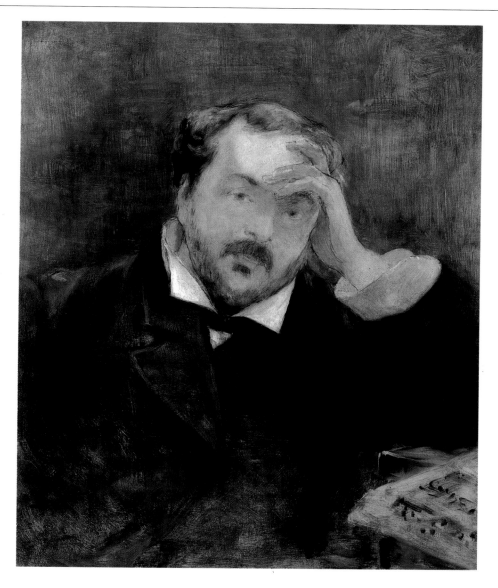

The Chabrier Estate Sale

Emmanuel Chabrier died on September 13, 1894. Two years later, on March 26, 1896, almost his entire collection was sold at auction at the Hôtel Drouot. Durand-Ruel bought many lots. Several of the most important items, including Manet's *A Bar at the Folies-Bergère* and *Skating*, were bought back by Madame Chabrier, who was forced, nonetheless, to sell them to Durand-Ruel in May, 1897. In the midst of rising prices for Impressionist works, the Chabrier estate sale marked the step between the first test—the Duret sale—and the Chocquet and the Doria sales in 1899.

 What mental image shall we retain of Emmanuel Chabrier? Rather than imagining the Wagnerian surrounded by his disciples, which is how Henri Fantin-Latour represented Chabrier in his painfully solemn *Around the Piano* (Musée d'Orsay, Paris) of 1885, let us recall the unexpected aspects of Chabrier that Edouard Detaille, who did not limit himself to painting soldiers, captured in his sketch of *Chabrier at the Piano*, and, especially, the man Manet depicted in his simple yet intimate portraits.

191

194

190, 195

Ernest May

196 Edgar Degas. *Portraits at the Stock Exchange.* c. 1878–79. Oil on canvas, 100 × 82 cm. (39⅜ × 32¼″). Musée d'Orsay, Paris (Gift of Ernest May).
The man in the middle is Ernest May. This painting appeared in the catalogues of the fourth and fifth Impressionist exhibitions. It is likely that, as often happened, Degas did not finish the work in time for the 1879 exhibition and so postponed its presentation to the public by a year.

Ernest May slipped in among the followers of Impressionism very unpretentiously at the group's fourth exhibition in 1879: in the catalogue of that exhibition, under Number 61, *Portraits at the Stock Exchange*, by Degas, we read that the painting

197 Jean Béraud. *Ernest May.* 1880. Oil on panel, c. 25 × 15 cm. (c. 9⅞ × 6″). Private collection, Paris.

198 Anonymous. *Madame Ernest May.* c. 1885. Photograph. Private collection, Paris.

199 Anders Zorn. *Mr. and Mrs. Ernest May.* 1888. Watercolor, c. 80 × 100 cm. (c. 31½ × 38⅜″). Private collection, Paris.

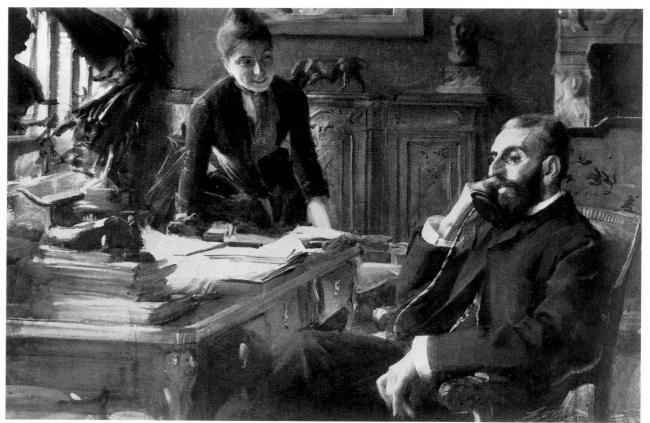

200 Claude Monet. *Sailboats.* c. 1872. Oil on canvas, 49 × 65 cm. (19¼ × 25½″). Musée d'Orsay, Paris (forms part of the "May Triptych" with a Pissarro and a Sisley [Pls. 201 and 202], donated in 1923 by Ernest May, subject to a life interest; entered the museum after May's death).

belongs to "M. E. M.," that is, Mr. Ernest May. The painting (now in the Musée d'Orsay, Paris) is a portrait, taken from life, of the Parisian financier May in the corridors of the Stock Exchange. In a letter from the same period to the engraver Félix Bracquemond, Degas presented May in a manner that was as unkind as the painted portrait: "He is going to be married, take a small town house, I believe, and arrange his little collection in a gallery. He is a Jew. He organized an auction on behalf of the wife of Mouchot, who went mad. You see, he is a man who has launched out into the arts."

Degas was correct: Ernest May, born in Strasbourg on July 16, 1845, married Marie-Héloïse-Jeanne Ferré on June 30, 1879; and the young couple settled in a town house at 27 A Avenue de Villiers, where they would live until Madame May died in 1906. The Mays had five children: Marianne, Etienne, Annette, Jacques, and Lise. The auction on behalf of the wife and daughter of the landscape painter Louis Mouchot took place on June 6–7, 1879. Everyone (especially the members of the "Artistic and Literary Circle" of Rue Saint-Arnaud, where the works donated by the

196

197
198, 199
203, 204

201 Camille Pissarro. *Entrance to the Village of Voisins.* 1872. Oil on canvas, 46 × 55 cm. (18⅜ × 22″). Musée d'Orsay, Paris ("May Triptych," see Pl. 200).

artists had been exhibited) knew that Ernest May had had a great deal to do with the success of that auction, which made it possible to give Madame and Mademoiselle Mouchot 150,000 francs. To tell the truth, the highest price at the auction was paid for a tiny painting (5½ × 4 inches) by Meissonier—18,000 francs, whereas Manet's pastel went for 100 francs. The entire set of fashionable artists had been mobilized to participate in this charitable event: Baudry, Heilbuth, Toulmouche, Gérôme, Leloir, as well as the "refused" painters: Manet, Caillebotte, Degas, and Sisley. A watercolor by Boudin was donated by "M.H.H." and a Pissarro by "M.A.H.," tastes and initials that betray the brothers Henri and Albert Hecht. As for Ernest May, he donated two views—of Venice and of Cairo—by Mouchot to the auction.

It was natural for Degas to talk about May with Bracquemond, for the engraver was supposed to work on a scheme for an art review devoted to prints, entitled *Le Jour et la Nuit*, that May and Caillebotte planned to finance. A little while before the 1879 exhibition, in a letter to Caillebotte, Degas referred to a dinner at May's that both men were to attend together.

202 Alfred Sisley. *Island of Saint-Denis.* 1872. Oil on canvas, 50 × 65 cm. (19⅝ × 25½″). Musée d'Orsay, Paris ("May Triptych," see Pl. 200).

Whatever Degas may have thought of the financier, May had conceived a passion for the artist's work. In accordance with May family tradition, soon after his first son, Etienne, was born on May 31, 1881, Ernest May asked Degas to portray the mother and the baby in its cradle. After several studies were made, the project was abandoned, putting an end to the direct contacts between Degas and his admirer. Ernest May owned Degas's *La Répétition au Foyer (Rehearsal in the Studio)* (Shelburne Museum, Shelburne, Vermont). *The Rehearsal of the Ballet on the Stage* (The Metropolitan Museum of Art, New York), and *Dressing for the Dance* (The Denver Art Museum); May lent this last painting to the 1880 exhibition.

Degas was not the only artist in the group in whom May had an interest, however. He probably bought his first Impressionist canvas from Monet in 1875, and others in 1878 and 1879. In difficult years, May—like De Bellio and Caillebotte—was one of the people from whom the Impressionists could request an "advance" of 100 francs. May visited the Hôtel Drouot regularly to purchase Old Masters, and he bought a Sisley at the Hoschedé auction in 1878.

It is hard to keep track of May's collection. Although he bought Monets, Pissarros, Sisleys, and one Renoir from Durand-Ruel, Ernest May entered into complicated exchanges, one in particular in May, 1882. In the end, the best idea of May's collection at a precise date is provided by the catalogue of his sale at Georges Petit's

204 Anonymous. *Ernest May in His Apartment in the Faubourg Saint-Honoré*, at the end of the collector's life. Photograph. Private collection, Paris.

◁ 203 Anonymous. *Ernest May's Bedroom*. c. 1920. Photograph. Private collection, Paris. One notices in particular several studies by Degas for *The Cradle*, depicting Madame May and her son. Above the bed is *Ernest May's Daughter's at La Couharde* by Albert Besnard.

on June 4, 1890. It contains more than one hundred Old Master and modern paintings, drawings, pastels, and watercolors. Noteworthy among the items were the three ballet scenes by Degas mentioned above; one Manet, *The Guitar Player* (Hill-Stead Museum, Farmington, Connecticut), purchased directly from the artist in 1879; 5 Monets, 6 Pissaros, and 4 Sisleys.

We do not know exactly why May held this auction. He probably had momentary financial problems, or he may have merely needed money to buy his estate, "La Couharde" near Queue-les-Yvelines, in the Paris area. The receipts of the May auction totaled almost half a million francs thanks to the Millets and Corots, sixteen in all, which May, like many collectors of Impressionism, had bought first. Among the Impressionists, Degas's work was—as usual—the most expensive; two of his paintings were sold for 8,000 francs. Manet came next: a picture was knocked down at 3,000 francs. The Monets went for between 1,250 and 2,100 francs; the Pissarros sold for between 800 and 2,100 francs; and the Sisleys for between 300 and 1,700 francs.

May bought back many works at his auction, in particular, Monet's *Sailboats*, Pissarro's *Entrance to the Village of Voisins*, and Sisley's *Island of Saint-Denis*. In 1924, those three paintings were donated together to the Louvre, along with *Portraits at the Stock Exchange* by Degas, which May had always kept, a small Renoir, *The Rose*, purchased in 1919 from Bernheim-Jeune, and works by Legros, Bracquemond, Corot, and Tassaert, as well as Old Master paintings. 200 201, 202 196

For Ernest May had continued to expand his collection after 1890, remaining faithful to Corot and buying a few more seventeenth- and eighteenth-century French paintings. However, May also liked certain contemporary artists: Anders Zorn, Albert Besnard, Lucien Simon, K.X. Roussel. Very intimately acquainted with museum circles, Ernest May became a member of the board of the Friends of The Louvre. He died in his Faubourg Saint-Honoré apartment on October 28, 1925.

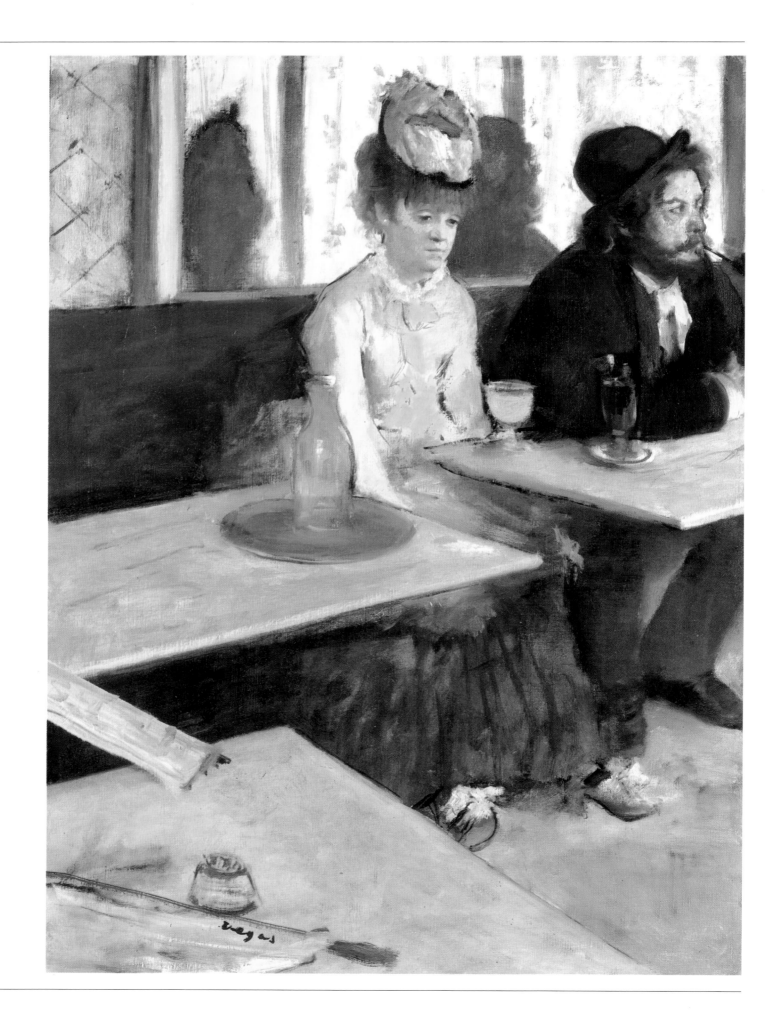

Chapter XIX

The Market for Impressionism Outside France: Great Britain

205 Edgar Degas. *Absinthe*. 1875-76. Oil on canvas, 92 × 68 cm. (37 × 27½″). Musée d'Orsay, Paris (Isaac de Camondo Bequest, 1911).

The chief efforts in the Impressionists' struggle to obtain recognition took place in France, especially in Paris. Thanks to Durand-Ruel, however, the Impressionists very quickly reached a public beyond the borders of France.

England and the United States were pioneers in this area. Elsewhere there were, to be sure, a few private collectors. But they were exceptions such as the Swiss artist, Auguste de Molins: De Molins, who lived in Saint-Cloud, was a painter himself and had exhibited with the Impressionists in 1874. Although he had bought works by Pissarro and Renoir as early as 1875, De Molins cannot really be ranked among collectors. Very important collectors of Impressionism would come to light in Germany, Holland, Denmark, Norway, Italy, and Russia. None of them began collecting until after 1890, however. Thus, their collections fall outside the chronological framework of this study.

Durand-Ruel in London: The German Gallery

Conscious from the start of the need to expand his market, Durand-Ruel set up an advanced position in London from 1870: the German Gallery on New Bond Street. Although he often complained about the indolence of his representative, Charles W. Deschamps, the nephew of Ernest Gambart, one of the most active dealers at the time, Durand-Ruel had faithful customers in London. He also worked with another dealer, MacLean in Haymarket. It was in London, late in 1870 and early in 1871, that Durand-Ruel exhibited works by Pissarro and Monet for the first time; he met the two artists through Daubigny, who had also taken refuge from the Franco-Prussian War in England. Those were decisive contacts: a whole series of exhibitions of what Durand-Ruel termed the "Society of French Artists," featuring, to a great extent, the Impressionists, would be held at 168 New Bond Street early in the 1870s. In 1883, Durand-Ruel once again attempted to organize an impressive exhibition on New Bond Street, but this time at Dowdeswell and Dowdeswell.

Several artists residing in London at the time also played a role, backing the dealer's efforts. In particular, these were friends of Degas: James Abbott McNeill Whistler, James Tissot, Alphonse Legros. Giuseppe de Nittis, and the critic George Moore, whose portrait Manet painted (The Metropolitan Museum of Art, New York).

Louis Huth

In 1872, Durand-Ruel sold a painting by Degas to a Whistler enthusiast: the financier Louis Huth. The painting was one of the most perfect masterpieces of that period by the artist: *Dance Class at the Paris Opéra*. It remained in Huth's collection until late in the 1880s. A French collector, the jeweler Henri Vever, an Impressionist enthusiast and collector of Japanese objets d'art, bought the painting at that time; so it returned to France.

Captain Henry Hill

Captain Henry Hill of Brighton was a more important collector than Huth; Hill was a customer of Durand-Ruel in London from 1874. By 1876, he owned a magnificent set of works by Degas: *In the Café*, better known as *Absinthe*, purchased through 205 Deschamps, and six ballet scenes (one of which is now in the Metropolitan Museum of Art, New York; one in the Corcoran Gallery of Art, Washington, D.C.; and one in the Musée d'Orsay, Paris). At that time, no collector in France owned as many works by Degas as Hill. Captain Hill had formerly served with the First Sussex Rifle Volunteers and seems to have started collecting early in the 1860s, buying English artists of the early nineteenth century. Then he became interested in contemporary English artists. Hill liked Naturalist subjects characterized by rather sentimental socialism, but he also owned Whistler's *Valparaiso: Nocturne—Blue and Gold* (Freer Gallery of Art, Washington, D.C.). Lastly, Hill bought French artists: Corot, Millet, Rousseau, Dupré, Fantin-Latour (highly appreciated in England thanks to his faithful enthusiast, Edwin Edwards), Bonvin, Vollon, and an enormous quantity of works by Madame Marie Cazin. Finally, when he was over sixty, Hill bought works by Degas and Monet. His collection contained more than four hundred paintings in all.

Hill's collection was sold at two auctions, held at Christie's in London on May 25, 1889, and February 20, 1892. At the second auction, the public booed Degas's *Absinthe*, which did not prevent Alexander Reid, a dealer in Glasgow, from 205 buying the painting. Reid, whom Van Gogh painted in 1887, was already a convert to Impressionism. Even in 1893, when the painting's new owner, the collector Arthur Kay of Glasgow, lent it to an exhibition in London, *Absinthe* still created a stir. Responding to the subject matter above all, several critics saw in it a symbol of the moral decay of a France intoxicated by alcoholic vapors and the Naturalist writings of Emile Zola. It is easy to understand the owner's decision to sell the painting shortly afterward to a Parisian dealer, who then sold it to Count Isaac de Camondo.

Degas's work converted another English collector to Impressionism. In June, 1881, Constantine Alexander Ionides, who lived in Brighton like Captain Hill, bought a version of Degas's *Ballet of "Robert le Diable"* from Durand-Ruel. Ionides would bequeath it to the Victoria and Albert Museum in London when he died. Of Greek origin, Ionides had worked at the London Stock Exchange. He probably owed his taste for the French school of painting (from Ingres and Delacroix to Courbet, Millet, and the Barbizon School) to the French artist Alphonse Legros. Ionides's purchase of a work by Degas remained an isolated event; but, considering the date, it is worth mentioning. It also heralded other great collections such as those of Sir William Burrell of Glasgow or Sir Hugh Percy Lane, an Irish art dealer.

Since the Royal Academy's refusal to exhibit works by Monet and Pissarro in 1871, the Impressionists had slowly made their way in England. Once again, Durand-Ruel's tenacity in keeping a branch in London had much to do with their eventual success. The London market was very small, nonetheless, and even seemed to grow smaller at the end of the century. In 1905, when Durand-Ruel exhibited his very best pictures at the Grafton Galleries, he sold only one work—by Boudin! The real success that saved Durand-Ruel would occur in the United States.

The Market for Impressionism Outside France: the United States

Since the mid-nineteenth century, European art dealers had seen the United States as a dream territory, in spite of the restrictive customs barriers. Old Masters from all schools were in great demand there, but contemporary French painting was also highly appreciated in the big cities on the East Coast.

There were ultrawealthy collectors in America who considered their collections, above all, as a part of their prestige. Perfect examples of this type of collector were William Henry Vanderbilt who, before he died in 1885, had formed a collection of more than one hundred paintings by academic artists, spending millions of dollars, or Alexander T. Stewart, who owned two of the most renowned paintings of the period (now in the Metropolitan Museum of Art, New York): Meissonier's *Friedland, 1807* and Rosa Bonheur's *The Horse Fair*, "snatched up" from under the nose of the French government.

There were also many cultured collectors, who often had a touch of the artist themselves: they had stayed in Europe, in Paris, and were acquainted with the latest developments in the art world. And, most importantly, they were wealthy enough to be able to form choice collections. The first collectors of Millet and the Barbizon School, of Corot and of Courbet were recruited among such people, as had happened in France at almost the same time. Thus, obviously, it was also a favorable social sphere for Manet and the Impressionists. A young cantatrice and a friend of Manet, Emilie Ambre, thought of showing a large painting by Manet, *Execution of Emperor Maximilian* (Kunsthalle, Mannheim), on her tour from New York to Boston in December, 1879 and January, 1880. However, even though a few critics were impressed by Manet's originality, it is likely that the prevailing opinion—alas—was that of the critic who definitely condemned the artist for being a member of the "ultra-slapdash school." This was the context in which Durand-Ruel would try his luck in the United States.

Durand-Ruel in New York in 1886

On April 10, 1886, shortly before the opening day of the eighth and last Impressionist exhibition in Paris, Durand-Ruel opened a huge exhibition entitled "Works in Oil and Pastel by the Impressionists of Paris" at the American Art Association, which moved to the National Academy of Design from May 25. It consisted of 48 works by Monet, 42 by Pissarro, 38 by Renoir, 23 by Degas, 17 by Manet, 15 by Sisley, and pictures by Boudin, Caillebotte, Forain, Guillaumin, Cassatt, Morisot, and about fifty others from Durand-Ruel's stock. There were also several works by Seurat on display. The exhibition was presented in a catalogue with a foreword by Théodore Duret.

The moral influence and financial backing of James F. Sutton, one of the founders of the American Art Association, whose objective, from 1877 on, was to promote the arts in the New World, had been a decisive factor in Durand-Ruel's decision to come to New York. Although neither the critics nor the general public knew anything about this kind of painting, it was generally well received. It is not at all sure that Henry James created a great stir with his article of May 13, 1876, in *The New York Tribune*, on the occasion of the Impressionists' second exhibition in Paris, when he

206

NATIONAL ACADEMY OF DESIGN.

SPECIAL EXHIBITION.

Works in Oil and Pastel

BY

THE IMPRESSIONISTS

OF PARIS.

MDCCCLXXXVI.

EXHIBITION UNDER THE MANAGEMENT OF

THE AMERICAN ART ASSOCIATION

OF THE CITY OF NEW YORK.

206 Title Page of the Catalogue of the Exhibition Organized by Paul Durand-Ruel in New York in 1886. Durand-Ruel, Paris.

spoke of "Cynical Artists." Since then, nothing more had been heard about the Impressionists, whereas Durand-Ruel was known as the dealer of the Barbizon School that the Americans loved.

Despite all that, there were already a few collectors of Impressionism in the United States. They lent approximately ten works to the second 1886 exhibition. Apart from one lender who did not give his name, there were three others: Alexander Cassatt, brother of the artist Mary Cassatt, Erwin Davis, and Henry O. Havemeyer.

Durand-Ruel's success in selling some paintings in 1886 worried his American fellow dealers, who were especially furious that he had been allowed to import paintings duty free. However, they were unable to prevent a second exhibition from being organized the next year. On that occasion, the "Impressionistic School" was

somewhat eclipsed by the works of Rousseau, Dupré, and especially by Delacroix's *Sardanapalus* (The Louvre, Paris).

The auction of Impressionist paintings that Durand-Ruel was forced to hold in New York afterward, on May 5–6, 1887, was not a success; but that did not undermine his determination to set up a business in New York. At first he rented a simple apartment at 297 Fifth Avenue; then, after moving several times, he took over premises at 389 Fifth Avenue, at the corner of Thirty-sixth Street. Durand-Ruel put his sons in charge of that important branch, crossing the Atlantic less frequently himself. Finally, at the end of the century, he completely stopped his transatlantic trips.

Some Other Dealers in the United States

Durand-Ruel was not the only dealer to champion the Impressionists in the United States. As early as 1866, Cadart and Luquet, known mainly for publishing prints, can take credit for having imported—only temporarily and in addition to works by Boudin—a painting by Monet that was somewhat lost in an exhibition of sundry works shown in New York and Boston. Alphonse Legrand seems to have followed up on their initiative late in the 1870s.

James F. Sutton, who was behind Durand-Ruel's coming to New York, acted as a dealer on his own; he worked in Paris, from 1890, with Isidore Montaignac, a former employee of Georges Petit. In 1893, Pissarro declared that Sutton had one hundred and twenty Monets and was in competition with Durand-Ruel to the detriment of the artists. An American dealer stated, "he has too many Monets on hand. If he doesn't make a good gamble soon, it may turn out to be a bad bargain."

Other American dealers introduced the Impressionists to the New World on a more modest scale, placing them in unexpected surroundings.

Samuel P. Avery of New York bought a series of prints by Pissarro from Portier in 1888. Later, Avery would donate them with the rest of his collection to the New York Public Library. George A. Lucas, an American expatriate who had been living in Paris since 1857, likewise acted as an agent for several American collectors. Whistler painted his portrait (Walters Art Gallery, Baltimore) in 1886. Lucas bought one of Pissarro's paintings from *père* Martin in January, 1870, *The Versailles Road at Louveciennes (Snow)*. He bequeathed it to the Maryland Institute in Baltimore, which deposited it in the Walters Art Gallery.

These men were exceptions, however. The stimulus that helped Durand-Ruel decisively would come from a woman, Louisine Waldron Elder, and later from her husband, Henry O. (Harry) Havemeyer. Mary Cassatt introduced both these collectors to the Impressionists and guided them in their choices.

An emulator of Degas and invited by him to participate in the fourth Impressionist exhibition in 1879, Mary Cassatt was the only American artist among the Impressionists. Therefore, though she was "only" a woman, Cassatt considered it her duty to defend the ideas of the Impressionists in America.

The Havemeyers and the First American Collectors of Impressionism

Mary Cassatt's Friend: Louisine Elder

In March, 1874, the widow of a wholesale merchant, Mrs. George W. Elder, a lady from New York's best society and vested with a solid fortune, arrived in Paris—an obligatory halt on a trip through continental Europe—with her three daughters: Annie, Louisine, and Adaline. One of them, Louisine, born in New York in 1855, was nineteen years old and passionately interested in all kinds of art. Thanks to Emily Sartain, another young American who had come to Europe to study painting, Louisine Elder made the acquaintance of Mary Cassatt, ten years her elder. Cassatt had been studying painting in Europe since the late 1860s; she pursued her studies with a steadfastness hardly expected of a young woman from Philadelphia's best society. Cassatt knew Italy, Spain, Holland, Belgium, and of course, the Parisian art world.

Louisine Elder was captivated by Mary Cassatt and saw her again with pleasure on her subsequent trips to Paris. Relying on her memory, Louisine recalled that it was in 1875, on the advice of Mary Cassatt, that she had purchased from the proprietor of an artist's supply shop, perhaps Portier or Latouche, a pastel and gouache over monotype by Degas, *Ballet Rehearsal (A Ballet)*. The pastel only cost 500 francs, but 208 Louisine had to borrow money from her sisters in order to pay for it with her allowance, especially as she was not long in purchasing, for 300 francs, a canvas by Monet, *The Drawbridge, Amsterdam* (Shelburne Museum, Shelburne, Vermont), and a fan painting by Pissarro.

So it was that the first Impressionist works set out for America, perhaps even before 1876, when an English translation for the group's name—Impressionists—first appeared in print. Ironically, it was Stéphane Mallarmé, a poet and an English teacher, who coined the term. We know for sure that, in February, 1878, Louisine Elder loaned her Degas to an exhibition being held in New York. It attracted, understandably, very limited attention, though the anecdote takes on a symbolic value: that pastel was the first work by Degas to be imported into the United States. It was not, however, the first Degas on American soil. Late in 1872, Degas himself had stayed and painted in New Orleans, where a part of his family resided.

Louisine Elder Marries Henry Osborne Havemeyer

Louisine Waldron Elder became Mrs. H.O. Havemeyer on August 22, 1883. The man 207 she married, Henry (Harry) Havemeyer, was born in 1847, and thus thirty-five years old. Harry Havemeyer was a rich man who had gone through the ranks of the family business, the Havemeyer and Elder sugar refinery, in which his family and the Elders were partners. Harry's ability and enterprising spirit would make him one of the tycoons of American industry, the so-called Sugar King. What is important here, however, is that Harry Havemeyer took an interest in painting and objets d'art, especially those from the Near and Far East. A customer of the New York gallery M. Knoedler and Co., Harry bought paintings by the Barbizon School, by Millet and Delacroix, displaying conservative tastes that many of the future collectors of Impressionism had in common.

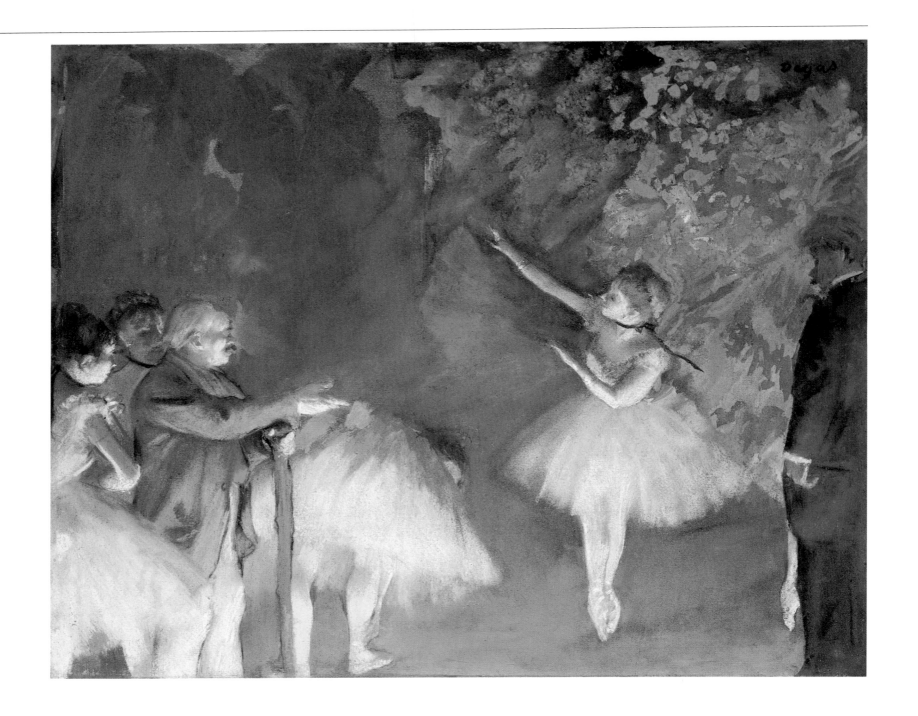

H.O. Havemeyer Buys a Manet

At the beginning of their marriage, Harry's wife had hardly any influence on his artistic tastes. The birth of their children—Adaline in 1884, Horace in 1886, and Electra in 1888—combined with Harry's intensely active professional life, which prevented him from going to Europe, hardly left the couple time to investigate new artists. Thanks to Louisine, the Havemeyer name figured along with that of Erwin Davis and Alexander Cassatt among the lenders at the exhibition Durand-Ruel organized in New York in 1886. The same year, principally to please his wife, Harry Havemeyer bought his first Manet, a still life entitled *The Salmon*. However, he did not take advantage of the low prices at Durand-Ruel's 1887 auction, held to sell off the dealer's Impressionist paintings rather than shipping them back to France.

209

208 Edgar Degas. *Ballet Rehearsal (A Ballet)*. 1876-77. Pastel and gouache over monotype, 55 × 68 cm. (21¾ × 26¾″). The Nelson-Atkins Museum of Art, Kansas City, Missouri (Acquired through the Kenneth A. & Helen F. Spencer Foundation Acquisition Fund). The first work by the artist that Louisine Havemeyer purchased; it was exhibited in New York in 1878.

"It was so new and strange to me! I scarcely knew how to appreciate it, or whether I liked it or not, for I believe it takes special brain cells to understand Degas. There was nothing the matter with Miss Cassatt's brain cells, however, and she left me in no doubt as to the desirability of the purchase and I bought it upon her advice."
(Louisine Havemeyer, *Sixteen to Sixty: Memoirs of a Collector*, New York: privately printed, 1961, pp. 249–50.)

209 Edouard Manet. *The Salmon*. 1869. Oil on canvas, 72 × 92 cm. (29 × 37″). Shelburne Museum, Shelburne, Vermont. Harry Havemeyer's first Manet, purchased in 1886.

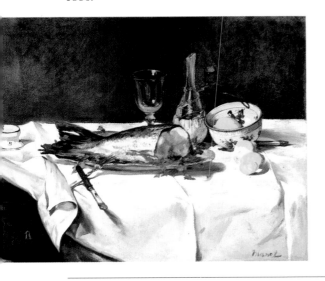

The Havemeyer Collection Grows

In 1889, the Havemeyers went to Paris for the Exposition Universelle, which gave them an opportunity to see Paul Durand-Ruel. He became their agent for Old Masters, Rembrandt, and Dutch and Flemish painting as well as for modern art.

To house his growing collections and give his Rembrandts suitable surroundings, Harry Havemeyer decided to build a home at 1 East Sixty-sixth Street in New York; his family would live there until 1891 (the house has since been destroyed). The Havemeyers entrusted the interior decoration to Louis C. Tiffany and Tiffany's mentor, the artist Samuel Colman. There were subtle, noteworthy details in the house such as bronze doors decorated with Tiffany glass and pebbles that Louisine had found on the beach. Henceforth the Havemeyer residence with its collections became a place of pilgrimage for connoisseurs. Louisine usually did the honors, but it was not rare to find the master of the house taking an active part at their regular Sunday afternoon concerts. On those occasions, the Havemeyers had the opportunity to note with pleasure the Impressionists' increased success in their country, a success for which they could, to a great extent, claim credit.

During the 1890s and the following years, the Havemeyers amassed the masterpieces now in the Metropolitan Museum of Art, New York, thanks to Louisine Havemeyer's bequest. Although they started early, the Havemeyers were young enough to benefit from what the earlier generation of collectors had assembled. They bought a lot, sometimes reselling paintings that did not seem worthy of the others. The Havemeyers paid high prices, and their only competitor seems to have been Count Isaac de Camondo. Paying almost half a million francs ($95,700) for Degas's *Dancers Practicing at the Bar* at the Rouart auction in 1912, Louisine Havemeyer set a record for the work of a living artist.

164

The Havemeyers' taste for Courbet, Manet, and Degas made them fundamentally different from other American tycoons. Mary Cassatt was mostly responsible for that, and she did not stop encouraging them. She also urged her friends to purchase works by El Greco and Goya, which the Havemeyers were the first Americans to appreciate. In 1904, when Durand-Ruel sent the Havemeyers *Majas on a Balcony* by Goya (The Metropolitan Museum of Art, New York), he also sent along Cézanne's *Self-Portrait* (Hermitage Museum, Leningrad), which Vollard had given him. That was a sign of the times: since 1901, Vollard had been selling the Havemeyers works by Cézanne, and Harry Havemeyer proved to be very generous to Vollard. Another adviser with whom they often met was Théodore Duret.

A Collection for a Museum

After a difficult period following Harry Havemeyer's death in December, 1907, Louisine again started buying during her frequent trips to Europe. During that same period, another aspect of her personality came to the fore: she began militating in favor of women's suffrage in the Women's Political Union and was arrested and imprisoned for demonstrating, a fact that scandalized her family and friends, including Mary Cassatt. Louisine's undaunted feminism induced her to loan her works by Degas to an exhibition promoting women's suffrage, an initiative that Degas (a misogynist) probably never knew anything about.

In May, 1922, Louisine Havemeyer received the cross of the Legion of Honor, and she was promoted to the rank of Officer in the French national order in 1928, a year after she donated Manet's *Portrait of Clemenceau* to the Louvre (now in the Musée d'Orsay, Paris). Louisine died in New York on January 6, 1929. Her children carried out her wishes by donating to the Metropolitan Museum of Art, New York, in addition to the works specifically mentioned in their mother's will, all the paintings and objects the museum deemed necessary for its collections. This would amount to 1,972 items: Old Master and modern paintings, sculpture, Near and Far Eastern

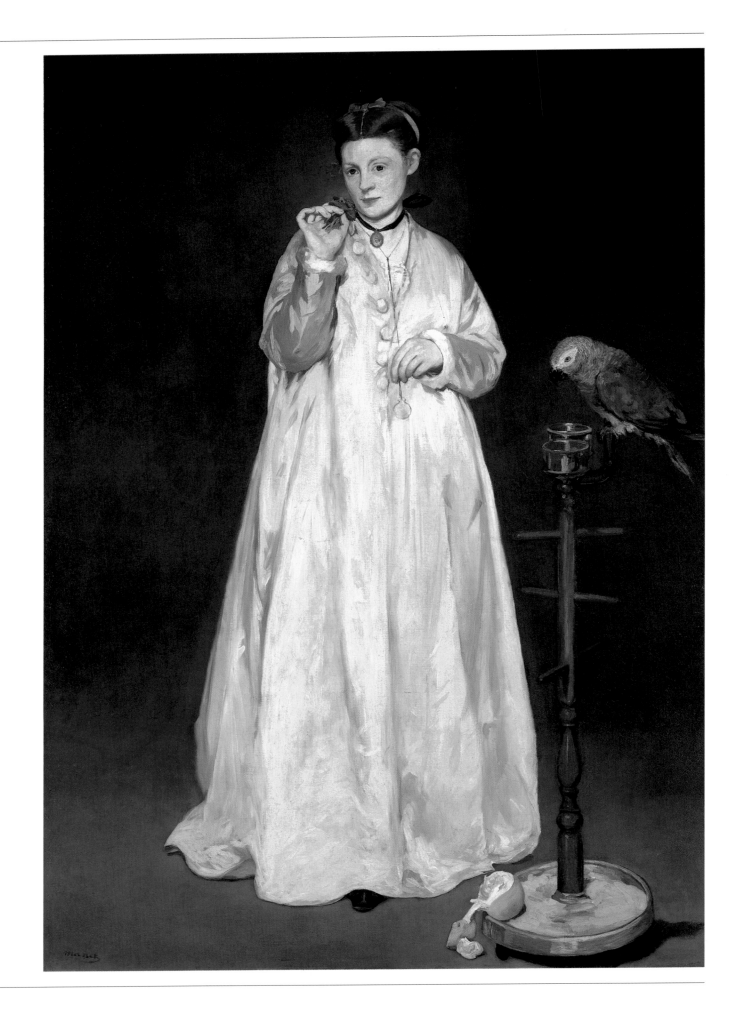

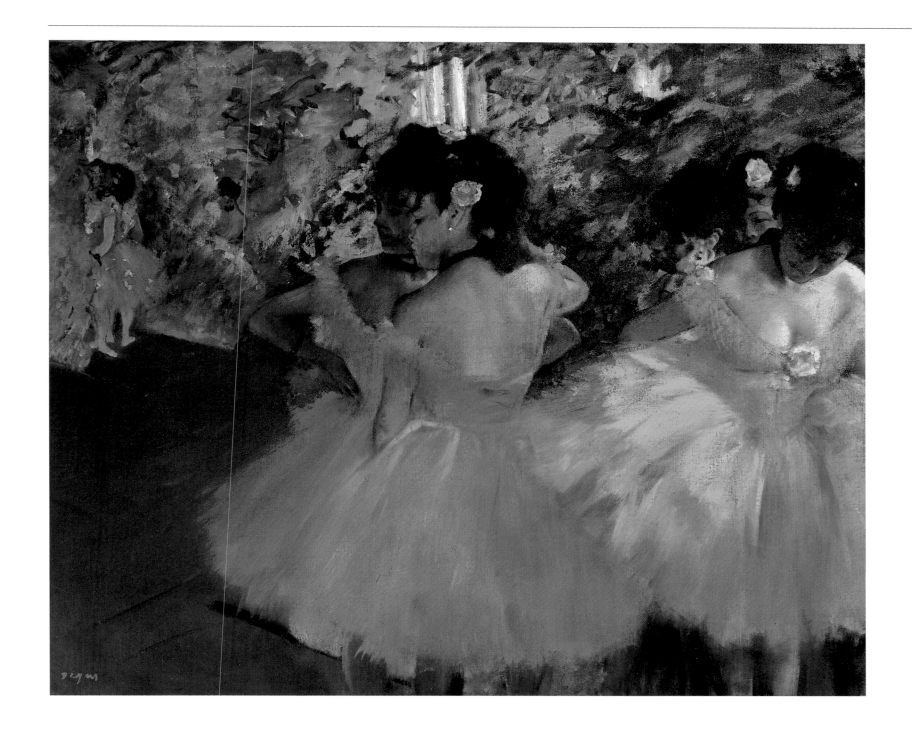

211 Edgar Degas. *Dancers.* c. 1876. Oil on canvas, 59 × 72 cm. (23½ × 29″). Hill-Stead Museum, Farmington, Connecticut.

◁ 210 Edouard Manet. *Woman with a Parrot.* 1866. Oil on canvas, 185 × 128 cm. (72⅞ × 50⅝″). The Metropolitan Museum of Art, New York (Gift of Erwin Davis, 1889).

objets d'art, drawings, and prints that would be dispersed among the museum's various departments. The Havemeyers' collection was so large that works could also be bequeathed to their children and grandchildren, and several auctions—the first of which contained more than one hundred paintings—were prepared. A few months afterward, Louisine's stately residence, which she had compared to the Palatine Chapel in Palermo because of its mosaics and gilding, was demolished to make room for new buildings.

Today, more than fifty paintings by Manet and the Impressionists remind visitors to the Metropolitan Museum of Art of the enduring enthusiasm of a young, nonconformist American girl for a group of unappreciated artists. Although the Havemeyer bequest contained only one Pissarro and one Renoir, the extraordinary scope of the Havemeyer collection is shown by Manet's *A Matador Saluting* (Pl. 39), *Mlle Victorine in the Costume of an Espada* (Pl. 58), and *Boating*; by Monet's *La Grenouillère*;

by Cézanne's *L'Estaque* and *Landscape with Viaduct (Mont Sainte-Victoire)*; and especially, by Degas's *Woman with Chrysanthemums, The Dancing Class, Dancers Practicing at the Bar*, and *Woman Having Her Hair Combed*, to name only the most famous. 164

The impetus the Havemeyers imparted had a lasting effect on the behavior of American collectors. Although their collections were less extensive than the Havemeyers', many collectors—sometimes friends of the Havemeyers and always customers of Durand-Ruel—formed remarkable collections, starting at the end of the nineteenth century. The American collections often found their way into museums, thus compensating for the more conservative tastes of contemporary Americans.

Two Pioneers: Alexander Cassatt and Erwin Davis

Mary Cassatt did not limit her proselytism to her friend Louisine Havemeyer. She made use, with varying success, of her older brother, Alexander J. Cassatt, and of all his business contacts in the railroad industry. In 1881, Alexander was able to acquire, among others, from Degas—after a long wait to which all Degas enthusiasts had to resign themselves—a very beautiful canvas, *The Ballet Class*, as well as several Monets, including *Green Park, London* (both in the Philadelphia Museum of Art).

Indeed, Mary Cassatt often bought pictures by the artists she admired either directly from the painters such as Pissarro, or from Durand-Ruel or other dealers, or at auctions such as Hoschedé's in 1878, or Manet's studio sale in 1884. Some of these works she bought for herself; others were purchased for her friends or relatives.

Only one other American can be likened to Louisine Elder, Mary Cassatt, and her friends: the wholesale merchant and businessman Erwin Davis. Through the American artist J. Alden Weir, Davis acquired two Manets in 1881: *Boy with a Sword* and *Woman with a Parrot*. He donated them both to the Metropolitan Museum of Art, New York, in 1889, a year before Manets *Olympia* entered the French public collections. Davis also owned works by Degas, including *Dancers* (Hill-Stead Museum, Farmington, Connecticut) and approximately twenty Monets, some of which he had purchased after the New York exhibition of the Impressionists in 1886. Already in March, 1889, Davis was forced to part with his collection, which numbered almost four hundred paintings if the Old Master works are included. 210 211

Some American Collectors After 1886

After 1886, for the first time, Durand-Ruel came into contact with the collectors who formed their collections outside the chronological limits of this study, the bulk of those collections being amassed primarily after 1890.

William H. Fuller was among the most well known of those collectors. Fuller was director of the National Wallpaper Company and passionately enthusiastic about Monet, whose first one-man show Fuller organized at the Union League Club in New York in 1891. Another New Yorker, Albert Spencer, sold off his Barbizon paintings in 1888, and bought works by Monet and Pissarro.

A writer and hydraulic engineer in Boston, Desmond Fitzgerald was staying in France in 1889. He bought a still life by Renoir from Durand-Ruel. Fitzgerald's favorite Impressionist was unquestionably Monet, whom he had discovered in Paris at Georges Petit's "Monet–Rodin" exhibition. In March, 1892, Fitzgerald lent five Monets to the second Monet exhibition in the United States, organized at the St. Botolph Club in Boston. Collectors in Boston paid especial attention to Monet, no doubt thanks to the efforts of the artist Lilla Cabot Perry, who had worked with Monet at Giverny in 1889.

Finally, Durand-Ruel himself mentions two more American collectors: a very young man, Alden Wyman Kingman, who would sell all his paintings by Monet back

to the dealer ten years later, and Cyrus Lawrence. This small nucleus of collectors was soon joined by new recruits: Alexander Cochrane of Boston, who would bequeath some Impressionist works to the Museum of Fine Arts in that city; the dealer L. Crist Delmonico, with premises at 166 Fifth Avenue in New York; and also W. H. Crocker of San Francisco, son of the financier Charles Crocker and nephew of Edwin B. Crocker, judge on the California Supreme Court and founder of the Crocker Art Gallery in Sacramento. Making a gesture both grandiose and pragmatic in 1890, W. H. Crocker bought from Durand-Ruel a ready-made collection of Millet, Delacroix, Corot, Courbet, Puvis de Chavannes, Pissarro, Boudin, Degas, and Renoir for exactly $ 100,000, more than a million francs at the time.

The Chicago lawyer Arthur J. Eddy was more modest and no doubt a better connoisseur. Both Whistler and Rodin did portraits of Eddy, who was responsible for bringing the famous Armory Show to Chicago.

Catholina Lambert, a silk manufacturer who owned the Bella Vista Castle in Paterson, New Jersey, should also be mentioned. His collections were sold at auction in 1916.

The artlover Harris Whittemore of Naugatuck, Connecticut, was also a member of the same generation of collectors. He was the son of John Howard Whittemore, an industrialist who owned an iron manufacturing firm. Harris Whittemore was also a customer at Durand-Ruel's in Paris from 1890, but it was Whittemore's encounter with Mary Cassatt in 1893 that renewed his interest in the Impressionists.

Whittemore's friend, Alfred Atmore Pope, founder and president of the Cleveland Malleable Iron Company, bought his first paintings by Monet at Boussod, Valadon and Co. in New York in 1889; later, however, Pope became a faithful customer of Durand-Ruel. Pope's country house, Hill-Stead, in Farmington, Connecticut, has been transformed into a museum and still houses a small but very fine collection of Impressionist works that Pope owned, including among others, Manet's *The Guitar Player* and *Dancers* by Degas. Pope's daughter, Theodate, was also a friend of Mary Cassett, but the artist bore Theodate a grudge for telling her father that paintings were made for museums and that the gold frames on the walls of his house made her ill!

Lastly, we must mention the Chicago real estate developer Potter Palmer and his wife, the energetic and sparkling Bertha Honoré Palmer, who were among the most splendid representatives of that generation of collectors. Their guide in artistic matters was Sara Tyson Hallowell. Between 1889 and 1892, they bought an impressive collection of Impressionist paintings, mostly from Durand-Ruel. So that the Impressionists—whom the jury had once again eliminated—would be on view at the World's Columbian Exposition in Chicago in 1893, the Palmers supported the idea of holding an exhibition with loans from private collectors. This resulted in the Loan Collection of "Foreign Masterpieces Owned in the United States." Thanks in part to Bertha Palmer, Mary Cassatt was commissioned to decorate the south tympanum of the Woman's Building of the Columbian Exposition with a mural. Eventually, Bertha Palmer would bequeath the main part of the Palmers' private collection to the Art Institute of Chicago.

Like their contemporaries Camondo, Depeaux, Personnaz, and Vasnier in France, all these American artlovers formed collections that are in museums today. Their energy and the discriminating choice they exercised in artistic matters, founded on the example of the few collectors who preceded them as Impressionist enthusiasts, set the fashion for forming the collections that, today, are responsible for the fame of our great museums.

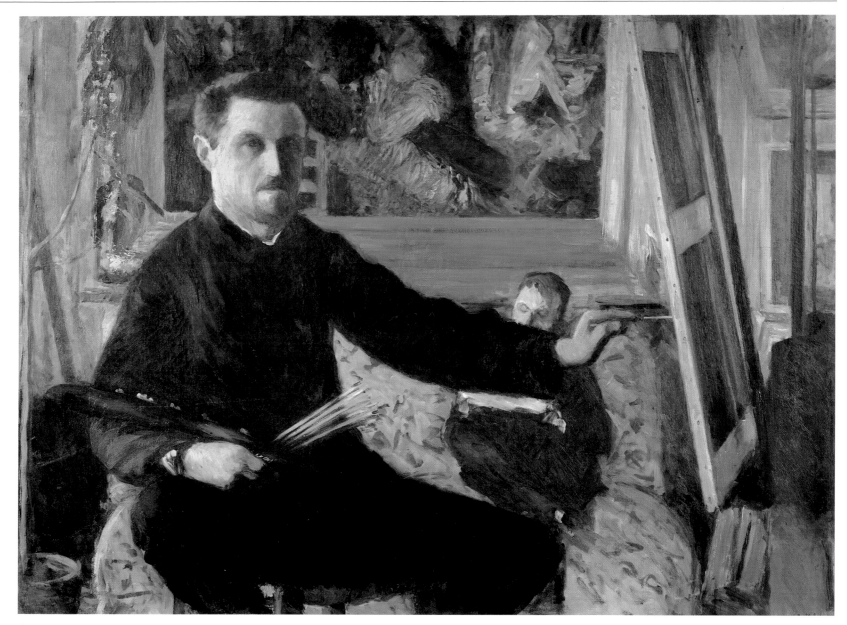

212 Gustave Caillebotte. *Self-Portrait in Front of "Dancing at the Moulin de la Galette"*. c. 1879. Oil on canvas, 90 × 115 cm. (35½ × 45¼"). Private collection, Paris. Renoir's painting is reversed, which suggests that what we see here is only its reflection in the mirror that Caillebotte is using to examine his own features.

Gustave Caillebotte

There is a name that does not appear on Théodore Duret's list, although one would expect to see it there: Gustave Caillebotte. It was certainly not omitted inadvertently. In 1878, Duret knew Caillebotte well; however, as in the case of Henri Rouart, Duret did not want to count the artists who exhibited with the Impressionists as collectors. Yet, if one of them deserved the title, it was surely Caillebotte.

An Impressionist Artist and Art Patron in 1876

No document permits us to date Caillebotte's first meeting with the Impressionists precisely. Degas may have already thought of inviting him to participate as an artist in the group's 1874 exhibition. Be that as it may, Caillebotte's membership in the group was already full and complete by 1876: on February 5 of that year, Renoir and Rouart both signed an invitation asking him to exhibit with the Impressionists. Caillebotte accepted and sent eight paintings to the exhibition on Rue Le Peletier, including his famous *The Floor Scrapers* (Musée d'Orsay, Paris). For the first time, in April, 1876, Monet noted in his accounts three purchases by "Mr. Caillebotte, painter," amounting to 1,000 francs. This entry mentioning Caillebotte's profession proves that Monet did not yet know the collector well. However, Caillebotte developed closer ties to the Impressionists very quickly. Proof is found in Caillebotte's will, which he wrote when he was twenty-eight years old, on November 3, 1876, having been deeply moved by the death of his older brother, René:

212

> It is my wish that the sum necessary to hold, in 1878, under the best possible conditions, the exhibition of the painters known as intransigents, or impressionists be taken from my estate. It is rather difficult for me to estimate the sum today; it could be as much as thirty, forty thousand francs, or even more. The painters who will figure in this exhibition are Degas, Monet, Pissarro, Renoir, Cézanne, Sisley, Mlle Morizot [sic]. I name those without excluding others.
>
> I donate the paintings I own to the Nation; however, since I want this donation to be accepted, and in such a way that these paintings will not go into an attic or a provincial museum but right into the Luxembourg [Museum] and later into the Louvre, some time must elapse before this clause is carried out, until the public, I will not say understands, but accepts this [kind of] painting. The time [needed] may be twenty years or more; in the meantime, my brother Martial or, in his absence, another of my heirs, will keep them.
>
> I ask Renoir to be my executor and to please accept a painting of his choice; my heirs will insist that he take an important one.
>
> Drawn up in duplicate in Paris, November third, eighteen hundred and seventy-six.

Thus, as early as 1876, Caillebotte had defined his position as an artist and an art patron.

The Impressionists did not hold a group exhibition in 1878, but Caillebotte—very much alive—had contributed funds and paintings to the one organized in 1877.

"Mr. Caillebotte, the youngest of the good men. Barely thirty years old. Former pupil of Bonnat, in whose studio he still was three years ago when he exhibited *The Floor Scrapers* at Durand-Ruel's. I admit that that canvas owed rather little to the master's school. It made a bit of noise, as I remember, at least among artists.... The Impressionists welcomed him enthusiastically, like a precious recruit.... He went into the fray like a pampered child, insured against extreme poverty, relying on that double force: willpower assisted by wealth. He had another sort of courage, which is not the most common, hardworking riches. And I know few men who have forgotten to the extent he has that they are persons of independent means, in order to remember that they must devote themselves above all to being famous. Famous or not, Mr. Caillebotte is a brave man. His apartment on Boulevard Haussmann, which could have been luxurious, has only the very simple comforts of a man of taste. He lives there with his brother, a musician."

Montjoyeux—Jules Poignard, "Chroniques parisiennes: les Indépendants (Parisian Chronicles: The Independent Artists)," *Le Gaulois*, April 18, 1879.

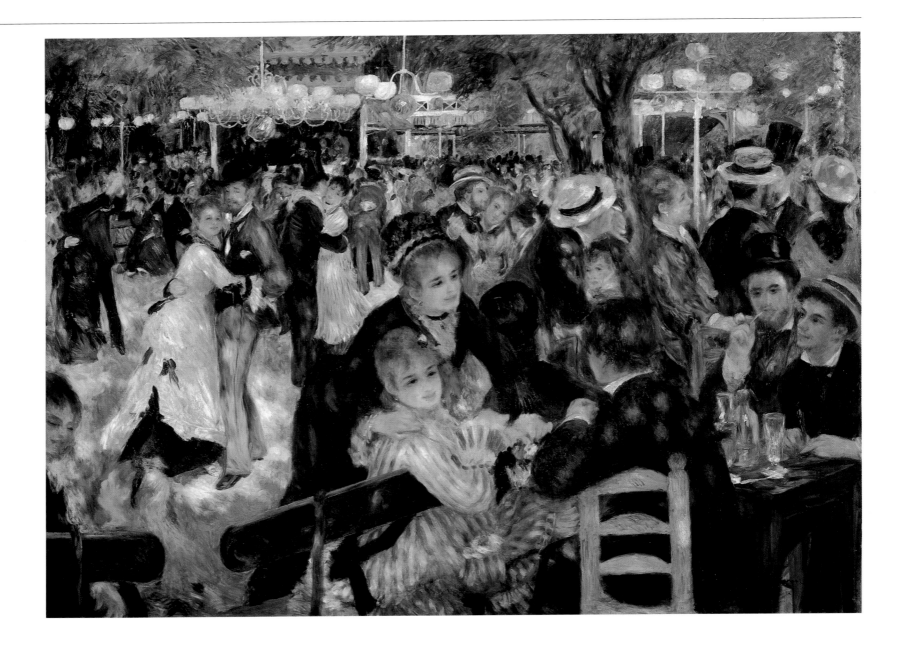

213 Pierre-Auguste Renoir. *Dancing at the Moulin de la Galette*. 1876. Oil on canvas, 131 × 175 cm. (51½ × 69″). Musée d'Orsay, Paris (Gustave Caillebotte Bequest, 1894). This painting was probably acquired by Caillebotte at the end of the third Impressionist exhibition in 1877. In July, 1879, a reporter for the magazine *L'Artiste* mentioned it as "a charming painting... one of the best works by Renoir.... purchased by Mr. Caillebotte who would not exchange it for Bouguereau's *Venus*," a reference to the amazing *Birth of Venus* (Musée d'Orsay, Paris), for which the French government had just paid 15,000 francs.

He paid for the rent of an apartment at 6 Rue Le Peletier and sent in six canvases. On May 28, 1877, Caillebotte—out of sympathy, for he did not need money himself—joined Pissarro, Renoir, and Sisley in an auction of their works at the Hôtel Drouot. We know little about the financial results of the auction, except that they were particularly disappointing. In 1879, Caillebotte again exhibited with the Impressionists (thirty paintings and pastels), as well as in 1880 and 1882.

When Caillebotte died in 1894, eighteen years after having written his will, Renoir took a few more than sixty works by Manet, Degas, Monet, Cézanne, Sisley, Pissarro, and himself, and two Millets from his friend's home to submit to the committee that was in charge of examining bequests to the French national museums. Before we see what happened to Caillebotte's collection, we must go back to Caillebotte as a person and as an artist. Recent studies by the art historians Marie Bérhaut and Kirk Varnedoe have described Caillebotte's personality accurately and with enthusiasm, emphasizing the profound originality of his approach.

Gustave Caillebotte was influenced by Japonism and by contemporary photography. He painted the modern Paris invented by Baron Haussmann as well as suburban gardens and is probably, except for Degas, the artist most representative of

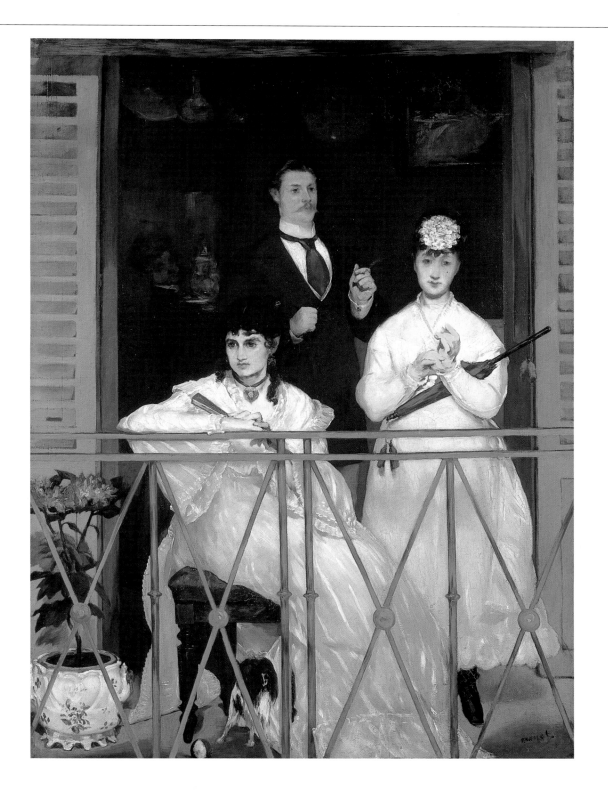

214 Edouard Manet. *The Balcony*. 1868–69. Oil on canvas, 170 × 124 cm. (67¾ × 49¼″). Musée d'Orsay, Paris (Gustave Caillebotte Bequest, 1894).
This is one of the rare paintings that Caillebotte bought at an auction: at Manet's studio sale in 1884.

the Naturalist yearnings of time. Caillebotte's visual acuity also corresponded to the hyper-Realist tendencies of our late twentieth century. The purpose of this chapter, however, is to examine the man and collector rather than the artist, now admitted, with good cause, into the Impressionist pantheon.

A Private Income of 100,000 Francs a Year

Gustave Caillebotte was born in Paris on August 19, 1848. His father, Martial Caillebotte, owned a thriving business that supplied military equipment, "Les Lits mili-

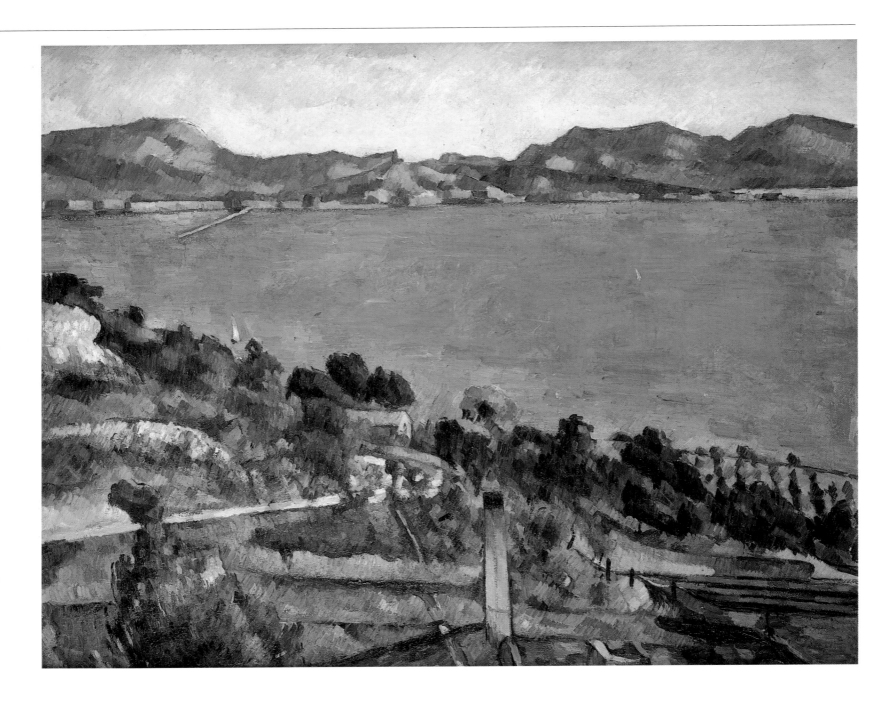

215 Paul Cézanne. *L'Estaque.* c. 1878–79. Oil on canvas, 59 × 73 cm. (23¼ × 28¾"). Musée d'Orsay, Paris (Gustave Caillebotte Bequest, 1894).

taire." A respected businessman, Martial Caillebotte was a judge on the commercial court for the Seine district and later became a Knight of the Legion of Honor. In 1868, he settled with his family in a town house (now destroyed) at 77 Rue de Miromesnil, at the corner of Rue de Lisbonne.

Gustave Caillebotte, after studying at the Lycée Louis-le-Grand, went on to study law. During the Franco-Prussian War, he was a member of the Security Police (Garde mobile de la Seine) and endured the hardships of the siege of Paris. Caillebotte's final choice of vocation became apparent when he was admitted to Léon Bonnat's studio at the Ecole des Beaux-Arts in spring, 1873. Although we know nothing of Caillebotte's friends from that time, it is easy to imagine that he kept company with Henri Rouart, a neighbor of his who lived on Rue de Lisbonne and belonged to the same social sphere as the Caillebottes. As we have seen, together with Renoir, Rouart was responsible for inviting Caillebotte to the 1876 Impressionist exhibition.

Gustave Caillebotte was very wealthy. His father had died on December 25, 1874, leaving more than two million francs to be divided between his third wife,

216 Edgar Degas. *Woman Coming Out of the Bathtub*. 1876–77. Pastel over monotype, 16 × 21 cm. (6¼ × 8¼"). Musée d'Orsay, Paris (Gustave Caillebotte Bequest, 1894).

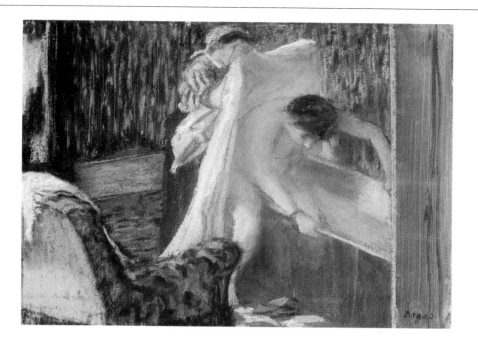

217 Edgar Degas. *L'Etoile (The Star)*. 1876–77. Pastel over monotype, 58 × 42 cm. (22⅞ × 16½"). Musée d'Orsay, Paris (Gustave Caillebotte Bequest, 1894).

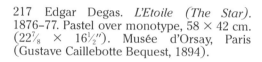

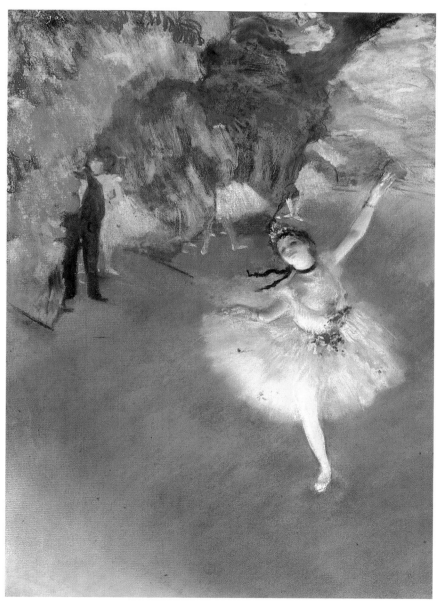

218 Edgar Degas. *The Chorus.*
1876–77. Pastel over monotype, 27
× 31 cm. (10⅝ × 12¼″). Musée
d'Orsay, Paris (Gustave
Caillebotte Bequest, 1894).
This work already belonged to
Caillebotte in April, 1877, the date
of the third Impressionist exhibi-
tion.

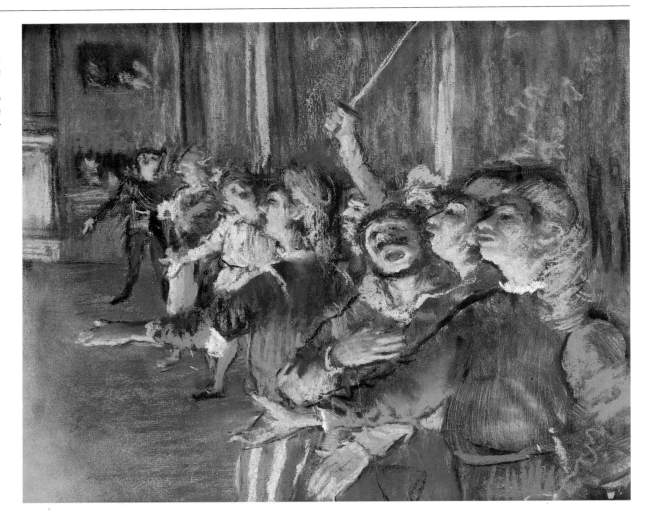

219 Edgar Degas. *Women on the
Terrace of a Café in the Evening.*
1877. Pastel over monotype, 41 ×
60 cm. (16½ × 23⅝″). Musée d'Or-
say, Paris (Gustave Caillebotte Be-
quest, 1894).
Caillebotte also loaned this pastel
to the third Impressionist exhibi-
tion.

▷
220 Pierre-Auguste Renoir. *The
Swing.* 1876. Oil on canvas, 92 ×
73 cm. (36½ × 28½″). Musée d'Or-
say, Paris (Gustave Caillebotte Be-
quest, 1894).

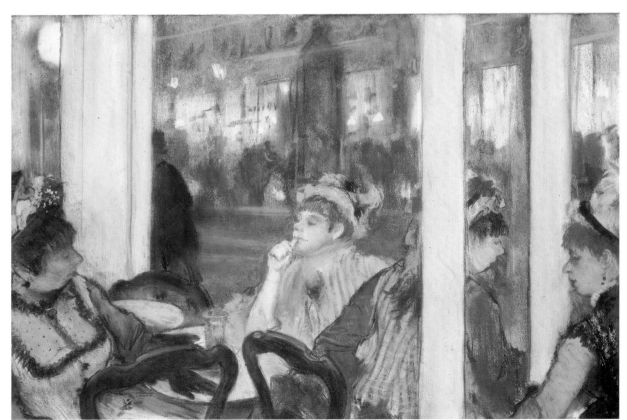

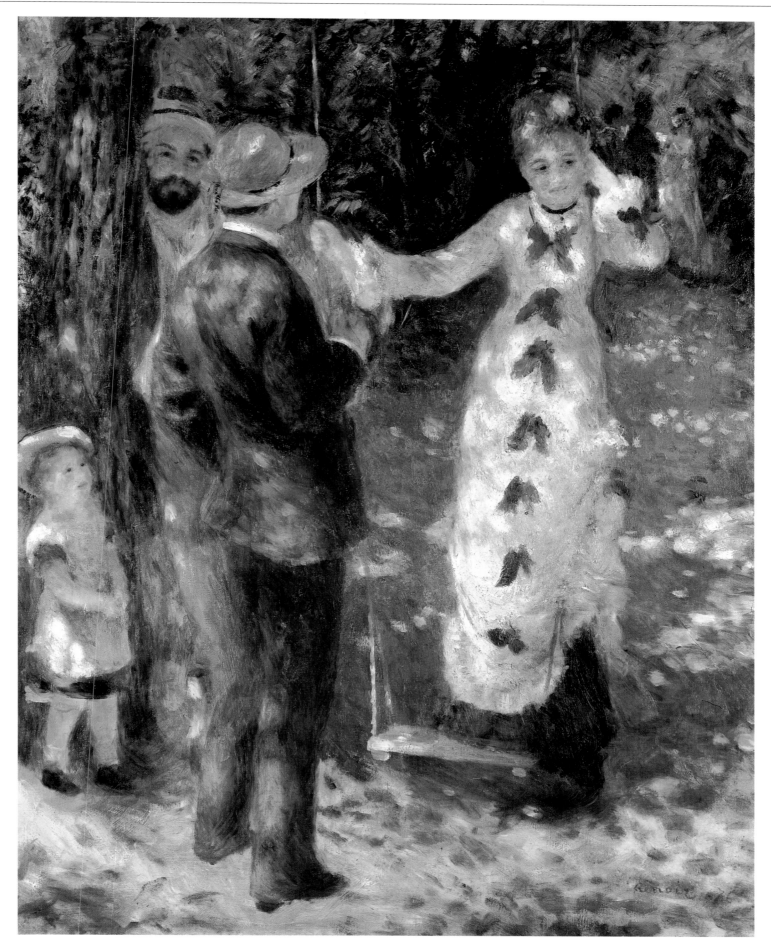

Céleste Daufresne, and his four children: Alfred, a priest, administrator of the Eglise Saint-Georges and later vicar of Notre-Dame-de-Lorette; René, Gustave, and Martial. In addition to the town house on Rue de Miromesnil worth 300,000 francs, Caillebotte senior owned several buildings in Paris, which brought in income, farms, and bonds, especially government bonds. René Caillebotte died suddenly on November 2, 1876, and then Céleste on October 21, 1878. Heir to a fortune comparable to the one Georges Petit inherited from his father, Gustave Caillebotte was indisputably a millionaire at thirty.

It is impossible not to contrast Gustave Caillebotte with Ernest Hoschedé, bankrupt at the same period because of his overzealous admiration for the Impressionists. Perhaps Caillebotte encountered Hoschedé at Montgeron, since the Caillebotte family owned an estate in nearby Yerres until the widowed Madame Caillebotte died. Gustave Caillebotte disliked ostentation. He settled in an apartment at 31 Boulevard Haussmann and shared it with his younger brother, Martial, a stamp collector and a musician, until Martial married in 1887. About 1880, Gustave bought a house on the banks of the Seine at Petit-Gennevilliers, which little by little became his main residence. He kept a splendid garden there and continuously exchanged letters on the subject with Monet, also an experienced gardening enthusiast.

Caillebotte also owned a series of sailing yachts that he raced; they had silk sails marked with the outline of a cat and picturesque names—Roastbeef, Condor, Inès, White Ass, Grasshopper—which have left their mark on the records of Parisian yachting in addition to the victories he won in the regattas on the Seine.

Gustave Caillebotte never married, but a young woman, Charlotte Berthier, lived with him until he died, from at least 1883 onward. That was the date on which Caillebotte added a codicil to his will, giving Charlotte a life annuity. Caillebotte, a leading citizen of Petit-Gennevilliers, was elected town councillor in 1888. Hating red tape, Caillebotte did not hesitate to pay certain of the town's expenses out of his own pocket! On his domestic staff, Caillebotte kept a cook, a maid and her two children, and two sailors. His way of life was that of the well-to-do, quite comparable to Monet's at the end of his life at Giverny, but far from the ostentatious society life that some fashionable contemporary artists adopted.

In reality, the only thing that counted for Caillebotte was painting: his own or, perhaps even more, that of his friends. So that it would survive, Caillebotte bought Impressionist art and worked at making it known, by offering opportunities for the Impressionists to show their work, since none of the official authorities made an effort to do so.

The Collector Gustave Caillebotte

Although it is regrettable that none of Caillebotte's account books have come down to us, we can nonetheless state that the majority of the works in his collection were acquired before 1880. The dates of the paintings prove this. Moreover, from April, 1876, Monet kept track in his notebooks of Caillebotte's purchases, as well as of the advances of money he made regularly and the rent he paid for a small apartment in Paris for Monet. The catalogues of the Impressionist exhibitions also mention loans by "M.C." or "G.C." in 1877 (Degas, Monet, Renoir, Pissarro), in 1879 (Monet, Pissarro), and in 1882 (Monet). After 1882, the last year in which he exhibited with the group, whose unity was definitively jeopardized, Caillebotte hardly bought anything, though he maintained close contacts, especially with Monet and Renoir. Early in the 1890s, Caillebotte even took the initiative of reviving the "Impressionist dinners" at the Café Riche. They were attended by the enthusiasts of the early years as well as by the artists.

As an art patron, Caillebotte did not restrict himself to purchasing works or lending money, to Renoir in particular. He actively participated in organizing the group's exhibitions in the late 1870s. Caillebotte's differences with Degas—about

221 Pierre-Auguste Renoir. *Study*, known as *Nude in the Sunlight*. 1875. Oil on canvas, 81 × 65 cm. (31⅞ × 25½″). Musée d'Orsay, Paris (Gustave Caillebotte Bequest, 1894). This was one of the key works in the second Impressionist exhibition in 1876. On the subject of this painting, *Le Figaro*'s all-powerful journalist Albert Wolff urged his readers: "Try to explain to Mr. Renoir that a woman's torso is not mass of rotting flesh with green and purplish blotches that denote a state of complete decay in a corpse." That abusive tirade did not prevent Caillebotte from buying the work, probably shortly afterward.

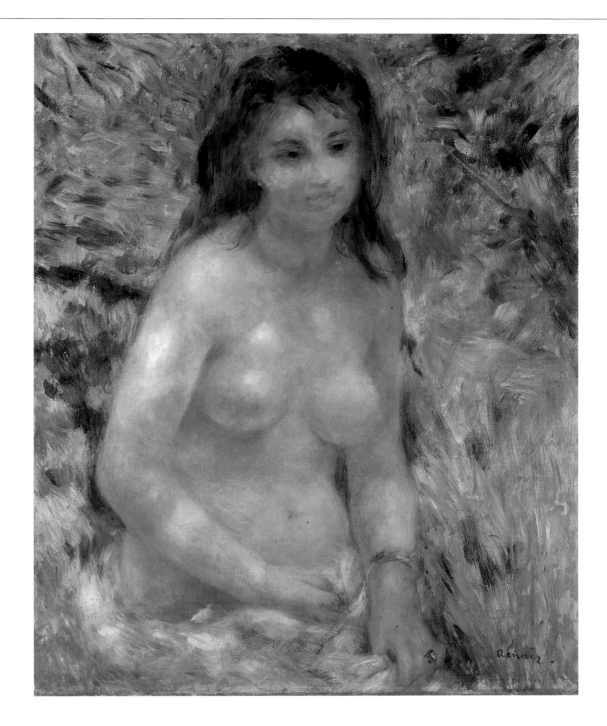

whom Caillebotte said, "though his talent is great, his character is not"—were not due solely to the collector's career as an independent artist. Caillebotte's admiration for his comrades impelled him to try to iron out difficulties in order to allow everyone's talent to manifest itself to the fullest. When money could help, he was ready to intervene. Thus he financed the unsuccessful attempt of Alphonse Legrand, one of the Impressionists' dealers, to market a type of decorative cement in partnership with Renoir. Together with Ernest May, he backed the project of publishing an art review devoted to prints, *Le Jour et la Nuit*, mentioned by Degas, Pissarro, and Mary Cassatt.

Caillebotte almost never made his purchases at auctions. For example, he does not seem to have done so, even through intermediaries, at the Hoschedé auction in 1878. For Caillebotte, getting a bargain was of little importance. He made exceptions and attended auctions only to sustain an artist's reputation: this was the case at the

253

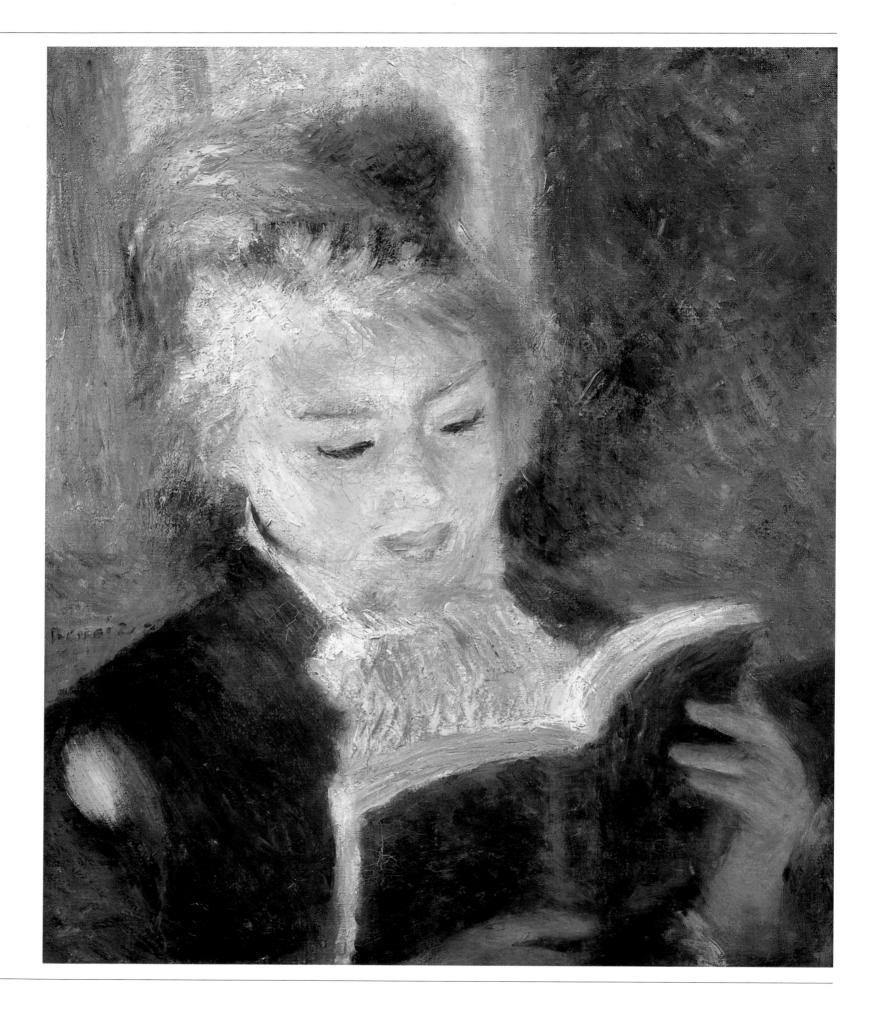

223 Pierre-Auguste Renoir. *Railroad Bridge at Chatou*. 1881. Oil on canvas, 54 × 65 cm. (21¼ × 25½″). Musée d'Orsay, Paris (Gustave Caillebotte Bequest, 1894).

◁ 222 Pierre-Auguste Renoir. *Girl Reading*. c. 1874. Oil on canvas, 46 × 38 cm. (18⅛ × 15″). Musée d'Orsay, Paris (Gustave Caillebotte Bequest, 1894).

sale of the contents of Manet's studio in 1884. Caillebotte won the bidding for a small study, *At the Races*, and for *The Balcony* (Musée d'Orsay, Paris), knocked down for 214 one of the highest prices at the auction; only Caillebotte, Rouart, Duret, or Chabrier could have afforded to pay that much. It was also Caillebotte's last chance to acquire an important canvas by Manet. We do not know how he came to own the two other Manets in his collection: *Angélina* (Musée d'Orsay, Paris), a strange, unattractive work, and *A Game of Croquet* (Private collection), an unfinished sketch. It is also worth mentioning that Caillebotte was one of the first subscribers to the fund Monet launched in 1890 to give Manet's *Olympia* to the French national collections.

Caillebotte was still alive in 1892, when the Fine Arts Administration, on the advice of Stéphane Mallarmé and Roger Marx, bought from Renoir his *Young Girls at the Piano* (Musée d'Orsay, Paris) for the Luxembourg Museum. A little later, Renoir dedicated a second version of the work (Private collection, Japan) to Gustave 255

224 Camille Pissarro. *Orchard with Flowering Fruit Trees, Springtime, Pontoise.* 1877. Oil on canvas, 65 × 81 cm. (25½ × 31⅞″). Musée d'Orsay, Paris (Gustave Caillebotte Bequest, 1894).

Caillebotte, proof of the never-failing friendship between the two men. Gustave Caillebotte was the godfather of Pierre Renoir, the artist's first son, born in 1885. Thus it was natural for Caillebotte to have kept Renoir as his executor from 1876 onward.

The Caillebotte Affair

It was thus Renoir who, very officially (in a letter dated March 11, 1894, addressed to Roujon), informed Henry Roujon, director of the Fine Arts Administration of the death of Gustave Caillebotte, aged forty-five, on February 21, 1894, at Petit-Gennevilliers, and of his bequest "of a collection of sixty works, approximately, by Messrs. Degas, Cézanne, Manet, Monet, Renoir, Pissarro, Sisley, Millet."

A "tricky business," the prudent official immediately observed. Even before the national museums' advisory committee, composed of the curators of the various

225 Camille Pissarro. *Red Roofs. Village Scene. Winter Effect.* 1877. Oil on canvas, 53 × 64 cm. (21½ × 25¼"). Musée d'Orsay, Paris (Gustave Caillebotte Bequest, 1894).

226 Camille Pissarro. *Harvest at Montfoucault.* 1876. Oil on canvas, 65 × 92 cm. (25½ × 36¼"). Musée d'Orsay, Paris (Gustave Caillebotte Bequest, 1894).

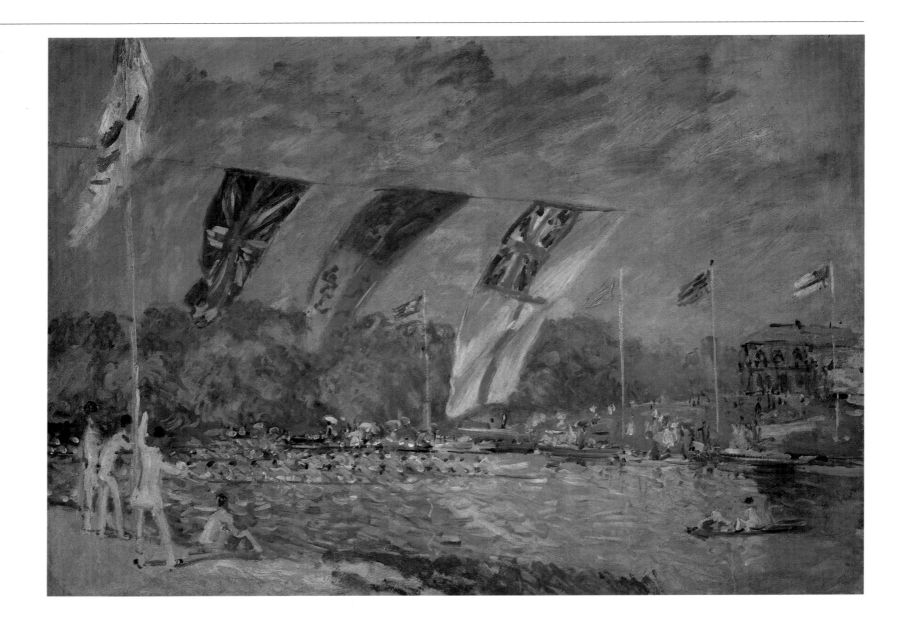

227 Alfred Sisley. *Boat Races at Molesey*. 1874. Oil on canvas, 66 × 91 cm. (26 × 35¾″). Musée d'Orsay, Paris (Gustave Caillebotte Bequest, 1894).

departments and chaired by the director of the French national museums, saw the works and actually learned the exact terms of the will quoted above, several Parisian newspapers were trumpeting the windfall: "This collection gives the Luxembourg [Museum] exactly what it lacks. This museum will finally be able to deserve the name of museum of living artists." It is true that, leaving Manet aside, Renoir was the sole Impressionist represented in the Luxembourg Museum at that time. And the critic added: "By simply removing one Cormon [whose gigantic painting *Cain* has found a new home in the Musée d'Orsay, Paris, in the meantime], it would be possible to accommodate a sixth of the collection."

The enthusiasm of the curator concerned at the Luxembourg Museum, Léonce Bénédite, was more restrained: rather hypocritically, he put forward, in favor of accepting the bequest, "the freedom of action that the curators of the Luxembourg will enjoy when, all tendencies being represented for the future in the Luxembourg, a curator will have only to give his attention to filling those most demanding gaps and will only need to request the State's financial intervention in order to acquire exceptional, undisputed works." But Bénédite revealed that there was not enough room to display the works *as a whole*. At no time did he consider "taking down Cormon," and he suggested building a temporary hall until the necessary reconstruction of the

228 Claude Monet. *Regattas at Argenteuil.* c. 1872. Oil on canvas, 48 × 75 cm. (17¾ × 29½″). Musée d'Orsay, Paris (Gustave Caillebotte Bequest, 1894). This is perhaps one of the first paintings by Monet that Caillebotte bought in April, 1876.

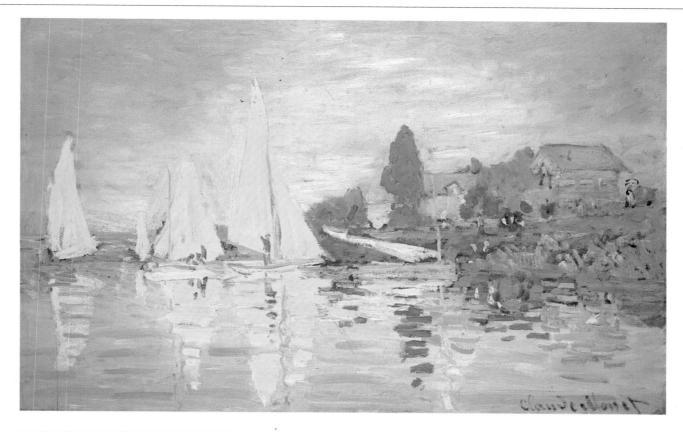

229 Claude Monet. *Luncheon in the Garden.* 1873-74. Oil on canvas, 160 × 201 cm. (63 × 79⅛″). Musée d'Orsay, Paris (Gustave Caillebotte Bequest, 1894). Monet regarded this canvas as a "decorative panel" and exhibited it under that heading at the second Impressionist exhibition. Caillebotte bought it from Monet for 600 francs on March 10, 1878.

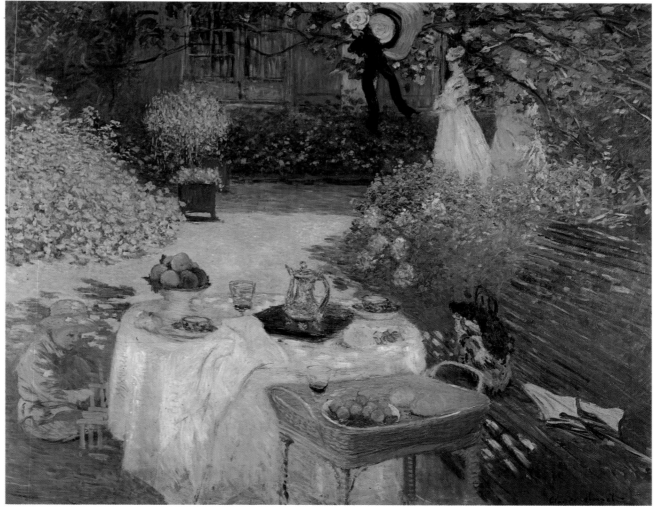

Luxembourg Museum was completed. In the meantime, it was obvious that only a few canvases would be hung up and that the rest were at great risk of being put in the "attic" or "provincial museum" that Gustave Caillebotte had wanted to avoid at all costs.

Renoir, like Martial Caillebotte, Gustave Caillebotte's heir (the other heir, Abbé Alfred Caillebotte, did not take part in the discussions), rightly insisted on complying with the will to the letter and on receiving a formal pledge from the national museums' direction that it would do so before delivering the works. Since neither of the parties wanted, or was able, to give in, the situation reached an impasse. Various compromise solutions were considered but set aside as illegal. The press, for or against the bequest, made matters worse by spreading false rumors.

The Impressionists in the Museum

Finally, early in 1895, Renoir and Martial Caillebotte, eager to put an end to the matter, agreed to a settlement. The museum chose forty items, including the two drawings by Millet, from the sixty-five initially proposed. However, the works were not actually hung up in the Luxembourg Museum until February, 1897. They are now in the Musée d'Orsay, Paris, a logical consequence of the evolution of the exhibition space available to the French national museums.

The Académie des Beaux-Arts waited until 1897 to protest—in a note addressed to the Minister of Fine Arts—the Impressionists' pushing their way into the museum, which it considered scandalous. And even then, the resolution was only adopted by eighteen votes against ten. Senator Hervé de Saisy's interpellation along the same lines on March 15, 1897, had little effect. These rearguard actions changed nothing. The Impressionists, "those malefactors who ruined young artists," were finally in the museum.

We would like to believe they were happy to be there. According to Vollard, on learning that several of his works were included in the Caillebotte bequest, Cézanne exclaimed, "Now Bouguereau can go to hell!" It is a wonder that two landscapes by Cézanne, *L'Estaque* and *Farmyard at Auvers*, were chosen from the five works proposed and *Bathers* (The Barnes Foundation, Merion, Pennsylvania), a more representative work, eliminated. Thanks to this bequest, however, Cézanne was reunited with the group from which he had gradually separated himself. The ups and downs of the affair helped the efforts of critics such as Octave Mirbeau and Gustave Geffroy, who were trying to gain recognition for Cézanne. Vollard stated that the controversy resulting from the Caillebotte bequest was one of the factors in his decision to present the first one-man show devoted to Cézanne in his gallery in 1895.

While Cézanne remained the odd man out for most of his contemporaries, it is more surprising to note how intensely reserved people still were toward Manet. The strident colors of *The Balcony* were not yet part of the visual universe of visitors to the museum; *Angélina*'s strangeness did not prevent it from being chosen in preference to *A Game of Croquet* (unfinished) or *At the Races*, both of which were refused.

From the start of the negociations, there seems to have been a consensus on the subject of the seven fine pastels by Degas; all of them were accepted. The direction of the museum had been trying to acquire a work by Degas for some time. His works were rare and, above all, from that time onward, expensive. In 1893, for example, Count Isaac de Camondo paid 30,000 francs for *Jockeys at the Tribune*, the same price as for Manet's *The Fifer*. Thus the Caillebotte bequest filled one of the gaps to which Bénédite referred. Degas, however, seemed to have been annoyed by the fact that he was being exhibited "in spite of himself." We also know that the Caillebotte bequest gave Degas, indirectly, a reason to feel indignant and an opportunity to quarrel with Renoir: in memory of Caillebotte and according to his wishes, Renoir had chosen a pastel by Degas, *The Dancing Class* (The Metropolitan Museum of Art, New York) from the Caillebotte collection. A little while later, being in need of

215

214

216, 217,
218, 219

71
60

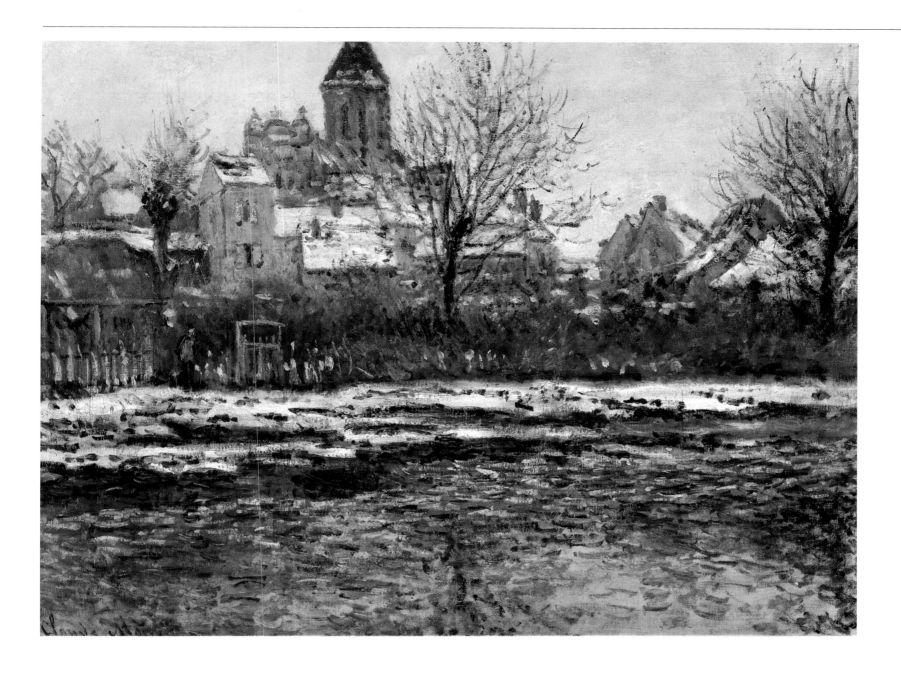

230 Claude Monet. *The Church at Vétheuil, Snow*. 1878–79. Oil on canvas, 52 × 71 cm. (20½ × 28″). Musée d'Orsay, Paris, (Gustave Caillebotte Bequest, 1894).
Gustave Caillebotte bought this work from the artist in January, 1879, and had it figure in the fourth Impressionist exhibition.

money, Renoir sold the pastel to Durand-Ruel; Degas learned of the sale and never forgave Renoir.

As an artist and as executor of Caillebotte's will, Renoir played a major role in the affair from the start. He may not always have been very skillful in that difficult role: Renoir was the source of the rumors according to which a part of the collection consisted of sketches that the artists themselves admitted were unworthy of being in a museum. It is likely that Monet was also of the same opinion. Even if that is correct, it obviously made an argument that was hard to counter for those who advocated making a selection from the bequest. Furthermore, Renoir seems to have quickly tired of the meetings with the authorities and the paperwork they entailed. He had reason to be satisfied nonetheless. Thanks to Caillebotte, three of his masterpieces became a part of the artistic heritage of France: *Dancing at the Moulin de la Galette, The Swing*, and *Nude in the Sunlight*. Only two landscapes were eliminated from the final selection.

213

220, 221

Pissarro, like Sisley, was consulted about the final choice by Bénédite in February, 1895. Both of the artists agreed to the list he submitted: six paintings out of nine for Sisley, and seven out of eighteen for Pissarro. They each restricted themselves to

suggesting that a single painting be replaced by another, to which the authorities agreed. Pissarro regretted very much that a large landscape of Louveciennes (Private collection) was rejected; however, *Red Roofs, Village Scene, Winter Effect* and *Orchard with Flowering Fruit Trees, Springtime, Pontoise* are numbered among the artist's most representative works. Pissarro's final opinion was unequivocal, for he confided in his son, Lucien, on April 29, 1897: "Have I told you that I have been to the Luxembourg? I was quite satisfied with my paintings; I believe I am very well represented. It is, for that matter, presented as only officials can manage: in a corridor, the paintings stuck one next to the other. That will not surprise you; experience has shown us so many times the general bad taste of the museums of France." 225
224

Unfortunately, we do not have an equivalent document for Monet. It is easy to imagine how he must have resented the officials' reserve: only eight out of sixteen of his works were selected. The majority were already old paintings (*Luncheon in the Garden*, 1873; *Corner of an Apartment*, 1875; *The Tuileries Gardens*, 1876; *Hoar Frost* and *The Church at Vétheuil [Snow]*, both 1879). The most important work was unquestionably *The Gare Saint-Lazare, Paris: Arrival of a Train* from 1877; but two very advanced studies of the same subject were refused. A sketch by Monet that found favor in this selection was not long in becoming one of the most famous and most often reproduced works in the museum: *Regattas at Argenteuil*. The most recent work by Monet that was selected dated from 1886: *Rocks at Belle-Ile, Brittany*. It is clear, that, in spite of their qualities, these works represent only one, somewhat overly intimist aspect of Monet's art. None of his big figure paintings, for example, were included. When Caillebotte died, Monet was completing his series on *Rouen Cathedral*. The visitors to the Luxembourg Museum would see a very different Monet from the artist that Durand-Ruel's customers discovered: Monet exhibited the *Rouen Cathedral* series there in May, 1895. Yet Monet had no need to fear the opinion of future generations of admirers: in September, 1894, Count Isaac de Camondo bought four of the *Rouen Cathedral* series (Musée d'Orsay, Paris) from him at one time. 229
118
230
137
228

The count, a rich artlover whose banker father had financed Durand-Ruel, had begun recently forming an unprecedented collection of the best Impressionist paintings available on the market, purchased at full price from Durand-Ruel. De Camondo's only French rivals at the time were François Depeaux, Antoinin Personnaz, and a little later, Etienne Moreau-Nélaton. All of those collectors would later donate their collections to museums: the first to the Musée des Beaux-Arts, Rouen, and the two others to the Louvre. The count's other rivals were all Americans: Harry and Louisine Havemeyer, and Bertha Honoré Palmer. Very quickly, it became known that the count intended to donate his paintings as well as his collections of Japanese art and his eighteenth-century furniture to the nation. Thanks to Count Isaac de Camondo, Monet, Renoir, and Degas entered the Louvre during their lifetimes (the count died in 1911), along with Manet, Pissarro, Sisley, Cézanne, and even Toulouse-Lautrec and Van Gogh. Moreover, no one was really surprised any more: the lessons of the Caillebotte bequest had been quickly understood.

The Lessons of the Caillebotte Bequest

By bequeathing a whole collection of "modern" paintings to the nation, Gustave Caillebotte really broke new ground. Never before had anyone in France made such a bold move. The few, rare donations to the Luxembourg Museum were usually made by the families of recently deceased artists and consisted of a few works: four small Meissoniers, for example, were donated by the artist's son in 1893. The donation of a portrait was frequent; either the model was famous, or it was a tactful way of getting rid of a cumbersome family effigy that one would not dare put up for sale. But, as a rule, museum collections in France were purchased by the state. However, with the exception of Sisley and Renoir, the state had not bought works by any of the artists in the Caillebotte collection.

The bequest made by Alfred Chauchard, the ultrawealthy founder of the Magasins du Louvre department stores—whose collection of works by Millet, Corot, the painters of the Barbizon School, and Meissonier was the stuff of dreams for the middle class at the end of the last century—did not enter the Louvre until 1909, i.e., even after the donation made by Etienne Moreau-Nélaton in 1906. And among the hundred canvases donated by that great artlover Moreau-Nélaton, there was room for Manet's *Le Déjeuner sur l'herbe* and for the Impressionists, although Corot and 59 Delacroix predominated. It is true that, again because of lack of space, the Moreau-Nélaton collection had to spend some time in "purgatory" in the Musée des Arts Décoratifs, Paris, before it entered the Louvre. The donor agreed to this, since he insisted that the works in his collection be kept together.

By keeping Gustave Caillebotte's initial project unchanged, Renoir and Martial Caillebotte challenged the authorities' resolve, thus causing the final ramparts of academism to fall and public opinion to grow accustomed to Impressionism.

The vicissitudes of the Caillebotte bequest are but one episode in the triumphant story of Impressionism—a story in which the roles of the good guys and the bad guys were established long ago. It may well be, however, that such a schematic interpretation of the events is oversimplified. It is true that the case in question brought distrust and suspicion into the relations between the state, public opinion, and artists. However, the Caillebotte bequest also proves that the initiative and enthusiasm of one individual, in art as in other fields, can overcome all obstacles and win universal approval.

Selected Sources and Bibliography

Note

Certificates in the French Registrar General's office were examined and in addition, for Paris, the land register, heirs' statements concerning the estate of the deceased, voters' registers, records of proceedings of societies, bankruptcy files, official reports of auctions as well as some documents in private archives. This has made it possible to add or correct several particulars.

The obituaries that appeared in contemporary newspapers as well as the auction prices that were regularly published have not been included here, to prevent the Bibliography from being too long.

General Works

MONNERET, Sophie. *L'Impressionnisme et son époque*, Paris, 1978–1981. Arranged as a dictionary, with entries on dealers and collectors.
REWALD, John. *The History of Impressionism*. New York: The Museum of Modern Art, 1946. 4th rev. ed. New York; London: Secker & Warburg, 1973. With annotated Bibliography. A French translation (1955) also exists.
ROSTAND, Michel. "Quelques amateurs impressionnistes." Thesis, Ecole du Louvre, Paris, 1955.
VENTURI, Lionello. *Les Archives de l'impressionnisme*. 2 vols. Paris; New York: Durand-Ruel, 1939.

The Artists' Correspondence

Cézanne. (John Rewald, ed.): Paris, 1978.
Degas. (Marcel Guérin, ed.): Paris, 1945; Oxford, 1947. The English edition contains a supplement.
Gauguin. (Victor Merlhès, ed.): Paris, 1984–89.
Monet. In: Wildenstein, Daniel. *Claude Monet: Biographie et catalogue raisonné*. Lausanne; Paris, 1974–85.
Berthe Morisot. (Denis Rouart, ed.): Paris, 1950.
Pissarro. (Janine Bailly-Herzberg, ed.): Paris, 1984–86.
Van Gogh. (V. W. van Gogh and J. van Gogh Bonger, eds.): London; New York, 1958; (Georges Charensol, ed.): Paris, 1960.

Diaries

GIMPEL, René. *Diary of an Art Dealer*. New York: Farrar, Straus and Giroux, 1966. Reprint. Translated by John Rosenberg. Introduction by Sir Herbert Read. London: Hamish Hamilton, 1986.
GONCOURT, Edmond de, and GONCOURT, Jules de. *Journal*. 4 vols. Paris, 1956.

Oeuvres Catalogues

BATAILLE, Marie-Louise, and WILDENSTEIN, Georges. *Berthe Morisot: Catalogue des peintures, pastels et aquarelles*. Paris, 1961.
BÉRHAUT, Marie. *Caillebotte: Sa vie, son oeuvre*. Paris, 1978.
BREESKIN, Adelyn Dohme. *Mary Cassatt: A Catalogue Raisonné of the Oils, Pastels, Watercolors, and Drawings*. Washington, D.C.: Smithsonian Press, 1970.
DAULTE, François. *Alfred Sisley: Catalogue raisonné de l'oeuvre peint*. Lausanne: Bibliothèque des Arts, 1959.
— *Auguste Renoir: Catalogue raisonné de l'oeuvre peint*. Vol. 1: *Figures (1860–1890)*. Lausanne: Bibliothèque des Arts, 1971.
LEMOISNE, Paul-André. *Degas et son oeuvre*. 4 vols. Paris: Paul Brame et C. M. De Hauke, 1946–49.
RODO-PISSARRO, Ludovic, and VENTURI, Lionello. *Camille Pissarro: Son art, son oeuvre*. Paris, 1939.
ROUART, Denis, and WILDENSTEIN, Daniel. *Edouard Manet: Catalogue raisonné*. 2 vols. Lausanne-Paris: Bibliothèque des Arts, 1975.
VENTURI, Lionello. *Cézanne: Son art, son oeuvre*. Paris, 1936.
WILDENSTEIN, Daniel. *Claude Monet: Biographie et catalogue raisonné*. 3 vols. Lausanne-Paris: Bibliothèque des Arts, 1974–85.

Exhibition Catalogues

"Hommage à Claude Monet." Paris: Galeries nationales du Grand Palais, 1980. Articles by H. Adhémar, A. Distel, S. Gache, M. Hoog.

"Pissarro." London: Hayward Gallery; Paris: Galeries nationales du Grand Palais; Boston: Museum of Fine Arts, 1980–81. Articles by J. Rewald, R. Brettell, F. Cachin, J.Bailly-Herzberg, C. Lloyd, A. Distel, B. Stern Shapiro, M. Ward.

"Manet." Paris: Galeries nationales du Grand Palais; New York: The Metropolitan Museum of Art, 1983. Articles by F. Cachin, A. Coffin Hanson, C. S. Moffett, M. Melot, J. Wilson Bareau, C. Becker.

"Renoir." London: Hayward Gallery; Paris: Galeries nationales du Grand Palais, 1985–86. Articles by J. House, A. Distel, L. Gowing.

"The New Painting: Impressionism, 1874–1886." Washington, D.C.: National Gallery of Art; San Francisco: The Fine Arts Museum, 1986. Articles by C. S. Moffett, S. F. Eisenmann, R. Shiff, P. Tucker, H. Clayson, R. Brettell, R. Pickvance, F. Wissman, J. Isaacson, M. Ward.

"Berthe Morisot, Impressionist." Washington, D.C.: National Gallery of Art; Mount Holyoke College Art Museum, 1987–88. Articles by C. Stuckey, W. P. Scott, S. G. Lindsay.

"Degas." Paris: Galleries nationales du Grand Palais; Ottowa: The National Gallery of Canada; New York: The Metropolitan Museum of Art, 1988–89. Articles by H. Loyrette, M. Pantazzi, D. W. Druick, P. Zegers, G. Tinterow, J. Sutherland Boggs.

Selected Bibliographies by Chapter (Chronological)

Ch. I Before 1870

DUMAS, Paul. "Quinze tableaux inédits de Renoir." *La Renaissance de l'Art français et des Industries de luxe,* July, 1924.

COOPER, Douglas. "Renoir, Lise and the Le Coeur Family: A Study of Renoir's Early Development." *Burlington Magazine,* May, September, October, 1959.

Ch. II The Parisian Art Market During the Impressionist Era: Durand-Ruel

Galerie Durand-Ruel: Spécimens les plus brillants de l'école moderne. Paris: Durand-Ruel, Rue Neuve des Petits-Champs 82, 1845.

LECOMTE, Georges. *L'Art impressionniste d'après la collection privée du M. Durand-Ruel.* Paris: Chammerot & Renouard, 1892.

ALEXANDRE, Arsène. "Durand-Ruel: Portrait et histoire d'un marchand." *Pan,* November, 1911.

FÉNÉON, Félix. "M. Paul Durand-Ruel." *Bulletin de la Vie artistique,* April 15, 1920. In: *Oeuvres plus que complètes.* Edited by J. U. Halperin. Paris; Geneva, 1970.

CABANNE, Pierre. *Le Roman des grands collectionneurs.* Paris, 1961.

WHITELEY, Linda. "Accounting for Tastes." *The Oxford Art Journal* 2, no. 1 (1979).

Institut de France: Academy of Fine Arts. Speech given by Mr. Charles Durand-Ruel, elected corresponding member of the Academy of Fine Arts, October 26, 1983. Published in 1984.

ISAACSON, Robert. "Les Collectionneurs de Bouguereau en Angleterre et en Amerique (Collectors of Bouguereau in England and America)." In: exh. cat. "Bouguereau," Paris; Montreal; Hartford, Conn., 1984–85.

Ch. III The Parisian Art Market During the Impressionist Era: The Other Dealers

ZOLA, Emile. *Carnet d'enquêtes: une ethnographie inédite de la France.* Edited by H. Mitterand. Paris, 1987.

NONNE, Monique. "Les marchands de van Gogh." In: exh. cat. "Van Gogh à Paris." Paris: Musée d'Orsay, 1988.

Carpentier and Deforge:

DAVENPORT, Nancy. "Armand Auguste Deforge, An Art Dealer." *Gazette des Beaux-Arts,* February, 1983.

Cadart:

BAILLY-HERZBERG, Janine. *L'Eau-forte de peintre au dix-neuvième siècle: La Société des Aquafortistes, 1862–1867.* Paris, 1972.

Legrand:

RIVIÈRE, Georges. *Renoir et ses amis.* Paris, 1921.

Martin:

DURET, Théodore. "Lettres de Manet et de Sisley." *La Revue blanche*, no. 139 (1899).
ALEXANDRE, Arsène. *A.-F. Cals.* Paris, 1900.
KNYFF, Gilbert de. *Boudin.* Paris, 1976.

Tanguy:

MIRBEAU, Octave. "Le Père Tanguy." *L'Echo de Paris,* February 13, 1894.
Tableaux modernes... vente... au profit de Mme Vve Tanguy. Auction cat. Paris: Hôtel Drouot, June 1, 1894.
BERNARD, Emile. "Julien Tanguy, dit le Père Tanguy." *Mercure de France,* December 16, 1908.
RIVIÈRE, Georges, *Paul Cézanne.* Paris, 1923.
LE GOAZIOU, Alain. *Le Père Tanguy.* Paris, 1951.
PERRUCHOT, Henri. "Le Père Tanguy." *L'Oeil,* June 15, 1955.
TRALBAUT, Marc Edo. "André Bonger: L'Ami des frères van Gogh." *Van Goghiana.* vol. 1. Antwerp, 1963.
ANDERSEN, Wayne. "Cézanne, Tanguy, Choquet [sic]." *Art Bulletin,* June, 1967.

Theo van Gogh:

REWALD, John. "Theo van Gogh, Goupil and the Impressionists." In: *Studies in Post-Impressionism.* Edited by I. Gordon and F. Weitzenhoffer. London, 1986.

Bernheim-Jeune:

L'Art Moderne et quelques aspects de l'art d'autrefois. Paris, 1919.
BERNARD, Tristan. "Jos Hessel." *La Renaissance de l'Art français et des Industries de luxe,* January, 1930.
DAUBERVILLE, Henry. *La Bataille de l'Impressionnisme*; followed by DAUBERVILLE, Jean. *En encadrant le siècle.* Paris, 1967.
HALPERIN, Joan Ungersma. *Félix Fénéon.* Paris; New Haven, Conn.; London, 1988.

Vollard:

VOLLARD, Ambroise. *La Vie et l'oeuvre de P. A. Renoir.* Paris, 1919.
— *Paul Cézanne.* Paris, 1924. English trans.: *Paul Cézanne: His Life and Art.* New York, 1926.
— *Recollections of a Picture Dealer.* Boston: Little, Brown, 1936. Original French ed.: *Souvenirs d'un marchand de tableaux.* Paris, 1937.
— *En écoutant Cézanne, Degas et Renoir.* Paris, 1938.
VLAMINCK, Maurice de. *Portraits avant décès.* Paris, 1943.
JOHNSON, Una E. *Ambroise Vollard, Publisher.* New York, 1977.

Ch. IV The Parisian Art Market During the Impressionist Era: Auctions

BODELSEN, Merete. "Early Impressionist Sales 1874–1894 in the Light of Some Unpublished Procès-verbaux." *Burlington Magazine,* June, 1968.

Ch. V Private Collectors: Théodore Duret, Etienne Baudry, Albert and Henri Hecht

Duret:

Tableaux... composant la collection de M. Théodore Duret. Preface by Théodore Duret. Auction cat. Paris: Galerie Georges Petit, March 19, 1894.
"Impressionisme et quelques précurseurs." *Bulletin des expositions* 3 (Jan. 22–Feb. 13, 1932). Letters to Duret.
FLORISOONE, Michel. "Renoir et la famille Charpentier." *L'Amour de l'Art,* February, 1938, Letters to Duret.
TABARANT, Adolphe. *Manet et ses oeuvres.* Paris, 1947. Chs. LVIII and LIX on Manet's studio sale.
FELS, Florent. "Théodore Duret." *Jardin des Arts,* October, 1963.
BIZARDEL, Yvon. "Theodore Duret: An Early Friend of the Impressionists." *Apollo,* August, 1974.
DISTEL, Anne. "Some Pissarro Collectors in 1874." In: *Studies on Camille Pissarro.* Edited by C. Lloyd. London; New York, 1986.
MACDONALD, Margaret, and NEWTON, John. "Correspondence Duret-Whistler." *Gazette des Beaux-Arts,* November, 1987.
INAGA, Shigemi. "Théodore Duret." Ph. D. dissertation, University of Paris VII, May, 1988.

Baudry:

BONNIOT, Roger. *Gustave Courbet en Saintonge.* Paris, 1973.

Hecht:

DISTEL, Anne. "Albert Hecht collectionneur (1842–1889)." *Bulletin de la Société de l'Histoire de l'Art français*, 1981. Published in 1983.

Ch. VI *Jean-Baptiste Faure*

Tableaux modernes composant la collection de M. Faure. Auction cat. Paris: 26 Boulevard des Italiens, June 7 1873.
Tableaux modernes dépendant de la collection de M. Faure. Auction cat. Preface by Emile Bergerat. Paris: Hôtel Drouot, April 29, 1878.
Notice sur la Collection Jean-Baptiste Faure suivie du catalogue des tableaux formant cette collection. Paris, 1902.
CURZON, Henri de. *Jean-Baptiste Faure.* Paris, 1923.
CALLEN, Anthea. "Faure and Manet." *Gazette des Beaux-Arts*, March, 1974. Part of a thesis: "Jean-Baptiste Faure (1830–1914): A Study of a Patron and Collector of the Impressionists and Their Contemporaries," University of Leicester, 1971.
"Degas et Faure." In: exh. cat. "Degas," *op. cit.*

Ch. VII *Ernest Hoschedé*

Tableaux modernes. Auction cat. Preface by Ernest Chesneau. Paris: Hôtel Drouot, January 13, 1874.
Collection H...: Tableaux modernes. Auction cat. Preface by Ernest Chesneau. Paris: Hôtel Drouot, April 20, 1875.
Vente judiciaire de tableaux modernes et anciens... composant la collection Hoschedé. Auction cat. Paris: Hôtel Drouot, June 5–6, 1878.
JAVEL, Firmin. "Le Mouvement parisien." *L'Evénement*, October 31, 1885.
GACHET, Paul. *Deux Amis des impressionnistes: Le Dr Gachet et Murer.* Paris, 1956.
WILDENSTEIN. *Monet... catalogue raisonné.* vol. 1, pp. 80–83, 91–92; vol. 2: pp. 40–41.
ADHÉMAR, Hélène. "Ernest Hoschedé." In: *Aspects of Monet.* Edited by J. Rewald and F. Weitzenhoffer. New York, 1984.

Ch. VIII *Georges de Bellio and Constantin de Rasty*

DURET, Théodore. *Histoire des peintres impressionnistes.* Paris, 1906. Enlarged Eng. edition: *Manet and the French Impressionists.* Philadelphia; London, 1910.
NICULESCU, Remus. "Georges de Bellio, l'ami des impressionistes." *Paragone*, September and November, 1970.

Ch. IX *Victor Chocquet*

Tableaux modernes... vente par suite du décès de M^me^ *V*^ve^ *Chocquet.* Auction cat. Prefaces by T. Duret and L. Roger-Milès. Paris: Galerie Georges Petit, July 1, 3–4, 1899.
REWALD, John. "Chocquet and Cézanne." *Gazette des Beaux-Arts,* July–August, 1969. With earlier Bibliography.

Ch. X *Georges and Marguerite Charpentier*

Tableaux, aquarelles, pastels et dessins... composant la collection de feu M. Georges Charpentier, editeur. Auction cat. Paris: Hôtel Drouot, April 11, 1907.
RIVIÈRE. *Renoir et ses amis.* Ch. X: "Les Soirees chez M^me^ Charpentier."
FLORISOONE, Michel. "Renoir et la famille Charpentier." *L'Amour de L'Art,* February, 1938.
ROBIDA, Michel. *Le Salon Charpentier et les impressionnistes.* Paris, 1958.
MOLLIER, Jean-Yves. *L'Argent et les lettres: Histoire du capitalisme d'édition, 1880–1920.* Paris, 1988.

Ch. XI *Jean Dollfus*

Tableaux modernes... dépendant des collections de M. Jean Dollfus par suite de son décès. Auction cat. Preface by André Michel. Paris: Galerie Georges Petit, March 2, 1912.

Ch. XII Charles Deudon, Charles Ephrussi, and Paul Berard

Deudon:

DISTEL, Anne. "Charles Deudon (1832–1914): Amateur et collectionneur." *La Revue de l'Art*, in press.

Ephrussi:

KOLB, Philippe, and Adhémar, Jean. "Charles Ephrussi (1849–1905): Ses secretaires: Laforgue, A. Renan, Proust; 'sa' *Gazette des Beaux-Arts*." *Gazette des Beaux-Arts*, January, 1984.
PAUL, Barbara. "Drei Sammlungen französischer impressionistischer Kunst im kaiserlichen Berlin— Bernstein, Liebermann, Arnhold." *Zeitschrift des Deutschen Vereins für Kunstwissenschaft* 42, no. 3 (Berlin, 1988). Published in 1989.

Berard:

Tableaux modernes … provenant de la collection de feu M. Paul Berard. Auction cat. Preface by L. Roger-Milès. Paris: Galerie Georges Petit, May 8–9, 1905.
BERARD, Maurice. "Renoir en Normandie et la famille Berard." *L'Amour de l'Art*, February, 1938.
BLANCHE, Jacques-Emile. *Portraits of a Lifetime.* London, 1937.
— *La Pêche aux souvenirs.* Paris, 1949.
DAULTE, François. "Renoir et la famille Berard." *L'Oeil*, February, 1974.
Vente d'autographes. Auction cat. Paris: Hôtel Drouot, February 16, 1979, and June 11, 1980. Letters from Renoir to Berard.

Ch. XIII Count Armand Doria and Nicolas Hazard

Doria:

Album souvenir de la collection Armand Doria, preceded by an essay on the life of Count Armand Doria by Arsène Alexandre. Preface by L. Roger-Milès. Paris, 1899.
ALEXANDRE. *Cals.*

Hazard:

Tableaux modernes … composant la collection de M. Hazard (quatrième vente). Auction cat. Paris: Hôtel Drouot, December 29–30, 1919.

Ch. XIV Henri Rouart

Henri Rouart:

Collection Henri Rouart: Première vente, tableaux anciens … modernes … composant la collection de feu M. Henri Rouart. Auction cat. Preface by Arsène Alexandre. Paris: Galerie Manzi- Joyant, 15 Rue de la Ville l'Evêque, December 9–11, 1912.
Collection Henri Rouart: Deuxième vente, dessins, pastels. Auction cat. Paris: Galerie Manzi- Joyant, December 16–18, 1912.
BAYET, Jean. "Vente Rouart." *Larousse mensuel*, no. 73 (March, 1913).
GORDON, Dillian. "Edgar Degas: Hélène Rouart in her Father's Study." exh. cat. London: National Gallery, 1984.

Alexis Rouart:

Objets d'art et de curiosité de la Chine et du Japon … composant la collection de feu M. Alexis Rouart (deuxième vente). Auction cat. Preface by P. A. Lemoisne. Paris: Hôtel Drouot, May 1–4, 1911.
Collection Alexis Rouart (quatrième vente): Tableaux, aquarelles et dessins modernes. Auction cat. Paris: Hôtel Drouot, May 8–10, 1911.

Ch. XV Dr. Paul Gachet

DOISTEAU, Victor. "La curieuse figure du Dr Gachet." *Aesculape*, August-December, 1923; January, 1924.
GACHET. *Deux Amis.*
— *Lettres impressionnistes.* Paris, 1957.
[VANDENBROUCKE, U. F., and SONOLET, J.]. "Qui etait le Dr Gachet?" exh. cat. Auvers-sur-Oise: town hall, May, 1980.

Ch. XVI Eugène Murer

GACHET. *Deux Amis.*
REILEY-BURT, Marianna. "Le Patissier Murer." *L'Oeil*, December, 1975.

Ch. XVII Emmanuel Chabrier

Tableaux, pastels . . . composant la collection Emmanuel Chabrier. Auction cat. Preface by André
 Maurel. Paris: Hôtel Drouot, March 26, 1896.
DELAGE, Roger. "Chabrier et ses amis impressionnistes." *L'Oeil*, December, 1963.
— "Manet et Chabrier." *Revue de l'Art*, no. 62 (1984).

Ch. XVIII Ernest May

Catalogue de tableaux anciens et modernes . . . composant l'importante collection de M. E. May.
 Auction cat. Paris: Galerie Georges Petit, June 4, 1890.

Ch. XIX The Market for Impressionism Outside France: Great Britain

PICKVANCE, Ronald. "Henry Hill: An Untypical Victorian Collector." *Apollo*, December, 1962.
— "L'Absinthe in England." *Apollo*, May, 1963.
KAUFMANN, C. M. *Victoria and Albert Museum: Catalogue of Foreign Paintings.* Vol. 2: *1800–1900.*
 London, 1973.
SUTTON, Denys. "Degas and England." In: *Degas inédit (Actes du colloque Degas, Paris, Musée
 d'Orsay, 1988).* Paris, 1989.

Ch. XX The Market for Impressionism Outside France: the United States

BÉNÉDITE, LÉONCE. "Les Collections d'art aux Etats-Unis." *La Revue de l'Art*, March, 1908.
BRIMO, René. *L'Evolution du goût aux Etats-Unis.* Paris, 1938.
FINK, Lois Marie. "French Art in the United States, 1850–1870." *Gazette des Beaux-Arts*, September,
 1978.
The Diaries 1871–1882 of Samuel P. Avery, Art Dealer. Edited by M. Fidell Beaufort; H. L. Kleinfeld;
 and J. K. Welcher. New York, 1979.
The Diary of George A. Lucas: An American Agent in Paris, 1857–1909. Edited by L. M. C. Randall.
 Princeton, 1979.
BEAUFORT, Madeleine Fidell, and WELCHER, Jeanne K. "Some Views of Art Buying in New York in the
 1870s and 1880s." *The Oxford Art Journal* 5, no. I (1982).

Ch. XXI The Havemeyers and the First American Collectors of Impressionism

MURPHY, Alexandra R. "French Paintings in Boston: 1800–1900." In: exh. cat. "Corot to Braque:
 French Paintings from the Museum of Fine Arts, Boston." Boston: Museum of Fine Arts, 1979.
WEITZENHOFFER, Frances. "First Manet Paintings to Enter an American Museum." *Gazette des
 Beaux-Arts*, March, 1981.
— "The Earliest American Collectors of Monet." In: *Aspects of Monet.* Edited by J. Rewald and
 F. Weitzenhoffer. New York, 1984.
— *The Havemeyers: Impressionism Comes to America.* New York: Abrams, 1986.
HALL, Helen. *Hill-Stead Museum House Guide.* Farmington, Conn., 1988.

Ch. XXII Gustave Caillebotte

RIVIÈRE. *Renoir et ses amis.*
VAISSE, Pierre. "Le Legs Caillebotte d'après les documents"; and BÉHRAUT, Marie. "Le Legs Caille-
 botte: Vérités et contre-vérités." *Bulletin de la Société de l'Histoire de l'Art français.* (1983).
 Published in 1985.
VARNEDOE, Kirk. *Gustave Caillebotte.* Paris, 1988.

List of Illustrations

The following list is arranged alphabetically according to the artists' names and the titles of their works. It includes all the paintings, drawings, engravings, pastels, and so forth, but does not include the photographs and letters. The numbers refer to the page numbers on which the illustrations can be found.

Acknowledgments

I want to thank the descendants of all the artists, collectors, picture dealers, gallery directors, and auctioneers who helped me. Without them, this book could not have been written. In particular, my thanks go to Elie Adam, François Bernet-Rollande, Mrs. Boulart, Philippe Brame, Philippe Cézanne, Claude and Robert Chambolle-Tournon, Jacques and Jean Chardeau, Guy-Patrice Dauberville, Mrs. M. Déon, Mrs. P. Deudon, Jean-Paul Deudon, Count Arnault Doria, Jean-François Dutar, Mrs. Escoffier, Mrs. Froissart, Diana Kunkel, Claude and François Le Coeur, Dr. and Mrs. Pol Le Coeur, Ségolène Le Men, Mrs. De Fréminet, Thierry Magrangeas, Mr. Marcus, Mr. Marin, Mrs. Martin-Lavigne, Matthieu Georges May, Dr. Jean-Pierre May, Mrs. Melia-Christian Renaudeau d'Arc, Michel Robida, Mrs. Agathe Rouart-Valéry, Mrs. Sandrea, André Schoeller, Mrs. Septier, Jean-Marie Toulgouat, Mrs. Trenel-Pontremoli, Mrs. Winocour, and all those who preferred to remain anonymous.

I would also like to pay special tribute to the memory of Charles Durand-Ruel (1905–1985), who gave me free access to the archives of the firm of Durand-Ruel, thus enabling me to start this investigation of the Impressionists' earliest collectors and dealers. Caroline Durand-Ruel Godfroy, Charles's daughter, and France Daguet helped me throughout my research. May they find in these lines proof of my gratitude.

Many thanks are also due to my colleagues, those at the Musée d'Orsay and those who work for other institutions, as well as to the curators and people responsible for the archives, registry offices, and libraries that I consulted: Luce Abélès, Hélène Adhémar, Marc Bascou, Marie Bérhaut, Roger Bonniot, Marie-France Crosnier-Lecomte, Anne Dary, Micheline Dion, Claire Frèches, Chantal Georgel, Véronique Goarin, Françoise Heilbrun, Professor Robert L. Herbert, Martine Kahane, Claire Joyes, Geneviève Lacambre, Antoinette Lenormand-Romain, Christopher Lloyd, Henri Loyrette, Laure de Margerie, Marie-Madeleine Massé, Caroline Mathieu, Charles S. Moffett, Philippe Néagu, Jean-Michel Nectoux, Monique Nonne, Anne Norton, Sylvie Patin, Mr. Pecriaux, Anne Pingeot, Rodolphe Rapetti, Anne Roquebert, Pierre Rosenberg, Marie de Thézy, Philippe Thiébaut, Gary Tinterow, Hélène Toussaint, Michael Zimmermann.

Photo Credits

Index of Proper Names

This book was printed and bound in January, 1990,
by Manfrini R. Arti Grafiche Vallagarina S.p.A., Calliano (Trento), Italy
Setting: Typobauer Filmsatz GmbH, Ostfildern-Scharnhausen, FRG
Photolithographs: Eurocrom 4, Treviso, Italy (color)
and Cliché + Litho AG, Zurich, Switzerland (black-and-white).
Editing: Constance Devanthéry-Lewis

284 Printed and bound in Italy